D1068022

A Boatload of Madmen

A Boatload

SURREALISM AND THE
1920

DICKRAN TASHJIAN

of Madmen

AMERICAN AVANT-GARDE

1950

THAMES AND HUDSON
NEW YORK, NEW YORK

First published in the United States of America in 1995 by Thames and Hudson Inc., 500 Fifth Avenue, New York, New York, 10110.

First published in Great Britain in 1995 by Thames and Hudson Ltd., London.

Library of Congress Catalog Card Number 94-60289
ISBN 0-500-23687-9 (USA)

British Library Cataloguing-in-Publication Data
A catalogue record for this book is available from the British Library
ISBN 0-500-97416-0 (UK)

Designed by Beth Tondreau Design / *Beth Tondreau and Robin Bentz*

Printed and bound in the United States of America

Christopher Columbus should have set out to
discover America with a boatload of madmen. And
note how this madness has taken shape, and endured.
—André Breton,
MANIFESTO OF SURREALISM,
1924.

This was the artist in America, a dinghy on a rough sea.
—Jimmy Ernst,
A NOT-SO-STILL LIFE,
1984.

Contents

List of Illustrations

Acknowledgments

I want to thank the National Endowment for the Humanities for a senior fellowship in 1976 and the John Simon Guggenheim Memorial Foundation for a fellowship in 1980, allowing me to complete the bulk of research for this project. The Academic Senate and the Program in Comparative Culture of the University of California, Irvine, also provided funding, resources, and sabbatical leave.

I was most fortunate in being able to enjoy the hospitality of several great libraries, here and abroad. The Harris Collection of the John Hay Library at Brown University once again provided me with the basis for my research; the Beinecke Library and the Sterling Library at Yale University; the New York Public Library; the library of The Museum of Modern Art; the library of The Art Institute of Chicago; the Harry Ransom Humanities Research Center at the University of Texas in Austin; the Archives of American Art of the Smithsonian Institution in Washington, D.C., New York, and Los Angeles; the Bancroft Library at the University of California, Berkeley; the research and art libraries at U.C.L.A.; Special Collections at U.C. Irvine; the Bibliothèque Nationale and the Fonds Doucet in Paris.

While the staffs of these libraries were unfailingly helpful, I must single out Barbara Wilson and Judith Throm, who went far beyond the call

of duty; Clive Phillpot, who always managed to accommodate me on short notice; Mary Russo and Rosemary Cullen, who tirelessly and cheerfully retrieved materials from the Harris Collection.

Many individuals helped in specific ways. In the gathering of illustrations, Judith Young-Mallin was especially generous and enthusiastic while Timothy Baum and Jason McCoy got me through some crucial impasses; Merry Foresta lent her time and experience in tracking down material; John Baker, Lynda Roscoe Hartigan, Tobey Moss, Martin Diamond, Mikki Carpenter, Sam Trower and Richard Feigen: they were just plain helpful, and with good cheer, no less. Viviane Wayne confirmed my translations from the French and refrained from smirking at my more egregious errors. In the bookmaking itself, Peter Warner took his chances, as did his editorial assistant, Laurance Rosenzweig, and Cary Warner did much more than smooth over the bumpy prose.

Others have provided support in ways that cannot be measured. A bow, then, to my colleagues in Comparative Culture, especially Dave Bruce, in better times; Elizabeth Schiller, Edna Mejia, and June Kurata, the staff of Comparative Culture; Charles Henri Ford, who has looked on from afar; Michel Oren, on Saturday morning treks; Miriam Hanson, who shared my puzzlements in the early stages of my research; Gwen Raaberg, who kept in touch over the years; Ray Smith, who kept me abreast of books, and more recently, irrepressibly, Richard Press; Naomi Sewalson-Gorse, whose long conversations ran up the phone bills but lowered the blood pressure; Lois Monteiro for more than hospitality but certainly that for so long; George Hunt, who kept me sane in the carpool lane during Irvine's reign of surrealism; Nate Sumner, for his magnificent excesses; Bonnie and Jim Clearwater, whose enthusiasms and energies have been contagious; George Monteiro and William Jordy, whose scholarship set the high standards for my own forays; Sam and Betty Eisenstein, Leonard Kaplan, Holly and Charles Wright, Bethany Mendenhall and Charles Lave for their necessary care.

Finally, for Charlie, Dick, and Phil: they would understand why this one's for Hannah.

Dickran Tashjian, Laguna Beach, 1994

Preface

Cultural history is rarely straightforward. Its discontinuities, misdirections, and contradictions are all compounded by contacts between cultures. In 1975, when I finished *Skyscraper Primitives*, a study of European Dada and the early American avant-garde, I thought that a sequel exploring the impact of Surrealism on American art would follow smoothly. Nothing like sequence emerged. Not only were the cross-cultural relations unpredictable, spilling over the boundaries of the avant-garde into other cultural areas, but the European development of Surrealism out of Dada had little or no relevance on the American shore.

The ironic reversals of my extended project soon became apparent. None of my expectations were met. Initially anticipating that the nonsense of Dada would hopelessly shatter any coherent cultural development, I was surprised to discover that American Dada was a relatively self-contained episode in our cultural history. Lulled by this unexpected turn of events, I thought that Surrealism, often described as a coherent movement rigorously led by André Breton, would proceed accordingly on American ground. No such luck, or perhaps all the luck in the world, for I have a far more interesting story to tell about Surrealism and its American encounters than a conventional narrative of "influence" yields. A preliminary outline of how I came to perceive the cultural trajectories of Dada, Surre-

alism, and the emerging American avant-garde sets the stage for the story that follows.

IN THE 1960S when I first began to trace the presence of Dada among American artists and writers, the project seemed formidable. Dada, after all, meant nothing: the word was nonsensical in origin and intent. I gradually came to the conclusion that Dada did not even conform to the avant-garde metaphor of movement, which implies coherence, if not orderly progression—characteristics that were vehemently opposed by every Dadaist worthy of the name. Subversive and deliberately ephemeral, Dada was understandably neglected by American art historians, who thought of it as a minor episode in their reconstruction of the origins of an American avant-garde during the early decades of this century.

Yet Dada *was* definable, though not by the ordinary canons of logic. As a nonsense term, Dada was devoid of fixed connotation and hence could mean anything among infinite semantic contradictions, from a baby's first cry to a French hobbyhorse. Although the origins of Dada remain controversial and mysterious to this day, the word itself can be traced back to Zurich, during the height of the First World War. Draft-dodgers, deserters, and the wounded from many warring nations drifted to that neutral zone in 1916. Many also happened to be artists and intellectuals disillusioned and sickened by the slaughter of the "great" war. They gathered at a small café called the Cabaret Voltaire, opened by the Alsatian poet Hugo Ball and his partner Emmy Hennings. In trading upon Voltaire's name, the proprietors emphasized his iconoclasm and wit while studiously ignoring his rationalism. As the birthplace of Dada, the Cabaret Voltaire paradoxically became a turbulent haven from the destruction raging throughout Europe.

From Zurich, Dada spread to Berlin and then to Paris in 1920. Earlier, Dada had infiltrated New York, though characteristically enough, before the word even came into existence in 1916. The French army commissioned the Spanish painter Francis Picabia to purchase a supply of sugar from Cuba. He arrived in Manhattan in April 1915, and vastly preferring to renew his friendship with the photographer Alfred Stieglitz, whom he had met on a previous visit in 1913, promptly abandoned his mission. Picabia was soon joined by his friend Marcel Duchamp, who had caused such a scandal at the celebrated 1913 Armory Show with his *Nude*

Descending a Staircase: New Yorkers called it an "explosion in a shingle factory." The two painters were fascinated by advanced machine technology, epitomized they thought by the burgeoning skyscrapers of New York. Eventually, Americans caught up in Dada were dubbed "skyscraper primitives" for their celebration of an American culture and society transformed by technology.

With "skyscraper primitives" I had found not only a title for my first study, but a narrative frame as well.[1] For all its scattershot energies, Dada was relatively self-contained in New York. A small group of painters and poets surrounding Duchamp and Picabia congregated either at Stieglitz's small gallery known as 291 or at the apartment of Walter Arensberg, a wealthy collector of avant-garde art. Expressing their views in a succession of little magazines, among them Stieglitz's *291,* Duchamp's *Blindman,* and Robert Coady's *Soil,* they focused on the machine from a variety of perspectives and attitudes, ranging from despair and nihilism to broad humor. New York Dada existed sporadically for a short period of six years, from 1915 to 1921, when Duchamp and Man Ray decamped for Paris. American interest in Dada shifted with them.

The Parisian episode was equally self-contained, even while it was connected to the earlier phase in New York. Through Man Ray, who, thanks to Duchamp, had gained quick entrée to the Paris avant-garde, Matthew Josephson, a recent graduate of Columbia University, met André Breton, Philippe Soupault, and Louis Aragon, all of whom had been won over to Dada by the Rumanian poet, Tristan Tzara, one of the instigators of the movement in Zurich. These young French poets, disillusioned survivors of the war, were enthusiastic nonetheless about the vitality of American life, its "primitive" qualities exemplified by American movies, jazz, skyscrapers, and advertising. So Josephson and his friends proselytized an American Dada in the pages of a little magazine called *Broom.* They engineered a brief and final flare-up in New York upon their return in 1924.

This Dada scenario led me to believe that a sequel on Surrealism and American art would take roughly the same shape—perhaps with even greater ease. Surrealism was positively stable in comparison to Dada. Nor was there any difficulty in identifying the origins of Surrealism. It began in Paris with the publication of Breton's *Manifesto of Surrealism* in 1924 as a reaction against the anarchy and aimlessness of Dada. I also found defini-

tions easy to come by, Breton having unequivocally offered his own in the *First Manifesto.* Borrowing a dictionary format, he equated Surrealism with "psychic automatism" as a means of expressing the unconscious directly through writing while assiduously avoiding rational control.[2] His concise definition has been kept in currency by literary and art historians ever since.

In committing himself to an exploration of the unconscious, the imperious and charismatic Breton remained at the center of Surrealism, surrounded first by his Dada friends Aragon, Soupault, and Paul Eluard. They were soon joined by visual artists such as Man Ray, André Masson, Max Ernst, and eventually Salvador Dali. Unlike the explosions of Dada, Surrealism remained an exemplary avant-garde movement, as Breton tried to maintain and direct a coherent group in search of the marvelous. Perhaps most important from an art historian's point of view was the fact that the Surrealists' preoccupation with the unconscious and its irrational manifestations was balanced by Breton's cerebral character, as he spun out ideas that could be distilled for a systematic comprehension of his movement.

Historical circumstances quickly overtook the prospect of a coherent Surrealism. Breton's quest for the marvelous, announced in 1924, within a year also became a political odyssey on the left, requiring tireless improvisation against the pressure of events. France suffered one crisis after another, while the Soviet Union went through its own policy reversals and betrayals. Precisely because of the ensuing conflicts, Surrealism was more fluid and improvisatory than the emphatic tone the original definition implied. Breton revised and refined his ideas under the pressure of events. He was both embattled *and* contemplative, constrained to engage in intellectual *bricolage* from the very beginning.

The complexities that informed the development of Surrealism compelled me to take Breton as my beacon rather than any fixed definition in charting the relationship of his movement to American culture and society. I have set my compass by his shifting concerns. But once again cultural history became problematic, almost overwhelming in its unpredictability, when I turned to American responses. I repeatedly found discontinuities where I had expected connections, especially during the 1920s. For one, Matthew Josephson's proposal for an American Dada never led to a home-grown Surrealism and thus failed to conform to the

European model whereby Paris Dada gave way to Breton's Surrealist project. By the end of the decade, Josephson's cohort Malcolm Cowley urged his generation to turn their backs on avant-garde activity in favor of a commitment to the left, led by the American Communist Party.

Because those whom I expected to be leading American participants in Surrealism threw me off course, I was left with a puzzling situation. The encounters between Americans and the French Surrealists hardly corresponded to what common historical wisdom, almost folklore, would have us believe. American expatriation in the 1920s should have led to extensive participation in international art movements. Similarly, the 1929 Crash on Wall Street should have depressed avant-garde activity. As Cowley's "lost generation" returned home to the Depression, Social Realism supposedly became the order of the day.

Yet Surrealism went against the grain of our conceptions of those two decades. The silence of American writers and artists during the early 1920s when Surrealism was in the making was nothing less than deafening, as though contacts with the French avant-garde, carried on during the previous decade, had almost not occurred. It was mainly during the 1930s that the American public came to know the Surrealists, who were then exhibited in American museums and galleries, discussed in symposia and lectures, and published not only in the little magazines and anthologies of the avant-garde but also in the commercial press. There the Surrealists gained virtual celebrity status in high fashion and advertising.

How, then, might we explain this turn of events, which runs counter to the facile generalizations that have been handed down to us about the 1920s and 1930s? On a ground level, the noted historian Daniel Aaron has cautioned against precisely such stereotypical views of the two decades between the wars.[3] On top of that, we need to question prevalent explanations that account for the cultural discontinuities between Europe and America during the 1920s. These explanations conventionally point to American provincialism and the slowness of international communication. Just on their face alone, such explanations are inadequate, especially the charge of provincialism. Americans oppressed by Victorian sexual mores and Prohibition certainly may have gaped at café life along the boulevards of Paris, but they were hardly any more provincial than Parisians, whose image of America was shaped by westerns and detective stories purveyed by the mass media. These American stereotypes were en-

thusiastically advanced by any number of sophisticated French artists and intellectuals during the years following the First World War.

More to the point, a small but growing public for avant-garde art began to develop in the United States during the 1920s: sufficient for Georgia O'Keeffe to live by the sale of her paintings; for the wealthy patron and painter Katherine Dreier to mount traveling exhibitions of her Société Anonyme, Inc.; for The Museum of Modern Art to open its doors in 1929. This growing awareness of modernism in general provided the basis for an interest in Surrealism as it developed in the 1920s and 1930s. Accompanying a tempered estimate of public hostility and indifference to avant-garde activity during the 1920s should be the realization that the mass media were in full gear by this decade. News of the latest Parisian fashions—in art and ideas as well as *haute couture*—traveled fast.

What emerges is this: Surrealism was hardly transferred in pristine form to an American avant-garde, which in any case did not exist whole to receive it during the 1920s. Fragments were shored against fragments. At the same time that Surrealism made its presence known to the public in France and abroad, Americans actively responded to the movement. Thus American writers and artists did not comprise a collective *tabula rasa* to bear passively a Surrealist imprint. A major part of their response involved their participation in the communication of Surrealism according to their own vested interests. The cultural diffusion of Surrealism was a process of mutual and often uncoordinated interaction among French and American participants, each with their own motives and goals. This process was never neat and orderly, any more than it occurred exclusively within the narrow confines of the art world.[4]

In running its course, then, Surrealism unpredictably careened out of Breton's control, beyond national boundaries and beyond the orbit of the avant-garde itself. The metaphor of avant-garde "movement" seems to have taken on a manic energy that only a Dali could generate, overshadowing the measured thought of Breton. Ultimately, accounting for the diversity of the American reception—the enthusiasm and skepticism, the exploitation and misreadings, the deceptions and self-deceptions—requires a new model of the avant-garde, predicated upon conflict instead of progress.[5] An avant-garde movement, therefore, should be seen as intrinsically volatile, threatening the very sense of community that it fosters.

Liberated from the idea that avant-garde movements are supposed to

succeed one another, we can entertain the historical possibilities of avant-garde risk and failure. Freed from an apotheosis of the avant-garde, we can examine the rubble of avant-garde movements; we can explore the origins of an avant-garde group in the wake of another movement. In sum, we can study the conflicts leading to the formation (and deformation) of an American avant-garde.[6] From this perspective we can explore the complexities of this period by understanding how artists and writers negotiated what had become the polarized notions of avant-garde activity and political commitment on the left. Surrealism provided a major forum for such concerns.

While an American avant-garde did not spring full-blown from the 1913 Armory Show in New York, its slow gestation during the 1920s accelerated with increased news of Surrealism during the 1930s and reached full pitch during the Second World War at a time when the Surrealists reached these shores in exile. Their presence in the close quarters of New York intensified the reactions and aspirations of American artists and writers, who moved between skepticism and attraction. This ambivalence, so crucial for the formation of an American avant-garde, soon dissipated. The end of the war simply became the occasion for the departure of the Surrealists, who had already ceded the cultural terrain to the Americans. A European retreat, however, did not mark the triumph of an American avant-garde, which lost ground to a consumer society energized by postwar prosperity. These ironies, which were brought on by a clash of cultural priorities and interests, colored the interactions of Surrealism with the nascent American avant-garde, and the mass media.

At a time when there has been a renewed interest in Surrealism—when art historians and cultural critics have been exploring the entire gamut of its reach, from politics to gender—there has been no detailed study of Surrealism in its American setting. While I do not claim to be comprehensive, I have tried to trace the resonance of Surrealism among American artists, writers, and intellectuals over a thirty-year period. Its presence added a complex chapter to American cultural history.

A Boatload
of Madmen

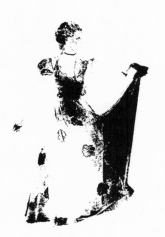

Introduction

I never even thought of what I was saying. . . . It was like, like automatic
writing. People go into trances. Don't know what they're saying. It just
comes out. Whole books sometimes. That's the way it was.
—From the movie KITTY FOYLE, 1940

What was this reference to automatic writing doing in a popular Holly-
wood movie based on a best-selling novel by Christopher Morley? Did
a casual allusion to automatic writing in 1940 signal an invisible shift of
Surrealism from Europe to America? After all, Salvador Dali had earned
notoriety in the American press during the 1930s, and André Breton and
other Surrealists had sought asylum in New York by 1941. Had Surrealism
gained widespread currency in the United States on the eve of the Second
World War?

The intervention of the mass media in widely dispersing ideas once
restricted to intellectual elites raises elusive issues concerning cultural
diffusion. Morley himself did not mention automatic writing in his novel;
screenwriter Dalton Trumbo certainly had literary interests beyond those
of the general public. The characters in the film represent only a small,
upwardly mobile segment of an Eastern urban population. Moreover, auto-

matic writing had to be explained to Kitty Foyle as well as to her 1940s audience. Automatic writing, a method devised by the Surrealists to tap into the unconscious, had hardly entered the popular lexicon, though Surrealism itself by then had come to connote simply anything weird.

The line in the film does suggest, however, the ways that the mass media dispensed Surrealism, or better yet, dispensed with Surrealism by diluting or debasing it. (Significantly, automatic writing crops up in the film version of *Kitty Foyle* among those who are editing a fashionable magazine, just as Surrealism was taken up by *Harper's Bazaar* and *Vogue* during the 1930s.) Although the reference to automatic writing enlivened an otherwise soporific narrative of a determined career girl, it did not shift the movie to a new realm so much as it ironically brought Surrealism full circle. Breton recalled in the first *Manifesto of Surrealism* that prior to the explosion of Dada's creative nonsense on the Paris scene in 1920, he was simply marking time, "pretending to search for an application of poetry to advertising (I went so far as to claim that the world would end, not with a good book but with a beautiful advertisement for heaven or for hell)." [1] With *Kitty Foyle* a Surrealist technique was diverted from cultural revolution to enter the service of soap-operatic seduction in the United States.

Perhaps this debasement had already been set in motion from within Surrealism itself in the late 1930s when Salvador Dali agreed to decorate the display windows of Bonwit Teller in New York. While the growing conflict between Breton and Dali—open disaffection by 1940—involved the painter's commercialism, a more profound issue concerned the role of the mass media and advertising in the dissemination of avant-garde ideas. Both issues were joined, fittingly enough, in America, where corporate capitalism and the mass media allied to create a consumer society. Artists, constrained to be entrepreneurs in order to survive, were complicit in that process.

This casual remark in *Kitty Foyle* thus begins to reveal the cultural and social terrain that Breton had to negotiate in the movement of Surrealism from Europe to America. It was ironic that the mass media took up Surrealism during the 1930s at a time when Breton was embroiled in radical politics and vying for the revolutionary status of his movement. This irony, with all of its twists, becomes all the more evident if we properly understand the precise nature of Breton's politics, which have often been misconstrued.[2] The issues over which he joined battle for more than a

decade had also engaged his American contemporaries in and out of the avant-garde.

Breton, a medical student before serving in the medical corps during the First World War, was left disillusioned after the Armistice in 1919. With other aspiring poets, he enthusiastically joined forces with Tristan Tzara in spreading the Dada gospel in Paris. His first *Manifesto of Surrealism* signaled an abandonment of nihilistic gestures in 1924 (and in the process severed an alliance with Tzara). Breton offered a trenchant definition, aimed at settling proprietorship of the term "once and for all" by reserving an entry in future dictionaries: "SURREALISM, n. Psychic automatism in its pure state, by which one proposes to express—verbally, by means of the written word, or in any other manner—the actual functioning of thought. Dictated by thought, in the absence of any control exercised by reason, exempt from any aesthetic or moral concern." [3] Given license by this sweeping definition to command a stage beyond the arts, Breton soon broached radical politics, where he became embattled on several fronts, as he tried to retain leadership of the Surrealists while developing his own position on the left.

One major front of that battle involved the very nature of the issues themselves. During the decade following the 1924 *Manifesto* Breton propelled Surrealism toward a cultural, rather than a political, revolution on the left—a crucial distinction. To complicate matters (and this has been a lingering source of confusion), Breton also insisted that his cultural revolution was predicated on the social and economic goals of Marxism as delineated by the French Communist party, the PCF. In short, Breton assented to the Marxist tenets of the PCF even while challenging its cultural platform. As a consequence, he argued most fiercely with party functionaries over the role of artists and intellectuals and the scope of their endeavors on the left.

Breton claimed complete intellectual independence, even as a party member—a stance that he held virtually from the outset of his venture on the left, as when, in 1925, he declared Surrealism a "means of total liberation of the mind." [4] He remained faithful to a libertarian, essentially anarchic, conception of Surrealism, refusing to knuckle under to political expediency. If he were to join a revolutionary political party, he expected to remain free to express his own ideas and feelings. Breton was clearly a leader who saw the need to live in the world but not be of it.

In disregarding party discipline while exercising his own over the Surrealist group, Breton also challenged cherished party dogma. He opposed Communist cultural policies of promoting proletarian literature and Socialist Realism by directing his Surrealist revolution against the dominant values, attitudes, and ideas of French culture itself. He grounded the concept of "surreality" in cultural subversion by seeking to override "certain purely formal oppositions of terms, such as the opposition of act to speech, of dream to reality, of present to past and future." [5] The task of the Surrealists was to engage henceforth in the mobilization of the imagination toward the marvelous, where Breton claimed that no such oppositions existed—oppositions upheld by the vulgar materialism of the PCF.

Breton brought Surrealism to political center-stage by maintaining that "the activity of interpreting the world must continue to be linked with the activity of changing the world. We maintain that it is the poet's, the artist's role to study the human problem in depth in all its forms, that it is precisely the unlimited advance of his mind in this direction that has a potential value for changing the world." [6] Breton sought to heighten the importance of cultural issues in the political discourse of a party that had dogmatically subordinated them to economic matters.

The Surrealists thus dramatized a crucial problem facing the avant-garde in general, an avant-garde that had been trivialized into mere entertainment by a complacent bourgeoisie or viewed with suspicion and often disqualified from revolutionary activity by the French Communist party. Breton's odyssey on the left eventually took him in 1938 to Mexico City, where he met Leon Trotsky, the Soviet revolutionary, in exile. Through the intervention of the Mexican muralist Diego Rivera, the two wrote a "Manifesto for a Revolutionary Independent Art. Their manifesto, circulated by the *Partisan Review* in New York, would precede Breton to the United States, where he fled in 1941 to escape the Nazi occupation of France.

Breton's period of asylum in New York during the Second World War was but the latest, though perhaps the most crucial, phase of the lengthy and complex relationship between the Surrealists and American artists. French and American avant-gardes developed at their own paces, making oblique points of contact. The infrequent connections and lapses occurred for many reasons, the most familiar being the clannishness of the Surrealists themselves. They were nothing if not a highly visible group, often accused of being insular and, worse yet, sectarian. Could one meet the

rigorous "membership" standards of Breton? Apparently very few Americans did during the 1920s. Not even in New York during the Second World War, when Breton was surrounded by visual artists, did he anoint many Americans—Arshile Gorky perhaps the most prominent among them, and then for only a short time, until Gorky felt disaffected.

This gap between the Americans and the French extended back to the First World War, when American artists with avant-garde aspirations were isolated in New York. Afterward they tended to remain isolated in the American colony in Paris. Man Ray was an exception that proves the rule. Attracted to anarchist ideas in New York's bohemian circles, interested in painting, assemblage, and photography, he eagerly joined Duchamp in conjuring a Dada spirit in New York during the First World War. Duchamp then paved the way for him to become the first American in 1921 to circulate among the Parisian Dadaists. Lacking contacts with the avant-garde community in Paris, a younger generation of Americans who went abroad after the First World War most often remained tourists and were hardly the "expatriates" they longed to be.[7]

Moreover, the first generation of an American avant-garde, especially those painters associated with the photographer Alfred Stieglitz, had slowly developed their own visual identities by the 1920s and were not about to embark upon a new European movement. Even though Georgia O'Keeffe and Arthur G. Dove were included in the landmark exhibition "Fantastic Art, Dada, Surrealism," mounted by The Museum of Modern Art in 1936, their entries qualified only by virtue of curator Alfred H. Barr, Jr.'s all-encompassing sweep. Marsden Hartley, also of the Stieglitz circle, rightly claimed that "O'Keeffe never painted a fantastic picture in her life." He went so far as to dismiss the exhibition as "an unkempt establishment." Taking his cue from James Thurber, whose cartoons were also on exhibit, Hartley sardonically concluded that "there is such a thing as taking the mind too seriously, and we think that the title of Mr. Thurber's book *Let Your Mind Alone* is good."[8] The Stieglitz circle clearly stood apart from Surrealism, thereby ceding the field to younger artists.

Another crucial source of discontinuities during the 1920s was the fragility of the incipient American avant-garde itself. Most American artists in the first quarter of the twentieth century knew about the European avant-garde at one remove and in a fragmented fashion. The 1913 Armory Show in New York points up some of the difficulties of under-

standing and assimilating avant-garde activities from abroad. Although this exhibition was a cultural landmark for its introduction of modern European painting to the United States, it did not automatically create an American avant-garde. American artists could not fabricate an avant-garde in purely aesthetic terms. Even though they had taken their formal models of innovation and experimentation from external sources, especially from Paris, which provided a rapid succession of avant-garde movements during the early decades of this century, it soon became clear, certainly by the 1920s, with the advent of Surrealism, that Americans could not simply appropriate a new style in order to qualify as avant-garde.

An assimilation of what was perceived broadly as "Modernism" required innovation from within. This did not mean that American artists could reject the European avant-garde out of hand. But the latter could not be viewed simply as aesthetic provender for the delectation of Americans. At the same time, American artists could not succeed in a social and cultural vacuum. Having disembarked from the values of their society, shaken loose in part by so momentous an event as the Armory Show, they needed their own avant-garde communities, which could provide the social and cultural milieu essential for the creation of avant-garde art.[9]

Galleries were needed to provide both a communal focus and exposure to the expression that was central to the avant-garde's existence. However, with the exception of Julien Levy's gallery, which regularly exhibited the Surrealists in New York during the 1930s, there were few other American galleries willing to exhibit modern art, whatever its nationality or avant-garde allegiance. (Stieglitz increasingly featured his own group at An American Place during the 1930s.) Despite a small but growing audience for the formal innovations and dissident ideas of the avant-garde, the American public in general still preferred a representational visual art that illustrated genteel sentiments. In this context, the opening of The Museum of Modern Art in 1929 was a bold venture.

Equally important in building a sense of community was the little magazine, which has remained a vital means of alternative publication for the avant-garde. No less driven by economics than the galleries, little magazines brought the news of Surrealism to American writers and artists. *The Little Review, transition,* and then *View,* introduced just before Pearl Harbor by Charles Henri Ford, a very young poet from Mississippi, offered

their readers a Surrealism circumscribed by the magazines' editorial policies and special interests.

The Depression in 1929 also brought pressure to bear upon this nascent American avant-garde, though it did not disintegrate before the onslaughts of world crises during the 1930s. To the contrary, it became deeply politicized, though not in a homogeneous fashion. The dislocations of the 1930s urgently raised the question of the nature of art, especially in its relation to society and politics. Although American political radicals had long urged their counterparts in the arts to join in common cause on social, political, and economic matters, the alliances that occurred were most often uneasy ones, involving intense jockeying over cultural issues.

If the connection between the avant-garde and radical politics on the left was not inevitable in any logical sense, neither was its disjunction. The tenuous relationship between American avant-garde art and radical politics was subject to debate on the ways that a relationship between the two might be imagined, conceptualized, and pursued. Although caught ambiguously between radical politics and elitist fashion during this American debate, Surrealism remained an avant-garde force on the American left because the movement was a paradigm of the problems and issues that surfaced in the attempts to integrate left-wing politics and artists of the avant-garde. Although compromised by its commercialism on the American scene, Surrealism tested the limits and possibilities of avant-garde experimentation in the service of revolution. As a reviewer for *Hound and Horn* conceded in 1934, the Surrealists were "almost the only ones who take up publicly the most disturbing problems, and who try to live as they think—particularly in political action." [10]

Given an unsettled situation in which art and ideas were vigorously debated, American writers and artists with avant-garde aspirations sought to shape their own cultural agendas when they came into contact with European movements. Thus in advocating an American Dada that clashed with Surrealism, Josephson and Cowley were unique only in being among the first to propose an American program. Similarly inclined were Margaret Anderson and Jane Heap, editors of *The Little Review*, a lively avant-garde magazine that sporadically published Surrealist material. After they stopped publishing in 1926 (with a farewell issue in 1929), Eugene Jolas, a journalist for the Paris edition of the *Chicago Tribune* took up the slack with *transition*, a little magazine in which the Surrealists also appeared

during the course of a decade of avant-garde publication. Along with Josephson and Cowley, these editors sought cultural goals that were sometimes derived from, sometimes at odds with, sometimes tangential to, Breton's Surrealism. This American pattern of ambivalence toward Surrealism continued unabated through the Second World War.

The debates over art and politics, the programs of the little magazines, the museum and gallery exhibitions, Surrealist publicity from Madison Avenue to a Dali pavilion at the 1939 World's Fair: all might have culminated in the triumphant arrival of Breton and the Surrealists in New York during the Second World War. Circumstances dictated otherwise. Some eyewitnesses depicted the exiled Breton as crippled and frustrated by the fall of France. Others saw him as arrogantly unbowed, despite his isolation from Americans and former colleagues alike. This conventional view is not entirely accurate. Despite depleted finances and (self-imposed) language barriers, Breton remained quite productive in New York. Moreover, his isolation from former friends was restricted to the falling away of Surrealist writers. By default, Breton came to be surrounded almost entirely by Surrealist artists, whose visual interests subsequently drew in American writers and painters alike.

The war established an indeterminate state of emergency that precluded business as usual. Although civilian life was always on the margin of military action, those on the sidelines inevitably participated in the drama, turbulence, and enervation overflowing the theater of war. Paradoxically, then, wartime conditions created a unique opportunity for Americans to engage the Surrealists—and not simply because they were on the scene. A heightened social stress under emergency conditions intensified the need for cooperative improvisation. Transitions and disruptions over an extended five-year period offered myriad possibilities of fleeting exchanges, passing alliances, and mercurial friendships. Kaleidoscopic transformations seemed the order of the day. As a consequence, the war dislodged the Surrealists sufficiently from their imagined cultural superiority to put everyone on an equal footing, even if only for the moment.[11]

Even so, Surrealism remained predominantly European in identity. The emigration of Surrealists from Paris to New York at the outset of European hostilities merely heightened the cultural ambivalence felt by many American artists and writers toward the European avant-garde now in their midst. This feeling was not simply a legacy of the facile chauvinism

of American Scene painters from the 1930s. This was an ambivalence deeply ingrained in American culture, dating back to the colonial experience, when cultural as well as political independence was sought. Some three decades after the Armory Show, a few artists and writers seeking to develop an American avant-garde came to realize that they could not simply imitate the European avant-garde no matter how much they admired its formal innovations.

Such attraction and rejection skewed the politics of American culture at its deepest reaches. Artists such as Joseph Cornell, Arshile Gorky, and Jackson Pollock were crucial in the 1940s not because in retrospect they are considered "major" figures but because their importance then arose from an uncanny ability to acquiesce to Surrealism and make it their own in an act of cultural and aesthetic transformation. The final chapters of this book are devoted to these three artists. Each chapter traces its subject's affinities with Surrealism, alongside his struggles to develop his own artistic identity. Understandably, then, not so much another survey of "American Surrealists" is needed as an examination of those American artists and writers who could negotiate an essential assimilation of Surrealism.

As William Carlos Williams astutely noted as early as 1921 when considering French-American relations, "If men are to meet and love and understand each other it must be as equals." [12] On that assumption he predicated the need for Americans to create their own art, an art that would conform to their own social and cultural experiences. Only then would there be equal footing with the French. Over the next several decades, two dominant forces were at work: one was European Surrealism, as much established as such a volatile phenomenon might be (and as organized as an iron-willed Breton could make it), and the other was an incipient American effort toward avant-gardism. The course of Surrealism and American art rode a precarious orbit through the magnetic fields. Transformations were inevitable.

AMERICANA

First American Phases of Surrealism

1

We are people of the same kind, of the same time, and more or less what happens to one of us one day will happen to the others the day after.

—Louis Aragon to Malcolm Cowley, circa 1932

Surrealism did not suddenly appear at America's doorstep with Julien Levy's 1932 exhibition in New York, not even with its slightly earlier appearance at the Wadsworth Atheneum in Hartford, Connecticut. This illusion has persisted, not because of some sleight of hand by Wadsworth director A. Everett "Chick" Austin, Jr., but because the trans-Atlantic drift of Surrealism was virtually invisible during the 1920s. Its traces were determined by the twists and turns of cross-cultural politics and sheer happenstance. These inauspicious beginnings are nonetheless significant, not because they set the course for subsequent developments during the 1930s and 1940s, but because they foreshadowed characteristic ways that American writers and artists would respond to Surrealism during the Depression and the Second World War. Matthew Josephson and Malcolm Cowley, Margaret Anderson and Jane Heap, and Eugene Jolas—Americans all in Paris—commandeered Surrealism in their little magazines as a springboard for their own cultural agendas during the 1920s.

Some terms of the exchange were initially set by the French. As a poet, André Breton understandably emphasized language and automatic writing in his 1924 *Manifesto of Surrealism*. From the very beginning, the Surrealists debated the role of the visual arts in attaining surreality, and so not until 1932 was there a critical mass of visual Surrealism for Julien Levy and his Harvard classmate Chick Austin to organize an exhibition surveying their work in New York. In the meantime, the American public was able to glimpse only a few Surrealist or proto-Surrealist paintings in a handful of adventuresome galleries in New York.

During the 1920s, then, Surrealism made its greatest impact on American writers. Their numbers, however, were limited by some stringent barriers. Those Americans who were in Paris could satisfy their curiosity in a direct fashion only by penetrating the inner circle of writers surrounding Breton—not an easy prospect since the aloof leader refused to learn English. Fortunately, Eugene Jolas, a young literary columnist for the Paris edition of the *Chicago Tribune,* assumed the role of cultural broker, offering his American readers a lively eyewitness account of the tumultuous birth of Surrealism. Although born in New Jersey, Jolas had spent his childhood in Alsace-Lorraine and then returned to New York as a teenager, eventually becoming a reporter on the large metropolitan dailies. Jolas was the right person on the Paris scene in 1923. A burly man with a voracious appetite for languages, he was able to converse readily with the French and other European avant-gardists.

From the outset Jolas acknowledged the power struggles of the Parisian avant-garde. "Nowhere [except in Paris]," he effused, "does the visitor from America face such a plethora of ideas, revolutionary concepts, boldly destructive philosophies, ferociously new esthetic principles." [1] Antagonisms reached new heights with the emergence of the Surrealists, whose infighting over dominance of the proposed movement during the summer and fall of 1924 provided Jolas with an ongoing subject for his column, called "Rambles through Literary Paris."

In late August 1924, Jolas welcomed this new movement as "an attempt to capture the evanescence of pure magic and ecstacy." The formation of Surrealism involved "preliminary skirmishes," as evidenced by a "significantly combative manifesto" published in *Le Journal Littéraire* on August 23, 1924. Breton had taken "violent issue" over the definition of Surrealism with Ivan Goll, an Alsatian poet who had established himself

in Paris. Whereas Jolas had previously described Goll as "a remarkable poet in two languages," he now announced rather casually that Goll possessed a "frontier mind." [2] Jolas's offhand manner was an attempt to mask his excitement at having discovered a fellow Alsatian in the thick of things.

"The Battle's On!" Jolas exclaimed in mid-October 1924, and so it was, as the conflict reached the proportion of a "civil war" among the Surrealists. Jolas attempted to sort out the various positions for his readers while the Surrealists struggled over "priority rights" to the term. A clue to his own position can be gleaned from a question he raised at this time. "Is there an international mind?" he asked. "Either it happens that a person pendulates too much toward one side or the other, or else his racial complexity makes him uncritically neutral." [3] As a hyphenated American whose European heritage was also mixed, Jolas hoped to qualify as that "international mind," which would be neutral, though not in an uncritical fashion.

On October 19, 1924, Jolas presented the opposing sides. With Breton he stressed the role of automatic writing for "the complete destruction of the critical function in the creator." Against Breton's experiments, derived from Freud, Jolas quoted from Goll's recent manifesto, which had appeared in the Alsatian's new journal, *Surréalisme*. (Breton's long-awaited Surrealist manifesto had only been partially published, Goll having beaten him to the punch.) Goll proclaimed Surrealism to be a "vast international movement" that "signifies sanity and rejects the tendencies of decomposition and morbidity." With an all-inclusive sweep, Goll meant nothing more by his appropriation of the Surrealist label than to provide "a general term for the entire modern literature and art." At the same time, he dismissed Breton's group as a "few ex-dadaists" who set up a "counterfeit of *surréalisme*" that serves only to shock the bourgeoisie. In turning to Freud for a "new Muse," they had confused art with psychiatry, Goll claimed. [4]

Through the end of 1924, and well into 1925, Jolas tipped the scales in favor of Goll, whom he inflated in an interview into "a figure of towering stature in contemporary literature." In contrast, he quoted Francis Picabia, who had recently attacked Breton as "an actor who wants all the first roles in the theatre of illusionists and is only a Robert-Houdin for provincial hotels." By late May 1925, however, Jolas reversed field and

hailed Surrealism as an "epochal force in contemporary thought." [5] If there was any doubt as to whose Surrealism, in his column of July 5, 1925, he reported an enthusiastic interview with Breton, the first with the American press.

Perhaps because of the publicity attending a recent Surrealist fracas at an awards banquet for Paul Claudel at the Closerie des Lilas, Jolas was eager to claim the Surrealists as his own discovery. He met Breton at the Surrealist leader's apartment on rue Fontaine. (Eluard and Aragon may also have been present.) Jolas gave Breton his head—could he have done otherwise?—with the result that the interview was somewhat disorganized, as the Surrealist leader discussed his ideas at random and with a rapidity that led Jolas to apologize for an "interview-express." He had to crib some material from *La Révolution Surréaliste* in order to render Breton coherent for his American readers.[6]

In the interview Breton emerged as a militant leader who questioned prevailing modes of thought, especially "reason and *le faux bon sens.*" His radical skepticism extended to the brink of nihilism: "We accept absolutely nothing," Breton boasted. Neither Jolas nor Breton indicated the positive goals of the group. Thus Breton's willingness to support revolutionary political parties of all stripes came across as something of a positive virtue. Such impartiality, however, suggested that Breton did not consider the class struggle as an end in itself but simply as a "point of departure." [7]

It is unclear why Jolas lent his approval to a movement that appeared to be so destructive, since he had seemed to agree earlier with Goll's criticism of Breton's position as merely negative, a residual Dadaism that had outlived its time. Jolas may well have been mesmerized by Breton's charisma, caught up as he was by the excitement and energy of the Surrealist project. "Never in French literature," he claimed, with characteristic hyperbole, "has there been such a violence of the spirit, such a destructive chaos of concept. . . . For [the Surrealists] are hysterically explosive against their age." [8]

On another level, Jolas was attracted to the literary work of the Surrealists. Earlier, as he was venting his disapproval of a literary tendency to theorize in a formulaic fashion, he claimed that Surrealism by way of contrast was entering a "period of creative accomplishments." He recommended Aragon's *Le Paysan de Paris,* which was being serialized in *La*

Revue Européenne. And after his interview with Breton he counted Paul Eluard as "one of the most gifted poets of France's younger generation." Jolas's interest in poetry itself was at odds with Breton's antiliterary bent. As Breton said in his interview, poetry (by which he meant automatism) was simply a means to an end: it alone was "capable of codifying the compromise between dream and reality." [9] This difference among others eventually led Jolas away from Surrealism to the "Revolution of the Word" in *transition,* a little magazine that he started in 1927.

JOLAS QUIT HIS COLUMN for the *Tribune* at the close of 1925 to return to New York. In the meantime, Matthew Josephson, an aspiring writer with a mercurial temper, took up the slack in brokering Surrealism for an American audience. The recent Columbia graduate had met the Surrealists in their Dada guise in 1921. As with Jolas, Josephson's timing was on the mark. He and Malcolm Cowley, a young veteran of the ambulance corps during the First World War, gained introductions through Man Ray, an American artist who had just settled among the Parisian avant-garde. From the beginning, they tried to participate in Dada and Surrealist activities.

Josephson made a large investment in Dada upon his first visit to Paris in 1921. If he was drawn to the idea of Dada as a movement, he was even more attracted to its shock troops, made up of witty, energetic, and intelligent Frenchmen roughly his own age. And there was always the immediate satisfaction of acting Dada: signing a manifesto, dashing off a dirty limerick, or slugging a waiter and precipitating a café brawl. Even so, as foreigners Josephson and Cowley remained on the fringes of Dada. Their French friends cautioned them that they did not really understand the chaotic politics of the situation. (Thus Josephson joined the group promoting *Le Coeur à Barbe,* a manifesto that Dada leader Tristan Tzara instigated against Breton's cherished project for an international congress on modernism. It never came off, thanks to Tzara's sabotage. No wonder, then, that Breton was cool toward the American.) [10]

Josephson, however, was ambitious. In the summer of 1922, with Dada entering its death throes, he saw his chance for a new direction. "After and Beyond Dada," as he titled his essay, appeared in *Broom,* the American little magazine published in Europe by Harold Loeb. In his essay Josephson was sensitive to the aftermath of Dada in the avant-garde

spirit of "Where next?" A successful quest beyond Dada was important to him because it would provide an opportunity to gain equal footing with his French friends. In the process he hoped to be propelled to the forefront of an American avant-garde. He was on a collision course with Breton.

"After and Beyond Dada" summarized a program that Josephson had outlined previously for the readers of *Broom*. Throughout the writings of Aragon, Soupault, and Eluard, the American found dominant "the play of intellect . . . freed from the syllogism as well as from empiricism, therefore

1. Marcel
Duchamp, cover,
The Little Review,
Spring 1925.

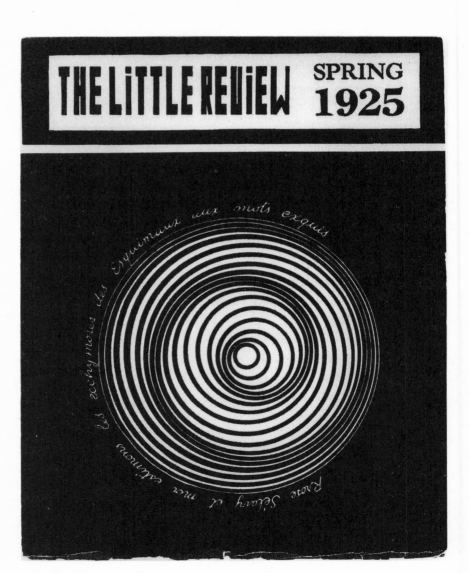

naked plundering intellect, in astonishing encounters and adventures."
This picaresque of the mind beyond Dada would yield "fresh booty"
among "contemporary American flora and fauna." As examples, Joseph-
son cited American movies, pulp journalism, jazz, and, in subsequent es-
says, advertising.[11] He urged fellow artists and writers to heed this cultural
fallout from advanced technology, which was rapidly transforming Ameri-
can society. Here was an opportunity to create a new art genuinely distinct
from the traditions of Europe, which had only begun to feel these social
and cultural developments pervading America.

With the demise of *Broom* (which survived on a shoestring until
1924), Josephson lost a forum for publicizing and explaining his program
for the American artist in the Machine Age. Not yet sold on Surrealism
as a marketing tool, American advertising and publishing were supremely
indifferent toward Breton and his small group. After failing to estab-
lish Dada in New York upon his return in 1923, Josephson went back to
Paris in 1926 and found another outlet for his ideas in *The Little Review*,
the little magazine published and edited by Margaret Anderson and
Jane Heap.

The Little Review was a logical recourse. Margaret Anderson had
started the magazine in 1914 in Chicago, then moved it to New York, and
finally to Paris in 1920. During the First World War Anderson became a
feminist and anarchist, positions that she never abandoned in editing *The
Little Review*, even though she quickly renounced formal ties with all po-
litical and social movements. Anderson conceived of her magazine as a
purveyor of ecstatic "moments" in an ongoing "conversation" with artists
and readers. Her slogan for the magazine indicated a close identification
with avant-garde values and attitudes: "*The Little Review* is an advancing
point toward which the 'advance guard' is always advancing."

The editors' independence lent an air of eclecticism to *The Little Re-
view*, which gained an unwarranted reputation for mindless literary exper-
imentation.[12] In actuality, the two friends harbored a radical politics
verging on a social agenda that Heap promoted after she assumed sole ed-
itorial authority in 1924. Attuned to Josephson's ideas, Heap mounted a
Machine Age exposition in New York in 1927, a pioneering attempt to
bring artists and engineers together so as to configure this new civilization
based on advanced technology.

In the meantime, however, *The Little Review* had gone through its

own Dada phase, encouraged by Ezra Pound, then foreign editor, and Picabia, who assumed that role for a single issue in 1922. Dada had gained a personal intensity for the editors after the U.S. Post Office banned the magazine from the mails in 1920 for serializing an "obscene" novel: James Joyce's *Ulysses*. The aggression and subversion of Dada epitomized the protest the editors wanted to mount against state censorship of the arts. Their enthusiasm for Dada, however, never really carried over to Surrealism, even though a shift of allegiance would have had a certain logic to it.[13]

Circumstances, for example, worked against the recruitment of Breton as foreign editor. He already had an outlet for publication in *Littérature,* and he was extremely reluctant to appear in translation or in magazines other than his own, especially one that published his mortal enemy, Jean Cocteau. (In her memoir of 1930 Margaret Anderson recalled Cocteau as "the most charming young man in Paris," worse yet, "catalytic," and made no mention of Breton.)[14] Then, too, Picabia's contacts for *The Little Review* deteriorated prior to the formation of Surrealism in 1924, as he deliberately distanced himself from Breton in a power struggle among the Parisian avant-garde. And to cap matters, Jane Heap left Paris for New York just at the time that Breton published his first *Manifesto of Surrealism* in late October 1924. Her departure obviously precluded a firsthand view of this new movement.

External circumstances alone were not a decisive factor, however, in the magazine's move away from Surrealism. Such problems might have been resolved in the wake of Heap's desire to promote "group effort" among American artists. In order to galvanize them, Heap organized a series of group numbers for her magazine. She continued to publish the Dadaists and those turning to Surrealism in a French number for the winter of 1923–24, where she featured the poetry of Louis Aragon, Paul Eluard, Benjamin Peret, and Jacques Rigaut, among others.

In this French number, René Crevel, a writer in Breton's circle, gained a forum to point toward Surrealism for the avant-garde. He put his finger on a fundamental problem facing the avant-gardist with revolutionary aspirations. Dada had become a mere source of amusement for sophisticated Parisians. It was all too easy, he warned, to go only so far, and thus become a pseudorevolutionary, making phony bombs. Here Crevel was in accord with Breton, who vehemently opposed not merely commercial writing but any writing that smacked of "literature." Anything "literary"

would eventually gain public acceptance. At the same time, however, Crevel realized that "life without tradition" had its own dangers, especially "in a century in which everyone boasts of not being literary." [15]

Only an individual of Nietzschean strength could transcend this dilemma, Crevel implied. This new superman would exist in the guise of the "superreal individual," one who had gained "absolute intellectual emancipation" by plunging with Breton into the unconscious through automatism. In his forthcoming *Manifesto* of 1924 the Surrealist leader would offer a virtual *vade mecum* on such practice by directing the writer to surrender to the "murmur" of the unconscious and become the "recording instrument" of this "Surrealist voice." By submitting to its dictation, writing appears to be "automatic." [16]

Following Jolas in offering one of the first English references to automatic writing by the group gathered around Breton, Crevel extolled the Surrealist technique for its liberation of the unconscious: "These mysterious words arise without affected romanticism, without calculated prose [hence the evasion of the "literary"]. They have multiple reflections and it is difficult not to be carried away by their spontaneous and free current." Crevel's Surrealism was individualistic in the extreme, allowing "the superreal individual to sing each his own song." He concluded his brief but important account of Surrealism with scorn for "opportunists" who would form schools and groups.[17]

Ironically enough, Crevel's individualism implicitly challenged the group discipline sought by Breton—not to mention Heap's desire for collaboration among Americans. With its internal contradictions, the Surrealist moment of *The Little Review* was about to explode. Josephson applied the match to Crevel's tinder in a subsequent issue devoted to a comparison of young French and American writers. "I saw Jane Heap, and undertook to help her with her Super-realist number, after explaining my own antipathy to the business," Josephson reported to Cowley during the spring of 1926. "I also undertook to write a letter attacking my anciens amis." [18]

With his own avant-garde interests, Josephson wanted to go on record against Breton by publishing an open letter to the Surrealists in *The Little Review*. In the process, he released a Pandora's box of cultural attitudes that would variously characterize subsequent American relations with the Surrealists. Frustrated by his Dada fiasco in New York, Josephson found Breton's disapproval of literature especially galling and hardly Gallic. "The French are by nature a race of *littérateurs*, artists," he claimed. "To

write a poem is easier for instance, than not to write a poem. Therefore art is become a contemptible thing and the most snobbish and the most nobly logical way is to commit artistic suicide." Their lamentable attitude went against the "desperate and precarious" situation of American writers. "In America we live in storm cellars or country-retreats," Josephson cried. "The bleakness of our situation here compared with the easy brilliance of my friends' in Paris . . . calls for a reserve of vitality and courage that is scarcely ever needed there." [19]

Although Josephson idealized the economic situation (and literary production) of the Surrealists, his resentment stemmed from an underlying cultural rivalry. He found it difficult to swallow the "superior Parisian manner" of his French friends, whose "silly" parlor games showed them to be in psychoanalytic arrears. Josephson's feeling of being one-up on the all-knowing French with regard to Freud was part of his declaration of cultural and intellectual independence in 1926. (In a letter to Cowley from Paris in 1927 Josephson recounted the difficulty of renewing friendships among the Surrealists after the break. At the same time he also claimed with pride, "I have never been more *independent* of mind than I feel now, never less willing to give my attention, tolerance, faith on any but the most rigorous terms.") [20]

Even though Josephson initiated this rupture, he could not cut loose from Surrealism. Surviving among his personal notes of 1927, probably written after Josephson had returned to France, was a meditation entitled "Microcosm: Concerning Super-realism," which left traces of his responses to Breton's 1924 *Manifesto of Surrealism* and the 1926 *Legitimate Defense* (against the depredations of the French Communist Party). A deep-seated ambivalence toward Breton and his ideas belied Josephson's calculated breach in *The Little Review*. There was Breton himself, "mandarin of the rue Blanche," but also a "fallen angel": Josephson observed that "with every year M. André Breton . . . becomes the more fascinating and tragic figure." [21]

Josephson used the Surrealists to address the public role of the avant-garde. He admired their "prodigious" moral energy and the "singular purity of their motives," which he claimed, however, was dissipated by their public behavior, "the dispersion and the spattering of their fuel at random." After his own efforts in New York, Josephson ruefully understood such wasted and wasteful efforts. His criticism of the Surrealists

would become a commonplace, though he scored an important point in recognizing the "inverted" antagonism of the avant-garde toward the public as an "amorous whipping." With this advice Josephson anticipated Breton by two years when the embattled leader finally acknowledged in his *Second Manifesto* that "the approval of the public is to be avoided like the plague." [22]

In his open letter of 1926, Josephson proposed that the Surrealists should truly heed Breton's antiliterary stance. "They have begun with logic," he argued. "Then let them cast off their literary robes; let them speak reasonably. Their field is the *quartier St. Denis*, in a barricade. Revolution, the race-track, the political arena, the stock market. Sell the French franc until the government falls again and again. Betray the country!" In a footnote Josephson reported that his protest had "an air of prophecy": "news has come recently that the Dadas, alias Superrealists, have shifted their objectives to political revolution, the majority turning Bolshevist and others Fascist." [23]

Josephson, however, was not to be outflanked by the leftward move of the Surrealists. Privately, he granted that the iconoclastic antics of the Surrealists had been permissible under the banner of Dada, "but in the name of Communism—Heaven forfend!" His irony equivocated somewhat, though in context it was directed primarily toward the Surrealists rather than the party discipline of the Communists. Thus he judged the Surrealists against the standards of the Soviet Union and the Communist party, supposedly comprised of pragmatists who live and act in the "Real World." [24]

In his unpublished critique Josephson misread Surrealism as "primarily an opposition to reality," thereby ignoring Breton's forthright rejection of such polarities in the *Legitimate Defense*.[25] Josephson simply anticipated the main Communist indictment of Surrealism during the 1930s as a form of mysticism. The Surrealists would be considered mere dreamers and hence escapists from the material realities of economics and politics governing class conflict. On such grounds, Josephson mocked the Surrealists for their ineptitude in the real world of politics.

In so doing, Josephson deferred to the privileged status of the 1917 Revolution and the Soviet Union granted by many western intellectuals during the 1920s. He failed to understand Breton's position in the *Legitimate Defense*. The Surrealist leader had taken pains to accept unequivo-

cally the economic and political program of the French Communist party in order to reassure those who erroneously perceived Surrealism as a rival in revolution. But Breton was not, as a consequence, willing to concede his intellectual independence, nor was he willing to relinquish his authority in the realm of culture. Far from being naive, he understood years before Josephson (and many other Americans) the need to maintain his own authority and intellectual independence on the left.

JOSEPHSON'S POLITICAL CRITIQUE of the Surrealists was given dramatic form by Malcolm Cowley, whose own farewell to Surrealism took almost nine years. He finally parted company with the Surrealists in 1934, with the publication of *Exile's Return*, subtitled a "narrative of ideas" about the 1920s. This disavowal had been in the works since 1931, when installments of what purported to be a history of a "lost generation" of writers from the 1920s began to appear in *The New Republic*.[26]

Cowley's feelings were never simple in rejecting the movement he had enthusiastically espoused as a young American writer in Paris. After the failure to transplant Dada in New York, Cowley eked out a living as a book reviewer, slowly drifting to the left and eventually becoming a self-described "ardent" fellow-traveler of the American Communist party. His political odyssey as a writer was anchored by an attraction to literary form and the group dynamics of literary production. Thus in a precocious essay in 1921 called "This Youngest Generation," he tried to characterize a coterie of new writers by their formal interests. *Exile's Return* would later establish Cowley's reputation as a literary historian of the 1920s, even though he had actually written a polemic championing the cause of the proletariat along Communist party line.

In *Exile's Return* Cowley seized upon Gertrude Stein's idea of a "lost generation" as a way to characterize his peers and generalize beyond his friends. In Ernest Hemingway's coinage, expatriation became a metaphor for existential drift in *The Sun Also Rises*. Cowley's signification was perhaps even more devastating. He thought that his generation had lost its cultural and moral bearings during the 1920s, only to become all the more lost among the social and economic ruins of the 1930s.

However much Cowley had been committed to his literary generation during the 1920s, his experiences during the early years of the Depression separated him from the attitudes that had characterized the Dada "aesthetes" of 1925. He came to think that the avant-garde of the 1920s was

superfluous, outstripped by economic events, necessitating a new American vanguard, overtly political and radical.[27] What better social and political model was on the horizon than the young Soviet Union? Cowley shifted his vision from Paris to Moscow. *Exile's Return* was a complex statement that tried to mediate between an American avant-garde and a vanguard of the proletariat.

Cowley's situation called for a distancing from old allegiances—not for an objectivity to write a "history" but for an understanding of his past in a way that justified his present position. In *Exile's Return,* Cowley was writing about a previous life and writing it off. As Edmund Wilson accurately surmised after reading a few installments of what would soon become *Exile's Return,* "I suppose all these premature memoirs on the part of the comparatively young mean that something has really come to an end for them and that they are merely cleaning it out of their systems." [28] A curious history, then, that would try to break with the past.

What was rather truncated by installments in *The New Republic* was given coherent shape in *Exile's Return.* It was, more than a history or even a mythic account, a "narrative of ideas," virtually a social allegory, as these literary pilgrims progressed from alienation to reintegration into American life. Their ultimate redemption would be political and would come from their eventual sympathy for the workers in the class struggle. *Exile's Return* said more about Cowley and his political preferences in 1934 than it did about the avant-garde and the Surrealists of the previous decade.

Cowley took a hard line against Dada in his final version of *Exile's Return.* While he had proclaimed himself an American Dada back in 1924, and said as much in *The New Republic,* he subsequently denied that he ever "in the least" regarded himself a Dadaist. Obviously he wanted to distance himself from his youthful errors. Previously, too, he had been willing to see something positive emerge from Dada. "Art was being given back to life and the artist was being reintegrated into the world," Cowley had claimed, "and so the Dada movement was not entirely sterile: the religion of art had died in giving birth." [29] Because this argument was merely asserted and not substantiated, it was unconvincing. But at the very least it implied a dialectic process, which was lost, ironically enough, when Cowley withdrew even this slight concession to Dada and asserted its utter worthlessness in his final version.

No good could come from the religion of art. As a case in point, Cow-

ley offered the cautionary tale of Harry Crosby, the profligate American poet who was associated with the avant-garde *transition* group and hence indirectly with the Surrealists. Crosby was disaffected from his elite Boston origins yet remained a parasite upon the family wealth. Lacking any positive alternative, he turned to sex and drugs and became a fanatical sun worshiper. In 1929 he shot himself in a suicide pact with his

lover.[30] A sad ending for a talented poet, but he belonged in the suicide tradition of Alfred Jarry and Jacques Vaché, progenitors of Dada and Surrealism.

Cowley saved Crosby's story for the penultimate section of *Exile's Return*, appropriately entitled "No Escape." But Cowley did not end on that bleak note. "Harry Crosby, dead, had . . . become a symbol of change," he hoped, and writers had to decide whether or not they wanted to save a dying capitalism that had spawned a lost generation. In an epilogue, therefore, Cowley concluded with a catechism on the social and political dimensions of art geared to engage a potential fellow-traveler. In his later memoir of the 1930s Cowley recalled finishing the epilogue to *Exile's Return*: "I remember that day as the high summit of my revolutionary enthusiasm. On the last page of the completed manuscript I wrote, 'New York, May 1, 1934,' as if to say, 'I too have marched in the [May Day] parade.' " [31]

To abstract Cowley's argument from the texture of his narrative reveals the Marxist framework of *Exile's Return*. In the prologue Cowley postulates a "general situation that is social and political before being literary," and toward the end of his narrative he asserts the primacy of the capitalist system as an economic base that supports a superstructure of the arts.[32] Even so, Cowley was hardly a vulgar materialist, espousing a simplistic economic determinism. His was a muted Marxism. It was his sensibility and decency that tempered the harsh outline, the high drama, of his political allegory. At the same time, however, he mistook the logic of his ideas for their inevitability, and hence for the inevitability of history. *Exile's Return* tried to pass as history when it was actually a political tract.

Among the avant-garde extremists Cowley indicted in *Exile's Return* were those associated with Eugene Jolas, who returned newly married to Paris from New Orleans in 1926. By the end of the year, he and Maria MacDonald Jolas were embarked upon the publication of *transition*, in the wake of *The Little Review*. Harry Crosby's story was intertwined with *transition*, which he had assisted financially and editorially. Cowley implied that Crosby might not have committed suicide if he had had sense enough to avoid bad company. Jolas and his wife decided to publish an international cast of avant-gardists, ranging from the Surrealists and other former Dadaists to James Joyce and Gertrude Stein, along with a retinue of liter-

ary eccentrics like Abraham Lincoln Gillespie and the Baroness Elsa Von Freytag-Loringhoven.[33]

The two editors were joined in their endeavor by Elliot Paul, an itinerant newspaperman (later described by Robert Sage, another coeditor, as "rotund and bewhiskered and as mischievous as a Katzenjammer Kid")[34] who had taken over Jolas's column at the Paris *Tribune*. In their opening issue, the editors announced their affinity for experiment, originality, and, with the Surrealists in mind, even violence. The appearance of the Surrealists in a little magazine outside their ranks indicated the degree to which Jolas had come to enjoy the trust of Breton.

Nevertheless, Jolas remained deeply ambivalent toward Surrealism, despite his attraction to Breton's group during the year following the publication of the 1924 *Manifesto*. Even though he was tempted seriously to consider "signing up" with the Surrealists (always a matter of pledging allegiance to Breton), he was put off by Breton's domination over the group and its exclusive makeup.[35] He preferred to stay a friendly outsider, having an informal alliance with the Surrealists. From that vantage point, he wanted to adopt one of Goll's basic goals of forging a broadly based avant-garde coalition from which a new movement might eventually emerge. Based on Jolas's generous vision, a collage format became the magazine's particular hallmark.

The task of reconciliation may have been herculean and beyond anyone's grasp, but without a mandate Jolas's efforts were all the more fraught with controversy and conflict. The project began innocuously enough, with an obligatory manifesto in the third issue, dated June 1927. The editors offered little that was original. Their "Suggestions for a New Magic" were derived mainly from Surrealism. In rejecting the documentary realism of American journalism, they claimed that "only the dream is essential" and called for "new words, new abstractions, new hieroglyphics, new symbols, new myths." Not surprisingly, the editors cited Breton and Aragon, along with Stein and Joyce, as harbingers of this "modern consciousness." [36]

Jolas began to distance himself from the Surrealists by pursuing the religious implications of his call for a "new magic." (In this regard Jolas anticipated Breton's interest in the occult during the 1930s.) Raised as a devout Roman Catholic, whose parents encouraged his entering the priesthood, Jolas wanted to establish a "metaphysical basis" (more properly speaking a religious base) which he thought the Surrealists lacked.[37] Full

of energy and enthusiasm, Jolas was hardly a spiritual quietist. His poet might retreat into the self, but the explosion was aimed outward. Jolas's mysticism was volatile, matching his eagerness to set the pace for the avant-garde.

By gearing his religious hunger to a contemporary angst, Jolas felt obliged to sketch a social critique to explain why the poet needed to escape. Unfortunately, his social criticism remained on an abstract level when it wasn't smothered by the claustrophobic rhetoric of a manic-depressive theology. Jolas's *bête noire* was the machine, which was transforming American society. Extended to the arts, industrialization ground out a commercial literature, shallow and formulaic.[38] Parroting H. L. Mencken on the "philistine" but without his scathing wit, Jolas was vague if not superficial, and certainly ponderous, in his social explanations.

The perfunctory quality of his social commentary suggests that Jolas was mostly interested in religious issues. He was soon disabused of a utopian vision of "the new spirit as a vast orchestra in which each instrument brings its share of the rhythmic and harmonious creation." [39] Simply trying to take center stage among the avant-garde meant that he was fair game for attack. The appearance of the Surrealists in *transition* increased his vulnerability. Jolas further aggravated his situation by moving from an evolutionary to a revolutionary view of avant-garde development. His appropriation of "revolution" was anathema to conservatives and an affront to radicals, who resented interlopers on what they considered to be their turf.

The attack came first from the right, unexpectedly spearheaded by the English painter and writer Wyndham Lewis. During the First World War he had led a British avant-garde into a "Vortex" of activity in his combative magazine called *Blast*. By 1927 he had dissociated himself from the avant-garde, which he claimed had been corrupted by the "hypnotism and hoax" of advertising. As a self-styled "enemy" (presumably of all that was not rational), Lewis derided the "revolutionary simpleton," who was the "creature of fashion," mindlessly extolling the idea of movement for its own sake. In the second issue of his one-man magazine *The Enemy* Lewis blasted Jolas and company directly by charging that *transition* was a hotbed of Surrealism and Communism. Its supporters were hardly true artists but rather "mondain revolutionary fanatical politicians." [40]

To complicate the situation, Jolas was severely undermined by Josephson, who joined the editorial staff in the spring of 1928 with the thought of using *transition* to announce his own avant-garde program for the machine as against Breton and Surrealism. For the summer issue, Josephson helped put together an "American Number" with a separate section titled "New York: 1928," compiled in the Hotel Chelsea by former allies from his Dada days in New York: Slater Brown, Kenneth Burke, Robert M. Coates, Malcolm Cowley. Satire in the Dada vein now served to score the escapism of American expatriates and the role of mass media in American society.

In an "Open Letter to Mr. Ezra Pound, and the other 'Exiles'," Josephson accurately predicted that Europe would soon be Americanized by the mass media. He urged American expatriates to give up their life of forlorn wandering in the "hollow land" abroad. Although America was a "cruel mistress," Pound would be better off at home, where he might join fellow artists and intellectuals in the active shaping of the mass media. Despite the dangers of becoming "centurions of Soap," "pro-consuls of hydro-electricity," despite the absurdities of doing a stint as radio singers or television hoofers, Josephson was sure that the participation of the "thinking class" would achieve what he vaguely called a "spiritual equilibrium." [41]

Josephson's "Open Letter" to American expatriates prompted a reply from Mike Gold, literary editor of *The New Masses*, which represented the cultural arm of the American Communist party. He applauded the "esthetic" Josephson for calling Americans home, but ignored Josephson's position completely for his own ends. Gold's initial literary strategy for his radical magazine (established only a year before *transition*) was to recruit all newcomers interested in the development of proletarian culture. Because the American Communist party did not have a political monopoly on the left, Gold was obliged to nurture a cultural constituency from a small pool of artists, including those attracted to the avant-garde. In a patent effort to steal Jolas's thunder, he touted *The New Masses* as a "magazine of American experiment" that shunned "minor esthetic cults." [42]

Gold used *transition* as a pretext to schematize American writing in its most recent phase, which he thought had grown out of an older "democratic-Socialist idealism" (represented by Whitman). The First World War had adversely educated *transition* writers: "They write like soldiers who

have been betrayed by their commanders," Gold claimed. "It is good writing but full of despair. They believe in nothing but the empiric sensation, or the undisciplined chaos of the subconscious." The next phase in this rather simplistic dialectic would embrace either "Communist or Fascist discipline." While Gold scorned some *transition* writers as mere "fashion followers" or "silly snobs," he praised Jolas as a "poet with a tragic vision," in an effort to win over *transition* writers.[43]

Jolas suddenly faced the prospect of being engulfed by the left just as he was about to ward off a frontal attack by the right and insubordination from within. Equally important, he did not want to be driven into the Surrealist camp. How could Jolas steer an independent course for *transition*? The occasion obviously called for some fine distinctions, which would be ignored in the heat of the moment. Instead, Jolas began to rally for a bold defense of a position that could withstand attacks from the left as well as the right, while simultaneously distinguishing himself from the Surrealists. An impossible task was in the offing.

In December 1927 Jolas and his editors counterattacked by dismissing Lewis as a second-rate painter if not a second-rate thinker and reactionary crank: "Gouge the camouflage out of *The Enemy* and you will have the *London Times* sputtering with virtuous indignation about Russia's plans to dynamite the British Isles." [44] Lewis's attack, however, was hardly a reactionary smear confusing the avant-garde with left-wing politics, for *transition had* published the Surrealists, who *were* courting the French Communist party (however unsuccessfully).

As a result, Jolas and company were forced to describe themselves as fellow-travelers, both of the Surrealists and the Communists, assenting to their call for the destruction of contemporary society. In virtually the same breath, however, they tried to assume an air of detachment: "We care not a hoot for political activities, whether they be Communist or Royalist." [45] Jolas would consistently distance himself from both the right and the left, though he waffled considerably in his attraction to anarchism, and he was hardly apolitical, as he liked to imply.

Jolas anticipated Breton's political strategies by trying to situate himself independently on the left as someone other than a fellow-traveler of the Communist party. Claiming a "world-conscience" for *transition* in an effort to assume the mantle of social responsibility, he granted that the situation of the American worker was far from ideal.[46] Later, he would call

upon an "intellectual proletariat" to destroy the present social and economic system, with its "anachronistic regime" that exploited the worker. But while calling for "revolutionary action," Jolas parted company with Gold by deploring the Marxist-Leninist idea of economic and political centralization. As an Alsatian, he preferred instead a "regional consciousness" to counteract a "grey and monotonous" life under collectivism.[47]

Laying out a political philosophy, however, was not Jolas's forte, and his political notions would become increasingly garbled. Jolas was much more incisive in proclaiming his views on art and its intersection with politics. His pretext was *America Arraigned,* a collection of poems commemorating Sacco and Vanzetti, recently convicted and executed in Massachusetts on charges of armed robbery and murder. Jolas claimed to have read the collection sympathetically, but in the final analysis found it to be "utterly unimportant." [48] Inasmuch as the execution of the two immigrant anarchists had deeply moved the left, Jolas's dismissal of art on their behalf made his position unequivocal and inflammatory.

In the June 1929 issue of *transition,* Jolas threw down the gauntlet with a group "Proclamation" announcing a "Revolution of the Word." Whatever minimal rapprochement he had sought with the Communist party was shot with this manifesto's extreme position on art and politics. Of the twelve points, the last implicitly rejected the aesthetics of the Communist party, which was moving surely toward Socialist Realism. "The plain reader be damned," an emphatic dismissal of the masses, who supposedly required a simple message, followed from the postulate that "the writer expresses. He does not communicate." The writer should ignore the audience and focus instead upon expression, liberated from the need to propagate "ideological ideas." Severing connections with society allowed a stress upon words as "independent units," manipulated as the writer wished but with a thrust toward the fabulous, the lyrical, and the hallucinatory.[49] The manifesto, just this side of solipsism, implicitly defined the artist as an individual in extremis responsible only to art.

The Surrealists were conspicuous by their absence from the manifesto and the issue of *transition* in which it appeared (in part because Jolas wanted to revolutionize the *English* word). Joyce, who was always a shining light of the magazine, was clearly implicated in the manifesto, even though he had not signed it. Yet as early as their first-year review of *transition,* Jolas and Paul quoted Breton in agreement that "the mediocrity of

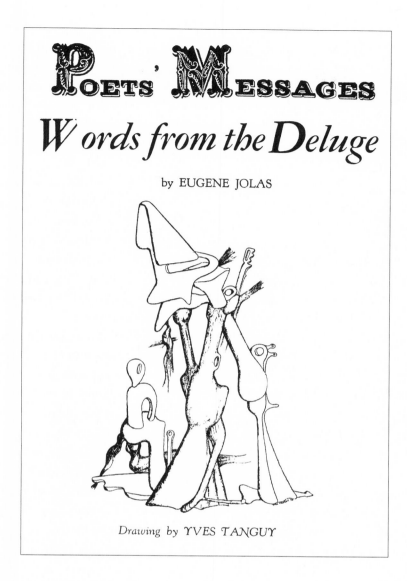

Poets' Messages

Words from the Deluge

by EUGENE JOLAS

Drawing by YVES TANGUY

3. Eugene Jolas, *Words from the Deluge*, 1941. Cover drawing by Yves Tanguy.

our universe depends essentially upon our powers of enunciation," and they called upon "all those who love language . . . to destroy the traditions of language." [50] Breton was present at the germination of Jolas's revolution in language.

Jolas, however, misread the nature of Surrealism, as Josephson had done before him. Jolas tried to distinguish his views from the Surrealists' by claiming that "we do not hold with them that writing should be exclusively of the interior." Yet from this misrepresentation he offered a vision

of the artist's efforts remarkably close to that of the Surrealists: "The wedding of reality with the automatic expressions of the subconscious, the intuitive, the somnabulist, the dream, will lead us to a revolutionary mythos." [51] Jolas thus lent the appearance of staking out his own position in an unexplored territory, but one which Breton in actuality had already claimed.

Yet Jolas rightly distinguished himself from the Surrealists by stressing poetry, which Breton had rejected in concentrating on larger issues of creativity unfettered by social and cultural expectations. Jolas still managed to move to an original position by recognizing a need to develop a linguistic competency for the unconscious. "There are certain states of mind for which language has not yet found an adequate manifestation," he observed. More specifically, "the images of the dream need a language that may be expressed through that of our conscious state." For Jolas, the greatest error of the Surrealists was to continue "to write in the traditional style of French." [52] True to his multilingual Alsatian origins, Jolas wanted to move on to a universal, international language.

While Jolas struggled to disentangle himself from the left, and somewhat sophistically from the Surrealists, with his "Revolution of the Word," he still had to deal with Josephson's enthusiasm for technology. Typically, Jolas sought to synthesize Josephson's program and Surrealism. Thus in "Notes on Reality," which appeared in the November 1929 issue of *transition*, Jolas implicitly contrasted *his* "notes" with Breton's "Introduction to the Discourse on the Dearth of Reality," which had appeared two years before in *transition*. Although Breton wanted to make the leap from "wireless telegraphy" to a "wireless imagination," he was less interested in the connection between technology and the imagination than in celebrating the imagination on its quest for the marvelous. [53]

Jolas, on the other hand, ingeniously construed reality as "a new image of the world"—a prophetic reality that took account of modern technology and its magic even while he rejected the "empirical vision" of "the proletarian primitives, and their brothers, the skyscraper-futurists"—references to Gold and Josephson. Saluting the Surrealists for their emphasis upon the unconscious, but citing their failure to go beyond it, Jolas expanded upon the synthesis he sought: "Conquering the dualism between the 'it' and the 'I,' [the "new creator"] produces new myths, myths of himself in a dynamic environment, myths of new machines and inventions,

fairy tales and fables, legends and sagas expressing a hunger for beauty that is not passive and gentle like that of former ages, but hard and metallic like the age towards which we are going. He brings the fabulous again within our reach." [54]

Even though Breton's Surrealism was precisely a merging of dream and waking reality, he did not really attend to waking reality as a certain kind of world, as Josephson saw and understood it in attempting to lure the Surrealists away from their "tepid dreams." Building on Josephson, Jolas in turn envisioned new work that would be "the static point produced by the dynamic representations of the world and the spontaneous movement of the dream." [55] Except for its ascribed "static" quality, what else was Jolas talking about but Breton's Surrealist point of the marvelous, with Josephson's vision of the modern world replacing Breton's rather abstract sense of waking reality?

Having absorbed and reformulated the ideas of his rivals, Jolas found a decisive synthesis in the ideas of Carl Jung. Thus in the next issue of *transition* (June 1930), he published Jung on "Psychology and Poetry." The Swiss psychoanalyst seemed made for *transition*. Unlike Freud, who concentrated on individual neuroses, Jung described the artist as a *"collective man,"* who plumbs "the primal experience, the dark nature of which requires mythological figures." The result is "a creative act which concerns the entire contemporaneous epoch." [56]

In a companion essay on "Literature and the New Man," Jolas extolled Jung's ideas as "an epochal step forward." The editor renounced the "puerile narcissism" of current individualism to embrace Jung's collective unconscious. Jolas felt that he could meet leftist charges of escapism by contending that the artist now faced "the dark and sinister aspects of life. He represents life in its universal relationships and is not afraid to destroy in order to create his vision." [57] Thus the artist would be revolutionary in opposing society by assuming a mythmaking mission.

Jolas's introduction of Jung appeared in the final issue of *transition* in the summer of 1930. The problem was not a lack of money but the "expenditure of time and labour." [58] The indefinite suspension of *transition* lasted almost two years, when Jolas returned refreshed to publish *transition* until 1938. During this hiatus, Jolas tried to settle his accounts with Surrealism. In the valedictory issue of June 1930, he acknowledged the Surrealists for their forays into the unconscious. Yet he denied that *transition* had be-

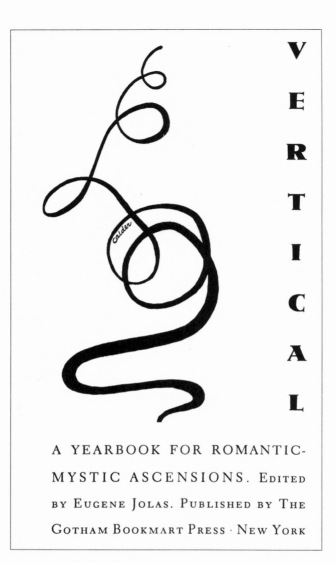

**4. Eugene Jolas,
ed., *Vertical:
A Yearbook for
Romantic-Mystic
Ascensions.***
*New York: Gotham
Bookmart Press, 1940.
Cover by Alexander
Calder.*

come "an annex of the surrealist movement." [59] For Jolas, the Surrealists erred in trying "to evoke the subconscious in its raw and absolute state 'without the intervention of reason.'" Unlike Breton, who condemned the pursuit of poetry as a form of careerism, Jolas sought "aesthetic organization" and poetry from the unconscious. Thus he staked out his own terrain in "the problem of the word." [60]

For Jolas, the poet engaged in an autonomous act of creation. This "imaginative spirit" would make a revolution, independent of the left,

which wanted to impose its collectivist and materialist ideology on artists. When *transition* returned in 1932, Jolas no longer sought a dialogue with the left. Building on the ideas of Jung, he launched the magazine as "an international workshop for Orphic creation" in a "vertical age." Political independence and the Jungian mission would go hand in hand toward a "true collectivism" found in a "community of spirits who aim at the construction of a new mythological reality." [61] Imbued with this utopianism, Jolas stood as an outpost of romantic idealism against the ongoing depredations of the right and the left during the 1930s—much in the same position as Breton and the Surrealists, and hence, with no little irony, they were closer allies than Jolas was willing to acknowledge.

2 The First Papers of Surrealism

It may not be too much of a simplification to state that, America being one of the most fascinatingly unreal portions of a world which the young European, following the War, beheld with new eyes, it was not unnatural that the American theme and the impulse to the discovery of a Super-realism should meet and be, to a degree, amalgamated. The thing, in any event, happened.

—Samuel Putnam, THE EUROPEAN CARAVAN

In 1942 André Breton and Marcel Duchamp organized an exhibition called "First Papers of Surrealism," which celebrated the New York arrival of the Surrealists in their escape from a Europe overrun by the Nazis.[1] Surrealism, however, had made its way to America by the early 1930s. Not the reserved Duchamp or even the forceful Breton but the brash Dali had come to represent Surrealism to most Americans. He had crossed the Atlantic on more than one occasion in pursuit of his career, beginning with the inclusion of his painting *The Persistence of Memory* in the first Surrealist exhibition in America in 1931 and closing the decade with his pavilion at the 1939 New York World's Fair (see Fig. 15). But Dali's American life was only part of the story of Surrealism in the United States. His success and failure also depended upon the responses of the mass media and the cultural institutions in New York. Their intervention

in the presentation of Dali and Surrealism established some crucial parameters in the reception of this movement by Americans.

ON NOVEMBER 16, 1931, the *New York Times* announced the closing of the Colonial Exposition in Paris. While there was little reason to mention Surrealist opposition to the fair as a celebration of French imperialism, the omission of a Surrealist event closer to home was less understandable, for "The Newer Super-realism" opened at the Wadsworth Atheneum in Hartford, Connecticut, on the same day that the Colonial Exposition closed.[2] Prior to the Wadsworth exhibition, Surrealist painting had been scarce in New York. Just a few Surrealists had been shown at a large survey of modern art held in 1926 at the Brooklyn Museum under the auspices of Katherine B. Dreier's Société Anonyme, Inc. And in 1930, when there were several painters in the Surrealist fold, only Joan Miró and Giorgio de Chirico were included in the Modern's exhibition called "Painting in Paris." If New York's galleries and museums were slow to pick up on Surrealism, then the news media could hardly be faulted for their neglect.

It is all the more remarkable, then, that Surrealism arrived en masse at a small, provincial museum, and ironic, too, that urbane New York was scooped by the conservative hinterlands. Yet there should be no doubt about Hartford's conservatism, which can be gauged by the comments of Charles Courtney Curran, secretary of the National Academy of Design, who had come to town during the Surrealist exhibition to present his portrait of Mark Twain to the Wadsworth Atheneum. While condemning modern movements "without qualification," he was sanguine about the way the American work ethic impoverished art. "The American businessman finishes his working day too tired for the pursuit of art," he claimed. "He wants to go to musical comedies, if he wants to do anything. His wife, on the other hand, has the leisure for self-cultivation. It is she who is responsible for much of the picture buying and the inculcation of artistic desires in the children." The secretary's plea for a genteel culture did not pander simply to a local aberration. At about the same time, the *Hartford Courant* reported the banning of Whistler's etchings at customs in Chicago. A government official "declared he blushed when he untied the shipment" from abroad.[3]

Although Hartford was a conservative enclave, the choice of the Wadsworth Atheneum for the first Surrealist exhibition did not compare to

the use of the staid Salle Gaveau for a Dada demonstration in Paris, when rotten meat and tomatoes had been hurled across the elegant concert hall. Actually, Hartford took the exhibition in stride, probably because of the local prestige of the museum, which tried to domesticate Surrealism and make it respectable. The *Hartford Courant* printed sober reviews of the exhibition, warning its readers that "spectators who know their Freud . . . may find much to be shocked at in these pictures." Yet the reporter hastened to add that "the fastidious need not fear seeing the show." A provincial Hartford *had* to take Surrealism seriously, but primarily as an educational opportunity. Bookmarks reminded borrowers at the Hartford Public Library that the exhibition should be on their cultural agenda.[4]

This mix of the academic and the avant-garde might appear at first glance to have been as absurd as any incongruous juxtaposition conjured by the Surrealists. Yet the encounter was hardly fortuitous. It derived generally from the intrinsic nature of museums as repositories of high culture, and specifically from the enthusiasms of Chick Austin, the young director of the Wadsworth Atheneum. Prior to the Surrealist exhibition, he had organized a series of exhibitions of modern art, the most recent having been "Painting of De Chirico" in 1930. Austin's tie to Surrealism came through Julien Levy, whom he had known as an undergraduate in the Department of Fine Arts at Harvard University. Levy has claimed to have initially organized the "Newer Super-Realism" for his own recently opened gallery in New York before he turned it over as a favor to Austin for its American premiere in Hartford, though there is some evidence that Austin may have been the originator. In the event, however, the two shows were not identical.[5]

After leaving Harvard and returning to New York, Levy had met Duchamp in 1927 at the Brummer Gallery (where Miró was exhibited in 1929). Duchamp, who always maintained his mobility, proposed that Levy join him abroad. They sailed together to France in 1927. Duchamp and then Man Ray thus gave Levy entrée to the Surrealists. Back in New York, Levy eventually decided to open a gallery for avant-garde art in 1931. Needless to say, his Parisian contacts set him on a Surrealist course for the next decade and beyond. According to Levy, the "Super-Realist" show was a year in the making. His decision to lend it to the Wadsworth was not without mixed motives. A museum would provide the necessary cultural authority for material not yet sanctioned by American society, while in

turn his good friend Chick Austin would gain enhanced status from an innovative exhibition. As an amateur magician Austin was especially attracted to the marvelous sought by the Surrealists, in particular Dali's sleight-of-hand images that seemed to appear and disappear on the canvas.[6]

The "Newer Super-Realism," though "extensive and solemn," according to Levy, was a success.[7] It consisted of fifty paintings by nine artists, including Dali, Ernst, Masson, Miró, and Picasso. Ernst and then Dali had the greatest number of paintings on view, though Dali's *Persistence of Memory* (owned by Levy) dominated the exhibition. The modest foldout that served as a catalogue was barely able to conceal the cross-purposes of cultural mediation. The cover illustration was a pastiche by George Platt Lynes, a young American photographer. Entitled *As a Wife Has a Cow,* the montage of a marble female figure holding a book against a shadowy background with a cow was reminiscent of Ernst in form, De Chirico in imagery, and Gertrude Stein in motif! On the inside of the fold-out a poem by Cary Ross, a young associate of Stieglitz, was juxtaposed against an excerpt from "Soluble Fish," one of Breton's early exercises in automatic writing. A list of the paintings on exhibit and a sketchy chronology ("1916: The Birth of Dada . . . 1924: A Crisis") was supplemented by a text taken from Samuel Putnam's anthology of European writing, which was about to be published.[8]

Austin had cleverly excerpted passages from Putnam's *European Caravan* to create an educational text for the uninformed viewer at the exhibition. Putnam, on the other hand, had written an account with political overtones. He located Surrealism in an atmosphere of nihilism bred by the First World War. Dada, of course, was its predecessor, "its roots . . . sunk in social chaos." The logical end was either suicide, as in the instance of Jacques Rigaut (who took his life in New York in 1929), or indiscriminate slaughter, as suggested by Breton's dictum that "the simplest Surrealist act consists of dashing down into the street, pistol in hand, and firing blindly, as fast as you can pull the trigger, into the crowd." No matter that Putnam translated the "simplest" Surrealist act as the "ideal," what little reassurance there was for conservative Hartford came from his dismissal of Surrealism as "the foam on the crest of a wave of irrationalism." [9]

Austin's selections from Putnam's text had the effect of filtering a filter. Putnam had a strong antipathy toward the Surrealists, with a prefer-

ence for the Communists if he could not persuade the avant-garde to join him in his own program, which called for a return to "content" as opposed to the "aberrations" of "over-experimentation." In *European Caravan* he ridiculed the Surrealist call for a cultural revolution as vague and inevitably in conflict with those favoring a political revolution.[10] Although Austin deleted political issues from the exhibition foldout, the impossibility of avoiding Putnam's pejorative view of Surrealism was the price he had to pay for the convenience of using a readymade explanation of the movement. The Surrealists emerged as impotent, uncritical, self-indulgent, and platitudinous—a curious assessment in an exhibition celebrating their work.

A careful reader of the foldout might have been surprised by this hostility were it not glossed over by educational intent, which was geared not to a comprehension of the Surrealists from their point of view but to a confirmation of an American viewer's own reasonableness by way of contrast. Thus it was easy to gain the complicity of a reader willing to be the standard against which the deviations of Surrealism might be judged. In this fashion the Wadsworth began the depoliticization of Breton. The walls of the exhibition gave little or no hint of his revolutionary ambitions, while Putnam's text in the foldout politically subverted the movement. (Less than a year later, Breton would agree to edit a Surrealist number of *This Quarter*, published by Edward Titus, the husband of cosmetic queen Helena Rubenstein, with the proviso that Breton refrain from political discussion.)[11]

The "Newer Super-Realism" stayed in Hartford for six weeks before it traveled to New York, where it was installed in the two rooms of Julien Levy's gallery at 602 Madison Avenue and properly retitled "Surrealism," as the movement has been known ever since in English. Although the Wadsworth show was pared down to meet the constraints of space, Levy's installation gained the advantage of intimacy and intensity. "It was packed with the force of the unconscious, of our secret desires," he has recalled enthusiastically. At the same time, Levy made other additions, some idiosyncratic, some with an eye toward suggesting an American Surrealism. He included a canvas by Pierre Roy, who had Surrealist affinities but was independent of Breton's group. A fellow-traveler might have been tolerated, but the Surrealists were dismayed when they heard that Levy also exhibited some drawings by Jean Cocteau, who was Breton's bête noire.[12]

Levy's additions suggest the elusive terrain of Surrealism, complicated by Breton's efforts to expand its borders even while securing them against imposters. The fluidity of Surrealism was both its strength and weakness, requiring the arbitration of Breton for a semblance of stability. A Surrealism without Breton could generate the spurious next to the real thing, as in the instance of the Wadsworth brochure.

Despite such ambiguity, Levy's nod toward an American Surrealism bore significant possibilities on two fronts. First, he encouraged the efforts of American artists who were attracted to Surrealism. Thus he was the first to exhibit the mysterious constructions of Joseph Cornell, a shy young man with no art credentials who had diffidently arrived at the gallery from Queens at about the time of the "New Super-Realism" at the Wadsworth. Levy also included some photo-montages by George Platt Lynes and Man Ray's *Boule de Neige,* which he described as "a glass ball filled with water in which floated a photograph of a girl's eye . . . enveloped in a snowstorm of floating white flakes when the globe was agitated." Equally important was his effort to find Americana that was surrealistic, as evidenced by a "frieze of negative photostats, a series of shocking cover-page seriocomic collages from the New York *Evening Graphic,* the yellowest of vulgar journalism and incredible Americana featuring the story of 'Peaches' and her 'Daddy' Browning," as Levy later recalled in his *Memoir of an Art Gallery.*[13]

Levy understood that Surrealism, far from being a mere style, required cultural assimilation if it were to take root in America. Josephson, who wrote an incisive and generous review for *The New Republic,* not only agreed with Levy but went a step further in making a bold and not entirely ironic prediction. "Looking at this new collection of superrealist paintings, photographs and objets d'art," he suggested that "the movement is destined to great fortune in America." He looked forward to "superrealist furniture, newsreel theaters, skyscrapers, supplanting 'Modernart' which has given us so little for our money." Above all, he admired Levy's inclusion of the tabloids. "Perfect superrealism," he claimed. "The lesson of *The Evening Graphic* is that we have long been producing superrealist art in the raw state."[14] Here was an exhibition that corroborated Josephson's enthusiasms for an American culture unencumbered by Europe.

In the process, however, Breton was left by the wayside. Having shed the pedagogical demands of a museum exhibition, Levy's show had the

virtue of being mounted by someone committed to Surrealism without dogma. For Levy, the absence of Breton gave him latitude from "orthodox representation." The American felt free "to present a paraphrase which would offer Surrealism in the language of the new world rather than a translation in the rhetoric of the old." Even if the issue of flexibility (or compromise) were set aside, the presence of the literary Breton in an exhibition of graphic Surrealism would have remained problematic. Thus even though Breton was duly acknowledged at the Wadsworth as the leader of the Surrealists, he was tucked away in a small foldout and absent from the walls of the museum, where Dali emerged dominant. Levy referred to *The Persistence of Memory* as "10 by 14 inches of Dali dynamite," as did the American press over the coming decade (see Fig. 15).[15] An exhibition had the potential of a broad visual impact, which Breton could never achieve with his manifestos or poetry in America, especially since they were likely to remain untranslated from the French and hence generally inaccessible to the American public.

Over the course of the 1930s Levy established his gallery as a major center of Surrealism in New York. After the opening exhibition of Surrealism he presented one-man exhibitions for Man Ray, Cornell, Dali, and René Magritte. Yet a single gallery could not compete with the cultural resources of a museum, even one that had begun as recently as 1929. Thus the major Surrealist event of the decade in the United States was "Fantastic Art, Dada, Surrealism," organized in 1936 by Alfred Barr (another Harvard classmate of Chick Austin's) at The Museum of Modern Art.[16] There, Surrealism fell victim to the cultural imperialism of the Modern. Over Breton's protests, the exhibition became an art-historical survey, a sprawling affair of almost seven hundred objects.

Breton had wanted Barr to focus entirely on Surrealism, which in the exhibition was made to share center stage with Dada and other predecessors categorized as fantastic art, extending back through the nineteenth to the fifteenth century.[17] Peripheral material aside, the Surrealists were well represented. Max Ernst led the group with forty-eight pieces; Miró had fifteen; Man Ray, Dali, and Yves Tanguy, fourteen apiece; Masson, thirteen; and Magritte, seven. Overwhelmed by this expansive survey, one critic commented on the "appalling abundance" of artifacts and rightly cited the "dangers of superficial resemblances" in a curatorial attempt at Surrealist archaeology. Another critic felt caught up in "a bewildering itinerary" and

recommended the need for "a more ruthless selectivity on an aesthetic basis." Lewis Mumford in *The New Yorker* apparently wanted it both ways. He thought on the one hand that "the final result of such inclusiveness and exhaustiveness is that one begins to find surrealist images sticking out of every hole and cranny." Yet out of cultural pride he stressed "the wild surrealist element that has been present in American art and in American humor from the very beginning." In his eyes Georgia O'Keeffe and Arthur Dove belonged among the Surrealists.[18]

Mumford, among others, advanced his criticism on aesthetic grounds. He complained, for example, that "one loses sight of two or three of the great landmarks in painting that lead up to surrealism. These landmarks, though included in the show, are swamped in the weltering, dreamlike confusion of it." [19] An aesthetic point of view was understandable, for the exhibition must have been stunning. In this grand collection of twentieth-century work a viewer could have seen Henri Rousseau's *The Dream*, Pablo Picasso's *Figures on the Seashore*, Jean Arp's *Automatic Drawing*, Dali's *Persistence of Memory*, Ernst's *Here Everything Is Floating*, Man Ray's *Observatory Time—The Lovers*, Tanguy's *Black Landscape*, and a series of *Exquisite Corpses*, a game that the Surrealists played by taking turns producing a collaborative image through automatic drawing.

Within a museum context, reinforced by Barr's art-historical inclination to instruct the American public, these Surrealist works were rendered ambiguous.[20] A museum installation highlighted their aesthetic qualities at the same time that it began to transform them into works of art, legitimized into the mainstream of art history, and fit to be objects of consumption. As one critic lamented (though from a negative point of view), "mistakes can be dignified by the term art." [21] Conversely, the museum took the edge off the revolutionary or radical aspirations of these works, "mistakes" or not, by absorbing them into an established art network.

That this process of accommodation was not entirely smooth was indicated by the hostile judgments of many New York critics. Surrealism still maintained the capacity to shock. Emily Genauer, for instance, claimed that she required a "stiff drink" after viewing the show. Royal Cortissoz, who went back to the days of the Armory Show, was still fulminating about work that was "repellent" and boring.[22] There were problems even within the Modern, as A. Conger Goodyear, a trustee of the museum, tried to persuade Barr to delete some artifacts, most notably Meret Oppen-

5. Jacqueline Lamba (Breton), Yves Tanguy, and André Breton, *Exquisite Corpse,* **1938, collaborative collage.**

Collection of Timothy Baum, New York. Photograph by Nathan Rabin.

heim's fur-lined tea cup, which was a particular target of ridicule. Barr vigorously opposed what he considered to be "censorship" and suggested that the Surrealist aesthetic of "incongruity, spontaneity and humor" was difficult to accept yet essential to show.[23]

The political dimension of Surrealism was not entirely suppressed. Barr was extremely circumspect about the matter, claiming in his preface to the exhibition catalogue that "Surrealism as an art movement is a serious affair and that for many it is more than an art movement: it is a philosophy, a way of life, a cause to which some of the most brilliant painters and poets of our age are giving themselves with consuming devotion." [24] His statement had an ambiguous double-edge. He took an apologetic tone in anticipation of the usual public uproar. Even though he was willing to bow toward Breton's disavowal of art as usual, he made only an oblique reference to the political thrust of Surrealism as a "cause." Similarly, Barr's brief chronology omitted any mention of Surrealist politics. A reader (versed in French) wanting to be educated would have had to have pursued a cryptic reference to Breton's "repudiation of former collaborators" by turning to the *Second Manifeste du Surréalisme* and *Position Politique du Surréalisme* (1935), cited in the bibliography.[25] In his introduction Barr explicitly distanced the Modern from Surrealism with the disclaimer that "the Museum does not intend to sponsor a particular aspect of modern art, but rather to make a report to the public by offering material for study and comparison." Taking refuge in the notion of scholarly objectivity, Barr suggested that Surrealism was too contemporaneous a movement to be submitted to evaluation, yet with his art-historical bent he hoped for a "few masterpieces" to emerge.[26]

The central essay for the catalogue was written by Georges Hugnet, who had become associated with Surrealism in Paris. Barr dissociated himself and the Modern by noting that Hugnet was "comparatively detached and retrospective" in writing about Dada, but "of Surrealism he writes more as an active participant and apologist." Hugnet incisively represented the radical interests of the Surrealists. Although he acknowledged the appeal of Surrealism for those "dissatisfied with life and reality" (thereby exposing Surrealism to charges of escapism), he stressed that "during the course of Surrealist development . . . the marvelous comes to light within *reality*." He openly proclaimed the revolutionary attitude of Surrealism while discreetly asserting Breton's will to be independent from

the Communist party in his radical course, the goals of which he made clear: "Politically and poetically Surrealism seeks man's liberation." [27]

Unlike Barr, who worked within the premises of art history, Hugnet denied the existence of Surrealist art. "There are only proposed means," he claimed. And instead of locating the motive force of Surrealism in a "deep-seated and persistent interest" in the unconscious (Surrealism as "natural"), as Barr did,[28] Hugnet identified the ideological character of Surrealist exploration. "Man is what he has been made," Hugnet argued. Through the layers of false ideology "it is important to reveal to him that which hides him from himself." Countering a typical accusation that the Surrealists embraced an "ideology of nihilism and frustration," Hugnet concluded with an eloquent prospect: "In the night in which we live, in the carefully preserved obscurity which prevents man from rebelling, a beam from a lighthouse sweeps in a circular path over the human and extra-human horizon: it is the light of Surrealism." [29]

Such an argument in its sophistication and humanity went far beyond Barr, who defended Surrealism by proposing that the Surrealists were hardly any crazier than the world we live in. Lewis Mumford took the same tack in speculating that an "insane" Surrealism might assuage our insanity: "Here surrealism, with its encouraging infantile gestures, its deliberately humiliating antics, helps break down our insulating and self-defeating pride." [30] Such generalized connections between Surrealism and society were superficial, and though they at least pointed toward some of the social implications of Surrealism, they tended to obscure its political character, which, when noticed, was subjected to muddled attacks. A local chapter of the Defenders of Democracy construed Surrealism as "a new move by international communists in their war on standards in religion, industry, society and the arts." [31] Such an accusation came at a time when Breton was persona non grata in the French Communist party!

Without Breton on the scene, Surrealism was vulnerable to distorted interpretations and assessments that generally went unanswered. Man Ray, who had returned to New York for some freelance fashion photography in time for the exhibition, was incensed by the slander of the Defenders of Democracy. Though he mounted a spirited counterattack, he had never been especially interested in politics and thus was not the person to defend Surrealism in the political arena. At best, he compared the critics of Surrealism to those who thoughtlessly maligned President Roosevelt's

program. "President Roosevelt has been called a Communist by just such people, who have little idea what he has tried to accomplish, but are quite certain that they are against it," he argued. The *New York Herald Tribune* headline, "Man Ray Finds Surrealism in Roosevelt Boat," was certainly onto something.[32] There was an essential absurdity in aligning the politics of Surrealism with the New Deal, no matter how radical Roosevelt's agenda might have appeared at the time.

The *Herald Tribune* could take neither the Surrealists nor their self-righteous opponents seriously: "Defenders of Democracy Get Madder and Madder Over That Fur-Lined Cup," ran a caption. Much more insidious was the urbane criticism of Henry McBride, who assumed the guise of political neutrality even while he irresponsibly referred to Breton as the "Stalin of this political party" and lectured the Surrealists for embracing "lawless license" in the guise of liberty. And he was skeptical in the extreme about a Freudian course for artists, which led, he felt, to "disastrous results."[33]

McBride was prescient about the forthcoming season of Surrealism in New York:

> These Surrealists are out to capture New York; and if you do not watch out, if you do not quickly arrange some system of defense, they will do so. The shattering bombardments now emanating from the Museum of Modern Art are not the first attack upon this fair city. On the contrary, there have been so many and apparently harmless onsets in the recent years that the guileless citizens got used to them, and last Tuesday evening, when the opening explosions of the private view occurred, the fashionable multitude allowed them to detonate unconcernedly, just as though nothing had happened.

McBride, of course, knew better. "In reality the ground had been shot from under their feet," he claimed, conjuring a playful yet apocalyptic vision: "The poor things had no longer any place to stand. They had nothing left, no clothes, no house, nothing to eat, and certainly nothing in the way of fashion. All they had was a dream and it was a bad dream at that."[34]

What actually happened was not so grim, and not without some amusement. Unfortunately, in the process, Surrealism itself became the victim. Surrealism in the museums and galleries of New York enjoyed a

6. Richard Taylor,
cover, *The New
Yorker*, January
9, 1937. Cover
drawing by
Richard Taylor;
© 1937, 1975.
*The New Yorker
Magazine, Inc.*

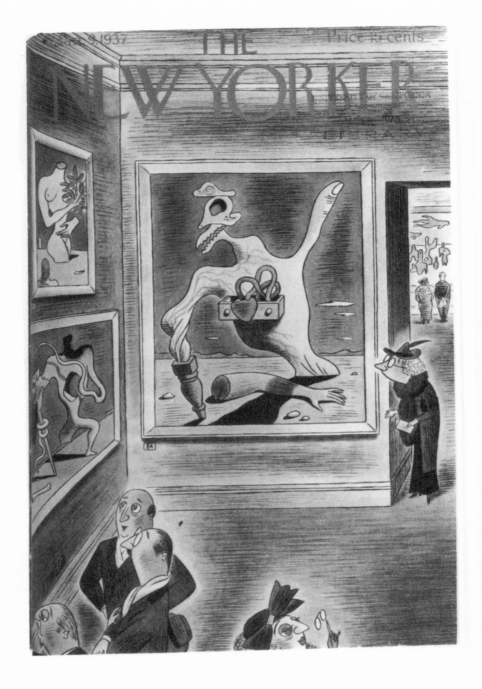

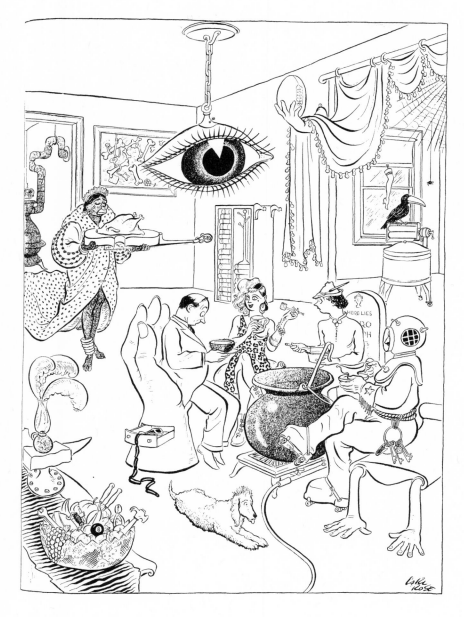

7. Carl Rose, "A Surrealist Family Has the Neighbors in to Tea," cartoon, *The New Yorker*, January 2, 1937, p. 19. Drawing by Carl Rose; © 1937, 1975. *The New Yorker Magazine, Inc.*

mixed fate. The movement had been taken out of Breton's strict control and settled into a quasi-academic environment, whose art-historical and educational interests did not always coincide with those of Breton, who sought a cultural revolution. Yet the results were not entirely dismal, nor did they run entirely counter to Breton's vision. A cultural revolution, after all, required a change of consciousness, which was affected, if not determined, by such institutions as comprised the art network. The penetration of New York's museums and galleries created an opportunity for Surrealist subversion, along with the risk of a takeover by those very same institutions of the dominant society.

THE INCIDENCE OF SUCH RISK rose sharply with the arrival of Salvador Dali in America in 1934. By this time Dali was an established Surrealist painter who had joined Breton's group in 1929. Despite his bizarre imagery and equally bizarre behavior, the Surrealists began to suspect him of commercial pandering in the 1930s. In the United States, his fame initially rested within art circles. He began by making something of a splash when he took honorable mention with *Enigmatic Elements in the Landscape* (1934) at the Carnegie International in Pittsburgh. In itself the painting was not especially shocking. The canvas belonged to what Julien Levy has described as Dali's "adulterated" style, when he tried to accommodate his work to a Paris/New York market during the mid-1930s.[35] In the Carnegie competition Dali's painting was overshadowed by another landscape, *South of Scranton* (1931), painted by a young American, Peter Blume, who took first place and created a stir among critics because of the discrepancy between the title, which earmarked the work as regionalist, and the dreamlike image. (A longtime resident of Wilkes-Barre, Pennsylvania, protested to the New York *Herald Tribune* that "no location south of Scranton, as far south as the Mason-Dixon Line . . . fits the picture.")[36] Blume was immediately dubbed a Surrealist.

Dali's first trip to New York in 1934 revealed him to the American public at close hand. The catalyst for the journey was Caresse Crosby, widow of the socialite poet Harry Crosby. Dali had met her through the Surrealist writer René Crevel, whose novel *Mr. Knife and Miss Fork* had been translated into English by Kay Boyle and published by the Black Sun Press, which Caresse continued in Paris after her husband's suicide in 1929.[37] She urged Dali to go to the United States. Despite his fears of

crossing the ocean, he was finally overcome by those purveyors of upper-middle-class American affluence, *The New Yorker* and *Town and Country*, which he found at the Moulin du Soleil, the Crosbys' estate outside of Paris. "Each image that came from America," Dali recalled, "I would sniff, so to speak, with the voluptuousness with which one welcomes the first whiffs of the inaugural fragrances of a sensational meal of which one is about to partake." [38]

Having scrounged up the money for passage, Dali and his wife, Gala, sailed with Caresse Crosby on *The Champlain*, carrying along the paintings for his second one-man show at the Julien Levy Gallery in November 1934. Upon landing in New York, Mrs. Crosby persuaded reporters in need of a story to interview Dali. He had prepared himself by having a two-and-a-half-yard-long baguette baked during the crossing, which he conspicuously displayed during the interview. For some inexplicable reason, the reporters ignored the bread, but were still amused by the paintings. Dali was equally impressed by the reporters' skill in picking up the right details to create a journalistic sensation. Perfect bedfellows in the making. [39]

For publicity, Dali had the advantage of firsthand association with the Surrealists in Paris. During his early exhibitions at the Julien Levy Gallery in November 1933 and 1934, he was thought to have "rejuvenated" Surrealism or alternately to have been "superficially" neurotic in his painting. [40] Suspicions about the real thing, whatever that was, had already begun, especially among the Surrealists, even as the American press was erroneously elevating Dali as the leader of Surrealism. Debates over the issue of whether or not his painting was the work of a "madman" probably would not have reached the level of intensity (and foolishness) that they did, and Dali himself might not have gained such ready entry into the world of high fashion if he had kept out of the public eye. The American public, willing to view the modern artist as "crazy" ever since the 1913 Armory Show, was all the more willing to be seduced by the handsome Dali, as photogenic as a Latin lover on the Hollywood screen. [41]

In his autobiography, written in 1941, Dali claimed that he was moved by the occasion of this first trip to New York to write "New York Salutes Me," a Surrealistic paean to New York, characteristically celebrating Dali. What was significant here was his opening conception of the Surrealists:

There are existing already in the world a number of incommensurable "living madmen" who profess to revive "the same prerogatives for dream and delirium, the same fetishist credit as accorded reality," who extend at each moment the "most demoralizing discredit to the rational-logical-practical world," who exchange the substance and shadow of objects, the substance and shadow of love, who affront aesthetes and highbrows with the perverse mechanism of erotic imagination, and who emerge at sundown to watch, with infinite cannibal nostalgia, the distant and sparkling sewing machines cut in blocks of ruby: such are the *surrealists.*[42]

Much was secondhand in the passage: the allusion to Lautréamont's sewing machine, the quotations from Breton. Indeed, the tract began with what had become a conventional reference to Breton's definition of Surrealism in terms of "pure psychic automatism" from the 1924 *Manifesto.* During the intervening decade Breton had moved from a "passive" receptivity of the dictates of the unconscious through automatic writing to a more active quest for the marvelous in, say, the simulation of madness, whereby the real and the surreal were inextricably joined in human experience. In this tract, however, Dali went the full route to define the Surrealists as "madmen."

Dali's definition was, of course, symptomatic of his egotism, defining everything in terms of himself and stressing his pathology. Who among the Surrealists was like Dali? While they all tried to gain access to their unconscious, only a few, like Robert Desnos, had been able to cultivate automatic speech. And only Dali enjoyed a status among the Surrealists something like that of Arthur Cravan earlier among the Dadaists. If Cravan had been the wild man of Dada (and there were several in the competition), Dali alone was the crazy of Surrealism. His persona was thought to be integral to the paintings, despite skeptics who thought that his "madness" was merely part of his act. Inasmuch as the issue is impossible to resolve, it is more to the point to understand that he behaved like a deviant. And like many deviants, he remained functional, especially in financial matters (guided by his wife Gala). By stressing deviant behavior, Dali assumed the role of Surrealist performer for an American public that willingly engaged his act. His was mainly a theater of publicity and self-advertisement.

At first, Dali's performances were subdued, nothing like his later lecture in 1936 in London, when he appeared in full diving gear and was forced to quit for lack of oxygen. (Gala had the key to his helmet and was taking a coffee break, so he almost suffocated before she could be tracked down.)[43] Thanks to Chick Austin, Dali had an exhibition at the Wadsworth, Surrealism's provincial outpost, in December 1934, following his one-man show at Julien Levy's. He also gave an illustrated lecture there (reported by the *New York Herald Tribune*) to a crowded hall of two hundred people.[44] The audience, anticipating a spectacle, was apparently disappointed because Dali did not live up to his paintings. No raving maniac, real or feigned: here instead was an intense, handsome, and dapper young man trying to explain the general nature of his canvases.

On January 11, 1935, Dali gave another illustrated lecture ("Surrealist Paintings: Paranoiac Images") at The Museum of Modern Art on the occasion of the presentation of *The Persistence of Memory* to the museum on its fifth anniversary. *The New York Times* had interviewed him two days before at the Levy Gallery. Whatever opportunity there was for a genuine exchange was thrown away, as clearly evidenced by the *Times* headline: "Surrealist's Art Is Puzzle No More: You Don't Have to Know What It Means Because Painter Doesn't Either, Dali Says." As it turned out, at the lecture Dali slyly deviated from his prepared text, which Levy had translated previously, much to the amusement of those in the audience who understood French. The lecture was reported as "disturbing," probably not least to Levy, who had to improvise a simultaneous translation, the audience "tense, incredulous, baffled and appreciative." [45]

The lectures were about Surrealism, but inevitably they focused on Dali. And restrained though he was, apparently sincere in the endeavor to explain himself, Dali did not resolve the questions raised by his canvases. The "Limp Watches," as *The Persistence of Memory* became known, remained a mystery ("It makes some people quite ill," claimed a reporter).[46] *The New York Times* implied that it was all meaningless anyhow, and Dali himself did not help matters by his particular disclaimer of madness. At the Wadsworth lecture he first made his now-famous assertion: "The only difference between me and a madman, is that I am not a madman. I am able to distinguish between the dream and the real world." With its semblance of paradox, the statement was sufficiently ambiguous that conventional reasoning preferred only two conclusions. If Dali was insane, then

he could be dismissed as a lunatic who had duped the art world. If he was not insane, then he was a charlatan. In either case Surrealism was discredited. But the ambiguity would not go away, and so Dali remained at the center of attention as a not-mad madman. From the point of view of public relations, keeping matters in a state of irresolution was the best way for Dali to generate interest.

The "Bal Onirique," held on January 18, 1935, on the eve of the Dalis' departure for Europe on *The Normandie* took the painter from the sanctity of the museum into the social whirl of New York. The dance, a costume ball dressed up by Surrealism, was concocted by Caresse Crosby and Joella Levy, Julien's wife. For ten dollars, a couple could attend as a dream and perhaps win the original Dali drawing used on the invitation. Held at the Coq Rouge, which was decorated with the carcass of a large steer embracing a bull fiddle (the steer's cavernous innards propped open with crutches, a favorite Dali motif, and housing a phonograph), the dance provided Dali with a heightened sense of public theatrics. He appeared wearing a "glass window in his shirt bosom, featuring in this tiny showcase a pink brassiere." [47] (Caresse Crosby, who came as a horse, had gained some prominence for perfecting, if not inventing, the bra.)

Everyone profited from the Bal Onirique. Gala, whose gown was "of transparent red cellophane and whose head was adorned with images of a doll and a red lobster" (an "exquisite corpse," according to Dali, alluding to the mélange of images created by the Surrealist game), played the Surrealist queen above-it-all. "Yes," she said haughtily, "it was an experiment to see how far New Yorkers would respond to a chance to express their own dreams. Only a dozen or two actually succeeded in this expression. The others may think that they are expressing themselves, but, really, they have betrayed themselves." (Dali himself was more impressed with "the frenzy of imagination in which that night at the Coq Rouge was plunged," but then again he was always prone to exaggeration in his prose.)[48] Those foolish New Yorkers were slapped on the other cheek as it were by a lurid account in the *New York Mirror*, whose Sunday magazine offered a double spread of commentary and photographs. While *The New York Times* chose to ignore the dance as an event beneath the dignity of its society page, the *Mirror* played it up in the best of tabloid traditions.

There was nothing better than a foolish highbrow event for a lowbrow audience. "Critics Applaud Dali's Paintings While Mortals Grow Dizzy,"

crowed the *Mirror*. It was all a "cockeyed fuss," but amid the shrill praise there were a "few still born comments by the plain public which sounded like 'Nuts.'" The *Mirror* could hardly ignore its "plain public," which loved to be titillated under the guise of moral indignation. "You would have seen women in white shimmering gowns with green snakes emerging from their heads," the *Mirror* leered, "a man in a tailcoat but minus the trousers, a woman fully clothed in front but (at first glance) nude from the rear elevation, a woman giving birth to a doll from the top of her head, and other novelties equally startling." Leading this Sodom and Gomorrah was Dali, the "newest idol" of "Gotham's Smart Set," piously scored as a decadent. With the Depression at its height, the *Mirror* emphasized class differences: "Maybe society, having turned night into day, decided to go the whole hog and turn night into nightmares. . . . On the other hand, maybe they were just having fun, and doing it in a way to show ordinary mortals that they hadn't any inhibitions after midnight." To rub it in: "New York society must have its fun, and those who had the money for a pair of tickets, and weren't afraid to exhibit their dreams—and considerable anatomy—had a good time at the Bal Onirique." [49] Julien Levy's quest for American Surrealism among the tabloids in 1932 was fullfilled by Dali's scandal for the *Mirror*.

Dali could not have cared less for the drubbing he took from the tabloids because he recognized their publicity value, even though he would express contempt for the "millions of psychologies in a state of inanition" that were fed such tripe. [50] Thus he was not averse to doing a series of drawings that appeared intermittently during 1935 and 1937 in another tabloid, *The American Weekly*. The first set of drawings, entitled "New York as Seen by the 'Super-Realist' Artist, M. Dali," and published in February 1935, compared unfavorably even with his earlier tract, "New York Salutes Me," which in itself did not ring true, as though Dali, aware of previous European avant-garde tributes to that most modern of cities, felt obliged to go through the same motions. The drawings were slack, careless, and derivative of other work he had done. And they were clearly watered-down by Dali himself. Included among images organized slapdash on the page were limp watches ("Sadness of Time Passed"), visual puns ("Phantom in Central Park," "Woman or Horse? A Picture of Doubt"), and a replay of the invitation to the Bal Onirique ("Woman's Infinite Mystery"). [51] The drawings are significant only because they were

Dali's first entry into American popular culture, but otherwise their schlock value made them not even worthy of being dignified as Surrealist kitsch. Unlike Man Ray, Dali was unwilling to give his best to commerce. He offered whatever would pass.

The Bal Onirique with its attendant publicity was a clear sign that Dali would have a broad appeal. *Vanity Fair* had been correct in citing him among the "New Reputations of the Year" in the summer of 1934 (along with Mae West, who later became one of his erotic subjects). The magazine continued to make that reputation by illustrating two Dalis in February 1935.[52] When he returned to New York in December 1936 for his second one-man show at Julien Levy's (coinciding with the large Museum of Modern Art exhibition of the Surrealists), he was elevated to stardom by *Time,* which featured him on its December 1936 cover (photographed by Man Ray), thereby implicitly nominating him as the "leader" among all the Surrealists on exhibition at the Modern. Befitting his celebrity status Dali went to Hollywood in February 1937, where he consorted with the Marx Brothers and painted a portrait of Harpo. His usurpation of Breton's leadership—something that Dali could not achieve in Paris—occurred with his manipulation of the media in the United States. Dali would ascend to the heights of popular culture in all its sleaze and glory at the 1939 New York World's Fair.

AFTER RETURNING FROM EUROPE in February 1939 for a third exhibition at Julien Levy's, Dali was invited by his dealer to become involved in a large-scale project to design a Surrealist pavilion at the forthcoming New York World's Fair. (Levy had been approached with the idea by Ian Woodner, a Harvard-trained architect who knew Alfred Stern, who evaluated proposals for the World's Fair.)[53] The setting was certainly appropriate, with an enormous potential for publicity. The fair itself had surreal overtones, providing a playground for the marvelous, for those moments when dream and waking reality were magically united. Only there could one find a building in the guise of a giant cash register posting the daily attendance at the fair, the mounting numbers representing "a century of progress," attendance to the bottom line being every American's dream. Only there could buildings like an erect "trylon" set against an oval "perisphere" emit Freudian reverberations. This World's Fair would offer Dali a congenial environment if only he could live up to it.

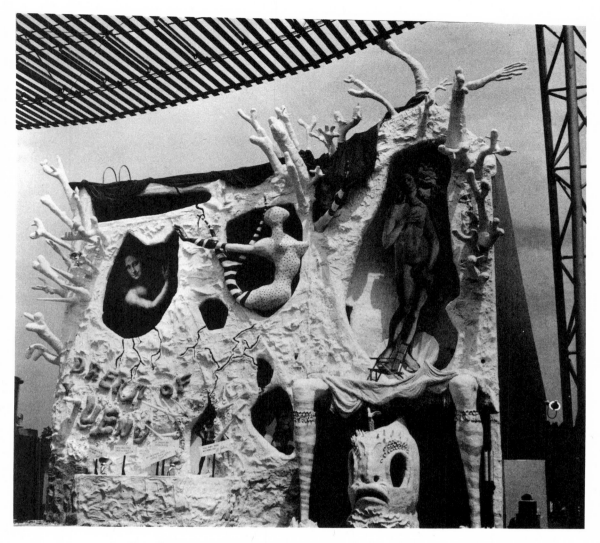

8. Facade for Salvador Dali's "Dream of Venus" Pavilion, 1939
New York World's Fair. Photo attributed to George Platt Lynes,
gelatin-silver print, 5⅝ x 4⁷/₁₆ inches. *The Museum of Modern Art, New York.
Gift of James Thrall Soby.*

In the original prospectus, submitted in March 1938 to the Director
of Exhibits and Concessions, Levy proposed the idea of a "Surrealist
house," modeled upon an amusement park "walk-through" and trans-
formed by Surrealist theory and principles. He insisted upon the authen-

ticity of design and effect by proposing the collaboration of the Surrealists themselves, including Dali, Ernst, Magritte, and Duchamp, who would each design an exhibit based upon his own painting, though in three dimensions and animated if possible. These exhibits were to surround a "central room furnished in the surrealist manner and inhabited by surrealist waxworks." Levy distinguished this aspect of the project from a gallery reserved for "serious works of art by leading painters and sculptors, European and American." This area apparently had educational overtones, for he compared it to the displays found in the Museum of Science and Industry. And in line with such displays, he suggested the possibility of a commercial sponsor whose product might be the object of "surrealist methods in advertising." [54]

Although Levy stressed the far-ranging appeal of Surrealism as evidenced by Dali's "surrealist cartoons" for the Hearst syndicate and the large crowds at The Museum of Modern Art for "Fantastic Art, Dada, Surrealism," he was aware that the project could not be too exotic if it was to attract the American public. Consequently, he proposed a structure "adopted and modified to satisfy American taste," requiring a fun-house prototype. He included a "nightmare corridor," comprised of "a labyrinth, trap-doors, magic carpet . . . but accurately based on a reproduction of typical dream sensation"; a "human kaleidoscope," built so that someone could enter a prismatic cylinder and create images for viewers outside; a photographic booth where "the public may have their picture taken before one of several surrealist backgrounds." Satisfying the passive voyeur and the active participant, Levy's proposals were a clever synthesis of the familiar and the exotic, both deeply embedded in American popular culture, as at Coney Island. Everything depended upon the execution, and it was clear that he cared about execution, but he also brought his awareness of the significance of humor in Surrealism into the project. "It is therefore possible," he rightly claimed, "to build a 'Surrealist House' that is hilarious entertainment and at the same time an authentic surrealist experiment." [55]

Experiment it was, and like most experiments the results were mixed. With the building of the National Cash Register looming large over the fairgrounds, financial negotiations between the fair administration and the two Surrealist principals continued well into the summer of 1938. Levy had problems gaining financial backers, who were mainly interested in an

amusement house even after they finally assented to a Surrealist project. As late as July the situation was not entirely settled. The fluidity of negotiations was indicated by a letter from George P. Smith, Co-Director of Amusements, to Maurice Mermey, Director of Concessions. After running

9. Salvador and Gala Dali flanking a "liquid lady," Edward James and Julien Levy kneeling, left and right, on the occasion of producing Dali's "Dream of Venus" Pavilion for the 1939 New York World's Fair. *The Young-Mallin Archive, New York.*

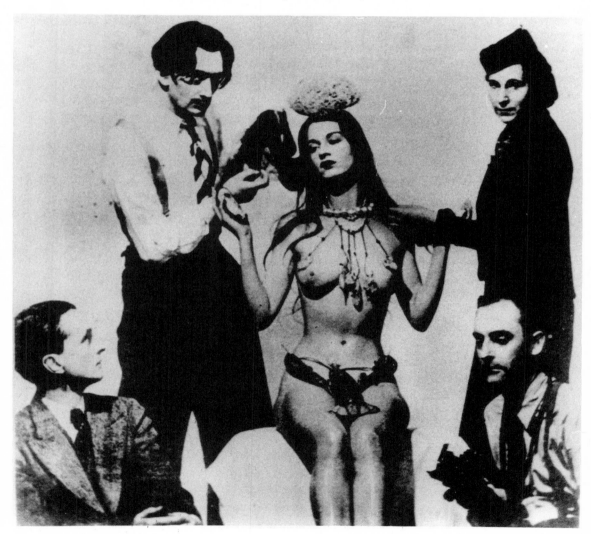

through the give-and-take of financial dealings for the previous six months, Smith was skeptical about Levy's request for the use of live models in the pavilion. "I suspect that they wish to work out some peep shows, after their conversation with Billy Rose," he wrote. "I told them that there was nothing that said they must or must not use living models, in their Concession Agreement, and that we would require them to have their details approved in advance. I also told them that if they provided a satisfactory show with Surrealist living models, we had not the slightest doubt that it would be approved." [56]

As matters turned out, Smith was prescient about the peep show, but at that point Levy's plans for a Surrealist House had not been substantially changed. With Dali's arrival in February 1939, the project began to move, though not in a direction anticipated by Levy. Dali was keen on the project, and Levy's backers were keen on Dali, whose name they recognized would draw crowds. As a consequence, Levy was edged out of any significant role in the project, though Woodner stayed on as architect to carry out Dali's plans.

The basic rectangular structure (approximately 50 by 90 feet) and its plot of 9700 square feet with a 120-foot frontage in the amusement section of the fairgrounds remained the same. Hewing to an essential Surrealist attitude, the project was to have nothing to do with "serious" culture, including fine art, segregated elsewhere on the grounds. In that fashion it by-passed the art network entirely, but found itself among a variety of girlie shows. Sally Rand and her "Nude Ranch" had been rejected by fair officials, but Billy Rose and his Aquacade featured Eleanor Holm, the former Olympic star. According to one account, the most impressive amusement was "the Crystal Palace, which, in its Museum of Changing American Taste, has reenactments of famous girls in fair history, from Little Egypt to Stella, the breathing painting, and on to Miss Rand's fan dance. As a climax it presents a new attraction in Rosita Royce, who performs clad in a flattering covey of doves." (When asked what might happen if someone were to throw birdseed on the stage during her performance, Rosita replied, "These birds are serious about their careers. They won't let themselves be distracted.")[57]

The original plans for the Surrealist fun-house called for "an exterior in the form of an eye, the symbol of surrealism," according to Levy. "The pupil of the eye will be made up of movable facets of projected

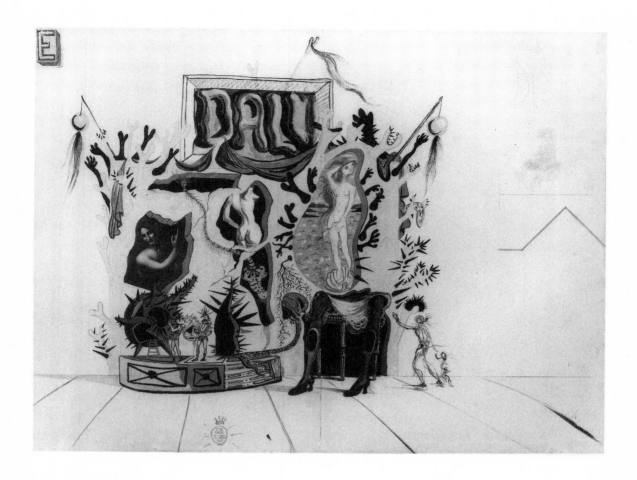

photographs in color which when combined in various positions present amusing and surprising relationships." [58] Dali revised freely. In his watercolor cartoon of the exterior, his name loomed above the facade. This self-advertisement was eventually excluded from the building, which otherwise took on a plaster-cast biomorphic appearance, covered with protruding hands and organic appendages. Two gartered legs stood as columns on either side of the entrance, filled with a kiosk in the shape of a fish. Above the entryway was a large photomural of Botticelli's *Venus* and on the side was another mural of the *Mona Lisa*, beneath which was inscribed "Dream of Venus."

Inside, the exhibition remained a walk-through, though hardly as varied and as elaborate as Levy's initial conception. The spectator saw two large tanks, one filled with water, the other dry. In the first, an underwater-

10. Salvador Dali, *Drawing for the World's Fair Building*, 1939, watercolor, 30 x 40 inches. *Courtesy the Woodner Family Collection. Photograph by Eric Pollitzer.*

scape, was a variety of paraphernalia borrowed from Dali's paintings. As described by *Vogue*, there was "a lost city, a submerged Pompeii, dead but for three live mermaids who swim through flexible rubberoid branches of trees, past long tendrils of typewriters. They swim past a writhing woman, chained to a piano, with the piano keys carved out of her rubberoid stomach; past strangely jointed figures that look like a mixture of Dali and Pinocchio." A press release described the swimmers as "living mermaids clad in crustacean fins, long gloves and little else." The other tank contained Venus herself, a "beautiful show girl," according to the same press release. She reclined on a "36-ft. bed, covered with white and red satin, flowers and leaves. Scattered about the bed are lobsters frying on beds of hot coals and bottles of champagne," according to *Life*. There were also mannequins with birdcage heads, open umbrellas hung upside down, and a backdrop painted by Dali. The dry tank served a functional purpose by providing a resting place for the swimmers, "liquid ladies," as Dali called them.[59]

The artifacts underwater had been manufactured out of rubber according to Dali's design by one of the backers from Pittsburgh. Whereas Dali was ecstatic over the possibilities of "soft construction," the "Rubber Man," as Levy would call the manufacturer in his memoir, had been attracted to the project because he had initially wanted to promote an aquatics exhibit with mermaids using rubber tails of his design and manufacture. Although he was persuaded to invest in the project, he and Dali were soon at loggerheads. In his autobiography Dali termed the project a "nightmare," and claimed that his backers wanted only his name as an attraction, with the result that "the pavilion turned out to be a lamentable caricature of my ideas and of my projects." No wonder, then, that there were delays in the project, leading to postponements of the opening. Telegrams were sent to invited guests (Alfred Barr among them): "SALVADOR DALI DREAM OF VENUS PRESS RECEPTION POSTPONED FOR FEW DAYS DUE TO COMPLEXITY OF SUBCONSCIOUS YOU WILL BE ADVISED OF OPENING DATE REGRETFULLY." [60]

The matter of Dali's artistic integrity was rendered suspect by the project. His insistence upon reversing the mermaid (which may have had its source in a painting by Magritte) was not intended simply for the sake of shock. It established on the exterior of the building a reversal of logic that was dramatized in the two tanks. As Levy has noted, "The Dali enter-

prise . . . was to be a lovely dream, but upside-down, as dreams often are. Venus had been born from the sea. She dreamed of where she had been born, from where Love came. Underwater there was the landscape of her prenatal home. . . . In the next section, which is not under water, Venus is born. She is Love, drowned like a fish out of water." [61]

But such an interpretation was undermined by the context of the pavilion. *The New Yorker* could only list the "Dream of Venus" as a "girl show." *The Art Digest* captioned its brief account of the pavilion with an equation: "Freud + Minsky = Dali." It was not just the prurient elements

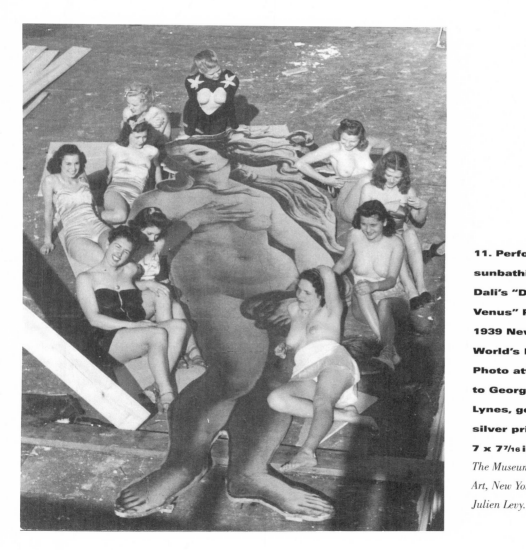

11. **Performers sunbathing at Dali's "Dream of Venus" Pavillion, 1939 New York World's Fair. Photo attributed to George Platt Lynes, gelatin-silver print, 7 x 7 7/16 inches.** *The Museum of Modern Art, New York. Gift of Julien Levy.*

in the press releases. The very conceptualization of the pavilion invited titillating interpretations. At first the pavilion had been named "Dali's Bottoms of the Sea." According to one commentator, "the plural was deliberate and indispensable, because, as Dali pointed out, the bottom of the sea signified in surrealism the bottoms of man's mind, and everybody knew there was no end to *them*." Needless to say, the obvious was too difficult to resist, and there was speculation that Gypsy Rose Lee might be approached to add her talent to the bottom line.[62]

By May 1939, "Dali Dream of Venus" was settled on as the name. When the fair reopened the following year, Dali had pulled out and the pavilion had become an aquatics act called "20,000 Legs Under The Sea," something that seemed an inherent possibility from the start. No, the Rubber Man was informed, the Deputy Commissioner of Public Health did not allow young seals in the tank with the girls. Yes, it was possible to sell rubber thumbs outside the amusement. Boys underage were not permitted to see the show. There were complaints from the Reverend Bowlby of the Lord's Day Alliance, and the reprimand that the World's Fair need not "cater to morons, nor to sex addicts." [63] Such was the comedy of errors that continued daily at Dali's failure.

Dali abandoned and disavowed the project in November 1939 more out of anger than regret. Before he left for Europe once again, he issued a manifesto grandiosely titled, "Declaration of the Independence of the Imagination and the Rights of Man to His Own Madness." The final straw for Dali had been the argument over the Venus on the facade:

> The committee responsible for the Amusement Area of the World's Fair has forbidden me to erect on the exterior of "The Dream of Venus": the image of a woman with the head of a fish. These are their exact words: "A woman with a tail of a fish is possible; a woman with the head of a fish is impossible." This decision on the part of the committee seems to me an extremely grave one, deserving all the light possible cast upon it. Because we are concerned here with the negation of a right that is of an order purely poetic and imaginative, attaching no moral or political consideration. I have always believed that the first man who had the idea of terminating a woman's body with the tail of a fish must have been a pretty fair poet; but I am equally certain that the second man who repeated the idea was nothing but a bureaucrat. In any case, the inventor

of the first siren's tail would have had my difficulties with the committee of the Amusement area.[64]

Of course Dali was right. He had become embroiled in an important conflict between patron and creator. But Dali had also lost credibility by virtue of his publicity-seeking. A decaying Dali Dream of Venus became emblematic of his decline in the United States.

3

Surrealism in the Service of Fashion

Schiaparelli gives a strange hurricane twist to the flaming red velvet hat Eric
drew for our current cover—a twist that shoots high at the side-back—
take notice! The caracal scarf has dyed streaks of bright blue-green through the
black fur—it looks as if the dressmakers are becoming Surrealists. And, to
climax it all, blue-green kid gloves. Hat from Saks Fifth Avenue, New York
and Chicago.

—VOGUE, September 1, 1936

"Fantastic Art, Dada, Surrealism" at The Museum of Modern Art provided a glamorous center of gravity for the world of fashion over the winter of 1936. Here, casting the aura of Rockefeller money over Surrealism, was the only museum devoted exclusively to modern art. The Modern, the Rockefellers, and New York City gave Surrealism an American cachet it had not previously enjoyed, either in a single gallery, such as Julien Levy's, or in a regional museum, such as the Wadsworth Atheneum in Hartford. None of the New York newspapers had covered the event in Hartford and the exhibition had received scant attention even when it traveled to Julien Levy's gallery in 1932. One imagines that a social pecking order was keenly felt in the provinces of Hartford, even though the Wadsworth Atheneum had scored a coup on New York. Thus in reciting

the inevitable litany of those who poured tea at the Sunday afternoon opening, the *Hartford Courant* singled out Julien Levy among the guests as a "distinguished connoisseur" from New York, leaving no doubt about the ultimate source of social validation.[1]

The opening at the Modern five years later was also a gala event. The invitation was not above its own form of advertising. A superb Max Ernst collage graced the cover, and inside, reminiscent of Apollinaire or Marinetti (probably any artist who might evoke the "modern" would do), was a field of floating adjectives: "nightmarish," "automatic," "marvelous," "bizarre," "paranoiac," "absurd," "mad," "lunatical," "incoherent," "oneiric," "preposterous," and the like. The words ranged from those used by the Surrealists themselves to titillating epithets chosen in anticipation of scandalized critics. The lexicon was more or less Surrealist but it was hardly used surrealistically. No matter, however, for its rhetorical puffery was soon confirmed by *Vogue*'s "Spot-Light": "There is enormous fun at the Modern Museum, where the Surrealists are still sending dinner-parties into whoops. . . . It proves once again that the Modern Museum is the only witty museum." [2] Breton's "humeur noire" had apparently been upstaged by the "circus showmanship" of the curator, Alfred Barr.

"Fantastic Art, Dada, Surrealism" established a plateau of interest for American fashion magazines, led by *Harper's Bazaar* and *Vogue*. During its run from December 6, 1936, to January 31, 1937, the exhibition provided excitement for the holidays and enlivened a dormant winter season for the fashion industry. Interest swelled just before the exhibition. Offering a preview, as it were, in the November 1936 issue of *Vogue*, Dr. M. F. Agha, art director of Condé Nast publications, catechized on "Surrealism or the Purple Cow," while *Harper's Bazaar* ran an article titled, "The Surrealists," which offered an accurate prediction: "One sure thing, you aren't going to find a solitary place to hide from surrealism this winter." [3]

Harper's Bazaar was in a position to fulfill its own prophecy by boosting Surrealism in its January 1937 issue. The cover, displaying an image of an astrological chart (in retrospect, reminiscent of Joseph Cornell's iconography), was "composed" by Man Ray, and inside, readers discovered fashion photographs by George Platt Lynes and Man Ray, a feature on Paul Eluard's daughter ("Writings in the Sand"), a visual allusion to Man Ray's *Observatory Time—The Lovers* in an article on cosmetics called "Lip Service," and Man Ray's own gloss on Marcel Duchamp's *Paris Air* (1919),

which had been sealed in a glass ampoule as a gift for Walter Arensberg but was here montaged for *Harper's Bazaar* with "Miss June Preisser of the Ziegfeld Follies. Her bathing-suit, Bergdorf Goodman." [4] Better to encapsulate a live show girl than dead Parisian air for a fashion magazine.

Man Ray's embrace of commercial photography as a way to support himself in Paris during the 1920s, his longstanding affiliation with the Surrealists, and his extensive freelancing for *Harper's Bazaar* during the 1930s inevitably made him the Surrealist star of the January 1937 issue during The Museum of Modern Art's exhibition in New York.[5] (Events converged: Man Ray had returned to New York on a fashion assignment at the time of the exhibition.) Whereas Man Ray reserved his talents for *Harper's Bazaar*, Salvador Dali gravitated toward *Vogue*, which commissioned him for several Surrealistic fashion projects, including a magazine cover. Dali, however, was too hot a publicity item to remain the property of a single magazine. He was also featured in *Harper's Bazaar*. The active participation of Dali in the fashion world went beyond collaboration to commercial capitulation. He above all other Surrealists became a celebrity on the stage of high fashion during the 1930s.

The ground for this development had been set by *Vogue*'s predecessor, *Vanity Fair*, during the previous decade. Its editors had occasionally nominated a Dadaist or Surrealist for *Vanity Fair*'s "Hall of Fame," a feature reserved for those who were in the cultural news. Tristan Tzara was nominated in 1922 "because, unlike most of his associates, he is sincere in his passion for the destruction of 'the good, the true and the beautiful' of tradition." And in 1934, Dali (along with Tamara Toumanova, Joseph Cornell's favorite ballerina) joined this pantheon that included Mae West, Fiorello La Guardia, and Glenn Cunningham.[6] That any given grouping might be as incongruous as a rogue's gallery actually made little difference. The real star was not so much the nominee as *Vanity Fair* itself, which made the feature a self-congratulatory exercise: *Vanity Fair* deemed itself the magazine in the know and hence an arbiter of taste and high culture for American society at large.

Because Man Ray freelanced for *Vanity Fair* in the 1920s, the magazine ran a page of his Rayographs as early as 1922, soon after he had accidently discovered for himself the photographic technique of creating images without a camera. Entitled "A New Method of Realizing the Artistic Possibilities of Photography," the article reproduced four Rayographs,

a photograph of Man Ray himself (rather bleakly staring off into space), and a brief explanation of his method, which entailed exposing objects on light-sensitive paper in the darkroom. The Rayographs became an occasion for art appreciation of the most banal sort. Each illustration was captioned with a catalogue of the objects Rayographed (thereby dissipating their mysterious appearances) and a brief but comforting interpretation: "Note the contrasts of light and shade," "a full and curiously satisfying photographic composition," and so on, as though the reader were felt not to be capable of drawing a "proper" response to these strange new images.[7] Such a verbal context not only measures the underlying conservatism of a magazine that wanted to appear au courant, it also suggests how such a magazine filtered Surrealism to a large readership.

A desire to appear sophisticated and fashionable colored *Vanity Fair* throughout, and conditioned its presentation. As might be expected, simplification and domestication characterized *Vanity Fair*'s mediation between the avant-garde and the American public. Equally important was the celebrity status accorded to the avant-garde, but in every instance it was a status subordinated to *Vanity Fair*'s self-esteem: the avant-garde gained the cultural headlines thanks only to the sophisticated acumen of the magazine. In contrast to what happened later, the avant-garde was simply *in* the news as an object of reportage. During the next decade, the Surrealists actively contributed to the cultural news that magazines such as *Harper's Bazaar* and *Vogue* purported to manufacture, as the relationship between Surrealism and fashion reached new collaborative heights. Surrealism became the extreme instance of an avant-garde movement that entered the orbit of commercial interests. No other movement up to that time was so courted by high fashion and at such length.[8]

AT FIRST GLANCE, a working relationship between the Surrealists and the fashion industry should have been unlikely, given the radical political stance of Breton. After all, here was a movement that Breton irrevocably bound to a revolutionary course, yet it was featured in fashion magazines during the 1930s. Revolutionary aspirations were presumably set against the social status quo, which was partly maintained by the constant flux of fashion in support of the economy and the social interests of the affluent classes. Even Surrealist participants could not escape this orientation. Thus Man Ray's photograph of Paulette Goddard decked out in a

luxurious silver fox coat and muff appeared in *Harper's Bazaar* in December 1936.[9] (That was the year that she costarred with Charlie Chaplin as the Depression-poor gamine in *Modern Times*. In the film she modeled a mink for Charlie when he became a night watchman in a swank department store. It didn't take much for *Harper's Bazaar* to pick the better part of Hollywood's social schizophrenia.)

Beyond offering advertisements for clothing available in commercial outlets, a fashion magazine in its very articles and features is implicitly an advertising vehicle for the fashion industry—its designers and salons, with their seasonal products. As a consequence, the fashion magazine is an advocate for a way of life conducive to the never-ending purchase of luxurious apparel. *Harper's Bazaar* was in the business of creating desire, as a two-page spread for Gorham's Sterling so tellingly visualized in 1936: a beautiful young woman looks out over New York City, ignores her lover and leans eagerly toward her heart's desire, the silver setting in the Manhattan night sky (see Fig. 16).[10]

The clothing industry fabricated an ideological rapport: the new of the avant-garde, which was akin to the marvelous as conceived by the Surrealists, was easily translated as the fashionable so as to enhance the sale of new garments. Such a presupposition accounted for a fashion photograph by Louise Dahl Wolfe in which The Museum of Modern Art was appropriated as a setting to model the latest clothing: "A New Line in a New Museum—Schiaparelli's Tunic Dress Embroidered in Golden Bells Beside Brancusi's Revolving 'Miracle' at the Museum of Modern Art." At least Brancusi's sculpture was given equal billing in the caption.[11] In this process, Surrealists such as Man Ray and Salvador Dali, allied artists like George Platt Lynes, Erwin Blumenfeld, Pavel Tchelitchew, and to a lesser extent Joseph Cornell, became involved in the business of selling fashion.

The first reason for this collaboration was obviously economic. Cast as entrepreneurs in a competitive market economy, American artists had to find means of selling their art or alternatively to find other work, perhaps in related fields, in order to survive. Man Ray, for example, not only studied painting under Robert Henri, leader of the Ashcan School during the first decade of the twentieth century, but also trained as a commercial artist and worked for an advertising company in New York. The fashion industry, which has always depended upon visualization to publicize its products, required photographers in the 1920s because of technological

advances in magazine production. With his expertise as a photographer, Man Ray was a resource for fashion magazines in a way that Joseph Cornell, who did not do photography, could never have been, so on an economic level at the very least, a *mariage de convenance* was possible for those who could provide the necessary technology.

An economic explanation alone does not suffice. Survival was extremely difficult for avant-garde artists because their work was not within the artistic conventions generally accepted by society. Despite the enthusiasm of the Parisian Dadaists, Man Ray's work had not sold at Librairie Six (Philippe Soupault's bookstore) in 1921. Ever practical, he took the indifference of the marketplace as a sign that he could not support himself by his avant-garde work. It became all the more imperative to turn to photography for his livelihood. As a photo-cataloguer, Man Ray had gained an income from a clientele of painters in New York. He then added portraiture to his repertoire of services. In Paris, he managed to give up art documentation in favor of portraiture and fashion photography. Later he recalled with but a little exaggeration that he "was head over heels on photography and making hundreds and thousands of dollars" not long after his arrival in Paris.[12]

Even so, Man Ray's avant-garde photography conformed to the prevailing socioeconomic pattern and did not sell. Surrealism became a kind of exception to this rule during the 1930s when it was not merely accepted but widely exploited by the fashion industry. Although the fashion magazines could have easily continued to expropriate the skills of various Surrealists without publicizing Surrealism, the industry soon discovered that Surrealism itself could be used to sell fashion. In the fashion magazines, Surrealism was moved from the background, as in a photograph of an unidentified Max Ernst painting behind a labeled dress in *Harper's Bazaar*, and brought to the foreground.[13] Surrealist and near-Surrealist imagery, which stressed dream and fantasy, eroticism and sexual revery, was recognized as compatible with the blandishments of a fashion magazine and could be effectively converted to serve fashion rhetoric.

The conversion was eased by a longstanding element of fantasy in fashion. In an article for *Harper's Bazaar* on Helena Rubenstein's New York salon, the imagery stood just this side of the surreal in juxtaposing beauty therapy against the maintenance of a machine-age city such as New York. Helena Rubenstein, the reader is told, wants "to prevent and

repair city-worn faces." [14] The "Derma-lens," which enlarges one's pores to the size of manhole covers, has nothing if not the appearance of a Magritte painting.

As a consequence of these affinities, Surrealism in the fashion magazines was always mediated by the interests of the fashion industry. Thus Surrealism could be used to sell a way of life directed by high fashion. "It's a Beautiful Day," ran an article in *Vogue*: "Chirico's white horses. Ladies sunning under artificial sun . . . milk baths . . . miniature rooms in shadow boxes. . . . These are no Surrealist babblings," the reader was assured. "They are the first, exciting impressions you receive in Helena Rubenstein's brand-new beauty establishment." [15] Here in the guise of an article was an advertisement for the salon of Helena Rubenstein. By disclaiming any association with Surrealism, this pseudo-article refused to concede that Surrealism was as genuinely exciting as the experiences provided by the fashion industry. In actuality, the reader was presented with pseudo-Surreal images: "Surrealist babblings" were indeed an accurate description of images that were not so much Surreal as they were surrealistic, in a debased manner.

In its most overt commercial guise, Surrealism was used in advertisements in and out of the fashion industry. Despite the implicit advertising that fashion magazines had already undertaken for several years, Gunther Furs tried to lay claim as "the first national advertiser to use surrealism in commercial copy," as reported in *The New York Times*, February 12, 1937. Actually, Sloane's Furniture had jumped the gun in *The New Yorker* with a De Chirico pastiche and some coy copy: "Sloane *could* do this. . . . Your taste in decoration may not run to Surrealism or Dadaism or any other form of violence. But if you wanted a room done in the manner of exaggerated reality, Sloane *could do it for you.*" The following year Abbott Laboratories and Container Corporation joined the Surrealist bandwagon. By 1943, *Printer's Ink*, a trade journal for advertising, added Sylvania, American Locomotive, Pittsburgh Steel, Textron, and RCA to the Surrealist roster. [16]

This advertising trend was first noted publicly by M. F. Agha at a luncheon of the Advertising and Marketing Forum of the Advertising Club of New York on January 22, 1937. Over a year later, the phenomenon of advertising and Surrealism was extensively surveyed in *Scribner's Magazine*. The trade journals caught up only in 1943. Most of the commentators puzzled over how a radical movement, "a weird thing for weird people,"

could attract conservative and practical businessmen. None searched too deeply for reasons. Surrealism as an eye-catching purveyor of dreams was seen as consonant with the goals of advertising; the Surrealist technique of juxtaposition was thought to be visually effective. It was conceded, finally, that Surrealism was "diluted" in advertising, but no one caught the irony of being excited about an advertising novelty that in actuality trafficked in pseudo-Surreal, hence banal and secondhand, images.[17] Despite its vitality, Surrealism could not withstand the onslaught of advertising.

Surrealism wore out in this context, but not because it came as cheap ready-to-wear for the fashion world. Hidden were the ideological constraints that defined the appearance of Surrealism in fashion magazines. It had to be shaped according to a broad set of characteristics that fashion could exploit toward its own ends, and not without violence to the integrity of Surrealism. Agha's catechism on "Surrealism or the Purple Cow" in *Vogue* (November 1936), which purported to introduce the lay reader to Surrealism on the occasion of its major exhibition at the Modern, was actually an assassination attempt in bad faith of the most elusive sort. The interlocutor, in the time-honored tradition of Plato, was sufficiently obtuse and occasionally obnoxious, so as to serve as a foil for the "master," who was intended to appear witty and knowing, ostensibly sympathetic toward Surrealism (in contrast to the interlocutor's antagonism), yet ultimately superior to it. In acknowledging the "cultural importance" of Surrealism, the master says in an aside, "Please do not laugh—I really mean it," thereby retaining superiority over the interlocutor and appearing serious and sincere, all the while opening the possibility of the ridiculous.[18] Agha, with the reader in tow, thus had it all ways.

With his doctorate on display, Agha was, of course, the "master," who had the last word, at the expense of Surrealism. The reader existed between the master and the interlocutor: perhaps not so wise as the former but certainly more intelligent than the latter. In the interplay between the two personae, the reader could eventually side with the master in the illusion of having been educated about Surrealism, but in reality having had his own suspicions and prejudices confirmed by an exchange at the end:

INTERLOCUTOR: I told you that Surrealism is not a pleasant thing.

MASTER: But you must admit that it makes fascinating dinner conversation.

INTERLOCUTOR: This is a matter of taste.
MASTER: Precisely. Like everything else.[19]

Surrealism was finally just "a matter of taste," at best "fascinating dinner conversation." Both the master and his interlocutor had trivialized the movement, each to his own satisfaction. The reader's own sophistication could reign unchallenged.

The entire catechism was shot through with distortion and duplicity. Agha reduced Surrealism to "Dada with a dash of Freud." It became essentially an escapist movement from the unpleasant reality of the current economic depression. (Agha realized that he should not entirely denigrate the idea of escapism, a stock-in-trade of the fashion industry, so he argued that escape could still provide "some of the greatest achievements," as, for example, the best-selling novel *Anthony Adverse!*) Arp, Tzara, and Ernst were merely "left-overs" from Dada, whereas Pierre Roy, Dali, and De Chirico (all featured in *Vogue*) were "among the most important painters of our times."[20]

The reader was finally reassured that Surrealism was dead: "The Surrealistic movement in French letters reached its apogee about ten years ago and has been on the decline ever since. Surrealistic painting created a mild sensation a year or two later and seemed to pass out of the picture in Europe soon afterwards. Some people even say that there is no such thing as Surrealism; that the whole movement died of paranoia long ago, and was disinterred only because the American newspapers needed something to talk about." It does not suffice to say that Agha exaggerated reports of Surrealism's demise. His was a self-serving statement. In an embalmed state Surrealism was distanced and made safe to discuss, but above all, it was rendered a target of condescension. Agha indicted the news media for the revival of Surrealism but only half-heartedly, because Dali was characterized as a publicity seeker *par excellence*: "Even the most sensational newspaper could not have invented Dali."[21] Agha blamed the newspapers and Dali for their complicit scandalmongering, as though his own catechism and position at *Vogue* had nothing to do with the mass media.

Agha's sanctimony swelled and strained in describing the widespread influence of Surrealism: "What is a snobbish art scandal today, is an accepted style tomorrow, and a merchandised style the next day"—a process which, though hardly inevitable, struck very close to home, to the

point that he acknowledged: "We had Surrealist ballets, Surrealist fashions, including suits by Schiaparelli, with bureau drawers instead of pockets, and dresses with lumps of coal or nuts instead of buttons, and with door-hinges on the shoulders." [22] Agha remained silent on the role of *Vogue* in those developments.

What accounted for this inconsistency (if not contradiction) within the larger pattern of denigration found in the catechism? Agha was constrained to acknowledge the collaborations between fashion and Surrealism because otherwise there would be no rationale for discussing Surrealism at all. But fashion had to be declared the dominant partner. Toward that end, the integrity of Surrealism was called into question as verging on "commercialized insanity." Surrealism—especially as represented by Dali—supposedly initiated the decadent extremes of fashion. The fashion world, and implicitly *Vogue*, stood at a distance and set the proper norms, from which Surrealism had deviated. Surrealism had to be seen as a scandalmonger that fashion could exploit in disavowal. A clue to Agha's hostility can be gleaned from his estimate that "Surrealism is a deadly serious, grim, ferocious business, bathed in '*Sang et putréfaction.*' " [23] Agha construed Surrealism as the antithesis of fashion by virtue of its bloodthirstiness—vaguely described, but implicitly political and revolutionary.

Certainly by the 1930s the revolutionary character of Surrealism was highly visible, yet it was precisely that revolutionary character which had to be ignored by the fashion magazines, for the industry catered, of course, to an economic elite, whose ideological presuppositions were not to be disturbed. What with his good looks, Breton could have easily been featured in fashion magazines, probably to better advantage than Dali, who always had something of the comic and ridiculous about him (though Dali's burlesque appearance meant that he would not have to be taken entirely seriously by fashion arbiters and their readership). But Breton was consistently excluded from the American magazines by virtue of his outspoken revolutionary stance. Thus Agha cited Breton simply as one poet among many in the movement. Implicitly set against Breton was Dali, who supposedly personified "the Surrealist school of today." [24] (Accompanying the catechism and in support of this view was Cecil Beaton's portrait of Dali.)

Quite clearly, Breton's Surrealist version of Marxist revolution was unacceptable to the world of fashion. But there is a larger, less obvious

point to be made, hinging on the anathema of the idea of commitment for an industry predicated on a short-term, seasonal turnover of goods. Thus even politics, and most certainly revolution, could be represented in fashion magazines so long as they were not taken seriously. No doubt the industry was deeply conservative in its support of capitalism, but its interests were better served not so much by appearing "neutral" so as not to offend any of its readership and market, but rather by making politics a part of style so as to trivialize it.

Revolution, yes—but only as a "revolt against monotony" at the fall fashion openings in Paris. Or, for a more "neutral" position, consider a two-page spread in *Vogue*: "Schiaparelli swings right with all the calm splendour of monarchy in the purple dress on the left [side of the page]." This layout faced another Schiaparelli design on the right-hand side: "a coat that brought the house down. Strong revolutionary-red. Horseguard's cloth, thick as felt, cut as relentlessly as for an army man. Brass buttons. Straight sleeves. It's the smartest swing left of the decade." For a more grisly metaphor: "Storm Troopers" was the caption in a *Vogue* feature on rain gear.[25]

Such images were not innocent metaphors, nor were they so metaphoric as not to be attuned to specific current events. Juxtaposed against a long article on "The Surrealists" in *Harper's Bazaar* was a pictorial entitled "Flaunting Their Faith":

> Women may be grim for a time when fighting for a cause, fiercer, more pitiless even than their men; but somehow, soon or late, the romantic spirit will out. Because women must flaunt their faith, they must carry it high for all to see. And so, this season, politically minded scarfs. They started in Italy, in the full flush of Il Duce's triumph over Ethiopia, were seen at all the Italian lake resorts last summer, turned up at Henri Bendel in October. Miss Peggy Stevenson flaunts one of soft black crepe. Behold sprawling across her shoulder the bold signature of *Mussolini*! And, above it, is copied his triumphant blast to the Italian people after the fall of Addis Ababa.[26]

Without even token disapproval of international gangsterism, the blurb offered a glowing account of Il Duce's "triumphs." "Fascinating fascism," as Susan Sontag has noted in recent years.[27]

The message was rendered all the more bankrupt by the way that politics became grist for the fashion mill. Women flaunt their faith during "the year of the Surrealists," as the succeeding article claimed (a year of commercial exploitation, apparently). The juxtaposition hardly resulted from a kaleidoscopic view of political extremes during a volatile decade. It was the result, rather, of a sensibility that saw little or no difference between Surrealism and fascism because each could be consumed by the dictates of fashion. Thus a Man Ray photograph of French Empire fashions for *Harper's Bazaar* was coyly captioned, "Directoire . . . or Shall We Call It Dictatoire in This Era of Dictators." [28]

Despite this bleak view of the relationship between fashion and Surrealism, the Surrealists were hardly a passive lot, simply accepting the imprint of fashion. It is also necessary to consider the relationship from their perspectives, especially those of Breton, Man Ray, and Dali, who negotiated the relationship between Surrealism and commerce in different, often opposing ways. The encounter generated ambiguities and contradictions among individual Surrealists that dispel the notion of an inevitably close or reactionary partnership in every instance. [29]

No one was more intransigent than Breton, who scorned the idea of work or any other rapprochement with bourgeois society. He managed to keep his writing free from commerce and was intolerant to the extreme of those who did not, threatening them with expulsion from his Surrealist company. Not working at the business of society was an appropriate ideal for the Surrealist leader, who sought the marvelous elsewhere and by other means. But Breton was obliged to work hard to resist social acceptance of the wrong sort. Whereas Dada seemed to thumb its nose spontaneously at society, Breton strained to keep his movement at a healthy distance. He knew from experience that after its initial shock Dada became acceptable to a Parisian society eager to be entertained by what it took merely as the latest blague. By 1930 he knew that it was "absolutely essential to keep the public from *entering* if one wished to avoid confusion." [30]

MAN RAY GAINED A MEASURE OF LATITUDE from the righteous Breton partly because the Surrealist leader was much more tolerant toward visual artists than he was toward the writers in his movement. Thus he recognized a painter's need to sell his work, whereas he was strongly opposed to any sort of literary commerce. (Despite such an inconsistency, he did set limits

to a Surrealist painter's commercialism, as Dali would eventually discover.) Man Ray, however, not only managed to remain friends with both Breton and Dali but also stood somewhere between the two in his attitude toward commerce.

With a forceful (though laconic) assertion of his anarchistic sensibility, Man Ray was able to go his own way without losing a place among the Surrealists. And so he won a tenuous freedom to take commissions from the fashion industry, which found him attractive for many reasons. He was first of all a superb craftsman as a photographer, always the man with the radiant hands ("mains rays"), who brought to his fashion photography an unerring sense of elegant style, gained through a simplicity of visual effect. Thus in a photograph of a Schiaparelli short evening dress of the "palest pink with butterflies," the model's lift of the skirt serves to indicate that it is circular even as it hints at her own possible metamorphosis into a butterfly. In an advertisement for Bergdorf Goodman, Man Ray neatly shades the model's right eye to create a mysterious visage.[31]

On a fundamental level, the fashion industry demanded technical competence and visual reportage from its photographers. Lee Miller, Man Ray's intimate friend and studio assistant, took up fashion photography after she left Man Ray in 1932, having started out as a young fashion model for Edward Steichen in New York. In the March and April issues of 1934 she photographed full-page ads for Hattie Carnegie and I. Magnin. Her visual statements were characterized by simplicity: a demure model wearing a boldly striped evening dress, for example, was posed standing against a bare wall with dramatic (but not melodramatic) lighting.[32] Miller obviously fulfilled the assignment in a straightforward way. Man Ray, too, could work in a direct manner as in a superb portrait of Mrs. Ernest Simpson in the May 1936 issue of *Harper's Bazaar*.[33] The subtle outline of her left shoulder and the tonal gradations down her side, counterpointing the white trim of the bodice, indicate the care that Man Ray exercised in printing this image.

But such qualities alone would have hardly raised Man Ray above mere competence as a fashion photographer. It was largely an unerring sense of the erotic combined with an eye for originality that allowed him to remain a Surrealist in the realm of fashion and in turn raised him above his Surrealist peers working in the fashion industry. Joseph Cornell's eroticism, for example, was simply too rarefied for the fashion magazines to

perceive. And among photographers, George Platt Lynes, while a superb technician, engaged in a rather cold manipulation of mannequins. His libido was elsewhere, in the homoerotic tableaux that he preferred to stage for his camera's eye. Although fashion also called for theatricality, Lynes's private images of young men had a sexual charge lacking in his fashion work, which he simply tolerated as a means of financial support.[34]

In contrast, Man Ray attempted to integrate his work. He saw no compromise in the quality of his photographs for fashion magazines. His essential sense of anti-art, cultivated by Duchamp and Dada, led him to contend that "everything is art," including commercial photography.[35] Quality went beyond craftsmanship to include the formal and thematic values of his photography. Man Ray's Surrealism and fashion found a common ground because he pursued his erotic images with originality in his fashion photography, and the fashion world found them attractive.

Even though Man Ray offered his services to *Harper's Bazaar* in 1934, just when Alexi Brodovitch became art director and gave photographers artistic license, it is obvious that the magazine maintained editorial control over its array of fashion images.[36] In October 1934 *Harper's Bazaar* published Man Ray's striking photograph of an Augusta Bernard gown at Bergdorf Goodman (see Fig. 17). Here was a model's distorted mirror reflection, which emphasized the sinuous curves of the clinging gown. The elongated slant of the mirror further distanced the model as an exotic and mysterious female, her back turned to the viewer, who sees an image of an image: artifice is all.[37]

Although Man Ray brought Surrealist values to the assignment by quoting the photographic distortions of André Kertész, Kertész's were uncompromising in their "ugliness" and their visual difficulties. Man Ray simply retained a recognizable figure that does not challenge the viewer to the extent that Kertész's do. Moreover, *Harper's Bazaar* could gain the last word. A discreet caption describing the gown was the only visible concession to "reality" against distortion—a concession, that is, to the commercial necessity of informing readers about what the fashion houses have to offer.

Harper's Bazaar also contextualized other work by Man Ray. Thus a painting such as Man Ray's *Observatory Time*, which with its erotic aura of floating lips would have been in itself an appropriate subject for *Harper's Bazaar*, was presented merely as a backdrop for a model (see Figs. 19 and

20). Even though the total image was redeemed in part by the marvelous gesture of the reclining model, who raises her hand languorously to the painting hung above her, the caption subordinated Man Ray to the needs of the industry. Although he was tacitly acknowledged as the painter of the canvas, he was brought to the foreground only as a fashion photographer concentrating on the model. The painting simply provided an exotic setting for the beach coat by Heim. Moreover, *Harper's Bazaar* could do a series of knockoffs with the lip motif.[38] (The fashion industry's attraction to this painting was further evidenced when Helena Rubenstein temporarily retained it for her salon after The Museum of Modern Art exhibition in 1936.)

In addition to industry pressures, ambiguities on the part of Man Ray himself emerged in *Photographs by Man Ray 1920 Paris 1934,* published by collector, curator, and critic James Thrall Soby in Hartford, Connecticut. In his introductory statement, "The Age of Light," Man Ray rightfully called his collection of photographs "autobiographical images," because taking photographs had become a part of his daily life. Here were portraits of his friends, Duchamp and Picasso (who reciprocated with an occluded ink wash of Man Ray for the frontispiece) and lovers, Kiki and Lee Miller. But above all, the photographs recorded Man Ray's participation in Surrealism, with testimonials by Breton, Tzara, and Duchamp, who took the guise of his fictive alter-ego, "Rrose Selavy." So Tzara described the Rayographs as an occasion "when things dream" while Rrose Selavy divined the faces of men portrayed as "landscapes." Man Ray's photographs of women, especially, became a celebration of the life force of Rrose ("Eros, c'est la vie"), their bodies sensually rendered—arms, breasts, hands, lips, buttocks, profiles; a woman relaxing in a café, modeling a gown, dreaming, self-absorbed, posed against an African mask, but always sensual and erotic. Against such images, Man Ray's question appeared almost rhetorical: "What can be more binding amongst human beings than the discovery of a common desire?" [39]

Even as these images express Surrealist values, they could have just as easily belonged in a fashion magazine, just as many of his fashion photographs could have been included among his erotic Surrealist images if the advertising context had been removed. (On one entire back cover of *Minotaure,* the Surrealist-oriented publication of the 1930s that rivaled any fashion magazine for the fine quality of its production and design,

Man Ray advertised the new Parisian address of his portrait studio with an image of a beautiful model's elegant profile.) [40] In any case, Man Ray submitted photographs of comparable quality to *Harper's Bazaar*. In the May 1937 issue, for example, there was a two-page sequence depicting a woman in a somnolent state: in the first photograph she is wearing a black lace cape that conceals her empire dress; it is revealed in the second photograph as she reposes against a white pedestal and urn. This dramatic sequence, with its highlights and shadows, unveils the woman—as mysterious and erotic. These and any number of other photographs for *Harper's Bazaar*—models in negligees, legs in sheer stockings ("Silken Shadows")—continued to celebrate the women he gathered together in his book in 1934. [41]

A comparison of Man Ray's fashion photographs taken under commercial pressures and expectations with the portraits of women he carefully selected and orchestrated in his 1934 collection reveals a blurring of contexts. The situation is ambiguous because Man Ray was not divided between commerce and "serious" art so much as he assumed a double identity as both an avant-garde *and* commercial photographer. Hence he could claim that he enjoyed fashion photography because of the opportunities for sexual encounters with the models. "When editors of fashion magazines impressed upon me that I must get sex appeal into my work, they were talking my own language," Man Ray asserted. "I replied that every picture I did had sex appeal, if one were really sex conscious enough to see it." [42]

His attitude was refreshingly crass in contrast to Breton's high-flown idealization of "woman": according to Breton, Man Ray was seeking in his female portraits the "perfect incarnation," "an oracle one questions," and in their collectivity the portraits were a "Real Ballad of Women of the present." Man Ray exerted a strong literal streak against such high-flown effluvia in "The Age of Light": "The awakening of desire is the first step to participation and experience," he claimed. And elsewhere, he averred, "When I look at a painting or a photograph of a nude I want to forget I am looking at a painting or a photograph, I am looking at a nude!" [43]

Man Ray's reaction to a nude painting was also refreshing in light of the pretensions of art "appreciation." His literalness involved a basic impulse to break down arbitrary distinctions between art and life. But juxtaposed against the world of fashion, his attitude was hardly different from

that of the philistine thumbing through fashion magazines for a sexual thrill. Was that model dreaming of him or of Man Ray? Or was she thinking about her salary and her sore feet? In his doubleness Man Ray stood between the avant-garde and the world of fashion. "Aesthetics" was as important as sex to him, if for no other reason than that he would lose access to the beautiful models without his camera. His response to the fashion editors who wanted sex appeal was thus ambiguous. They may have been "talking his language" (Man Ray as worldly-wise, one of the boys), but in his reply he alluded to Freudian theory so as to aggrandize his own sexual drive while contemptuously challenging the powers of their own sexual perceptions. Man Ray was playing a macho game as his way of maintaining a distance from supposedly crass editors.

For the fashion editors, sex appeal in advertising was an important rhetorical device for selling the latest garments. The new and unfamiliar would be stabilized if the latest fashion could be seen to perform the traditional function of enhancing one's body, making one more sexually attractive. The emphasis upon sex made Man Ray's photographs consonant with the dominant values of fashion; it also overrode possible reservations that his work was too original, too avant-garde, and hence beyond the fashion audience. Conversely, the eroticism of Man Ray's photographs conformed to the visual criteria dictated by fashion. His models were generally beautiful or beautifully rendered, their bodies sensually celebrated, and portrayed with elegance. Their sexuality was never overpowering and always in good taste.

For all that Man Ray denigrated technique and felt a necessity to express contempt for the medium (in order to bend it to his will), his sexual interests in photography were always shaped by form and technique. Solarization, sensual grainy textures, soft focus, unguarded poses, close-ups, unusual cropping—such play with the possibilities of form heightened the eroticism of his models. His photographs transcend the ephemeral nature of fashion, but they are all the more interesting *because* of their fashion context. In their doubleness they play with commercial stereotypes and formulae; they risk banality and many survive. A photograph plays with the hackneyed gesture of the dropped handkerchief: here is "Padova's gold lamé sandal clasped thrice with jewels," with "Quaker's sheerest sandal stocking"—dreams money can buy at Saks Fifth Avenue (see Fig. 18). Yet the reader sees only the exposed foot and the man's hand stretching down

to grasp the silk handkerchief—an intimate moment in what promises to be a sexual adventure. Elegance and mystery: perhaps they will lead to the marvelous. The editors wanted some sex appeal; they got a little more. As Man Ray exclaimed to the astringent Breton: "You know me; I exhibit upon any unconditional invitation, anywhere; I like to carry my propaganda into the enemy's camp. It is the only effective propaganda. We do not need to convert those who are already on our side." [44] How did he count the world of high fashion? That was a risk Man Ray was willing to take.

THAT IT WAS DIFFICULT TO RESIST the blandishments of society was demonstrated by Dali, who was eager to exploit the commercial possibilities of his Surrealist activities. And so he was finally expelled by Breton, who wickedly divined the anagram "AVIDA DOLLARS" from Dali's name. Nevertheless, Breton himself was unable to avoid all of the inconsistencies of being in society but not of it. Nor was Dali's a simple case of having sold out his Surrealism. Neither was exempt from the existing ambivalence between the avant-garde and society, here dramatized by Surrealism and high fashion. [45]

The risks of the fashion world were such that a Surrealist might negotiate them successfully and still falter, as in the instance of Salvador Dali. Among the drawings that Dali executed for *American Weekly* in February 1935 was "Aviation Tendencies in Fashion." Dali and the fashion industry were about to take off together. His first effort at fashion design, published in the fall of 1935, was strictly imaginary, as *Harper's Bazaar* made clear. Exploiting the Surrealist emphasis upon dreams, the magazine came up with Dali's "Dream Fashions." His illustration superimposed Surrealist visual motifs upon conventional fashion poses. Two women, tall and slender as models are supposed to be, assume their slouches in the foreground of an endless De Chirico plain. One, in a bare-backed gown, reads a letter, the other slings her pelvis forward and stretches out her arms. They stand among furniture with organic appendages, and in the distance there is an outcropping of a ferocious beast. The commentary assured the reader, "Not any of these are at Bergdorf Goodman, Marshall Field, or Bullock's Wilshire, California." [46]

Soon they were. Elsa Schiaparelli, the Italian designer, was a key figure in promoting Dali's ideas. Once she had accepted Surrealism as a fashion (and hence fashionable) source, the industry no longer had to rele-

gate Dali's designs to the realm of the imaginary. Breton's dictum of 1924 would take on an unintentional irony: "What is admirable about the fantastic is that there is no longer anything fantastic: there is only the real." [47] The "real" in this case would be Schiaparelli's designs: were they Surreal or ersatz?

Thus in January 1936 Schiaparelli posed two models in a "Surrealist Background," as the feature was called in *Vogue*: "Rope, hurtling out of oblivion, surrealist-fashion; spring-coiling over Schiaparelli's purple dress: incredibly straight and clenched with a metal slide," ran the caption. The Schiaparelli design for the cover of *Vogue* in September 1936 was considered sufficiently strange for the editors to suggest that "it looks as if the dressmakers are becoming Surrealists." *Harper's Bazaar* was quick to follow with Julien Levy's endorsement that "Schiaparelli is the *only* designer who understands surrealism. Her dress with the bureau drawer pockets [based on a Dali drawing] and her vanity case covered with fur [probably echoing Meret Oppenheim's fur-lined teacup] are Authentic." [48]

While there is no gainsaying Levy's assessment, and with all due credit for her adventurous spirit in collaborating with Dali, Schiaparelli's contribution lay mainly in transposing Dali's Surrealist ideas to clothing. Their most powerful effect was achieved in a "Tear-Illusion" dress with a head scarf in 1937 (see Fig. 21). Its irony was ambiguous: here at first glance was an elegant gown whose shreds alluded to the prevailing European vandalism, yet the tears, trompe l'oeil as they were, indicated ultimately that destruction was illusory, fashion was all. In the end, her designs simply skirted the surrealistic, as with the embroidered fantasies of Jean Cocteau on the back of an evening jacket.

In March 1937 *Vogue* gave Dali his own lead (along with De Chirico and Tchelitchew) to visualize a fashion subject:

> A chiffon dress from Bonwit Teller (and I. Magnin, California) and jewels from Olga Tritt were selected by Vogue as a subject for Salvador Dali. He felt that the flaming intensity of this dress calls for a setting representing a desolate beach, full of bewildering objects, and a trombone of gold decorated spoons and glasses of peppermint, sparkling like a tremendous jewel in the foreground. He said: "The most elegant women are drawn to beaches by the vertigo of trombones, the jewels, and by a thirst for poetry."

Dali's use of Surrealist visual motifs, becoming conventions in themselves, rapidly turned into formulaic settings for fashion. Thus he reiterated images for his first *Vogue* cover in June 1939. Whatever mystery the cover might have radiated was dissipated by the editors' felt need to catalogue and explain to their readers (as had *Vanity Fair* earlier): "Symbols by Salvador Dali, the fantastic Surrealist: flowers for the beauty of women, a skipping figure for the remembrance of her childhood, a skeleton ship for the sadness of things past." Inside, Dali completely abandoned his Surrealism to offer a two-page spread of hastily sketched models cavorting in the latest bathing suits.[49]

A few years later, "Original tie patterns conceived and sketched by the famed painter Salvador Dali" were displayed in a full-page advertisement in *Esquire*. The reader was assured that "the artist's genius keeps the ties in excellent taste." Dali's "genius," if such a word may be used, originally resided in his *bad* taste, his unerring eye for exposing social inhibitions. The mention (let alone the practice) of balls of snot lovingly rolled for inclusion in his paintings may have been embarrassing, but it was a lot less embarrassing than the "genius" of the tie ad who guaranteed "excellent taste" in cravats, whose "abstract" blotches aspired to high schlock.[50]

Dali attracted commissions because of his ability to create a spectacle that would generate publicity. One of his biggest moments, which sealed his image with the American public, occurred in 1939 when he was asked to dress the windows of Bonwit Teller. He had been commissioned previously by Bonwit's over the Christmas holidays in 1936, but not with such shattering success. However, his first effort allowed him to expand the "tiny showcase" he had worn at the Bal Onirique into actual store windows. It was humorously recounted as a "Surrealist Episode" in the *New Yorker's* "Talk of the Town":

> A young couple we know happened to be at a very gay dinner party that included a Bonwit Teller executive. Late, late in the evening, everybody decided to go over to the store and watch Dali at work. They found him and his wife knee-deep in teaspoons, whiskey glasses, and other unrelated objects. He immediately began sending everybody out on errands, for things he had forgotten to order. Our young couple were sent out for a live lobster. They finally got one from the kitchen of the Place Elegante, and brought it, struggling indignantly, back to Bonwit Teller's.

When he saw the lobster, Dali was indignant, too. "But," he said, in French, "it's not red." Somebody pointed out that you couldn't have a lobster alive and red at the same time, and Dali said grimly, "Well, *I* will. I'll *paint* it red." This aroused all the humanitarian feelings of our young matron, and she slipped out into the street and hunted up a cop. "I have a cruelty-to-animals case for you," she said, crying tears of pure brandy. When she had explained what was going on, the cop just shook his head and told her his hands were tied. "Lobsters ain't animals," he said. She went back indoors, determined to save the lobster herself, and found it already on the boil, down in the basement, where Bonwit Teller has a stove. Dali used the shell to drape over a telephone, and gave the claws to his assistants, who by this time were pretty hungry.[51]

Dali had already used the lobster motif in a painting called *Gala et l'Angélus de Millet précédant l'arrivée imminente des anamorphoses coniques* (1933), just as it recurred in a witty assemblage entitled *Téléphone-homard* (1936), and it would reappear on the costumes of his "liquid ladies" in the 1939 World's Fair "Dali Dream of Venus."

When Dali returned to New York in February 1939, he was eager for new projects. Upon seeing Fifth Avenue shop windows with "so much surrealist decorativism," he decided to take up the challenge of presenting "an authentic Dalinian vision." Julien Levy arranged matters with Bonwit's window dresser, Tom Lee, and Dali went to work, believing that he had *carte blanche*. He decided to render one window "Day," the other "Night," using turn-of-the-century mannequins, which were not quite as slender as those of the 1930s. According to Dali in his memoir, *The Secret Life of Salvador Dali*, "I detested modern manikins, those horrible creatures, so hard, so inedible, with their idiotically turned-up noses. This time I wanted flesh, artificial flesh, as anachronistic as possible. We went and unearthed in the attic of an old shop some frightful wax manikins of the 1900 period with the long natural dead woman's hair. These manikins were marvelously covered with several years' dust and cobwebs." [52]

Dali and Gala worked through the night of March 15 until six the next morning to finish the display:

In the "Day" display one of these manikins was stepping into a "hairy bathtub" lined with astrakhan. It was filled with water up to the

edge, and a pair of beautiful wax arms holding up a mirror evoked the Narcissus myth; natural narcissi grew directly out of the floor of the bedroom and out of the furniture. "Night" was symbolized by a bed whose canopy was composed of the black and sleepy head of a buffalo carrying a bloody pidgeon in its mouth; the feet of the bed were made of the four feet of the buffalo. The bedsheets of black satin were visibly burnt, and through the holes could be seen artificial live coals. The pillow on which the manikin rested her dreamy head was composed entirely of live coals. Beside the bed was seated the phantom of sleep, conceived in the metaphysical style of Chirico. It was bedecked in all the sparkling jewels of desire of which the sleeping woman was dreaming.

Despite Dali's claim to have constructed a "manifesto of elementary surrealist poetry," [53] the deliberate banality of the theme may have affected the conception as well. While the myth of Narcissus fit the self-absorption of high fashion, a "hairy bathtub" was at best a witty echo of Meret Oppenheim's fur-lined cup. Dali's one genuine metaphor in his description, which tends to dispel any mystery by its allegorizing, reduces dreams ("the sparkling jewels of desire") to consumer goods found in those shops.

When Dali and Gala returned to Bonwit's late in the afternoon to inspect their handiwork, they discovered that the displays had been changed. Customers had complained about the mannequins, which the store management decided to replace with clothed figures. Dali's furious attempt to persuade management to restore his original design failed, so he walked into the window display area intending to overturn the hairy bathtub filled with water. The tub went through the window and Dali followed, a dangling shard of glass narrowly missing him: "Dali surged into the south window and carved his name on the police blotter," as the *Times* put it. Two detectives on the scene arrested Dali on charges of malicious mischief and booked him at the East Fifty-first Street station. The judge suspended sentence on the grounds that Dali was simply exercising artistic temperament.

"Bathtub Bests Surrealist Dali in 5th Ave. Showwindow Bout," ran the *Daily Mirror* headline. "Dali, Surrealist, Has a Nightmare While Wide Awake," according to the *World-Telegram*, complete with cartoons. The *Herald Tribune* was more graphic: "Dali Comes Out Store Window With a

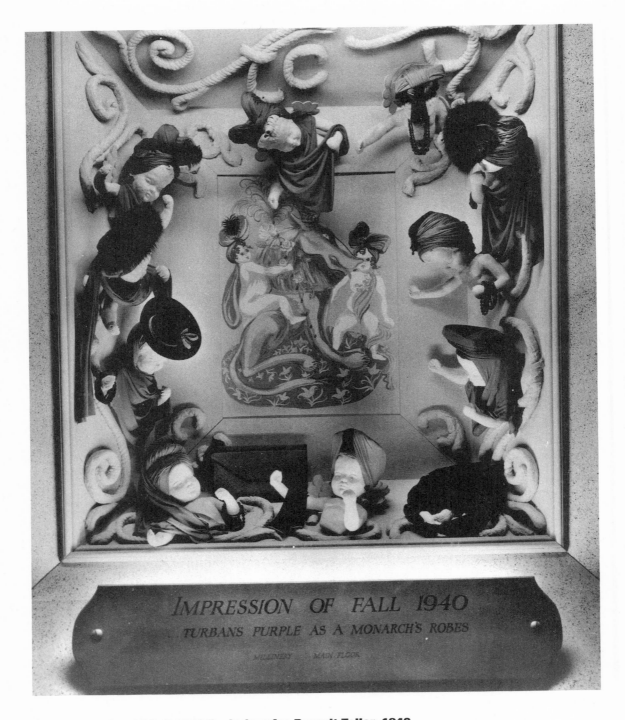

IMPRESSION OF FALL 1940
TURBANS PURPLE AS A MONARCH'S ROBES
MILLINERY · MAIN FLOOR

12. "Impression of Fall 1940," window for Bonwit Teller, 1940.
Tom Lee Papers, The Young-Mallin Archive, New York. Figs. 12 and
13 date from the period when Tom Lee was collaborating with
Salvador Dali on the "Dream of Venus."

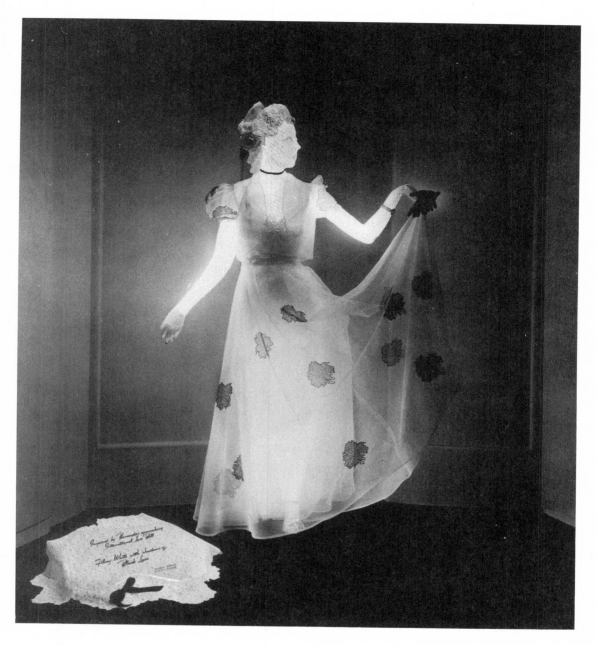

13. Window for Bonwit Teller, 1940. *Tom Lee Papers,*
The Young-Mallin Archive, New York.

Bathtub," and the *New York Times* explained what happened: "Art Changed, Dali Goes on Rampage in Store, Crashes Through Window Into Arms of Law." [54]

The episode at Bonwit's was emblematic of the ambiguity surrounding Dali's American life. It occurred at the intersection of high fashion and the avant-garde, of commerce and popular culture. This particular situation was volatile, but vitality should have come largely from the work itself. Was it possible to create an effective Surrealist manifesto in a store window? It is not clear that Dali's window designs were anything other than the schlock that he had foisted off on the fashion world before. Not that Bonwit's deserved any better, considering its attempt to censor the windows. A serious issue had been lost in the judge's misplaced notion of artistic temperament.

Despite such fiascos, publicity for Dali continued apace and reached a culmination in *Life* magazine in April 1941. Having remarried a wealthy Virginian, Caresse Crosby invited the Dalis to Hampton Manor, near Fredericksburg, a haven from the European war, where Dali worked on his *Secret Life*. In "Life Calls on Salvador Dali," a regular *Life* feature that was most often reserved for social events, Dali was photographed feverishly working on his autobiography while being entertained by a Hereford bull; sketching Gala; playing chess (shades of Marcel Duchamp); posing the black servants in the front yard. But best of all, there was Dali ogling a bemused Gala as they lounged before a pot-bellied stove in the local general store: a Walker Evans setting became a Surrealist occasion with Dada overtones.[55]

Dali's exhibition at The Museum of Modern Art in 1941 dispelled somewhat a sense of exile coloring his sojourn to the provinces of Virginia. Dali, of course, *was* in exile, perhaps more than he realized. The raging European war had cut him off from his aristocratic patrons, while here in the New World he would be shunned by the Surrealists, who excommunicated him because of his commercialism and suspected reactionary political views. Despite its prestige, his one-man show at the Modern in 1941 had a retrospective air, signaling the close of the first phase of his career in America. Surrealism would never be so fashionable in quite that way again.

Man Ray
on the Margin

I've been in Paris all summer working. . . . What with abstract and portrait photography, movies and now and then a painting, I have plenty to do. But it's all one thing in the end. Giving restlessness a material form!
—Man Ray to Katherine Dreier, September 24, 1928

By sailing to France in 1921, Man Ray reversed a process of assimilation begun as the son of Russian-Jewish immigrants. Like many first-generation Americans eager to shed an eastern European past, Emmanuel Radnitsky had invented the name "Man Ray" when he was an art student in New York. The new name was short, easy to pronounce, and difficult to forget. For a little fellow, topping off just above five feet, the name had a macho snap to it. Best of all, it sounded modern—not a bad choice for someone who would become fascinated by the latest machine technology. With a single stroke Man Ray economically rendered his effort at Americanization synonymous with modernization if not modernism.[1]

Assimilation was not without irony, however, for Man Ray simply shed an unacceptable ethnic exoticism for the exoticism of the avant-garde. The decision to follow his friend Duchamp to Paris in 1921, then, was not to discover old roots but to confirm his new identity among the Eu-

ropean avant-garde. Years later Man Ray claimed to have arrived in Paris on the fourteenth of July. No matter that the date was off by several days: it symbolized his sense of liberation; not the American Fourth but Man Ray's *French* independence from the cultural tyrannies of American provincialism.[2]

After establishing a beachhead at the Hotel Boulainvilliers in Paris, with the help of Duchamp, Man Ray recycled a photograph titled *New York 1920* into a collage that he called *Trans atlantique* (see Fig. 22). In its own right, this photograph of New York right beneath his feet, documenting the sort of debris found in the gutter, could be antithetically paired with an earlier work of 1917, also called *New York*. With its strips of wood stepped back and clamped together at a tilt, the earlier assemblage succinctly evokes the sleek skyscrapers rising from the streets of Manhattan. The two together summed up Man Ray's ambivalence toward his hometown.

Man Ray gave resonance to his ambivalence by pasting *New York 1920* above and against a section of a street map of Paris, the city that would become his new home. With similar grey tonalities, these collage elements balance a chaotic, destructive image of New York against an ordered vision provided by a map, a visual construct that represents not the actual terrain but a schematic of the terrain. The counterpoise was appropriate, since Man Ray did not yet know Paris and required a guide. These two territories, one familiar and signified with a photographic presence, the other still abstract and in need of exploration, are separated by "Trans atlantique," the words demarcating both the ocean barrier and the ocean liners that could join the two continents.[3] The collage, then, represents a crossing from the New World, Man Ray's former world, into the Old World of Paris, where the new of the avant-garde reigned. It was the sort of reversal that appealed to Man Ray's ingrained sense of irony.

Although Man Ray was eager to relocate in 1921 because he was disgruntled with the New York art world for its indifference to his work, he hoped to be able eventually to maintain addresses on both sides of the Atlantic.[4] There was nothing unreasonable in thinking that a crossing could occur in either direction, yet *Trans atlantique* suggests in the best Dada fashion that a crossing might occur in both directions at once. While Man Ray would make Paris his European home base for the better part of two decades, *Trans atlantique* does not gravitate finally toward Paris but rather establishes magnetic fields between the two cultural centers in Man Ray's

life. In retrospect, the collage emblematizes his willingness to remain on the cultural margins, to explore the territories betwixt and between all fixed points; indeed, to render fixed points fluid, to go with a state of flux. No wonder, then, that *Trans atlantique* has a background sketch of a chess board that connects the emblems of New York and Paris. Beyond its reference to Duchamp, the motif suggests that Man Ray undertook his lifelong explorations along the margins in the spirit of play.

What was Man Ray able to make out of this ambiguous territory that he staked out as his own? Above all, he became a cultural chameleon, blending with his environment but showing his American colors when it suited his needs. Far from becoming an alienated expatriate, he was quickly accepted among the Parisian avant-garde through the auspices of Duchamp, who (like Picasso) was clearly Breton's equal and something of a legend by 1921. While the objects that Man Ray brought with him reinforced his avant-garde status, he also had photographic skills that soon made him the preeminent photographer of Paris, with the avant-garde, the aristocracy, and the fashion industry for his clientele. By dint of hard work he became highly visible, no less energetic than Dali in New York a decade later, but without the same disastrously commercialized results.

On top of Duchamp's recommendation, Man Ray's nationality gave him cachet among the Parisian Dadaists, who were enthusiastic about things American, including New York, which with its skyscrapers had soared above Paris to become the most modern of modern cities. (By the 1930s Henry McBride, who should have known better, would come to see Man Ray as European—a sign of his indeterminate status.)[5]

At the same time that Man Ray's American identity led to his acceptance among the avant-garde groups of Paris, it also allowed him to steer an independent course, taking on the coloration of both Dada and Surrealism. At base, he retained a Dada sensibility that had been shaped by his initiation into the avant-garde when he met Duchamp in 1915.[6] His first Parisian exhibition at the Librairie Six in December 1921 was necessarily comprised of Dada work accomplished back in New York. Prominently displayed were several images done with an airbrush, "aerographs," Man Ray had called them, paintings by machine. As one might expect, the machine-mad, anti-art Parisian Dadaists were enthusiastic about his work. Well into the 1930s (and beyond), Man Ray turned out objects with a Dada sensibility of wit and irony. *Trompe l'Oeuf* (1930) and *Auto-Mobile* (1932)

continued the sort of clever verbal and visual interplay that can be found in an earlier image of cogs and wheels titled *Dancer/Danger,* a 1920 work on glass once owned by Breton, where the words can be read either way.[7]

As the 1920s evolved, Man Ray collaborated extensively with the Surrealists. In 1928 he filmed *L'Etoile de Mer,* which was predicated on a poem by Robert Desnos. By the 1930s he became especially close to Paul Eluard, with whom he collaborated on *Facile* (1935), a volume of poetry and photography, and then on *Les Mains Libres* (1937), a collection of his drawings illustrated by Eluard's poetry. Equally important, just as he had documented Duchamp's projects in New York during the First World War, he also served as documentarian for Surrealist projects throughout his two decades abroad.

As one of the first Americans to witness the Surrealists in action during the 1920s, he sequentially photographed the group at the Centrale Surréaliste in Paris. In the first photograph, the men attentively surround who else but Simone Breton—the sexism of the Surrealists was notorious—as she sits at the typewriter and takes dictation from Robert Desnos, whom Breton celebrated in the first *Manifesto* as capable of *speaking* Surrealist at will: "He reads himself like an open book, and does nothing to retain the pages, which fly away in the windy wake of his life." [8] Their concentration in the first photograph turns to amazement in the second, as Desnos has apparently plumbed new depths of his psyche. The first photograph is almost a commonplace in standard histories of Surrealism, but the second, snapped just moments after the first, offers a rare Muybridge-like glimpse into the experimental activities of the Surrealists in closed session.

In 1939 Man Ray tried writing (1937) with a camera in *Man With Light* (see Fig. 24). Seated in a darkened room, Man Ray photographed himself as he wrote with a flash pen behind a frame. His calligraphy exists only as light moving through space. The evanescence of his gesture is caught through the intervention of his camera, the drawing continuing to exist only as a photograph. The invisibility of photography as a medium and the transparency of the frame holding Man Ray's writings conceal the nature of his self-portrait, the artist blurring the boundaries between media.[9] He reminds us that photography was once considered "nature's pencil."

While Man Ray's automatic photography clearly belonged within the

Surrealist camp in its emphasis upon psychic automatism, some of his work picked up exclusively Surrealist themes. Along with his fashion photography for *Harper's Bazaar* during the 1930s, Man Ray's monumental painting *Observatory Time—The Lovers* (1932–1934) has an erotic aura that coincided with Breton's newly declared emphasis upon love in the 1929 *Second Manifesto,* an interest that would escalate into *Mad Love* by 1937 (see Fig. 19).[10]

Other work of Man Ray's, most notably his Rayographs, was claimed by both the Dadaists and the Surrealists. By serendipitously discovering how to make Rayographs soon after his arrival in Paris, Man Ray enhanced his stature as an avant-garde photographer (see Fig. 25). The images conformed to Dada with their illusion of happenstance, and in their primitive directness, they were virtually a parody of straight photography: after all, hadn't Man Ray bypassed the negative completely in bringing his objects to the printing surface? What could be more straightforward, and what could transform the intense mimeticism of straight photography into more abstract shapes than Man Ray's cameraless process? Tristan Tzara claimed them without hesitation in 1922 as "pure Dada creations," and while he continued to write about the Rayographs in the 1930s after Dada was long gone, the cameraless images became Surreal with their mysterious and irrational appearances, as though emerging from the unconscious.[11]

Man Ray did not try to resolve his ambivalence toward Dada and Surrealism. Instead, he sustained fluid discourse between the two movements without committing himself irrevocably to either. In his detachment, Man Ray emulated Duchamp, who remained deliberately aloof from every movement, including Dada. In 1921 Duchamp had refused to show at a Dada salon in Paris, sending Tzara a succinct but scatological telegram from New York: its message, "Pode ball," was a phonetic kiss-off ("peau de balle," or "balls to you") that signaled his unequivocal independence even from the scattershot anarchy of Dada projects.[12] Duchamp's stand allowed him to choose his own moments of participation, as he would do in helping to realize the large Surrealist exhibitions of the late 1930s and 1940s.

Man Ray discreetly followed suit—not being able to afford the blunt manner that came with Duchamp's status. He had first been attracted to the Frenchman's independence when he studied art before the First World War at the Ferrer Center in New York, named after Francisco Ferrer, the

Spanish anarchist. Man Ray illustrated some covers for *Mother Earth,* which was edited by Emma Goldman, the most controversial anarchist in the United States at the time. In 1919 he helped the anarchist sculptor and poet Adolf Wolff publish a single issue of *TNT*—a wonderful title that detonated (and parodied) all the stereotypes of bomb-throwing anarchists.[13]

Abiding by his anarchist principles, Man Ray shied away from the Surrealist political declarations issued in Paris during the 1920s and 1930s that would have pinned him to the Communist party or the Soviet Union. Although he was cautious about signing manifestos because he was a foreigner—"freedom of speech was reserved for the French," he later recalled—his political endorsements followed a pattern of anarchism. He signed *Hands Off Love!* (1927), which affirmed Charlie Chaplin's sexual freedom; *L'Affaire de l'Age d'Or,* which condemned the French Fascists who vandalized Luis Buñuel's film of that name and the accompanying Surrealist exhibition in 1930; *Misère de la Poésie* in response to the Aragon affair of 1932; and "The Time When the Surrealists Were Right," in 1936, the occasion of Breton's final break with the French Communist party and the Stalinist line of the Soviet Union.[14]

Man Ray's low-key adherence to anarchism made his relationship with the Surrealists sound easier than it was. While he enjoyed good timing, arriving in Paris when Dada was still simmering and everything seemed possible and the atmosphere open, the very same circumstances initially distanced him from Breton. The Frenchman's failure to endorse Man Ray's exhibition at the Librairie Six was not surprising. The American's friendship with Tzara (who would encourage him to pursue the possibilities of the Rayograph) came about during the Rumanian's dispute with Breton over the efficacy of calling a Congress on Modernism (which fell apart in the planning in January 1921). The divisiveness continued as late as July 1923, when Man Ray showed his first film, *La Retour à la Raison* (made on the urging of Tzara once again), at the Dada Soirée du Coeur à Barbe, organized by Tzara and vehemently opposed by Breton. (Man Ray's "alliance" with Tzara was based on a friendship that was initially less ideological than circumstantial, since he lived near the Rumanian upon his arrival in Paris.)

Breton's struggles to gain control of the Parisian avant-garde during the hiatus leading up to the 1924 *Manifesto of Surrealism* impelled him to

seek ideological purity in the years following. He placed a high premium on total participation in group manifestations, so he continued to find Man Ray suspect. Thus in the 1924 *Manifesto* he included the American among those who were not "always" Surrealist because of their ego. Breton judged that "they were instruments too full of pride." [15] There may well also have been the matter of the photographer's emerging commercial success in the fashion industry.

Whatever the reason, Man Ray blithely refused to knuckle under. As a consequence, his 1926 film *Emak Bakia,* whose title pointedly means "Leave Me Alone" in Basque, was not received enthusiastically by the Surrealists in its debut at the Vieux Colombier Théâtre. Even though Man Ray knew that he had "complied with all the principles of Surrealism: irrationality, automatism, psychological and dreamlike sequences without apparent logic, and complete disregard of conventional storytelling," he realized afterward that he had been "too individualistic," having failed to clear the project beforehand and to "present the work under the auspices of the movement to be recognized as Surrealist." [16]

Even though the rift with Man Ray eventually healed, Breton persisted in making stringent demands upon the American's loyalty. Thus by virtue of his "occupation or his character" Man Ray was one of those excluded by the Surrealist leader from the debate over the direction of Surrealism in 1929. Man Ray attended the inquest anyhow, held at the Bar du Château, and survived Breton's purges (which were made public in the *Second Manifesto*).[17] But even during those apparent contretemps, Man Ray's photographs appeared throughout *La Révolution Surréaliste,* Breton's first Surrealist magazine, and then in *La Surréalisme au Service de la Révolution,* which began in 1930.

Man Ray's "offense" (beyond his association with Tzara at the start of his stay in Paris) stemmed from his deep sense of individualism, which Breton ultimately managed to respect. In an interview years later, Man Ray recalled that "Breton was consistently kind to me and always found that I fitted in. I had no quarrels with the Surrealists. I trusted them and they trusted me." [18] He was not being nostalgic or disingenuous in describing a generally favorable relationship with the Surrealists. The mutual trust that allowed him freedom of movement was ultimately akin to faith, and probably no less arbitrary, but his independence can also be traced to his role as a visual artist whose anarchism colored his entire personality.

• • •

AS AN ACKNOWLEDGED LEADER among American artists in New York during the First World War, the individualistic Duchamp corroborated and reinforced Man Ray's early sense of independence, which was nurtured in local anarchist circles. Before Duchamp, Man Ray's Belgian wife, Adon Lacroix (previously married to the anarchist Adolf Wolff), had exposed him to the writings of Isidore Ducasse, who wrote under the mysterious pseudonym of the Comte de Lautréamont. (Since his French at the time was limited to her tutelage, she read him passages from Lautréamont's 1869 book *The Chants of Maldoror*.) Man Ray came to admire Lautréamont for offering "a world of complete freedom." [19] Because little is known of Lautréamont's life, there is no way to gauge how this young man exercised his freedom except through his writing, especially *The Chants of Maldoror*, in which he was free to imagine the worst, and did, by creating the demonic Maldoror, who behaves in the most despicable fashion, remorselessly. Breton was quick to hail Lautréamont as a nineteenth-century precursor of Surrealism.

In comparison to Maldoror's sexual libertinage (among other savageries and barbarisms), Man Ray's personal inclinations have to be considered fairly tame, involving the sort of macho posturing that his male cohorts would have found obligatory if at all worthy of comment. Like Lautréamont, however, Man Ray took his own work as the measure of his freedom. In 1948, in a series of statements that had the most overt political meaning, Man Ray summed up his anarchist stance: "I simply try to be as free as possible. In my manner of working; in the choice of my subject. No one can dictate to me or guide me. They may criticize me afterwards, but it is too late. The work is done. I have tasted freedom." [20] It is crucial to note that Man Ray defined his freedom in terms of his work, indeed, sought his freedom in his work, where disturbing ideas and feelings symbolically liberated a libido that was at home with the Marquis de Sade and Maldoror.

On the grounds cleared by Duchamp and Lautréamont, then, Man Ray sustained his artistic integrity by his inventiveness. His Dada friend Hans Richter rightly described him as "an inventor. He just cannot help to discover and reveal things because his whole person is involved in a process of continual probing, of a natural distrust in things 'being so.' " In his reflexive and protean inventiveness, Man Ray was an American coun-

terpart to Jean Arp—who came under fire from his Dada friends for producing so many biomorphic images that looked suspiciously like art. "What can I do?" Arp shrugged. "It grows out of me like my toenails. I have to cut it off and then it grows again." As Arp's mechanically inclined complement, Man Ray felt compelled to tinker with things, and to transform them in the process.[21]

Despite his close, chameleonlike friendship with the charismatic Duchamp, Man Ray was not an already-made, a minor replica of his friend. Duchamp's great gift to Man Ray had been to give license to the younger man's penchant for innovation in a restrictive New York climate. Even though the Frenchman later paved the way for his American friend in Paris, Man Ray was left there on his own (the peripatetic Duchamp having departed for New York in January 1922) and became a *succès d'estime* through hard work. More specifically, Duchamp affirmed for Man Ray an essential principle that guided his own work: the need to interject ideas into art once again, painting having become "retinal"; to discredit the old saying, "stupid like a painter." [22]

In their instance, an interplay of Dada spirit and generosity allowed plagiarism but more. A quick study, Man Ray also came to value the idea in art. Like Duchamp, he was willing to take conceptualism to its extreme. He once claimed that he was satisfied simply in having thought about a project, without any felt need to materialize it.[23] More characteristically, however, Man Ray moved between idea and enactment, gravitating toward the palpable realm of artifacts beyond Duchamp's domain of ideas and language.

His deep commitment to the object itself often took a literal turn, as evidenced in one of his earliest abstractions, *Tapestry* (1911), which ended up on the wall of his studio, but which at the outset served as a coverlet on cold nights in his cabin in Ridgefield, New Jersey. During the course of painting *The Rope-Dancer Accompanies Herself with Her Shadows* in 1916, Man Ray actually strung up the canvas on a pulley with ropes so that he could raise and lower the painting from the ceiling of his small studio as a kind of literal rope-dancer. *Cadeau*, the famous flatiron with a row of long tacks glued on the bottom, had its genesis at the opening of his 1921 inaugural exhibition in Paris, where, before it disappeared, Man Ray intended to offer it in a drawing for his new friends.[24]

Man Ray was prolific, indeed prodigious, in contrast to the austere Duchamp, who single-mindedly pursued his complex project, *The Bride Stripped Bare by Her Bachelors, Even,* for almost a decade. The significance of the multiplicity of Man Ray's work lay in the movement itself, "giving restlessness a material form," as he wrote to Katherine Dreier in 1928.[25] Objects became way stations for Man Ray in their various permutations and combinations of media, ideas, and themes—a veritable web of artifacts that contributed to the texture of his life. Unlike Oscar Wilde, who wanted to turn his life into a work of art, Man Ray made objects to be the decor of his, with a function that went beyond the decorative. Each piece occupying his apartment and studio was instrumental in the fabrication of Man Ray's avant-garde identity.

IN DEVELOPING AN ELUSIVE PERSONA, Man Ray did not want to be identified with any single art form, preferring to work between and among media. As a consequence he became especially ambivalent toward photography, because it threatened to entrap him in the need to earn a living. That he was worried about his financial prospects surfaced in 1921 at French customs, where he was questioned about one of his assemblages. He assuaged the skepticism of an inspector toward *New York 1920,* an olive jar filled with ball bearings, by claiming that it was a "studio decoration": "Sometimes artists didn't have any food, it would give me the illusion that there was something to eat in the house." With his success as a commercial photographer, Man Ray soon managed to avoid the life of a starving artist, and indeed he assiduously disavowed the ascetic life in Paris. Hence his relief after settling in Hollywood at the onset of the Second World War: he had regained all the old accoutrements, "a woman, a studio, a car"—a common, even banal version of the American dream made possible by his commercial photography.[26]

From this perspective, photography provided Man Ray not only with economic but also aesthetic freedom. He could henceforth paint and make objects for his own satisfaction without bowing to the demands of the art market. His avant-garde work became all the more an intimate part of his life. At the same time, however, in the delicate balance between freedom and necessity, commercial photography could also be a snare. Despite his success, Man Ray railed against the time and energy his livelihood demanded. He found that the best strategy to tip the equilibrium toward freedom was to erase distinctions between photographic and nonphoto-

graphic work, to master photography by assimilating it into avant-garde activity and, if need be, then to reintroduce it, transformed, into the realm of commerce.

Such a strategy demanded that Man Ray evade fixed cultural views of photography so as to maximize the flexibility of his movement among media. The uncertain cultural status of photography during the early decades of the twentieth century facilitated his evasions. Despite its existence for the better part of a century, photography continued to be problematic as a new technology when Man Ray joined the avant-garde of New York around the time of the 1913 Armory Show. Those photographers who entered the lists as pictorialists sought to manipulate negatives and prints to make photographs that had the look of painting (atmospheric in the vein of Impressionism)—hence to demonstrate that photography could indeed be a fine art. Alfred Stieglitz took up the cudgel as a straight photographer, assiduously avoiding all manipulation in order to explore the possibilities of photography as its own medium with its unique properties, defined in terms of sharp focus and clear images.[27]

By 1922 Stieglitz ran a symposium in *Manuscripts* that posed the question: "Can a Photograph Have the Significance of Art?" Despite its circumspect air, the question had become more rhetorical than not for Stieglitz. Having waged a long campaign to establish the autonomy of photography among the other arts, he was not about to settle for a negative answer. Predictably, many of the respondents acknowledged his leadership as a photographer whose work should be deemed art. Those rare few who denied the possibilities of photography were exposed as reactionary.[28]

Oddly enough, Man Ray was not included among the respondents. Even so, he had an able representative in Duchamp, whose reply bluntly circumvented Stieglitz's game:

Dear Stieglitz:
Even a few words I don't feel like writing.
You know exactly what I think about photography. I would like to see it make people despise painting until something else will make photography unbearable.
There we are.
Affectueusement.
Marcel Duchamp.[29]

Duchamp's involuted dismissal mirrored Man Ray's attitude toward the media of art, stated most explicitly in 1934, with the publication of a selection of his photographs by James Thrall Soby in Hartford. "A certain amount of contempt for the material employed to express an idea is indispensable to the purest realization of this idea," Man Ray claimed in his introduction to this collection of photographs, which were dazzling in technique and technical range. He would later reemphasize this point: "To master a medium means that you've got to despise it a bit too." [30] So long as a medium remained simply a means to an end, Man Ray felt able to maintain his independence as an artist.

In 1926 Man Ray had come to this from another direction, in an article for *Paris Soir*. "I maintained that photography is not artistic!" he averred, and why? "A form of expression is only capable of evolution and transformation to the degree that it is not artistic." [31] In taking this position, Man Ray reiterated a view favored in Stieglitz's influential magazine *Camera Work* in the half-dozen years prior to its demise in 1917. By denying photography the status of art, Stieglitz and then Man Ray were circumventing the aesthetic conventions that served as models for photography. Such conventions, they realized, restricted the development of photography as its own medium.

In 1928 Man Ray went beyond Stieglitz and took up Duchamp's view. He was again asked, "Is Photography an Art?" And again he responded in the negative: "It doesn't need to be an art," he claimed. "Art has been surpassed. We need something else. We need to use light now. It is light that I create. I sit before my sheet of photographic paper and I think." Even though Man Ray was referring specifically to the process of Rayography ("the direct impression of rays of light, the creator of pure inventions") his reply was sufficiently ambiguous to encompass photography itself as the creator of light, thereby sanctioning photography beyond art. [32]

In practice, Man Ray defected to the pictorialists in terms of manipulation, but he boldly went so far beyond their efforts that his photography did not simply imitate painting, but ironically came round to Stieglitz's original intent in demonstrating the visual possibilities of the photographic medium. That Man Ray was not content to remain with the pictorialists was signaled by his painting a portrait of Duchamp in 1923 that had the appearance of a photograph—not in its high mimeticism, though the image is representational, but in its graphic textures and tonalities. By

painting an imitation photograph, Man Ray reversed the pictorialist's endeavor to make photographs in imitation of painting.

With the Rayograph, Man Ray subverted the authority of photodocumentation to the extreme: the cameraless photograph "records" objects that never existed in the way they are visualized in the photograph. Hence knowledge of an object that is manipulated on the contact sheet is virtually irrelevant. But again, Man Ray thought of Rayography in the context of painting—especially abstraction. In a 1928 interview he asserted, "We no longer use our eyes for painting . . . so I have also suppressed the eye of my camera—its lens." [33] It was a witty and incisive way to describe his Rayograph abstractions as akin to the imagery of nonrepresentational painting.

MAN RAY'S OWN DESIRES, to the extent that he could not realize them, drove him to a dark eroticism that was more profound than the glamorous images allowed by the fashion magazines. Thus he vented his contempt for the fashion industry openly in a drawing entitled "Couture" for *Les Mains Libres*: a slender woman in the latest gown is sexually assaulted by a pair of scissors, in a variation on Lautréamont.[34] The source of the violence is, of course, ambiguous. Insofar as Man Ray drew the image, the violence remains his; yet the image could be taken to expose the violence perpetrated by the fashion industry on women, turning them into sex objects, isolating parts of the body for display in a process that shares more with the pornographic than with the erotic.

This was a process in which Man Ray was complicit. Thus he could breezily describe the use of mannequins in the 1938 Surrealist exhibition in the language of rape, no less violent for the intended wit of the extended conceit. The mannequins ("nude young women") were "kidnapped" and "violated" by the Surrealists. The "victims" remained compliant females, submitting with "charming goodwill." "Aroused" by their sexual "frenzy," Man Ray "undid and took out his equipment and recorded the orgy." [35] He was not simply a voyeur but an active participant by the very act of photographing the figures.

These attitudes had surfaced earlier in Man Ray's collaboration with Eluard on *Facile*, comprised of love poems to Eluard's wife Nusch, photographed nude in the shadows. On the surface, the photographer sought a lyrical eroticism in posing Nusch in the manner of an elegant fashion

model. Glamour, however, was not entirely the point. Man Ray's photography does not serve as mere illustration for the poetry. Nusch's nude figure floats darkly along the margins of Eluard's poems, solarized in an aura of light, superimposed, and bathed in shadows—establishing a fluid discourse between the verbal and the visual.[36] Her sensual presence frames the poetry and gives palpable definition to her lover's extravagances. Yet the photographs of Nusch, submissive, ambiguously in bondage, hint at Man Ray's characteristic movement between the love idealized by Breton and the radical materialism of Georges Bataille, an apostate Surrealist whose dark vision challenged Breton's views during much of the 1930s.[37]

In his moments of despair, when he courted nihilism, Man Ray must have found Breton's optimism naive if not skewed. The Greek myth of the Minotaur, the bull that lived at the heart of a labyrinth built by Minos, became an apt metaphor for the raging forces within. In 1937 Man Ray photographed a terrifying image that brought the beast to life (see Fig. 26). Man Ray created an effective double image: it was simultaneously a bull and a human figure whose head remained in dark shadows and whose outstretched and upraised arms outlined the bull's horns. Man Ray recognized the essential element of this ancient myth: the monster is human, both male and female.

This latent androgynous creature exposed by Man Ray has to do with the mind that can imagine, and visualize, the body in metamorphosis—melting, as in the darkly solarized photograph of a sleeping nude who demonstrates *The Primacy of Matter over Thought* (1929). Man Ray's inversion of the cliché points to the primacy of the artist, working with materials that give shape to the urgency of ideas—of desires. The represented body, then, can become what?—a Breton solarized as an archangel, a Breton who understood that photography was not art and so could see Man Ray as "l'homme à tête de lanterne magique." [38]

This mythmaking has little to do with reputation and everything with identity. Man Ray, Breton perceived, is a magic lantern, a source of light, a sorcerer of light, effortlessly projecting images even as he sees them. Kiki, a popular artist's model in Montparnasse, had another, more intimate view. In her memoirs, she recalled Man Ray soon after he had arrived in Paris and they had become lovers: "He speaks just enough French to make himself understood; he photographs folks in the hotel room where we live, and at night, I lie stretched out on the bed while he works in the dark. I can

see his face over the little red light, and he looks like the devil himself; I am so on pins and needles that I can't wait for him to get through." [39]

Kiki did not get it quite right either. The Faustian metaphor is conventional, if not banal. But the sexual heat has an exact glow. Years later in his own autobiography, Man Ray described virtually the same circumstances merely in passing: "the balcony was the bedroom where Kiki had to remain quietly while I was receiving." [40] His coolness is understandable. He was preoccupied by clients or work of the darkroom, just as she was caught up in sexual anticipation—with hardly a difference. Man Ray found that deferred pleasures were bearable, perhaps preferable, because of the desires exposed in the images he was making. In either case, he could lose himself in the dark, where each image would radiate a self-portrait, an alter ego that only another great alter ego, Duchamp's Rrose Sélavy, could understand. "Men before the mirror," s/he divined from Man Ray's portraits, were imprisoned, held captive by their faces. For Man Ray the chameleon, the camera became his mirror at night, offering multiple "autobiographical images" fragilely comprised of "oxidized residues"—the process became his way of forestalling the fixed image in the morning.[41]

Man Ray played out his aggressions in an extended dialogue with Isidore Ducasse, who had assumed the guise of the Comte de Lautréamont in writing *The Chants of Maldoror*. In 1920 Man Ray constructed *The Enigma of Isidore Ducasse*, which now survives as a photograph of an object bound and wrapped in burlap (see Fig. 27). The enigma clearly refers to the concealed object—or does it? Nothing is ever so clear with Man Ray. The object under wraps was supposedly a sewing machine, which alludes to Lautréamont's statement, later singled out by the Surrealists from *The Chants of Maldoror*, a "chance encounter of a sewing machine and an umbrella on a dissecting table." [42]

A narrow focus on this specific image, however, yields little. Man Ray's subsequent photograph of a sewing machine and an umbrella in 1935 is disappointing in its explicit depiction of an imaginary juxtaposition that excited so much in the way of Surrealist assemblage. The larger framework of Lautréamont's *Chants* casts a complex resonance for Man Ray's earlier assemblage. "Enigma" is the operative word in its title, and one remains uncertain of the concealed object: is that really a sewing machine under there? [43]

The mystery is compounded by the fact that the object is tied up. The mound might really conceal a live human being held in restraint or it might even be a corpse, a possibility suggested by a fundamental displacement that occurs in *The Chants of Maldoror*. A beautiful young man is stalked and eventually kidnapped in a gunnysack by Maldoror, who compares his beauty to the fortuitous meeting between a sewing machine and an umbrella. Although the imagery chosen for the vehicle of the simile has heterosexual connotations, the comparison serves to describe homoerotic feelings bound up with murderous violence, made all the more horrific by Maldoror's calculating manner. His male prey is thus displaced by an aggressive heterosexual image of the sewing machine coupled with the umbrella to the point of cruelty and pain.

The scale of Man Ray's *Enigma* should, of course, immediately confirm or deny the possibility of a human body, dead, alive, violated, in the sack; but scale is impossible to determine because all that remains is a photograph whose visual field is consumed by a close-up of the object. Having taken a photograph, Man Ray destroyed (or disassembled) the artifact, just as Maldoror asks some butchers to kill the "dog" that he claims is in the sack. Man Ray's camera did not merely document the cloaked object but rather lent it drama and indeterminacy by portraying it as a dark and looming mound.[44]

To further complicate matters, the title of Man Ray's photograph-assemblage is ambiguous. Did Man Ray create an object representing an enigma in Lautréamont's writing—the umbrella-sewing machine configuration, say—or did he create an object representing the enigma of Lautréamont himself as an artist and as a human being? In either case, Man Ray kept viewers in the dark in regarding an object that remains forever inaccessible. By virtue of his fascination, *The Enigma of Isidore Ducasse* would turn up again in 1935 as *Enigma II*, the hidden object wrapped in heavy paper instead of burlap. Still later, it would be depicted in a painting called *La Rue Ferou* (1952). A cart bearing the assemblage (now as large as a human body) is being dragged to Man Ray's newly found studio after his return to Paris in 1951.[45] Man Ray would further displace Ducasse's male object with women. Echoes of the *Enigma* reverberate in *Venus Restaurée* (1936), a plaster-cast female that is headless and armless, but tied nonetheless, and in photographs of bound women, his lovers among them.

This eruption of violence in Man Ray's work subsided, yet it surfaced periodically. If *Enigma* implied violence in its concealments, *Cadeau* was an openly aggressive Dada gesture, a year later, in 1921. The iron with its tacks could be construed as a weapon or, worse, as an instrument of torture. *Object to Be Destroyed* (1922), a metronome with a photographed eye (Maldoror's cyclops?) attached to the pendulum, was destroyed, and resurfaced as a drawing in 1932. By this time, the work had taken on new meaning for Man Ray. With the drawing, which was published in the Surrealist issue of *This Quarter* (see Fig. 23), came a set of instructions:

> Cut out the eye from a photograph of one who has been loved but is seen no more. Attach the eye to the pendulum of a metronome and regulate the weight to suit the tempo desired. Keep going to the limit of endurance. With a hammer well-aimed, try to destroy the whole at a single blow.[46]

The missing lover was, of course, Lee Miller, the beautiful young American fashion model who had joined Man Ray in 1929 to become his photographic assistant, model, and companion. An independent woman who believed in open relationships, she left him three years later.[47] The debonair fashion photographer, as Man Ray had portrayed himself, gave way to a portrait drawn by Picasso, where he looks gaunt, withdrawn, grim, and haggard, in retrospect sexually obsessed by the loss of Lee Miller.

Her eye then graced the pendulum of the metronome in its latest mutation. Her symbolic mutilation was to be followed by the destruction of the entire metronome. Man Ray's sexual aggression extended inward as well as outward. The eye here begins as an omniscient observer, offering a detached yet self-conscious monitoring of the painter at work, as Man Ray later claimed. With its mechanization, the eye also becomes the photographer's eye (including Lee Miller's), gaining movement, and by implication energy, hence the metronome's final reincarnation as "perpetual motif." This energy is bound up with sexuality, since the encounter of the eye and pendulum suggests either a relentless penis or a vagina penetrated by the pendulum.[48] Man Ray's invitation to destroy the metronome also invited self-destruction as well as the viewer's complicity.

Man Ray's bleak view of sexuality during this difficult period of separation was belied by a witty photograph (1931) of an apple whose stem he

replaced with a screw. Without a title, the image still economically conjures mythic origins in the Garden, the apple and sexual knowledge here on the verge of transformation by advanced technology into an ominous and threatening mechanism. The viewer is caught between the object and a deft gesture, whose trace has been captured by a photograph. Its wit resides in an economy of means, and its humor in the vulgarity of American slang, unstated but self-evident. Yet these very same qualities disguise the disturbing juxtaposition of the organic and the mechanical, the literal depiction of a metal screw capable of penetrating and violating the skin and flesh of an apple.[49]

Man Ray's anger and frustration took a different turn in his painting *Observatory Time—The Lovers* (1932–1934), his first monumental painting since *The Rope-Dancer* of 1916. The lips floating above the Paris sky by the observatory near the Luxembourg Gardens (in Man Ray's neighborhood) had their genesis in the lips of Kiki, his first Parisian lover (see Fig. 19). Man Ray recalled that her lipstick on his collar came to mind when he began this canvas in 1932. He had already photographed her lips, which served as the immediate visual model for a template drawn to afford an enlarged transfer to the canvas. In the process, he switched from Kiki's lips to those of Lee Miller (who was Kiki's successor as his lover). Although the final image is vaguely threatening (as in the hackneyed notion of a "devouring woman"),[50] those hovering lips over the landscape are marvelously erotic.

That Man Ray intended the image to be affirmative is evident from a lyrical prose-poem that he published with an illustration of *Observatory Time* in the Surrealist-oriented *Cahiers d'Art* in 1935. Poised in the nether time of dawn, between sleep and waking, that propitious moment of dreams, Man Ray addresses the mouth of his lover. "*Seul réalité, qui fait valoir le rêve, répugnant à l'éveil, elle demeure suspendue dans le vide, entre deux corps* [Reality itself, which makes the most of dreams, loath to awaken, remains suspended in space, between two bodies]." He imagines her lips, suspended between two bodies, separated by a sinuous horizon, just as the earth and sky, as two lovers, are separated. In a long passage that follows, Man Ray moves from this duality to union with his lover, as the painter renounces sight for touch alone, his lover's lips requiring only the sense of touch, not even voice, for to be silenced with one's fingers, the mouth must still be touched ("*Ne serait-ce que le doigt qui se pose sur elle*

pour l'empêcher de parler, la bouche silencieuse doit toucher.") Attracted, as if to the lips of the sun, he finally kisses her: "*je vous rejoins dans la lumière neutre et dans l'espace vide, et, seul réalité, je vous embrasse avec tout ce qui reste encore de moi: mes propres lèvres* [I rejoin you in the neutral light and in the empty space, and, lone reality, I embrace you with all that remains of me: my own lips]." [51]

Man Ray later prosaically confirmed the image, latent in the floating lips, that contributes to the erotic charge: "The lips because of their scale, no doubt, suggested two closely joined bodies." Significantly, he worked on the painting not in his studio but in his apartment, where it hung over his bed "like an open window into space" (or like a dream) for several years before entering the art network in a Surrealist exhibition in London and in The Museum of Modern Art's "Fantastic Art, Dada, Surrealism" in 1936. Despite its size (over eight feet in length), the painting required the intimate context of his apartment to sustain its dominant aura for Man Ray. [52] That he would construct in 1934 a purselike object with lips drawn in cord (suggesting the sinuous line of automatic writing) and titled *Mon Rêve* underscores the personal dreamlike quality pervading the entire image.

Man Ray would not let the dream subside. In painting *The Woman and Her Fish* in 1938, preceded by a drawing for *Les Mains Libres* in 1936, he depicted a woman and a fish stretched out against each other, their angle of repose and general configuration matching *Observatory Time*. Even though the floating lips of the earlier painting have been transformed into a floating woman-and-fish, the metamorphosis into "two closely joined bodies" simply reveals another dream, ambiguously transferred to the sleeping woman. With its combined phallic and vaginal shape, the fish is both male and female. In any case, the aggressively heterosexual Man Ray changed the gender of participants in an infamous incident in *The Chants of Maldoror*: Maldoror engages in a "long, chaste and hideous coupling" with a female shark in "one glaucous mass exhaling the odors of seawrack." [53] In 1937 Man Ray drew two monsters locked in a devouring embrace. Within two years he would flee from the monsters of war in Europe.

5 Surrealism on the American Left

Some of my best friends are surrealists. . . . Come, come, roll up your folding watches; it's time to wake up and walk out of your somnambulistic trance.

—Adolf Wolff, letter to the editors, ART FRONT (January 1937)

Adolf Wolff's choice of imagery in urging his Surrealist friends to join the Communist fold was both witty and apt. Dali's *Persistence of Memory* had captured the American imagination, and Dali himself had come to embody Surrealism for most Americans. Although he had not quite screwed up the courage to challenge Breton for the leadership of Surrealism in Paris, he became a pretender to the throne in the United States, where the absent Breton had been eclipsed by Dali's antics.

In responding to Surrealism, then, American artists were often responding to Dali, who was not only visible but also a *painter*, unlike Breton, and hence germane to their immediate concerns, which, during the Depression, often took a political cast. This picture was complicated by the fact that the American left never shook its ambivalence toward Surrealism in general, even though a cultural spokesman like Mike Gold had become openly hostile toward the *transition* group as surrogate Surrealists by the beginning of the 1930s. Both radical painters who aspired to a "So-

cial Surrealism" and the "Post-Surrealists" from California had to contend with Dali, who was a lightning rod for artists along the entire political spectrum.

Never one to avoid controversy, Dali laid down the gauntlet in *Art Front,* a journal with leftist leanings. "Most advanced in the aesthetic domain," he boasted in 1937, "is the surrealist phenomenon which attempts to resolve the most astonishing and recent discoveries of the imagination."[1] So Dali, the Surrealist suspected of reactionary politics, challenged Louis Aragon, the Surrealist who had abandoned Surrealism for the French Communist party. His defection was all the more dramatic because he had been one of Breton's founding partners of Surrealism. Their divergent political odysseys had gone international and were hotly debated among American artists and intellectuals.

Apart from Dali, no one generated leftist contradictions and ambiguities more than Aragon, the Surrealist apostate. In February 1933 news of the Aragon affair filtered to the United States through *Contempo,* which published an account of the previous year's controversy along with his poem "Red Front," translated by e. e. cummings.[2] In January 1932 the Surrealists had rallied around their comrade, who had been indicted for advocating the murder of government authorities in the poem. Although the government charges were eventually dropped when it became evident that a *cause célèbre* was in the offing, "Red Front" fueled acrimonious controversy between the Surrealists and the Communist party.

In *Contempo* Jay Du Von tried to unravel the issues, which had proliferated in confusion among the various factions on the French left. Breton defended Aragon's poem—correctly, as Du Von noted—on the grounds that the government was attacking poetry for the first time as though it were on a par with political tracts or other polemical prose. Du Von also reported the response of *L'Humanité,* which construed Breton's argument to be merely a defense of poetry. The Surrealists were criticized for their apparent failure to support the workers in all phases and aspects of class oppression. "Their revolutionism is only verbal" was the ultimate dismissal.[3]

The Communists, of course, were hardly willing to be charitable toward the independent-minded Breton, so they seized any pretext to discredit his revolutionary aspirations. Breton understandably remained constant to Aragon, who had been perhaps his closest collaborator in the

Surrealist venture. Unfortunately, Aragon's voice on the left had become equivocal during the months after his return from the Kharkov Conference in November 1930. Was Aragon an independent Marxist, and hence still in the Surrealist camp, or had he defected to the Communists and submitted himself to party discipline and dogma? Breton did not know that his friend had caved in to party demands even though he was not authorized to represent the Surrealists.

In any case, Breton reluctantly defended "Red Front" as a "poem of circumstance"—a euphemism that scarcely disguised his contempt for proletarian writing over the past decade. ("Red Front" was not the work of a party hack, although it was certainly not a Surrealist document charting the unconscious or its nexus with reality.) The murkiness of the situation left Breton vulnerable to attack, and the most telling came from a dissident who argued that "*art for the revolution* should expose the poet to the same risks as any other form of militant communist activity." [4] For his generosity, Breton was rewarded by Aragon's public repudiation of the Surrealists' defense.

Du Von appeared to be noncommittal, but his juxtaposition of quotations left the impression that the Surrealists were enmeshed in a farrago of errors. Breton's opponents were given the last word: "The kind of poets worthy of the name are allied with [the workers]. Let the poets pay back stroke by stroke and not allow themselves to be buried under the rubbish of the society they are helping to destroy." This militancy simply echoed Mike Gold's old call for poetry to "grow dangerous again." [5]

Aragon filled the bill as a revolutionary poet after his conversion to Communism, or, rather, after party officials thought that they could trust him sufficiently to grant him membership. Their invitation was based on a declaration at the Kharkov Conference concerning the French Surrealists, who were characterized as a "younger generation of highly qualified petty-bourgeois intellectuals." Their revolt against "bourgeois individualism . . . *facilitated in the passage of several members of the group to a Communist ideology.*" [6] That was the sop that party bureaucrats were willing to offer for Aragon's capitulation. In other words, the Communist party was willing to recruit even the Surrealists, so long as proper ideology was attended by a compliance with party policies. This Breton consistently refused to do, at least not without exercising independent judgment first.

Aragon, however, did not become an immediate hero on the Commu-

nist left. In the aftermath of Kharkov, the John Reed clubs (organized to further Marxist culture in the United States) held a national meeting in New York and rejected the former Surrealist as an honorary member of the presidium because he had supposedly dodged responsibility for "Red Front" by refusing to immolate himself before the French authorities.[7]

There was also the matter of his residual Surrealism. Although "Red Front" complied with Marxist exhortation, the poem was written on the fringes of a French modernist tradition. How, then, was this poem acceptable? The question had been simmering before it boiled over in Stanley Burnshaw's essay on revolutionary poetry in *The New Masses* in 1934. Rejecting the formalism of T. S. Eliot on the grounds that it led only to "a defeatist reaction," Burnshaw brought up Aragon: "Immediately some writers will protest the foregoing analysis," he claimed. "They may say, for example, 'Aragon has written an important revolutionary poem (USSR) in Surrealist form—and the subject-matter of Surrealist verse is hardly proletarian or revolutionary!' " Burnshaw split hairs in defending Aragon against the indictment of unintelligibility. Aragon, he ventured, used Surrealist "techniques" in his revolutionary poem but not the "Surrealist mode of expression," by which he apparently meant automatic writing.[8] In reducing Surrealism to a technique and hence eviscerating it as a way of life, Burnshaw's argument hardly satisfied a felt need to square advanced poetics with politics. In the end, however, Aragon's heart was considered to be in the right place, whereas Eliot had declared himself a royalist in politics.

By 1934 Aragon had sufficiently established himself within party ranks so that Samuel Putnam could praise him for "no longer frittering away his time over the 'Surrealist object,' " having written another "enduring proletarian-revolutionary poem." Putnam cited a rousing passage from Aragon's "February": "The Soviets-Everywhere-the Soviets-Everywhere / The Soviets-Everywhere / In the mud with the tricolored flag." Though this sounds like nothing but Red cheerleading, Putnam considered "February" even more advanced than "Red Front" and marveled that "something is happening in France."[9] Such was conviction of Communist commitment.

The height of Aragon's reputation in the United States came in his message of May 1935 to the American Writers' Congress, reported in *The New Masses*. He still felt compelled to confess the error of his Surrealist

ways. "The bright noon-day of Surrealism" had revealed in retrospect only "the warped cult of a poetic world" fabricated by his friends—"an interregnum of fears and doubts." Having broken with those false revolutionaries, Aragon claimed to have become "an entirely new man, fired with a new energy," transformed by the poet Vladimir Maiakovsky, who had performed a laying on of hands in a Paris café. ("He was there, he made a gesture with his hand, he did not speak French.") Now Aragon urged his American comrades to work toward "the culture of tomorrow," its guidelines set in Socialist Realism. As a born-again Communist, Aragon could thus serve in a dual capacity as a positive and negative role model. He was the Surrealist "cured of his social malady," and so could speak with conviction because he had come to his senses.[10]

Aragon's rite of passage once safely negotiated allowed him to discuss aesthetic issues in public. The new Communist, however, had to dodge his Surrealist doppelganger in a talk on "Painting and Reality," held in Paris in 1936. Appearing in *Art Front* in January 1937 as an essay, it was implicitly a rebuttal of The Museum of Modern Art's exhibition of Dada and Surrealism. Inasmuch as the Surrealists were claiming to chart a new reality, which conflicted with Socialist Realism, Aragon rightly contended that "the question of realism" was an "open wound" among artists.[11] His own exploration of this issue was subtle and complex—at least in contrast to other Marxist aestheticians—though in the end his ideas remained within the camp of Socialist Realism.

To remain orthodox, however, Aragon had to recast some of his past thinking. Thus he was constrained to misrepresent an essay he had written in 1930 for an exhibition of collages held in Paris. In *La Peinture au Défi*, Aragon had identified collage as the new challenge to painting. His interpretation followed Breton's efforts to synthesize Surrealism and radical politics. For Aragon the denial of a commonly accepted reality liberated the marvelous, which in its intrinsically moral nature violently opposed the (bourgeois) world and its corruption. Working a variation on Lautréamont's notion that poetry must be made by everyone, Aragon predicted that collage would provide universal access to the marvelous. Collage, he argued, was "poor," unlike modern painting, which had become debased by its fashion among the bourgeoisie. Aragon singled out for special praise Max Ernst, whose use of photographs and steel engravings elevated his collages above the *papiers collés* of the Cubists and inexorably moved art from the realm of white to black magic.[12]

In "Painting and Reality," some six years later, Aragon claimed that the challenge to painting came from photography—he made no mention of collage at all. He abjured the "magical conjurations" of modern painting no less than its "flight from reality." [13] So much for the magic of collage, white or black! Whereas previously he had elevated Surrealist collage at the expense of Cubist *papiers collés*, his refusal to acknowledge collage and thus to misrepresent the entire point of *La Peinture au Défi* indicated the extent to which Aragon wanted to avoid crediting his former friends with the practice of an art that had radical egalitarian implications. At the same time, and here was the unmentioned bottom line, assemblage in any guise fell beyond the Communist pale of politically radical art.

As a consequence, Aragon retreated from collage by tracing the ironic coevolution of painting and photography with regard to the question of realism. The invention of photography, he rightly noted, threw painters in despair at its mimetic capabilities. Photographers, he claimed, were no less anxious. Aside from technical problems, they also harbored a sense of inferiority derived from the new medium's lack of status as fine art. Hence photographers came, ironically, to imitate painting. This trend culminated in the photography of Man Ray, whom Aragon damned with faint praise: "With Man Ray, the photograph thus becomes a sort of new criticism of painting which stops at nothing, not even surrealism. But at the same time its researches are tainted with the same sterility which had formerly affected painting; this photograph is detached from life, its subject-matter is the art which preceded it." [14]

Aragon's indictment misrepresented Man Ray's subversion of conventional boundaries between media so as to expand the possibilities of photography. Conflicting ideologies were also involved. Aragon conveniently ignored the photographer's anarchistic rejection of sectarian political positions. Man Ray's title for his introduction to his 1934 collection of photographs was seemingly straightforward: "The Age of Light," however, had an ironic reference beyond the realm of photography. How "civilized" was society, he asked, when its "all-absorbing motive" was "the problem of the perpetuation of a race or class and the destruction of its enemies"? By denying progress along class lines and locating it in the individual, Man Ray went against cherished Marxist tenets. Human solidarity derived not from class identity but from "the discovery of a common desire." Not Socialist Realism, but "an image whose strangeness and reality stirs our subconscious to its inmost depths," Man Ray contended, would awaken

desire as "the first step to participation and experience," eventually leading to change and perhaps even revolution.[15]

Sidestepping such contentions, Aragon set the snapshot, spontaneous, unposed, casual, and unretouched, against the "classical" but nonetheless "sterile" photography of Man Ray. With technical improvements that allowed for mobility, "photography, in its turn [after plein air Impressionism], has abandoned the studio and lost its static, academic character. . . . It has gone everywhere taking life by surprise; and once again it has become more revealing and more denunciatory than painting." [16] For this new photodocumentary with its potential for visualizing a radical criticism, Aragon recommended the work of Henri Cartier-Bresson (who, Aragon failed to note, associated with the Surrealists).[17]

What, then, might painters learn from photography, from what Aragon called "a device for broadening the field of human knowledge"? While his conclusion had a semblance of openness and tolerance for avant-garde work, it does not stand close scrutiny. He chided painters for taking a "reactionary attitude" toward photography, at the same time castigating them as "lost in abstraction." He praised Max Ernst once again, along with the politically oriented Dada veteran John Heartfield, for incorporating photographs in their assemblages but only regarded their work as "transitional." For Aragon painters should use photography as a "documentary aid": "the painting of tomorrow will use the photographic eye as it has used the human eye." [18]

On the basis of this narrow prospect for the camera in painting, Aragon proclaimed "a new realism in painting." Professing a modest reluctance to determine its "essentials," Aragon nonetheless predicted a "socialistic realism." Perhaps because his talk avoided the rhetorically orchestrated conclusion that had come to characterize Marxist aesthetic thought, it was necessary to add an epilogue in which the former Surrealist exhorted his critics to join him in "the unity of all our destinies." [19] Revolutionary zeal might carry the argument over its logical gaps and foregone conclusions.

In the spring of 1937 Dali gained a forum in the pages of *Art Front* to attack Aragon. Previously, he had taken something of a drubbing in mixed and negative reviews published by the magazine. Condemned by Clarence Weinstock as bourgeois, and faintly praised by Stuart Davis for his manual dexterity, Dali was eager to strike back, and so he jeered at the former Sur-

realist's descent "into that most servile of all conformity, Stalinist bureaucracy." Accusing Aragon of careerism, first by courting the bourgeoisie and then the Soviets, Dali went on to score proletarian art as a "pitiable and elementary idealization of the terms and myths furnished by the degradation of socialist work, big hands, and the illustration of political slogans." Dali dismissed Socialist Realism as a "luke warm formula." [20]

Name-calling and invective aside, Dali set forth a conception of Surrealism that was closer to Socialist Realism than he realized. Implicitly commandeering the notion of "scientific" inquiry, he argued that Surrealism reigned supreme as a "laboratory" for charting the human mind. Engaged in a self-styled "paranoiac-critical activity," Dali thought himself able to pierce the surfaces of history to reveal the fundamental human experiences from which art springs. With his eye on those constants, Dali claimed a "profound" content, just as Aragon stressed the verities of Socialist Realism.[21] That Dali sought the psychological, against Aragon's sociological or political, content should not obscure the sense of inevitability with which these rivals imbued their mutual quest for universals.

Art Front could not allow Dali to go unanswered. In the territory of modernism the Surrealists had effectively staked their claim as the most advanced among the avant-garde. Dali's attack on Aragon led off a "discussion" on "Surrealism and Reality." After accusing Dali in turn of careerism, Clarence Weinstock devoted his reply to a defense of proletarian art and its relation to Socialist Realism. He simply dismissed Dali and "his pseudo-revolutionary self-conscious Unconscious framed in a reactionary technique." [22] Moving to a philosophical plane, Samuel Putnam tried to refute Breton's ongoing attempt to synthesize Marxism and Surrealism. After patching together statements from Ludwig Feuerbach, Lenin, and György Lukács, Putnam finally argued that "Marxism and Surrealism are . . . diametrically opposed in their very essence." With this rejection of Surrealism came the obligatory bow toward Socialist Realism as "the only truly Marxist art." [23]

Despite such dismissals of Surrealism—dismissals that had become almost routine—*Art Front* was also willing to publish some positive views. Charmion von Wiegand's review of The Museum of Modern Art's Dada and Surrealism show appeared with Aragon's "Painting and Reality" in the January 1937 issue. Unlike many reviewers, she regarded the project seriously from a leftist vantage. She was not blind to the visual accomplish-

ments of the Surrealists, especially Max Ernst, who "incorporates in the body of his work all phases of surrealistic development." As she surveyed this "astonishing potpourri" with her political antennae, however, she picked up the absence of John Heartfield's photomontages from the exhibition.[24] She could not have known that this omission was in keeping with Alfred Barr's desire to avoid political statements that might compromise the museum's supposed neutrality.

More crucially, von Wiegand saw the Surrealists as reacting negatively to "the unbearable confusion and contradictions inherent in a dying social order." Dali painted "the festering sores of society, the murderous sadism, the pompous bombast, the cold violence which finds its physical outlets today in the methods of Fascist persecution and violence." [25] Her praise was murderously ambiguous, for in identifying the negative character of his work she came close to smearing Dali himself.

Von Wiegand was still willing to grant that "not all of Surrealism is merely decadent." Given the horrors of this world, she conceded that "it is no accident that the Surrealists have surrendered to the revolution and proclaimed their allegiance to it—albeit in their own anarchist fashion." Despite their alleged political errors, von Wiegand did not entirely reject the Surrealists: "Surrealism is contributing new discoveries of the inner life of fantasy by pictorializing the destructive and creative processes of the subconscious mind." She predicted that future art would return to (commonsense) reality in the guise of a socialist humanism and "find uses for the technical inventions of the modern escapists, whether Cubist or Surrealist." [26]

SOME AMERICANS DID NOT WANT TO WAIT until the future to appropriate Surrealist techniques and imagery for art on the left. Three painters in particular—James Guy, Walter Quirt, and O. Louis Guglielmi—attempted to merge Surrealism with a politically radical point of view during the course of the 1930s. Given the relatively small coterie of artists in New York committed to radical causes, it is not surprising that they were all familiar with each other's work. Yet the three painters did not form a movement, even though their painting has been recently categorized as "Social Surrealism." [27]

All three artists had been hit hard by the Depression. Guglielmi was the son of middle-class Italian immigrants who had failed to find the pros-

perity that had lured them to New York in 1914. Encouraged nonetheless to study art, Guglielmi became an impoverished painter during the 1920s. The Crash of 1929 did not alter his economic situation so much as exacerbate it. While Quirt grew up in Wisconsin, Guy groped to find direction in Middletown, Connecticut. He pursued an informal education at the New Haven Public Library and then took some courses at the Hartford Art School just before the Crash. As young men starting out, these painters were all disheartened by the grinding poverty that blocked their participation in the American dream.

All three painters comprehended their personal deprivations as part of a larger economic, social, and political situation. Whereas Guglielmi preferred to work in the studio to the exclusion of other political activity, Quirt joined the Communist party after moving to New York from Milwaukee, and was active in the John Reed Club, where he met Guy, who was drifting between New York and Hartford by 1930. Quirt became secretary of the club, while Guy simply enjoyed its congenial social atmosphere, which provided cultural activities and allowed him to meet other artists with mutual political interests.

Harsh economic conditions profoundly dominated their lives in a way that Surrealism, on another continent, never could. As a consequence, Surrealism was at one remove from their lives. Even if they had wanted to adopt Surrealism as a way of life (as Breton advocated), they would have found that the Depression had already immersed them in a life on the left, siphoning away any motivation to form an avant-garde movement. They did not "socialize" Surrealism so much as they "surrealized" their overriding social and political concerns.

The risks and difficulties involved in attempting such a synthesis were many. First and foremost, these young Americans did not have strong examples of Surrealist painting that clearly dramatized social and political issues. Moreover, American museums had stripped Surrealism of its political mission.[28] The American Social Surrealists were left on their own to work out visual solutions in an ad hoc fashion.

Because of their willingness to broach Surrealism, these artists became suspect among orthodox Communists. Guy has recalled that he and Quirt got into many arguments with painters who belonged to the John Reed Club.[29] Political orthodoxy, of course, tended to be doctrinaire and rigid, requiring of dissidents the courage of their convictions. Even Meyer

Schapiro, an astute Marxist art historian at Columbia University, could not reconcile Marxism and Surrealism. In an article for *The Nation* in 1937 Schapiro contended that the Surrealists' sense of dialectical materialism (the litmus test of true Marxism during the 1930s) was "muddled and cabalistic." He concluded that "the prison camp of the practical world is exchanged for an underground dungeon" of the unconscious, such that the Surrealists were left with a mechanistic view of human life.[30]

Although Schapiro was hardly a "muddle-headed revolutionary," he failed to see that Surrealism could be bent to political purposes. Even though, as he correctly maintained, there was no necessary connection between Surrealism and the left (or the right, for that matter), why should Surrealism not have become a "method of investigation," as Georges Hugnet had suggested in his catalogue essay for The Museum of Modern Art's Dada and Surrealism exhibition?[31] At best, Surrealism might offer a coherent way for American artists to interpret their social and political situations in their painting. At the very least, it could provide an entire range of visual techniques, as catalogued by Hugnet, even though Americans might run the risk of settling for superficial visual conventions that would be no less mechanical than those drawn from a repertoire of Social Realism.

Although Surrealism reached its height of public exposure by the mid-1930s, Guy had been in an advantageous position to see Surrealist painting earlier, by virtue of his apprenticeship in the Hartford area, where he attended Chick Austin's Surrealist exhibitions at the Wadsworth. Surrealism came at the right moment in Guy's artistic development. Grasping the need for improvisation, he later claimed, "My problem was to express my social-political beliefs with my conception of art." The content of American Scene painting did not suffice. He had "little patience [with] paintings of Kansas wheat fields, Pennsylvania oil rigs and the like." Even less satisfying was the prevailing view among John Reed Club painters that revolutionary art simply involved "picturing poverty [and] breadlines." [32] As a consequence, there was nothing compelling to hold him to the conventional iconography of the left.

At the same time, Guy discovered that "Surrealist imagery offered a way to express various times and various spaces in a single canvas." He sensed that traditional painting with its fixed Renaissance perspective could not adequately "express the dynamic struggles of society." Even so, he was understandably "confused" about European Surrealism. He

claimed to admire their technique "but could not see how they were expressing their political beliefs." [33] Surrealism was a powerful but perplexing attraction for a young artist who was just starting out.

While Cubism and Futurism might have provided greater insight to multiple or simultaneous visual presentations of time and space than Surrealism, Surrealism was close at hand for Guy, who was largely self-taught. Having casually met Dali when he lectured in Hartford in December 1934, Guy was particularly impressed by the double imagery that the Surrealist was developing in the 1930s. Whereas Dali intended his visual puns to be construed for their psychological effect, as evidence of paranoia made visual, the second image being as "real" as the first, Guy saw the technique as a form of "contraction of time and space." [34] Despite his downplay of psychology, he was not remiss in stressing Surrealist form, whose malleability rendered it serviceable in depicting contemporary social struggles in all their desperation.

Caught up by Surrealism, Guy provided a complement to the politically active Quirt. As he said later, "We had ideas that could be shared. Walter came from the Mid-West and was acquainted with the American labor movement and I had my Hartford, Surrealist background." Living in close quarters with Quirt, Guy could engage in a daily dialogue about Surrealism, and so he offered a necessary counterpoise to the skepticism and negative views of many artists on the left. On his part, Quirt brought a strong political commitment, as indicated by his membership in the Communist party.[35]

With his political interests honed on labor strikes in Milwaukee, Quirt understandably began as an illustrator for leftist journals when he arrived in New York. In *The New Masses* cartoons were the predominant art form, lending energy and humor to a magazine that was no less tendentious than its Hearst opponents. Outranked by veteran cartoonists William Gropper and Art Young in *The New Masses*, Quirt initially did small drawings that, though often space-fillers, were distinguished by their respect for American workers suffering economic depredations. Illustration remained a dominant concern for Quirt, who gave precedence to social and political ideas in his paintings. As one reviewer of his work noted, the titles of his paintings left no doubt about his politics.[36] Some announce an incipient culture on the left, as in *Traditions of May 1st*, while others evoke a biting irony in conjunction with the visual image, as with *Consider*

the *Lilies, How They Grow,* which depicts impoverished farmers in a desolate landscape. Such concerns set the base line from which Quirt raided Surrealism.

In contrast to the exchanges of Guy and Quirt, Guglielmi worked alone in establishing his version of Social Surrealism. 1932 was a turning point in his painting, as he emerged from the "cultural drought" of the previous decade to portray the "drama" of Americans caught up in the Depression.[37] His paintings charted the ethnic neighborhoods of Manhattan and Brooklyn, not with the aleatory play advocated by Breton for chance walks through Paris, but with a somber imprint that seemed almost preordained by his own struggles to survive, lending new meaning to De Chirico's haunting phrase, "melancholy of the street."

In 1943, just prior to his enlistment in the army, Guglielmi praised Surrealism for its metaphoric value, and in 1942 he had written to Sidney

14. Walter Quirt, "That'll teach him to respect the law," cartoon, *New Masses,* August 1932. *Courtesy Special Collections, Research Library, University of California, Los Angeles.*

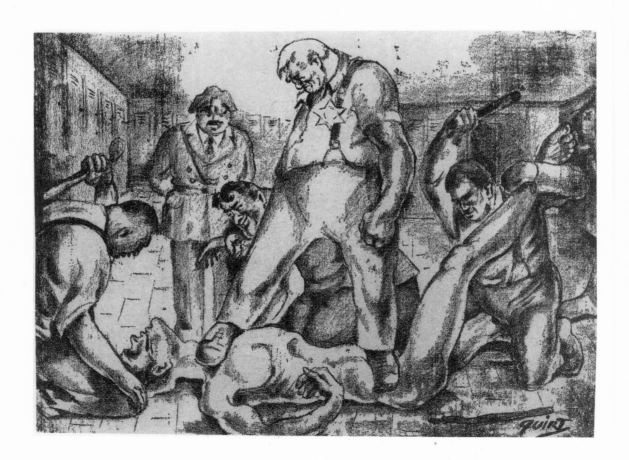

Janis, a collector of modern art from Buffalo: "The painter finds the poet." At the same time, however, he also noted that he wanted to make a "clear and realistic statement" in his painting.[38] Would he be able to reconcile this clarity with the fundamental ambiguities of poetic metaphor? The combination of social-political concerns with Surrealism required a delicate balance between the extremes of sloganizing and solipsism—"propaganda" set against "decadent fantasizing," according to the art polemics of the day.

In an early painting, and one of his most accomplished, *The Mill Hands* of 1934, Guglielmi took up a conventional labor motif without sentimentality and, most strikingly, without the upbeat that someone like Mike Gold would have demanded for Social Realism. The mill hands gather together in three groups, suggesting something of their social life, but their "solidarity" is undermined by a pervasive air of alienation at a moment between congregation and dispersal. The clarity of Guglielmi's vision, situated in the geometric precision of the building, highlights the isolation of these workers, whose eyes fail to make contact in the tight, claustrophobic environment that he has composed. Even if their vision is clouded and distracted by their circumstances, the painter implies that he can see clearly for them.

Guglielmi's early interest in the psychological dimension of social and political issues provided a bridge to Surrealism. He did not always sustain the subtlety of *The Mill Hands*. For example, in *The Hungry*, painted in 1938, Guglielmi reduced visual meaning perilously close to a message that is better suited to a poster. He exaggerated the pathos of a bleak couple by depicting a defeated man slouched over on the sidewalk to their right. Even so, *The Hungry* bears some effective Surrealist elements. The couple push a makeshift baby carriage piled with their belongings, which, in resembling a baby, verge on a double image in the manner of Dali.[39] A labyrinthine street scene offering simultaneous events lends an oppressive aura. The wall of the relief office at the corner is exposed to reveal a powerful and angry woman who looms over a cowering supplicant. The nightmarish, hallucinatory quality of the moment is reinforced by the ironic juxtaposition of a young woman in the background who acts out the lyrics of "Pennies from Heaven," a popular song during the Depression.

While *The Hungry* was precarious in its balance, others among

Guglielmi's paintings lost theirs in favor of presenting a message. Both *Phoenix* (1935) and *Memory of the Charles River* (1936) deploy a deep landscape that had become De Chirico's trademark, scattered with the usual Surrealist rubble. The first painting espouses a Marxist ideology that sweeps up the industrial order of capitalism into a revolution led by Lenin (see Fig. 28). The second recalls the Sacco-Vanzetti case, which still roused strong emotions as a barometer of proper political allegiance. Even Margaret Duroc, offering a "Critique from the Left" in *Art Front*, and hence presumably sympathetic toward such efforts, dismissed *Phoenix* as an "abstraction, not a chunk of life." [40]

Guglielmi captured a surreal moment of the marvelous in *Down Side El Platform (Bleecker St. Station)* which he also painted in 1937 (see Fig. 29). Like *The Mill Hands* this painting depicts a common event, an everyday urban scene—with a difference. Here, too, are some isolated figures: an African American woman stands off to one side of the platform, while two other elderly women are engrossed in their own affairs. A young man climbs the stairs to enter the platform. Here is a moment of waiting before departure. Above, on the roof of the station, is a man painting the roof red. Nobody below heeds him.

Seen from the artist's omniscient point of view, the roof painter is an anomalous figure. His appearance on the roof, though perfectly plausible, is not only unexpected but also surprising by virtue of his pose, which contributes to the Surreal moment of an otherwise prosaic scene. The painter leans forward on one arm against the pitch of the roof so as to paint with his other arm, the can of paint precariously set between his legs. He appears to be floating miraculously on the roof. Because of the shallowness of the picture plane and a relentless geometrical flatness, the roof painter appears to be suspended on the surface of the canvas and acts as a surrogate for the artist, who has created this sleight of hand as a Surreal moment out of a commonplace urban scene.

Although Guglielmi kept an eye on current events during the 1930s, he usually geared his paintings to general themes and issues. And so, even though he depicted a newsboy hawking tabloids announcing war, *The American Dream* (1935) converges on a stormtrooper brandishing a club over a fallen picketer. A bleak industrial space, echoing De Chirico, transforms this American dream into a nightmare of class warfare (see Fig. 30).

Guy, on the other hand, turned to the daily headlines in painting

Crempa Case and Bunker Hill in 1936. Earlier, Julien Levy had included sensationalized tabloid accounts of the sexual escapades of Daddy and Peaches Browning in his 1932 Surrealism show. No social meaning was intended beyond an amusing absurdity, whereas Guy focused on a specific conflict that managed to strike at the heart of American culture. Unlike Levy, who construed the tabloids as quintessential readymades of American Surrealism, Guy surrealized events as they were played out in dailies.

John Crempa and his family worked a six-acre truck farm near Scotch Plains, New Jersey. The local utilities company had erected power lines across their property despite a failure to agree on remuneration. (After the land was condemned, armed police guards were needed to string the wires.) Refusing to knuckle under, Crempa sabotaged the lines. Sheriff's deputies laid siege to the farmhouse, and in the ensuing fracas, Mrs. Crempa was gunned down. *The Daily Worker* had a field day with this tragic turn of events.[41] Here was a Polish-American farmer (and a war veteran to boot) resisting the encroachments of a powerful bureaucracy: the small individual pitted against large corporate interests; the sturdy yeoman against monopoly capital.

Like Dali's *Persistence of Memory*, Guy's *Crempa Case* is a small oil, dark and intense (see Fig. 31). In the background is a miniaturized Bunker Hill: past and present are ironically juxtaposed, as the colonial battle to achieve independence both valorizes Crempa's abortive attempt and comments on the decline of basic American values. All the actors in this drama are present: on the left a manacled and wounded Crempa, a mourning son, Mrs. Crempa's coffin; a bloody trail leads to the courtroom scene on the right where a judge peeks through his blindfold at the menacing detectives arraigned before him. Behind him is a giant lightbulb that fails to light up the dark landscape any more than it offers hope of an enlightened judiciary.

Guy's contraction of time and space allows the viewer to see the events simultaneously. He has compressed elements of the Crempa case into a radical editorial comment. There is no doubt where his sympathies lie, although the painting does not become mere propaganda, thanks to its pictorial structure. What would be otherwise discursive and discretely allegorical is tightly bound together to create a dark American landscape. While a knowledge of events enhances a response to the painting, *Crempa Case* is not a painting of circumstance, to paraphrase Breton's faint praise of Aragon's "Red Front." Guy's painting is no more a crude celebration of

the proletariat than his nightmare vision is escapist. Crempa and his family found a place in American history through Guy's radical "persistence of memory."

The persistence of Dali in the consciousness of these radical painters was far more problematic than mere stylistic borrowings might suggest, with Quirt a complex case in point. In February 1936 he showed fifteen paintings at the Julien Levy Gallery. Both Levy and Quirt took some good-humored ribbing about the uptown move of a radical painter who should have been (presumably) more at home below Fourteenth Street.[42] The venue was misleading in more crucial ways. Levy was Dali's dealer, a staunch supporter of Surrealism, and so with Quirt's paintings echoing the intensity and small size of Dali's, it seemed reasonable to assume that Quirt was a Surrealist.

Issuing a disclaimer to the press, Levy pointedly introduced Quirt as the gallery's first politically radical painter, who was chosen because he was "new and vigorous," his work "important even if its specific content be disregarded." In an accompanying exhibition brochure, Jacob Kainen, an art critic for *The New Masses* and *The Daily Worker*, acutely observed that revolutionary artists were caught in a bind, expected "to pictorialize political sermons for the masses, on the one hand, and to develop fresh, new plastic methods on the other." Kainen believed that this contradiction could be overcome because "revolutionary art is an ideology, not a method." Consequently, "it can be embodied in anything from the work of a primitive to the work of a highly sophisticated painter." [43]

Whether or not Quirt was able to bridge the contradiction perceived by Kainen, the mainstream press was generally disconcerted by the show, as though fixed on the dichotomy of form and content that had been a staple of the political debate about art for so long. One critic thought that the "Dali-ish style" was "effete" in an unsuccessful synthesis: "To marry surrealism to the class struggle is not the way to produce lusty 'radical' offspring." For some critics Quirt had achieved an ironic split between form and content. Whereas radical painters most often stressed the political message of their work at the expense of formal matters, Quirt's paintings were "rather too elegant to be good propaganda." Only a few thought that Quirt had achieved the proper balance between Surrealist form and radical content.[44]

Critics from the radical press offered a different view that more accu-

rately described the tack that Quirt had taken. They tried to distance Quirt from Dali and Surrealism, not simply by claiming that the resemblances were superficial, but by giving priority to European influences going back to the Renaissance. Even so, a fundamental ambivalence prevailed in their assessments. In *The New Masses* Charmion von Wiegand went so far as to claim that Quirt rejected the "decadent researches of modernist and surrealist art." In *Art Front*, however, Clarence Weinstock openly acknowledged Quirt's Surreal landscapes while describing the painter as a swashbuckling revolutionary, a "merciless marauder," who would ransack capitalist society and culture for anything that might enrich his art in the service of the working classes.[45]

Their characterization of Quirt lends consistency to his diatribes against Dali over the next several years. Hardly converted to Surrealism, he dug in his heels and trenchantly mouthed the prevailing leftist clichés at a symposium on the movement held at the Museum of Modern Art in January 1937. Sponsored by the American Artists' Congress, the symposium was organized by the painter Louis Lozowick, who in his concern to make "revolutionary art" was open to avant-garde experimentation, willing to go so far as to utilize Surrealist simultaneity, but with "reason, volition, clarity." Through Meyer Schapiro, who could not participate at the last moment because of illness, Dali was recruited onto the panel, along with the critic Jerome Klein and the former Dadaist Richard Huelsenbeck, a Manhattan psychoanalyst.[46]

In his intemperate attack on Surrealism (and Dali), Quirt divided the world into fascist and nonfascist art, either decadent or healthy to the extent that it upheld the revolution and the working class. Even Raphael Soyer, an artist on the left, later admitted that Quirt's performance took "chutzpa." For Anita Brenner, who reported for the *Brooklyn Daily Eagle*, "Quirt, voicing what was supposed to be the left position, embarrassed a good many of us who take the theories and implications of dialectical materialism seriously by expressing the left position in an unbelievably arrogant and dogmatic way."[47]

By implication, Dali was labeled a fascist. The matter had been festering since the early 1930s when he had painted *The Enigma of Hitler*. Breton called him on the carpet, presumably for having a psyche so politically deformed that he would be fascinated by Hitler. Despite a reluctant recantation, things went downhill. At bottom, Dali aligned himself with

the Spanish monarchy, not Franco's fascism. Equally important, Dali had really gotten the better of the argument by maintaining logically that dreams were there to be recorded, whatever their political content or implications. For once he had been right in challenging the limits of Surrealist freedom in the realm of the unconscious. Breton, however, had to be careful because Surrealism itself was accused of fascism in the doubletalk of the Stalinist left.[48]

In late 1941, as the Surrealists were fleeing Europe, Quirt wrote a series of essays that were published by Rose Fried, director of the Pinacotheca Gallery in New York. In "Wake Over Surrealism" Quirt pronounced the death of Surrealism. Whatever its initial promise in the exercise of free association, Surrealism as epitomized by Dali had become obsessed with neuroses: "His is a philosophy of negation recruiting forces for Terror," Quirt charged. Dali and his kind posed a real social threat because "they joined political parties and flirted with fascism." The inference was clear, and Peyton Boswell, the editor of *The Art Digest*, picked it up in the December issue, quoting Quirt extensively and implicitly with approval, though in the next issue he distanced himself from the allegation and published a letter in which Guglielmi rebuked Quirt.[49]

Quirt's lapse of logic came from jockeying for a position in Surrealist territory. He was now trying to steer a course between Surrealism and Social Realism. In a letter to Robert Coates, art critic for *The New Yorker*, Quirt protested that "use of the pictorial material and energy in the Unconscious is not synonymous with being a surrealist." In subsequent essays, he repudiated his "Social Content" past, as he called his political painting, on the grounds that such painting had proven to be bankrupt after a decade. It was primarily a "compulsive" manifestation of a destructive revolutionary "sadism." At the same time that he abandoned the left, Quirt did not want to relinquish the possibility of socially relevant art. Having undergone psychoanalysis, he had become interested in automatism, but only as a means of harnessing the "healthy impulses" of the unconscious that could be "projected outward toward a synthesis with reality," ultimately expressing the fantasies of society.[50] Like a character updated from Molière, Quirt slowly became aware that he was speaking Surrealism all along.

THE SURREALISM EXHIBITION at The Museum of Modern Art in 1936 testified against premature rumors of its imminent death. An exhibition called

"Post Surrealism: Subjective Classicism," which had originated at the San Francisco Museum of Art in 1935, contributed to the persistence of such wishful thinking. The show traveled to the Brooklyn Museum during the spring of 1936 before the landmark affair at the Modern in December. Any idea of succession was smothered by the prodigious energies of Surrealism at the Modern that winter. Ironically, many of the Post-Surrealists were invited into the enemy camp by Barr's selection of their work for The Museum of Modern Art show. Post-Surrealism seemed timed by one of Dali's limp watches, as Edward Alden Jewell, critic for *The New York Times*, scorned the Brooklyn exhibition in passing as "scarcely other than a backwash from the surrealist cult itself." [51]

Most prominent among the handful of painters on view at the anticipated wake of Surrealism were Helen Lundeberg and Lorser Feitelson, the acknowledged leaders of this new movement from Los Angeles. Feitelson was hardly a provincial Angelino. He had gained a sophisticated sense of art, traditional as well as modern, from his studies in Paris during the 1920s. As a consequence he was not about to dabble in American Scene painting upon his return—a movement that his partner Helen Lundeberg dismissed as "hopelessly sterile," involving "a stale rehashing" of past styles and "comic strip" subject matter.[52] Having discarded the American Scene as so much cultural detritus, they were still left with the ambition to outstrip the European avant-garde, which was most visible in Surrealism, and hence necessitated a declaration of "Post-Surrealism."

There were many reasons why "Post-Surrealism," rather than an alternative label, "Subjective Classicism," stuck with the critics. The high profile of Surrealism in the personage of Dali provided a readymade identity and a fashionable avant-garde tag for these California painters. Despite such advantages, complications arose because the intimation of a possible symbiosis could not be shed, even though "Post-Surrealism" promised a break with Surrealism. Implicit, too, was the possibility that Surrealism was dying, if not dead, in America, though Feitelson himself waffled on such a prospect. Further, Post-Surrealism seemed to substantiate the idea of progress in the arts: here was a movement that could be touted as the "Supermodern," in going beyond the "nihilism" of Surrealism; better yet, here was a movement that was homegrown, with its own glamour apparently emanating from Hollywood, "America's Postsurrealistic answer to Europe's Surrealism." [53]

Although the group did not issue a manifesto, and indeed it may be

misleading to speak of a coherent group, Feitelson had certainly thought out his position in carefully prepared statements for the press. In some informal interviews for the *Los Angeles Times* in 1935, Feitelson clarified the idea of Post-Surrealism. He emphatically rejected the automatism of Surrealism, because it was "uncontrolled by the conscious mind," although he conceded that "the Surrealists' method tends to become a way of discovering new material for works of art, rather than a method of creating art." [54] Breton would have agreed with Feitelson's understanding of Surrealism, though he would have emphasized psychological discovery for its own sake, without seeking art on the horizon.

Feitelson, however, intended to create art. The Los Angeles-based critic Jules Langsner best expressed the antitheses between Post-Surrealism and Surrealism: the new movement involved "impeccable esthetic order rather than chaotic confusion, conscious rather than unconscious manipulation of materials, the exploration of the normal functionings of the mind rather than the individual idiosyncrasies of the dream." [55] In the repeated disavowals of deviance comes a sense that part of the dream for aesthetic order came not only from a reaction against Dali but also from a desire for normalcy during the profound social dislocations of the Depression. Surrealism was disturbing precisely because its explorations of the unconscious sent reverberations throughout the social realm.

In order to find an aesthetic order, Feitelson and Lundeberg attended to matters on the canvas. Because the Post-Surrealists intended their paintings to explore "normal" mental processes, they predicated the deployment of images on the canvas on psychological factors. For Feitelson, "the length or size of an object depicted is not determined, as in the prevalent modes of composition, by the space in the picture it has to fill or by naturalistic proportions, but by the object's psychological importance in the whole picture, both as it affects the spectator and as it relates to the other idea-conveying objects in the picture." [56] Feitelson also stressed the need to control this subjectivity lest it assume deviant proportions.

The paintings of Feitelson and Lundeberg conformed faithfully to these aesthetic criteria, such that principles and practice generally appeared to be of a piece in a rational scheme. There were, however, some discrepancies between theory and painting that resulted in unexpected affinities with Surrealism. Even though their rationalism appeared to be at

odds with Surrealism, the Post-Surrealists had actually entered into a debate, if not a dialogue, with the movement by implicitly directing their credo against Dali and his work. Thus as early as 1934 in her statement of the "New Classicism" Lundeberg dismissed him among other Surrealists for his arrangement of "subjective material in accordance with the traditional principles of objective surface organization." [57] In an inconsistency that went unnoticed, her visual composition promised to be more surreal than the Surrealists'—by ordering imagery on the canvas according to psychological logic rather than Renaissance perspective and its concomitant representational imagery.

Lundeberg's argument here was predicated on what had become a rather common critique of Dali. Writers in *Art Front* had routinely scorned his paintings as "sophisticated illustration," with an "anachronistic" or "reactionary" technique. Only Stuart Davis caught Dali's major effect. He acknowledged that "the paintings of Dali are so concrete in their expression that the spectator cannot help but feel the earth beneath his feet." Through this intense visual mimesis, Dali "expresses with great clarity and precise discrimination the uncoordinated in human emotions and thought." [58] Dali's uncommonly intense "uncoordinations" rendered his best paintings radical even though they were superficially representational. In associating modernism with abstraction, Feitelson and Lundeberg claimed that their psychological modalities of pictorial space brought them to the cutting edge of the avant-garde in ways that Dali's "academic" style did not.

Their rationale for pictorial structure was not entirely evident in a consistent fashion from the paintings alone. Whereas the figures sexually coupled in Feitelson's *Love: Eternal Recurrence* (1935–1936) (see Fig. 32) loom large on the canvas and clearly occupy a place of importance in the overall structure (balanced against cosmic imagery on the right), the nude female in *Genesis, First Version* (1934) stands facing a mirror in "proper," that is, Renaissance perspective. The dream space of the painting is less dependent upon a psychological disposition of imagery than upon a view of cosmic vistas revealed by an uplifted curtain. It is the structural juxtaposition of interior and exterior space, doubled by the mirror and the truncations of the picture frame, that establishes a dreamlike dimension for the painting. The same holds true for Lundeberg's *Plant and Animal Analogies* (1934–1935), which is structurally organized according to Lun-

deberg's thematic rather than psychological concerns: she visualized a rational universe with a place for all things.

Although such an interpretation sounds banal and reductive, both Lundeberg and Feitelson were willing to talk about their paintings in that way. In so doing, they often stripped away the mystery and power of their work. Their assignment of meaning to otherwise enigmatic images in their paintings amounted to an allegorizing that would have been anathema to Breton.[59] They had not so much fallen prey to the narrative or literary element of their work (and Surrealism) as they were reacting against the irrationality of Surrealism, most prominently displayed in America by Dali's calculated zaniness. In the event, the two assiduously avoided the bad taste of the twentieth century that Breton and Dali zealously claimed to court. As a consequence, Post-Surreal paintings occasionally have something of the domesticated aura of the canvases of Pierre Roy, whose mildly enigmatic still-lifes—*Daylight Saving* (1929) and *The Electrification of the Country* (1930)—were shown at The Museum of Modern Art's 1936 Surrealist extravaganza.

In the main, then, Feitelson and Lundeberg depicted peaceful, meditative dreams rather than the violent nightmares favored by Dali. Both artists included a contemplative figure in their paintings as though to provide a model of how the viewer should regard their work. Feitelson, for example, depicted a man looking at a series of drawings, in *Filial Love* (1937). While it is not clear that this figure is a self-portrait, Lundeberg included a self-portrait in her *Double Portrait of the Artist in Time*; in the painting on the wall she portrays herself gazing intently upon some objects set on a table or desk. (This work is called *Artist, Flower, and Hemispheres.*)

Lundeberg's *Double Portrait of the Artist in Time* (see Fig. 34) was an implicit rebuttal to Dali's *Persistence of Memory* (1931). Painting itself enabled the persistence of memory for Lundeberg, who transcribed a childhood photograph of herself to the canvas. Years later, she could not resist revealing the significance of the hour on the clock (corresponding to the child's age); nor could she stop herself from normalizing the painting's enigmatic dramatic situation. "And instead of presenting myself as an adult before a painting of myself as a child, in *Double Portrait in Time*," we are told, "I reversed this possibility where a child casts a shadow which is that of an adult who appears in a portrait on the wall." [60]

Such disclosures undermine the strangeness the tableau has when viewed without words. Both the child and the adult are given a pose with matching "props" (Lundeberg's term), thereby creating an artificial air that underscores the aesthetic qualities of the image. Although the child is "live" in the painting, as opposed to the portrait of the adult artist on the wall, her pose appears frozen, with a "folk" quality that may be derived from its photographic source. The doubleness of the child's (self-) portrait is duplicated by the adult self-portrait, which was in turn painted twice. Finally, there is the arbitrary shadow (reminiscent of De Chirico), which emanates from the child up to the wall-portrait but could just as easily be cast downward. Then, too, the full length of the shadow suggests that someone, most likely the artist herself, is standing beyond the picture frame and gazing upon her own work.

In this complex of self-portraits that echo and displace one another by metamorphosis, local elements of artifice are transmuted into a complex metacommentary on art itself. With the pictorial present of the two-year-old child, projected by shadow into the future of the adult portrait, also existing in the pictorial present, and the shadow of the adult, looking back on herself as a child, Lundeberg created a meditation on portraiture and time reminiscent of T. S. Eliot's *Four Quartets*, while echoing Breton's focus on the marvelous.[61]

Whereas Lundeberg's painting is serenely oneiric and open, in an enclosed but light-filled room, Dali's *Persistence of Memory* generates anxiety upon anxiety along an infinite shoreline that remains dark and claustrophobic. Unlike Lundeberg's alarm clock, whose rational division of time remains intact, Dali's watches have been violated and assaulted; they are melting, subject to enormous heat or some other mysterious force. By visualizing this time warp(ed), Dali also distorts space. Just on this side of the hackneyed "sands of time," the beach and the ocean suggest an eternity that is terrifying in its obliteration of any human sense of temporality. Only a mutant organism has washed up on the beach.[62] That Lundeberg's *Double Portrait of the Artist in Time* withstands juxtaposition against Dali's small but demonic canvas testifies to the deceptive power of her cool artistry.

Feitelson was also capable of powerful canvases that transcended his desire for rational control of imagery and their meaning. If Lundeberg wanted to depict a rational universe, Feitelson was interested in origins—

presumably cosmic origins, but most especially sexual origins. The partially concealed Eve in *Genesis, First Version* is echoed in *Filial Love*, where a male figure, perhaps the artist himself, is depicted, ostensibly in meditation, but also as a voyeur, gazing upon a drawing of a nude couple in embrace. His contemplation does not ease our anxiety in the ironic realization that he has come upon a forbidden scene that the dutiful son has dared to visualize.

This primal coupling in turn was given acrobatic proportions in the seduction depicted in *Love: Eternal Recurrence* (see Fig. 32). A hat, clothes, gloves, are wittily draped over the scaffolding that sweeps this couple through the vast expanses of time and space. Their precarious act takes a fall in *Flight over New York at Twilight* (1935–1936), a large enigmatic canvas (see Fig. 33). The "flight" refers to a robust woman falling backward (along with some tumbling blocks at the picture plane) down an infinitely steep staircase, akin to the stepbacks of skyscrapers (accounting for the reference to New York). Alternately, she has already fallen at the top of those "stairs," which curl up like "paper" on the far right of the canvas and hence can be construed as a painted illusion.

The illusion of flight is heightened by the presence of a baby, whose legs are held by a mysterious hand, and who swoops toward the mother. She reaches with her right arm to clutch his outstretched arm while her left arm extends behind her as though to break her fall. Her awkward position balances against the poise of the baby, who is dropping some cosmic spheres. The geometric structure of the setting barely contains the tremendous energy of this moment approaching the violence of birth. Disparate elements add to the mystery. A daylight sky cut off by a "wall" or panel of indeterminate dark space serves as a backdrop, while a De Chirico train is stationed beneath a night table on the left.

Contrary to the desideratum of Post-Surrealism, rational contemplation does not resolve the mysteries of this painting so much as add to them. This is not to say that Feitelson tried to beat Dali at his own game of photographing a dream. Even though Feitelson's images are recognizable and hence to that extent representational, they are not part of the "real" world; although they might be part of an aesthetic order involving a simplification of form, the viewer is not completely taken in by the Renaissance frame. It is finally the turbulence of the image that overrides the painter's disposition of elements and thereby energizes the illusion of a disturbing dream.

As a spokesperson for the Post-Surrealists in *Art Front*, the painter Grace Clements tried to situate the movement on the left a few months before the show opened at the Brooklyn Museum in 1936. Years later, Helen Lundeberg recalled Clements as a "rebel daughter from a conservative, well-off family in Northern California. She was interested in left politics when we knew her. . . . She came to a lecture which Lorser gave around 1934–35. A gallery talk. She stood up and gave him an argument. . . . She was always interested in social problems. After arguing against Post-Surrealism, she got very interested. It appealed to her intellectually." [63] Clements became an adherent of Post-Surrealism, without losing her enthusiasm for radical causes.

In proposing "New Content—New Form" in her article for *Art Front*, then, Clements evinced an interest in synthesizing Post-Surrealism and political radicalism. The new content, of course, was concerned with a social consciousness attuned to a leftist politics. Clements underscored the need for new forms to express this new content: "It is puerile to expect a revolutionary art to spring into existence merely on the strength of good intentions or sincere convictions." She took her cue from the Surrealists even while rejecting automatism. From the Surrealists she borrowed the basic notion of focusing on psychological phenomena and "associative ideas," but, in accordance with Feitelson's Post-Surrealism (and the penchants of political radicals), these were to be rationally controlled. [64]

Quite obviously, Clements followed Feitelson's ideas closely, simply transferring them to the left. The accessibility of her own work was corroborated by a reviewer of the Post-Surrealist exhibition in Brooklyn. Her painting *1936—Figure and Landscape* was described as "the Statue of Liberty, an odd-looking horse [actually mounting the statue], [and] a weird curved skeleton." Though clearly beyond the pale for the reviewer, a museum guard easily decoded the painting. " 'It's against dictatorships,' he grinned; adding that it reminded him of a cartoon he had seen." [65]

In June 1936 Joe Solmon reviewed the Post-Surrealist show for the readers of *Art Front*. He found the results mixed, praising the work of Clements and Knud Merrild, while expressing disappointment in Feitelson and Lundeberg. He claimed that "Clements is the only one who gives a precise pictorial meaning to her social criticism." Lundeberg was dismissed as "a high priestess of astrology," while Feitelson engaged in a "florid eclecticism" replete with "religious-philosophical connotations which are a complete negation of the great class struggle today." [66]

Solmon's critique was misplaced only in that he took a part for the whole. Clements was the only cohort of the Post-Surrealists really committed to painting politically radical canvases. In thinking back to the 1930s in Los Angeles, Feitelson described two "liberal" factions, the Marxists and the "Independents," who "demanded freedom from the official dictates of any partisan aesthetics, academic or political. Those dedicated to Marxist aesthetics attacked the champions of individual expression as anarchists." [67] His language leaves no doubt as to which camp he belonged in.

Only as the 1930s drew to a close, with the fascists threatening throughout Europe, did Feitelson relent to an image that addressed the political situation. As a consequence, *Post-Surreal Configuration: Eternal Recurrence*, a large canvas of 1939, is less mystifying but more ominous than *Flight over New York*. Feitelson replaced the falling woman with a nude sprawled on a ledge, her face half hidden in shadows. She appears inert, perhaps dead, possibly raped, without the energetic motion of the woman in *Flight over New York*. A naked male stands in the foreground, separated from her by a figure wearing a helmet. Is he climbing toward them or is he digging a grave? The geometry of *Flight over New York* has been replaced by a rocky wasteland.

This bleak image gains its emotional power from a total "configuration" of visual elements, which abjure a symbolic or allegorical reading. Despite the possibility of a story line, the pressure of events submerged whatever narrative animated the scene, so the viewer is left witness to a destroyed world. With *Post-Surreal Configuration*, Feitelson followed Guglielmi, who in 1938 brought the devastation of war home with *Mental Geography*, his painting of a gutted Brooklyn Bridge (see Fig. 35). International events threatened to engulf the utopian dreams, divergent as they were, of Surrealism and Post-Surrealism alike.

The Prison-House of Politics: Poetry on the Left

6

We are blue air, blue water, which elements if not too worldly, also serve to connect disparate worlds, and which are to be found almost everywhere in the familiar.
—Parker Tyler, typed fragment for an advertising project

In these times, when the pressure of immediate events is never relaxed, poetry, jostled by the melodrama of the headlines, often becomes a meaningless twitter, or relapses into non-poetry. It is only the stoutest imagination which can ride the contemporary earthquake. The exercise of surrealism has toughened the muscles of the poets we have just been considering. . . . This is enough to demonstrate the value of surrealist influence today as a source of plasticity transcending the rigid confines within which politics tends to imprison us.
—H. R. Hays, "Surrealist Influence in Contemporary English and American Poetry," Poetry, July 1939

"Blues started with a jump," boasted the coeditors in a postmortem of their short-lived poetry magazine. A precocious Charles Henri Ford quit high school and published *Blues* in 1929 from Columbus, Missis-

sippi. He was soon joined long distance by "the beautiful Parker Tyler" in Greenwich Village. ("Parker is the most beautiful thing I ever saw in pants," wrote associate editor Kathleen Tankersly Young from New York, "long hair, about as long as mine, and mascara on his eyelashes.") Judging from the early reviews, *Blues* caused a sensation; it was at once "the big blue blasphemous baby of Charles Henri Ford" and "the most colossal travesty on literature." One outraged critic branded the editors as communists nihilistically waving the red flag. While such misplaced (and ironic) political smears were common during the 1920s, *Blues* was additionally subjected to sexual innuendo. Upon her publication in the magazine Gertrude Stein was called a "literary jellybean of a she-man with a feminine name." Lewis Ney, who helped publish *Blues* in New York, turned the gay-baiting on itself by flaunting the magazine as a "bi-sexual bi-monthly." [1]

Some critics, however, came closer to the mark. James Rorty in *The Nation* dismissed *Blues* as "a potpourri of badly dated modernistic attitudes and techniques with an underlying arriviste psychology." [2] Although Ford made large claims for *Blues* as an avant-garde journal, the contents of the magazine were advanced largely from the perspective of Columbus. While *Blues* was certainly notable for some of its contributors (William Carlos Williams and Stein most prominent among them), it was even more remarkable for the manner in which Ford managed to recruit them. A combination of naiveté and nerve allowed Ford to write to notable avant-garde figures and ask for contributions to a new little magazine starting out in the provinces of Mississippi.

There was also no little generosity in the response of someone like William Carlos Williams, who had established his credentials as an American modernist among an earlier generation of experimental poets. Self-interest also came into play since publishing outlets were hard to come by; all the more so for Williams, who, despite an avid interest in Dada and Surrealism, remained on the fringes of avant-garde groups because of his strenuous medical practice in New Jersey. He must have found *Blues* a godsend because the magazine appeared to conform to his theory of "contact," which advocated an avant-garde rising out of local conditions. Even though one critic found the origins of the magazine "mysterious and odd," *Blues*, in Columbus, Mississippi, had the potential of being both indigenous and international in its makeup. [3]

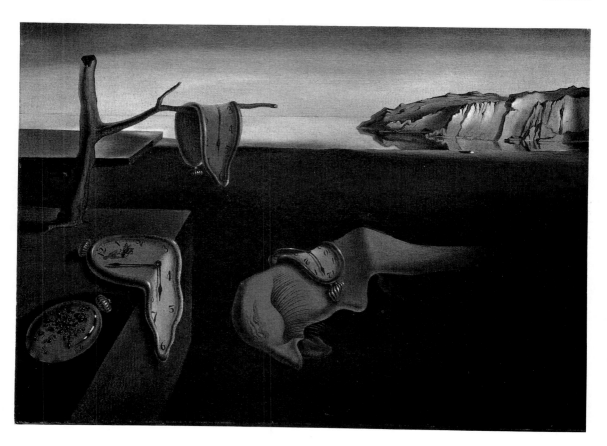

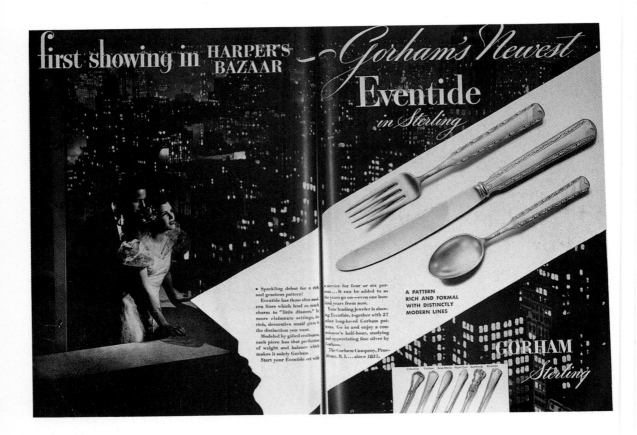

16. Advertisement for Gorham's Sterling, *Harper's Bazaar,* **April 1936.**

Courtesy Harper's Bazaar.

Above:

19. Man Ray,
A l'Heure de
l'Observatoire—
Les Amoureux,
1932–1934,
oil on canvas,
39 3/8 x 98 1/2
inches.
Private Collection.

Right:

20. Man Ray,
"Against his
surrealist painting
Observatory Time—
The Lovers, **Man**
Ray photographs a
beach coat by
Heim of white silk
painted with
brown foxes."
Harper's Bazaar,
November 1936.
Courtesy
Harper's Bazaar.

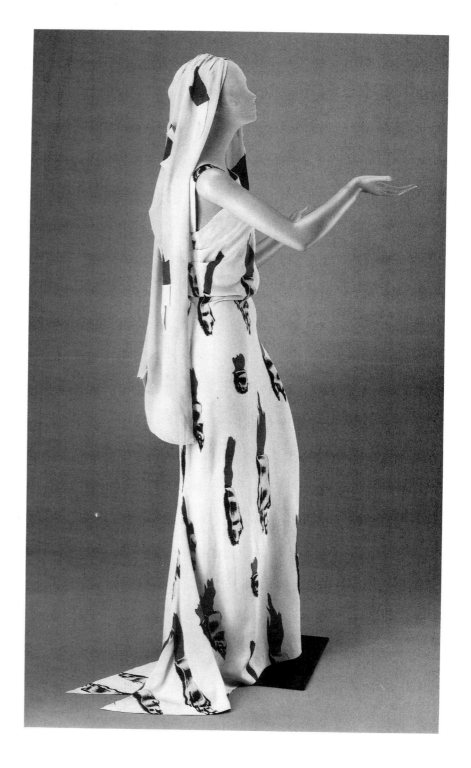

23. Man Ray, *Object of Destruction*, drawing in *This Quarter*, September 1932. *Photograph courtesy Bancroft Library, University of California, Berkeley.*

Below:
22. Man Ray, *trans atlantique*, mixed media, 1921, 36.7 x 24.8 cm. *Ewald Rathke Collection, Germany.*

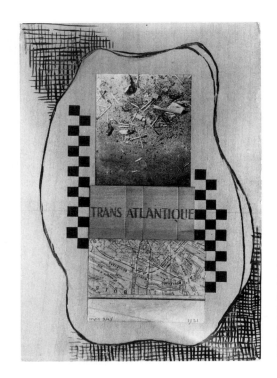

Opposite:
24. Man Ray, *Man with Light*, 1939, gelatin silver print. *The Baltimore Museum of Art: Purchased with exchange fund from the Edward Joseph Gallagher III Memorial Collection; and Partial Gift of George H. Dalsheimer.*

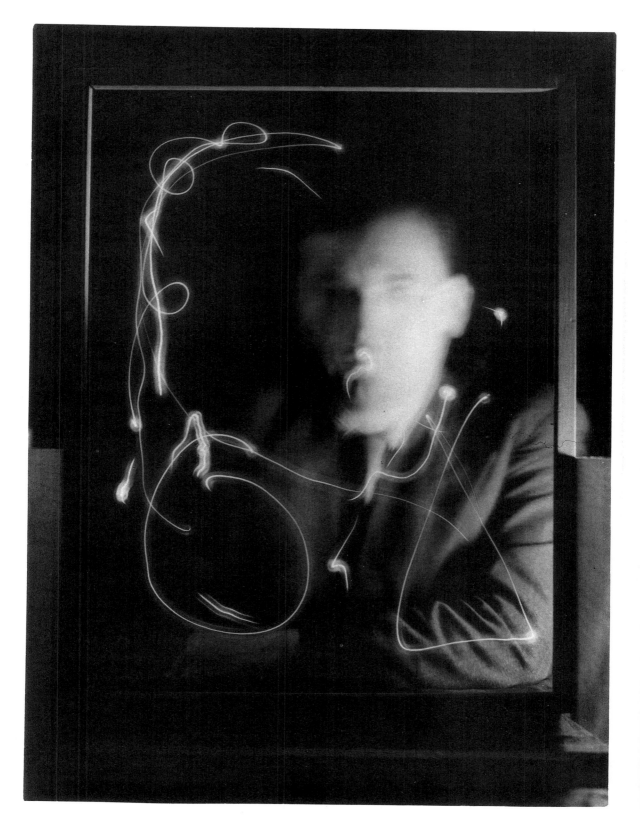

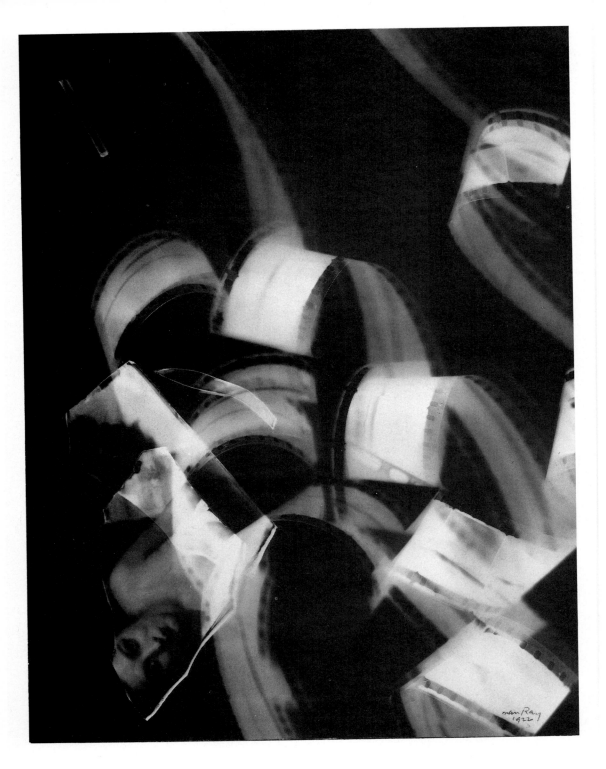

Opposite:

25. Man Ray, *Filmstrips with Kiki*, 1922, gelatin silver print, rephotographed montage of a Rayograph, 9³/₈ x 7 inches. *Collection of the J. Paul Getty Museum, Malibu, California.*

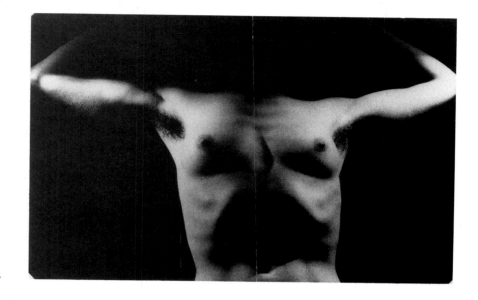

Right:

26. Man Ray, *Minotaur*, 1920, photograph. *Courtesy Man Ray Trust.*

27. Man Ray, *Enigma of Isidore Ducasse*, 1920, photograph. *Courtesy Man Ray Trust.*

Right:

28. Louis Guglielmi,

***Phoenix*, 1935,**

oil on canvas,

30 x 25 inches.

Nebraska Art Association,
Nelle Cochrane Woods Collection.

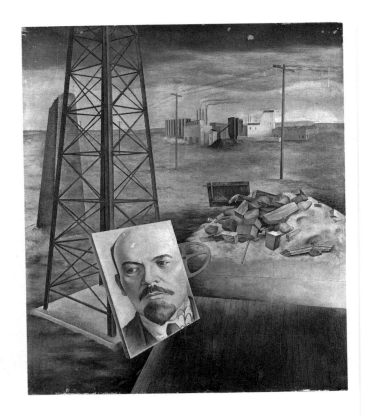

Below:

29. Louis Guglielmi,

Down Side El Platform

(Bleecker St. Station), 1937,

oil on panel, 20 x 30 inches.

Godwin-Ternbach Museum, Queens
College of the City of New York Art
Collection, WPA Deposit.

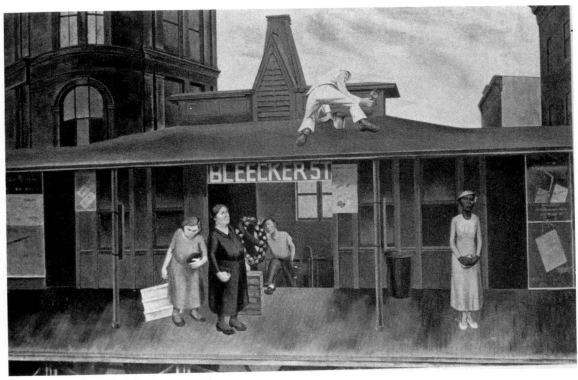

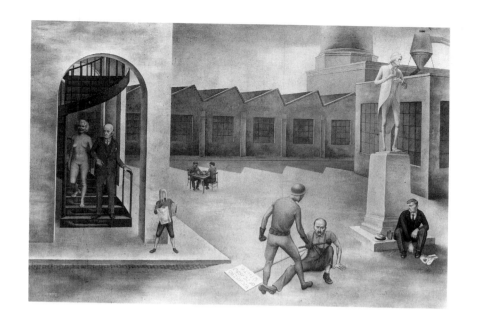

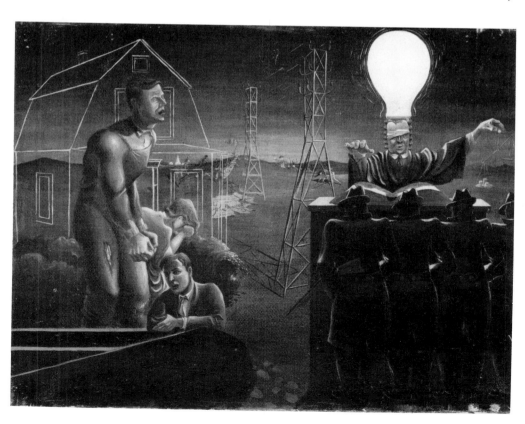

34. Helen Lundeberg, *Double Portrait of the Artist in Time*, 1935, oil on masonite, 48 x 40 inches. *National Museum of American Art, Smithsonian Institution, Washington, D.C.*

Above:

36. Morris Hirshfield, Nude at the Window, 1941, oil on canvas, 54 x 30 inches. *Private Collection. Photograph by Eric Pollitzer.*

Opposite: **35. Louis Guglielmi, Mental Geography, 1938, oil on masonite, 35³/₄ x 24 inches.** *From the collection of Mr. and Mrs. Barney A. Ebsworth, St. Louis.*

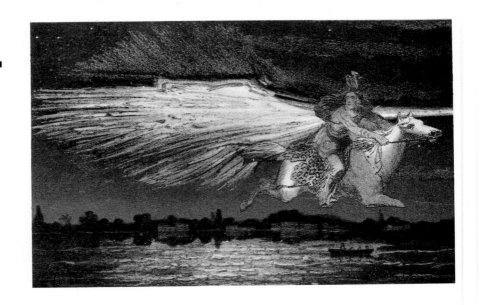

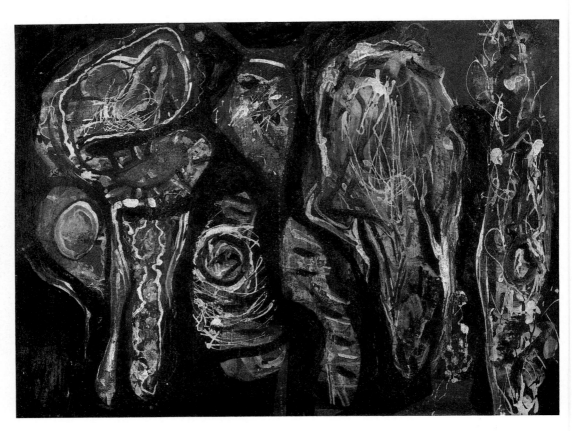

Even so, *Blues* was not on the cutting edge of innovation in the late 1920s. *The Little Review* and other magazines had beaten Ford to the punch earlier in the decade. The immediate point, however, is not so much to expose Ford's youthful enthusiasm (he was barely twenty years old) as to reveal the skill with which he created the illusion of innovation. From the outset, Ford was a master of publicity, if not for the avant-garde, then certainly for *Blues*, and indirectly for himself.

An ad in the staid *Hound and Horn* (Ford arranged such exchanges with other little magazines) trumpeted a typical exaggeration:

> AT LAST IN AMERICA . . .
> A MAGAZINE THAT DARES . . .
> BLUES . . . [4]

These self-advertisements were enhanced from the start by Parker Tyler, who, taking his cue from the typography of e. e. cummings, developed a good eye for designing ads, effectively integrating visual and verbal elements on the page. His talent would be important later in doing layouts for *View*, which was devoted equally to visual and verbal material.

Whereas *View* would be oriented toward Surrealism, *Blues* failed to develop a stance consistent with its identity and all that it implied. The title alone alluded to indigenous African–American music. Combined with its subtitle, "a magazine of new rhythms," and its point of origin, *Blues* seemed to promise the gait of a modern literature born in the American heartland.[5] Ford, however, failed to deliver a synthesis of regionalism and avant-garde innovation; instead his rhetorical sallies merely projected a series of fashionable poses, to the extent that Williams eventually felt compelled to criticize the editors for experimentation drained of meaning. "Experiment we must have," he claimed, "but it seems to me that a number of the younger writers have forgotten that writing doesn't mean just inventing new ways to say 'So's your Old Man.' "[6] As an avant-garde poet who had advocated the importance of form for more than a decade, Williams found himself in the awkward position of calling for restraint.

In his youthful exuberance, however, Ford was not about to be restrained. As though in tune with Josephson's call for poets to become commercial copy writers, he and Tyler reserved some of their best writing for the ads:

among the wagonwheels of mississippi the wide birds' wings of manhattan and past the luminous eye of the eiffel tower has moved with that solidity perceptible to the imagination alone

—and not only those but those who by the magnetic artificial axis of *227 gilman building, columbus, mississippi,* are building BLUES No. 10.[7]

Despite this roving consciousness, the editors kept their eyes steadily on Paris through the nine issues of *Blues,* which ended in the fall of 1930.

AFTER AN INTERIM IN NEW YORK, where Ford and Tyler flaunted their bohemian homosexuality, which they subsequently fictionalized as *The Young and Evil* (hardly successful without the obligatory ban from the United States mails), Ford sailed for Paris in the spring of 1931, glad to have left Columbus behind ("a bad disease, one that gets worse and worse").[8] Life in Europe was perhaps even more frenetic than in Greenwich Village, as indicated by his breathless letters to Tyler (dubbed "Parkertime") relating his sexual adventures and café escapades in the company of the writer Djuna Barnes, who became his close friend and confidant: "I would be lost without her. she is too marvelous as a person and is the Best Living Writer." In the process, Ford managed to meet Mary Reynolds (an intimate friend of Duchamp), Man Ray (in passing), the young French poet Jacques Baron, Samuel Putnam, the novelist Kay Boyle ("Williams said that you were fine and that we'd all like each other very much when you come over."), and, of course, the Russian émigré painter Pavel Tchelitchew, who would eventually become Ford's companion.[9]

Ford was also eager to establish himself in fashionable society, which was no less attractive than the Parisian avant-garde. As he explained to his father:

I must tell you that Paris society (meaning those that are titled or well-born), like, no doubt, modern New York society, is divided into two parts: the first, which I hardly know, is extremely respectable (probably), old, wealthy or not, but cares more for family-name than for fashion; the second, less boring, and more amusing, half, is the half that makes the mode, (found by glancing over the pages of Vogue, Harper's Bazaar or Femina), is interested in the latest sensation among art and artists whom

they ask to their houses, mixes up with the most advanced writers, musicians, actresses etc. etc.[10]

By 1936 his sister Ruth Ford was in Paris, Ford having cultivated the connections that would enhance her modeling career, begun in New York.

Ford, then, a young man in Europe for a large part of the 1930s, enjoying that betwixt and between world of the avant-garde, bohemia, and fashion, openly pursued a gay life that would have had to have been covert in Columbus and muted somewhat even in New York. His travels throughout Europe and the Mediterranean world were punctuated by stays in Paris (winter and spring of 1933–34, and the following spring of 1935) and New York, where he lived on Christopher Street during the winter when Dada and Surrealism were made fashionable at The Museum of Modern Art in 1936. Until the outbreak of war, he summered in Italy with Tchelitchew.

Despite all appearances of having an extended gay holiday in Europe, Ford was hard at work throughout the 1930s. His escape from a middle-class regimen gave him the opportunity to develop his skills as a poet. In 1936 he published *A Pamphlet of Sonnets,* and in 1938 *The Garden of Disorder.* In both volumes he included poems that had been submitted elsewhere in the small press as well as a significant number of new poems. (To his credit, Ford published only a few of his own poems in *Blues.* It was hardly a vanity press.) Tchelitchew contributed a drawing for each book, and Williams wrote a preface for *The Garden of Disorder,* thereby testifying on behalf of Ford's avant-garde credentials.

Along with his skills as a poet, Ford developed a surer sense of his stance toward Surrealism during the 1930s. Despite his claim that he became an "instant Surrealist" upon reading the poetry of Jolas in *transition* back in San Antonio during the late 1920s, the initial impact of Surrealism on Ford was not self-evident.[11] *Blues,* for example, did not (because it could not) draw the clannish Surrealists to its pages. And after Ford abandoned *Blues* in his desire to go to Paris in 1931, he did not immediately infiltrate the Surrealist group. Although he met individual Surrealists like Man Ray and Jacques Baron, he was perhaps too distracted by the gay life that Paris offered. Then, too, he was understandably drawn to Jean Cocteau, who was anathema to the homophobic Breton. (The Surrealist leader's antipathy did not mean, however, that gays

were not a part of the movement. The Surrealist poet René Crevel, for example, was Tchelitchew's lover before Ford arrived on the scene.)[12] Only by the late 1930s, during the course of working through left-wing politics, did Ford finally make his way to Breton and the Surrealist coterie.

In the meantime, almost from the outset Ford disagreed with the Surrealists on another issue that was perhaps even more fundamental than homosexuality. An intimation of their divergence surfaced in an essay Ford wrote with Tyler in 1930. In addressing a "New Generation in American Poetry," they urged the "experimental poet" "to feel his responsibility as a poet as keenly as his gesture as innovator." The distinction was subtly if not vaguely stated, though they implied that the poets of this new generation, coming after the "brilliant poetic technic" of someone like e. e. cummings, needed "a thorough discipline of the emotions" and an attention to form beyond innovation. There was an inherent conservatism in this position, made apparent the following year when Ford and Tyler voiced a preference for "cultural renovation" rather than revolution in the arts.[13] In this they also might have been reacting as much against Jolas's "revolution of the word" as against the Surrealists.

Their relatively conservative position contrasted with antipoetic Surrealist experimentation in 1935, when Tyler wrote an essay called "Beyond Surrealism." He argued that Breton's exclusive insistence upon automatic writing (a "methodology of the involuntary") overlooked the essential element of craftsmanship in art and precluded the possibility of any criticism beyond an impressionistic appreciation.[14] Breton, of course, never claimed that automatic writing was poetry, and in fact wanted to avoid the seductions of poetry as professionally practiced. Here, then, was a significant point of difference between the Surrealists and Ford, who came down squarely on the side of writing poetry.

In taking such a position, Ford and Tyler were in line with a critique of Surrealist writing offered earlier by Eugene Jolas, who had claimed that the unconscious might provide raw material for poetry but should not be taken as an inherent form of poetry. At the same time, in its sheer intoxication over language, *transition* was instrumental in directing Ford to the advanced writing in its pages. Although Jolas's magazine was initially eclectic if not ponderously encyclopedic, Ford was sufficiently sharp-eyed to discover the Surrealists among the avant-

garde writers packed into the cramped pocketbook format of *transition*. There he found Paul Eluard, Robert Desnos, and Jacques Baron, who was virtually the same age as Ford. And their appearance in English translation was important for Ford, since it was only after his sojourns in Europe during the 1930s that he gained proficiency in French (and helped translate some of the complex poems of Breton into English). Although the impressionable young Ford was drawn to Jolas's own heavy-handed attempts at poetry, he was soon attracted to the fluid French, especially Eluard, with his dazzling imagery (captured even in translation): "The lips have followed the sinuous road / of the ardent glass, of the starry glass / And in the sparkling well / Have eaten the heart of silence." [15]

Jolas also set an example for Ford by refusing to subordinate avant-garde experimentation to politics. Even so, Ford was inevitably drawn to the sexual politics of Surrealism, which surfaced in *transition*. Since he did not read Breton carefully until the late 1930s, he might well have passed over the Surrealist leader's work in *transition*. Nevertheless, the importance of the Surrealists' manifesto "Hands Off Love"—a defense of Charlie Chaplin indicted for sexual "deviance" by his wife in a divorce case—was not lost on a young homosexual seeking his own preferences in an avowedly strait-laced if not entirely straight America. The Surrealists described Chaplin "at the command of love. . . . Love sudden and immediate, before all else the great irresistable summons." [16] Beyond its ideology, Surrealist writing itself was suffused in eroticism—heterosexual, predominantly, but an eroticism nonetheless, and hence exciting in its promise for a young provincial who desired more cosmopolitan climes and attitudes. By the late 1930s Ford debated Breton over the place of homosexuality in the erotics of Surrealism.

Ford's poetry took an equally circuitous route toward Surrealism. What he assimilated was not immediately and specifically evident as Surrealism in his writing. His early poetry before the 1930s was romantic in sensibility, suggesting at best that he was receptive to the spirit of Surrealism even though he was not adept in its use of language. Nevertheless, there were hints of a nascent Surrealism. Ford associated the erotic with death ("Death has kissed me to my navel") in a poem for the Sex Number (!) of *Contemporary Verse*. And in "Short Poem About a Gunman," the sexual imagery implied violence as well as death:

I shall whisper softly (maybe kiss
and kiss too lightly round hard lips of a machinegun)
I shall whisper gunman
gunman yours is much the least.

The blatant sexuality aside, the poem is uncanny for eroticizing Breton's dictum in the *Second Manifesto*: "The simplest Surrealist act consists of dashing down into the street, pistol in hand, and firing blindly, as fast as you can pull the trigger, into the crowd." [17] It is unlikely that Ford had read the *Second Manifesto* at the time of its publication in 1929, when he wrote the poem.

In *A Pamphlet of Sonnets* in 1936, Ford dedicated his lyrics to his friends in the order of their successive intimacy in his life, beginning with Tyler, then Djuna Barnes, and finally Tchelitchew. Love remained a dominant theme. Ford also dedicated some poems to the Vicomtesse de Noailles, who was a patroness of the Surrealists. Among them was a poem titled "Dreams," which presented not a dream state so much as a statement about dreams ("If you could be impersonal as dreams / which walk away enfolded in the strife / to bring irresolution's foes to life"). Nevertheless, Ford's conclusion contrasts "the banal hearse / of actuality" against the compelling force of love: "your heart's asylum fuller than before / and love a lunatic athwart the door." [18] Here was Ford's version of "l'amour fou" espoused by Breton.

There is little evidence of automatic writing in Ford's early work. He later said that he did not engage in an "official" sort of automatism, though he claimed that his writing was automatic because he never knew what was coming next. [19] In this regard, Ford was closer to Williams's view that writing entailed an act of discovery. And it was Williams who, in his preface to *The Garden of Disorder*, caught a complex sense of Ford's Surrealism. In describing "the tortuous straightness of Charles Henri Ford," as Williams called his short essay, the older poet revealed a Ford through his own lens, but was no less accurate for that. Williams the antitraditionalist predictably objected to Ford's use of the sonnet form ("thoroughly banal"); what he appreciated most was Ford's "straightness," the younger poet's efforts "to revive the senses and force them to re-see, re-hear, re-taste, re-smell." [20] Here, then, Williams restated his major precept of contact, which he had developed in the early 1920s.

Ford's directness can be seen in the verbal images of his poetry. As early as 1930 in a poem such as "Commission," he paid attention to the particularities of experience in its precise detail: "Gather up the eyelashes that have fallen / into a square of cloth or with the wind's pollen." In "Sonnet" two years later: "It is with terror that the jewelled bat / at noon must flap the wavy air." [21] Despite the precision of this imagery, Ford's version of "contact" had far less to do with Williams's attraction to Objectivism of the early 1930s and was much closer to the Williams whose fluid poetic line shifts and feints through syntax and meaning.

Ford's mercurial precision compelled Williams, who valued directness above all, to qualify the younger poet's straightness as "tortuous." From another perspective, however, this paradox dissolved. At the outset of the 1920s, Matthew Josephson had been moved to emulate his lively French friends. His call for "a naked plundering intellect, in astonishing adventures" in American writing would find fruition a decade later in Ford's sensibility. [22] Ford consistently projected an active voice that draws the reader into a lively verbal consciousness of remarkable perception and imagination. Thus in "Commission" the reader is exhorted to "gather up the eyelashes," to pass through experience and "gauge the sombre sum of your disquiet." In "Sonnet" the terror of the "jewelled bat" is amplified and internalized: "night's sorrows / and morning's hate compel its cries to spat- / ter with thin blood the caverns and the hollows / that darkness in the body holds." [23] Both poems enter a subjective realm heightened by concrete imagery that promises yet eludes the meaning provided by everyday logic.

In his prefatory statement, Williams obliquely alluded to Ford's Surrealism by echoing Breton without mentioning Surrealism. Williams perceived a "special condition of mind" that was "generated" in reading Ford's poems "at one long stroke." In this psychological state (with its sexual undercurrent) the poems "form an accompaniment to the radio jazz and other various, half preaching, half sacrilegious sounds of a Saturday night in June with the windows open and the mind stretched out attempting to regain some sort of quiet and be cool on a stuffed couch." [24]

This setting for the mind subtly recalled a passage in the first *Manifesto* where Breton described how a strange phrase came to him as he was about to fall asleep. Its gratuitousness triggered successive phrases that eventually led to automatic writing. Williams provided an American

twist.[25] He imagined a person (a "mind") stretched out on a couch in the parlor during a hot summer evening, the window open, a radio playing somewhere on a Saturday night. Unlike Breton's experience, conjuring out of somnolence an image of "a man cut in two by the window," Williams's parlor window was open, as the mind takes in the music from the night. This was a banal scene, one that could take place almost anywhere in America, though Williams appropriately gave it a Southern flavor by adding "other various, half preaching, half sacrilegious sounds" to the "radio jazz" in recognition of Ford's Mississippi home, and echoing *Blues*.

Ford's poems *accompany* these sounds coming through the open window from the street, Williams claimed. They are the quintessential sounds of American popular culture. So, while Breton's experience was presented in a vacuum, as the reader is asked to focus on Breton's fascination with a strange phrase, Williams took an experience from the heart of American culture—its music and sounds perceived in a blend with Ford's poems. Like Breton, Williams seeks rest and meditation in response to the poems, the disquieted mind becoming receptive to these "sounds" of American life. His was no parlor game, and certainly not a form of psychoanalysis, but simply an immersion in American culture in its poetic radiations.

Williams predicated this experience upon multiple juxtapositions. There was first of all "a firmness of extraordinary word juxtapositions" in Ford's poetry. Such juxtapositions were to be found in virtually every one of his poems, though nowhere more evident than in the title poem, "The Garden of Disorder," with its opening line, "To lodge your harvest in the lion's mouth," and ending with "bouquets of terror / from the garden of revolution." Juxtaposition was one of Breton's basic "sources of poetic imagination" in the first *Manifesto*. Not metaphor or simile, but the juxtaposition of "two more or less distant realities" was an important source of the marvelous for Breton.[26] Ford became wonderfully adept in developing this principle into a fluid poetic technique, building verbal transformation upon transformation.

Williams regarded Ford's word juxtapositions (accompanying, and hence placed next to the sounds of American life) as "a counterfoil to the vague and excessively stupid juxtapositions commonly known as 'reality'." Thus Williams (like Breton) called into question prevailing cultural definitions of reality. In themselves, Ford's poems form an accompaniment to "a life altogether unreal," that state of repose achieved on the couch. Never-

theless, these poems "put a finger upon reality"—an ambiguous phrase that suggests both an identification and an indictment of reality.[27]

What, then, was the nature of the reality found in Ford's poetry? In 1938 Williams understandably had politics on his mind. He could see the political implications of Ford's poetry:

> This sort of particularly hard, generally dreamlike poetry is inevitable today when the practice of the art tends to be seduced by politics. As always you find the foil immediately beside the counterfoil. Poetry must lie against poetry, nowhere else. So this book can be enjoyed immediately beside whatever hard-bitten poet of 'the revolution' it is desired to place it and there fecundate—in active denial of the unformed intermediate worlds in which we live and from which we suffer bitterly.[28]

Ford's poetry, then, put a finger on political reality, and by contrast denied its dull pain.

While Ford wrote some poems with overt social and political content ("Plaint," about a lynching in Owensboro, Kentucky; "War"; and "A Curse for the War-Machine" most immediately come to mind from *The Garden of Disorder*), Williams's insight had more to do with the subversive qualities of Ford's "hard" yet "dreamlike" poetry. Ford could express "the desire to be in two places at once," as he titled one poem, and elide through the territory of the mind:

> Stones watch the sea like cats: the stone of sleep
> pulls me away from the dream that creeps
> like the cat to the shore: there hops the fish,
> I; stone and cat: both mine to wonder at.

Ford's play of words in astonishing juxtapositions was predicated on a declaration of anarchy, which had surfaced in some doggerel for Tchelitchew's "Paper Ball" at the Wadsworth Atheneum during the winter of 1936: "The only revolution I / corroborate is anarchy," chanted Ford, all decked out in a cowboy outfit. The notion served a sybaritic occasion, but it was engrained in a sensibility that could start a poem anywhere and often did, as Ford cultivated disorder for his own garden.[29]

DESPITE WILLIAMS'S PERCEPTIVE AWARENESS of the political subtext of Ford's poetry, Ford and Tyler remained curiously on the outskirts of radical political issues in forging their own path for an American avant-garde. As one might suspect, *Blues* had come in for attack from the Communist left in the late 1920s. In *The New Masses* Joseph Vogel, once a contributing editor of *Blues,* attacked the magazine as a "washy imitation" of *transition,* "its mama in Paris." He considered *transition* itself to be "one of the droppings" left behind by Ezra Pound. Both magazines entertained the "freakishness" of empty experimentation. Tyler archly responded in the November issue: "Mr. Vogel may understand a lot about the masses and whatnot (including communism) and a lot about the *proper uses* of virility: I certainly don't question the right of Vogel, communism, or a certain kind of virility to exist, but I do question his trespassing on artistic grounds, since I happen to be an artist." [30] While Vogel deserved Tyler's cut, the two antagonists unfortunately reinforced prevailing stereotypes of the macho proletariat as opposed to the effete and (pejoratively) gay artist.

Despite this mutual contempt, radical politics would not go away. Corresponding in 1932 with his father, who supported his trip to Paris, Ford enclosed a clipping of an article by Alex Small on Aragon's "Red Front" case. Small was tolerant, actually to the point of being dismissive, about the whole affair. Ford himself did not comment on Small's views. He may have offered up the clipping simply as an example of a Parisian scandal, though the idea of gaining such public attention would have appealed to him. In any event, this was the first reference to the Surrealists in letters written home. [31]

By 1936 Ford had turned his attention to Marxism. In a letter to Tyler, he chose his words carefully, "I want to study the philosophy of Marx in order to be able to use it: the moment it begins to use me then my strength as a poet and your strength as a critic will decline. That is why all propaganda in art stinks: we are spontaneously revolted by it for it contradicts our experience, i.e. truth." [32] By referring to the philosophy of Marxism, Ford in the manner of Jolas tried to distance himself from politics—an effort made evident by his rejection of propaganda in art.

The depth of Ford's immersion in Marxist philosophy cannot be readily gauged. His appointment calendars for the 1930s interspersed a lecture by Sidney Hook on "The Meaning of Marx" (January 6, 1936) and cocktails with Helena Rubenstein (January 19, 1936). After the May Day

Parade ("Photos of Lionel [Abel?] and Cop"), Ford entered the fall quoting Leon Trotsky: "Classes which have outlived themselves are not distinguished by originality." By the following spring of 1937, Djuna Barnes felt constrained to dampen her friend's enthusiasm. "When you get over your Communist fever," she admonished from Paris, "you may get down to loving persons." [33]

It is difficult to imagine that Ford had succumbed to abstract ideas. He was hardly a theorist of aesthetics, let alone politics, and rarely engaged in any critical writing, which he mostly left to Tyler. With a sensibility voracious for experience ("truth" in contradistinction to propaganda), Ford was bound to subordinate to his art whatever Marxism he picked up—an attitude that would move him toward the Surrealists in the matter of politics. No matter that Breton maintained the compatibility of Surrealism and Marxism: any avant-garde position on the left that did not elevate Marxism above art would have had some appeal to Ford. No matter that he might tersely jot in his 1936 pocket calendar, "Surrealism vs. dialectic materialism," only a few weeks after declaring his interest in Marxist philosophy to Tyler. From this antithesis dictated by common lore on the Communist left, the two friends would eventually find Breton's efforts at a synthesis of Surrealism and Marxism more congenial than not.

Political circumstances in the late 1930s brought Ford and the Surrealists together despite Tyler's earlier forecast that "this is a moment of extrications." Finding himself increasingly isolated on the left, Breton took advantage of a cultural mission to Mexico in 1938 to visit Trotsky in exile. His admiration for Trotsky extended back to the mid-1920s. The meetings at Trotsky's compound in a suburb of Mexico City were arranged through Diego Rivera, the Mexican muralist, who was also unable to stay in the good graces of the Communist party. Afterward, at a talk in Paris, Breton idealized Trotsky as the "immortal theoretician of permanent revolution." [34] Nevertheless, in his account of their meetings, the Surrealist leader betrayed an undercurrent of one-up-manship as they sparred to establish the proper ideological credentials; their jesuitical exchanges, according to Lionel Abel from later conversations with Breton, occasionally degenerated into shouting matches. [35]

From their meetings Breton and Trotsky (with Rivera primarily the go-between) fashioned a "Manifesto for an Independent Revolutionary Art." Citing an unprecedented menace against civilization resulting from

"the blows of reactionary forces armed with the entire arsenal of modern technology," the two leftist dissidents attacked capitalism, fascism, and Stalinism. It was not, however, business as usual. By acknowledging the individual as the prime source of creativity, they minimized the importance of collective behavior in the arts. Moreover, in calling upon writers and artists to oppose totalitarianism and capitalism, they indicated that art could exert decisive power in the revolutionary struggle. Implicit was a reconceptualization of art in the Marxist scheme of things; art was no longer merely relegated to a passive superstructure, conditioned by the "real" material forces of the base. For once in Breton's journey on the left, art was to be empowered and taken seriously in ways that it had not been taken seriously by the French Communist party. "No, our conception of the role of art is too high to refuse it an influence on the fate of society," the writers claimed.[36]

From this point of view, Breton and Trotsky roundly condemned Hitler's persecution and purge of artists in Germany; and eloquently denounced "the official art of Stalinism" (Socialist Realism), the product of a totalitarian regime that they claimed had spread a "twilight of filth and blood in which, disguised as intellectuals and artists, those men steep themselves who have made of servility a career, of lying for pay a custom, and of the palliation of crime a source of pleasure." [37]

The solution for "this shameful negation of the principles of art" brutally imposed by Hitler and Stalin was simply stated in absolute terms: the three dissidents—Rivera joined Trotsky and Breton—unequivocally called for a *"complete freedom for art."* Breton later revealed that Trotsky insisted upon a total independence for art, whereas he and Rivera were willing to allow the proletarian revolution to limit its freedom. The three arrived at a neat bifurcation in setting revolutionary policy: "If, for the better development of the forces of material production, the revolution must build a socialist regime with centralized control, to develop intellectual creation an anarchist regime of individual liberty should from the first be established. No authority, no dictation, not the least trace of orders from above!" [38] Socialism, then, for the forces of production; anarchism for the arts.

This prescription, however, was not as simple as it appeared to be. It was all well and good to claim that "true art is unable not to be revolutionary, not to aspire to a complete and radical reconstruction of society." [39]

But how would "true" art be discerned from the false? Wouldn't a centralized socialist regime have to make those distinctions? And wouldn't anarchism for the arts then go by the boards? Such a prospect would be likely both in fomenting a revolution in capitalist societies and in a socialist revolution achieved. Artists would be victimized.

The writers implicitly tried to meet these objections by addressing the conditions of artistic creativity. The real question under consideration was how true art would come into being. It could not be answered merely by asserting the inevitability of true (revolutionary) art. It was at this point that Breton's hand in writing the manifesto came to the fore. The "particular laws which govern intellectual creation," mentioned at the outset of the manifesto and presumably Marxian, turned out in the end to be Freudian. Artists, indeed all human beings, the argument went, were natural allies of revolution because sublimation restored the equilibrium between the ego and the world that had been broken by the decadence of capitalist society (and, presumably, by Hitler's Germany and Stalin's Russia as well). Through the restoration of an ideal self, the individual (artist) would feel the "primeval necessity" for emancipation, ultimately extended to the social realm and to all human beings.[40]

Artistic creation, therefore, was potentially political by virtue of its egalitarian base, inherent in all human beings, not solely in "isolated geniuses." As a consequence, the manifesto echoed Breton in urging that "the imagination must escape from all constraint and must under no pretext allow itself to be placed under bonds." The Surrealist leader did not get all that he wanted because this free play of the imagination was confined to "the realm of artistic creation," whereas Breton had previously sought to situate the Surrealist imagination outside the realm of art. Nevertheless, he had managed to articulate a tentative synthesis of Marx and Freud in a political arena that in the past had rejected such unorthodoxies.[41]

Finally, if the introduction of Freud into the political equation seemed cursory, there was still the conclusion of the manifesto:

> The independence of art—for the revolution;
> The revolution—for the complete liberation of art![42]

Such exhortation not only recognized the interdependence of art and politics but also set a prophetic tone to the enterprise: the achievement of a

genuine revolution would provide the most propitious circumstances for artistic creation.

This manifesto had several consequences. It provided Breton with a legitimate anchor on the left in Trotsky. The Surrealist leader was no longer isolated, even though Trotsky had been cast out from the Soviet Union. While at first reading, the manifesto was not overtly Surrealist, it did state Breton's cultural position on art and politics, and in the process dispensed with Socialist Realism. And so it allowed Breton's Surrealism the freedom to exist as a movement compatible with left politics.

With the manifesto came the creation of an organization, the International Federation of Independent Revolutionary Art (given the acronym FIARI in French, and IFIRA in English). At this point Ford entered the circle of Breton and the Surrealists. In a letter to Tyler dated April 5, 1939, Ford described at some length his comings and goings with the Surrealists in Paris. Much of it understandably had a political orientation:

A telephone call from Breton summoned me to a "confidential" meeting of the FIARI—the committee for CLE [the new magazine for the group]. There has been no large and general reunion as yet. I was asked to speak and reported the first call & plan for future organization (though I had to say I knew of no PLAN as yet) under auspices of PR [*Partisan Review*].

Inasmuch as the *Partisan Review* had renounced its Stalinist origins and was on the outs with the American Communist party, the editors were willing to publish the FIARI manifesto (translated by Dwight Macdonald) and a letter from Trotsky to Breton affirming the principles of the FIARI in the fall 1938 issue. The editors also endorsed a new, broadly based front of radical artists, which "should incorporate the international aims of the IFIRA in a program otherwise strictly adapted to American conditions." [43]

Tyler had become involved in Macdonald's formation of an American organization called the League for Cultural Freedom and Socialism, which would be affiliated with the FIARI. (Ford attended the first American meeting the night before he sailed for France.) [44] That had been some six months before Ford's extensive encounter with Breton and the Surrealists. By April 1939 Breton, Ford reported, was impatient for some news about the American organization from Macdonald. Announced as an interna-

tional organization for a show of strength against the Soviet Union, the FIARI needed an international cast of officers so that Breton might form a "World Committee." The FIARI suited Ford's developing political consciousness, but his concern, perhaps a hint of anxiety about American activity on that front, also had something to do with his desire to maintain a credible standing with Breton. So he concluded his letter to Tyler with a plea to "include much American IFIRA doings." [45]

Three weeks later, Ford was still waiting for news to pass on to Breton.[46] As a matter of fact, the FIARI did not take off in the United States. During the summer of 1939 Tyler signed the first statement of the League for Cultural Freedom and Socialism because it reiterated the manifesto from Mexico City. In contrast to Breton, Trotsky, and Rivera, who infused their ideas with passion, the league's statement appeared anemic. No wonder, then, that Tyler become disillusioned with prospects for the FIARI in the hands of the league. He was disappointed that only a few artists and writers were interested in the FIARI, and he thought that the editors of the *Partisan Review*, who were supposedly the main proponents of the FIARI, were waffling. As a consequence, there was no real consideration and development of the manifesto of Breton, Rivera, and Trotsky in the United States. "So far," he concluded, "they have only been parodied." [47] Aside from the FIARI business (Ford confessed that the Paris meeting "wasn't very brilliant"), the young American found himself in something of the role of cultural broker. After a formal meeting where papers were read, the group moved to the Deux Magots, their favorite café ("where the gang meets for aperitifs and ideas on Tuesdays, Thursdays, Saturdays, and Sundays," Ford wrote to his mother).[48] He suggested to Skira, editor of *Minotaure*, that he should contact the Gotham Bookmart for American distribution; in his letter to Tyler he berated James Laughlin for not publishing Breton's *Nadja*; and, mindful of his own career, he hoped that a French poet might be persuaded to translate *The Garden of Disorder.*[49]

Even though Ford had first initiated contact with Breton, the American's disposition toward the Surrealist leader was mixed in feeling.[50] Some of the problem arose from Breton's antipathy toward homosexuality. He loathed Jean Cocteau, whom Ford later characterized as "a natural surrealist." [51] In 1932 Ford had offered Tyler a wide-eyed account of Cocteau's *Blood of a Poet*, which was showing in Paris:

my dear youd love it. its much better than Thoma's review. there is scene after scene and episode after episode that takes your breath away. when the mouth comes off in his hand and he puts it to his breast is one and hes there afterwards with large wideopen cardboard eyes. lee miller is beautiful, alone and with the beautiful cow in the last scene (i saw her with man ray night before last in montparnasse) and the snowfight of the little boys they say is better than it was in the book les enfants terribles did you read it. (the Poet is nude from the waist up throughout the first part and is goodlooking!) i must see it again. the audience was divided and some whistled and some applauded and others yelled things. djuna [Barnes] was crazy about it too. one part she thought divine: a little girl with bells on her is going to be whipped by an old lady and the little girl flys up and is pinned to the wall like an angel.[52]

Ford's attraction was certainly based in part on sexual preference involving a gay sensibility, something that Breton was not about to countenance. No wonder, then, that Ford wittily stressed FIARI, "not fairy," in one of his inquiries to Tyler![53]

Ford and Breton apparently hit it off at their first meeting, deciding to meet a few days later. To his mother he described the lunch as "nine hours talking and discussing sometimes cussing." To Tyler he was more candid:

> My lunch with him lasted from one until night during which time we had a lot to say: I told him I was shocked at his puritanism in the Sex Conference in *Varietées* wherein he protested against discussing pederasty, so I bluntly said it must have been because of an inhibition and he agreed. Leonor [Fini] adds, Yes, he said he would be embarrassed to see a man in rose-colored pants. . . . I told him if I appreciated his lyricism inspired by "la femme" it was only because I substituted the symbol of the Other Sex.[54]

Ford concluded his account by exposing Breton's feminine identity:

> He is revolted by obvious Lesbians as well as "fairies" like we used to be. . . . Which doesn't OBVIATE his looking like a woman in the first place without wearing his hair long in the *2nd*. . . . Velvet knee pants

and silk stockings would make him the REINCARNATION of O. Wilde, for whom, as is, he's much more a DEAD-RINGER than Robert Morley. . . . In fact Miss Morley has to be made up to the high gods in order to HOLD A CANDLE to Miss Breton.[55]

Ford was not merely being bitchy. In Man Ray's photograph of Breton impersonating a nun, the patently anticlerical gesture overshadows the sexual implications of the guise. Androgyny became more explicit in a 1938 *Self Portrait* (*L'Ecriture automatique*): a young woman behind bars stands as Breton's double in the background.

Ford's wit combined with insight more than sufficed as a defense against Breton's antigay sentiments, which, in a manner of speaking, the young American managed to invert. The Surrealist potential to explore the human libido in its varied expressions was such that Breton's male chauvinism was all too narrow to remain unchallenged. Ford underlined Breton's dictum in the first *Manifesto*—"Man proposes and disposes. He and he alone can determine whether he is completely master of himself, that is, whether he maintains the body of his desires, daily more formidable, in a state of anarchy"—thereby ironically suggesting how well the student had learned from the master.[56] On this issue Ford's status as an American outsider and an unabashed gay was to his advantage, in that he was not a member of the inner circle and thus could elude Breton's dominance in all matters. At the same time, Breton could not dismiss Ford out of hand because he appeared to offer a liaison with the American FIARI. Thus Ford was able to broach the issues of sexual preference in the political context of affirming freedom in the arts.

Ford and Breton apparently managed to reach a precarious détente in the arena of sexual politics. Ford was also generous in his estimate of the Surrealist leader's intellectual accomplishments. To Tyler he confessed to have "underestimated" Breton and the Surrealist movement. Not having read Breton, Ford did his homework and came away impressed by *Les Vases Communicants* ("one of B's most brilliant works of prose"), *Position Politique du Surréalisme, L'Amour Fou,* and the *Second Manifesto.* He inscribed a copy of *The Garden of Disorder* to André Breton as "Lenine de la Révolution Surréaliste." [57]

There was, however, a major stumbling block for Ford, who disagreed with Breton's judgments about visual art. Ford was not impressed by Sur-

realist painting. Understandably, he was partial to the work of his lover Tchelitchew, who had completed a major canvas called *Phenomena*. It was temporarily in Paris, but Tchelitchew had painted it in his studio on East 57th Street in New York, where at Ford's urging William Carlos Williams had gone to see the work in progress. In "An Afternoon with Tchelitchew" Williams clinically described the large (eight- by twelve-foot) painting: "Nothing but human monsters of sort or another . . . Siamese twins, women with six breasts, acephalic monsters, three-legged children, double-headed monsters, sexual freaks, dwarfs, giants, achondroplastic midgets, mongolian idiots and the starved, bloated, misshapen by idea and social accident—of all the walks of life."

Prompted by the painter, the poet agreed that Tchelitchew was not a Surrealist because "these things are drawn from life." The painter was delighted: "What is surrealism? Anybody can do that. What a lot of fooling nonsense." Here, of course, Williams, always trying to steer clear of European dominance, was tacitly willing to misconstrue Surrealism as mere fantasy, but he was also tacitly willing to acknowledge its presence: "The deeper at moments of penetration is his mastery of their work, the more vigorously at other moments must he fling himself off from them to remain himself a man." [58] Tchelitchew drew Williams's admiration for having beaten the Surrealist painters at their own game.

According to Williams, then, Tchelitchew, already an accomplished painter, sought to distinguish himself from the Surrealists. Ford, however, was not loath to seek the support of Breton for his friend's career. In writing to his mother about a prospective luncheon with Breton in April 1939, Ford confessed, "I'm afraid my friendship with Breton will stand or fall with his reaction to PHENOMENA." He hoped that the Surrealist leader would be enthusiastic and thereby cause a public splash for Tchelitchew. Unfortunately, Breton was lukewarm about the painting, despite Ford's attempt to promote his friend as a "Surromantic." Disappointed by Breton's reservations, Ford wrote a letter to Tyler complaining that the Surrealist leader failed to follow the " 'independent' line taken in the manifesto." He claimed that Breton's aesthetic pronouncements were cast according to an artist's alignment or opposition to the FIARI.[59]

SINCE THE ULTIMATE AIM of the FIARI was to establish freedom in the arts, it was most appropriate that Ford salvaged his meeting with

the Surrealist leader by writing a poem about the occasion, which he called "An Afternoon with André Breton." He told his mother that "the enclosed poem was written some days later: the day recreated as if I had DREAMED about it." In simulating a dream, and by extension automatic writing to record it, Ford was not pandering to Breton; paradoxically, he remained all the more true to himself because he defied Breton's dicta about automatism in the first *Manifesto* by taking up the challenge that images of distant realities could not be willed. (In the margin of his inscribed copy from Breton, Ford scrawled, "Pourquoi pas?")[60] Against Breton's skepticism, Ford displayed his skills as a poet. Thus he gave himself the latitude to conjure the unconscious but also to make explicit comment. "Dreams may memorize what they please," the narrator tells us.

Ford took up a specific occasion in dramatizing a meeting with Breton: the reader becomes aware that it is one o'clock of a warm April afternoon in a café, with the appropriate accoutrements of social exchange—a "blue siphon-bottle" and "blond beer" on the table. And there are intimations of Tchelitchew's *Phenomena* (a "city of a hundred freaks") as a topic of conversation. Nevertheless, the poem cannot be described as an occasional poem, as Breton once generously defended Aragon's "Red Front." While the former Surrealist's poem was political melodrama looking for trouble, Ford's avoided melodrama but was no less political for that, in recognizing "the hornet . . . / that stings the afternoon" and coming to grips with a year "that . . . has no soul!"—a time of spiritual demise clearly in the offing.

The second challenge, then, was to write a political dream poem. Was it possible to make a political statement without sacrificing the ambiguity and specificity of the dream to an allegorical reading? Breton had insisted upon retaining the Surrealist image as image, without clarifying its opacity into rational discourse. The concreteness of Ford's imagery anchors the poem in a dream or dreamlike experience, but he did not insist upon verbal opacity. His dream emerges along with a subtle interpretation, in a process that does not so much reveal a meaning as ambiguous possibilities of meaning.

The afternoon with Breton begins in an ominous context of violence. Time itself seems on the verge of destruction: "Suppose," we are told, "the lion closed a fist on the calendar." Toward the end of the poem, "the lion

promenades with the leg of April unembowelled." Against this threat of destruction the narrator promises regeneration:

> This poem memorizes you, you André Breton,
> I suppose, as April once memorized the new leaves,
> as dreams may memorize what they please;
> nor is the wet blood forgotten by the dry bone.

Here, individual memory is mixed with the rebirth of spring, the autonomy of one's dreams (and desire), and death itself. These in turn have an aesthetic coloration, as it is the poem that memorizes (and memorializes) Breton.

This general backdrop of death and destruction is given a more specific character and urgency by the premonition of war: "The chocolate eggs of Easter hatch no peace-pigeons; / schoolgirls grow up, breed objects for war-ribbons." Both the symbolism of Easter eggs and actual human fertility prove to be barren. The poem offers an alternative:

> The bird, the bird said, I love this man:
> pull, pull all my feathers and cover your bed.
> Then what will you do? the man said.
> The bird replied, Hatch from your heart a hen of paradise.

In the absence of "peace-pigeons" hatched from chocolate Easter eggs this bird offers an erotic love (possibly, but not necessarily, homoerotic) that promises to be fruitful, bearing "a hen of paradise" from Breton's heart. Unconventional love, then, will replace the religious failure of the Christian tradition.

The narrator's offer of love takes an immediate guise of "the city of a hundred freaks." This, of course, most readily refers to Tchelitchew's canvas, which Ford hoped that Breton would admire, and which had served to test their friendship. But as Williams noted, back in the painter's apartment in Manhattan, the freaks are taken from life. They are not merely monsters from fantasy. Breton, however, does not recognize these freaks as his friends or as blood relatives ("as Hamlet would not have recognized Jocasta"). Breton does not recognize them because they are not disguised and hence stand in contrast to the "answers" of the "veiled women" held

hostage by innumerable horsemen (of the Apocalypse?). Freaks are not so much the answer, as is one's ability to love the deviant, the deformed, and the marginal in all of us, as part of us. The poem closes in the sadness of this rejection, as "the Virgin, Day, flies, flies from the negro, Night."

Whereas the poem ends sorrowfully and perhaps inconclusively, "An Afternoon with André Breton" was a triumph of Ford's poetic sensibility in redeeming "a dead bomb of history." Beyond the poetic multivalence of the dream, there were certain lessons to be learned from this encounter with Breton. Ford derived no little satisfaction in successfully testing his courage by boldly confronting the Surrealist's homophobia head-on. But he knew that he had gained only Breton's personal regard and no real shift in his attitude toward gays. He also learned (along with Tyler) that American politics on the left did not provide firm ground for common cause. Most importantly, Ford discovered that he could not depend on the Surrealists to make his way among the international avant-garde. Henceforth he would have to proceed without a European compass, as his friend Williams once realized when he was starting out during the First World War. With premonitions of the horrors to come, Ford took up the older poet's American voyage as a new decade began.

7 View and the Surrealist Exiles in New York

The arts are the only currency left which cannot be counterfeited and which may be passed from nation to nation and from people to people. It is true that this currency must now be smuggled part of the way by men for whom beauty stifles the pulse of terror. But it will some day return openly to the captive lands, and in America—let us make sure—it will never be refused or unjustly deflated.

—James Thrall Soby, ARTISTS IN EXILE, 1942

Ford's extended European stay ended abruptly in September 1939 when Nazi Germany invaded Poland. He had been on holiday with Tchelitchew in the French Alps when the American consulate advised its citizens to return to the United States. In a letter to his father soon after settling in Connecticut, Ford recalled the hysteria infecting France: "We wanted to get the first train to Paris and found that not only the first train was reserved but many trains after that, so we took the first one we could which was about 3 days away. On arriving in Paris we found the city in semi-darkness, a scarcity of taxi-cabs and the news that NO boats were sailing." Through Tchelitchew's theater connections with Jean Giraudoux, who had just been appointed commissioner of information, Ford and his party were bumped up to sail on the *Champlain*. "How lucky we were!" he

recalled. "Of course we took the extreme northern route and at night the ship was blacked out so torpedo boats wouldn't see us." [1]

Even though politics of the worst sort had overtaken Ford and Tchelitchew, the poet's energies did not falter. He was soon deeply involved in planning a new magazine. At first thought, he wanted to call the magazine "The Poetry Paper," and to set it up like a tabloid. Though he retained the slogan, "Through the eyes of the poet," and the format for economic reasons, he renamed the magazine *View* when it finally appeared in September 1940. Printed by James A. Decker in Prairie City, Illinois, to save money, *View* began on a shoestring. For more than a year Ford served as chief cook and bottle washer, doubling up his small apartment on East 55th Street as an office. As he wrote to his mother on December 9, 1941 (just two days after Pearl Harbor), "Oh I've been so busy running and rushing here and there and working on *View*—you must realize I'm an office-force of *one* besides advertising that I must get out and get." [2]

From the start, *View*'s format also signaled its topical character. Ford sought "a new journalism" involving poets, because ordinary newspapers were inadequate in times of crisis. "Now, more than ever," he insisted, "contemporary affairs should be seen through the eyes of poets," implying that poets were somehow capable of seeing their way through the forthcoming catastrophe. This new journalism would involve "news not always about but always by poets" on an international scale. [3]

Ford did not have to wait long for news to pour in from Europe. Writing from Megève, near the French-Swiss border, after the blitzkrieg of the Nazi war-machine, a stranded Kay Boyle expressed the prevailing mood of uncertainty in a "Communiqué" for the second issue of *View* in October 1940. "Here," she observed, "and at Annecy, everything is very quiet and no one knows what the future can possibly be" for the defeated French nation. [4] After crushing Poland, Hitler had attacked Denmark and Norway, moved against Belgium and Holland, and he then took Paris with lightning speed on June 14, 1940. A bewildered France was divided into two zones, a northern occupied territory from which the Nazis would soon conduct the Battle of Britain, and an unoccupied zone headed by the puppet Vichy government. To cap this disaster Hitler had dictated an armistice that included among its terms the return of all anti-Nazi refugees to Germany.

While Ford received communiqués from writers in Sweden, Cuba, and Great Britain, he attended primarily to the Surrealists, who were scat-

tered worldwide after the fall of Paris. The situation was grave, even though Dali provided some comic relief. His detention in Spain gave rise to speculation that he was lost in "his native country's calaboose," until he embarked for the United States with none other than Elsa Schiaparelli.[5] Max Ernst had been incarcerated as an enemy alien by the French at the outbreak of hostilities—an ironic turn in light of his outspoken opposition to Hitler. He would have been executed if returned to the Nazis. Nothing to laugh about.

Others enjoyed better luck. Yves Tanguy, along with Roberto Sebastian Matta Echaurren, a young Chilean painter latest in the Surrealist fold, had already arrived in the United States on November 1, 1939. (Tanguy, declared unfit for military service, had followed Kay Sage, an "American princess," who was just making her way in Paris as a painter attracted to Surrealism when the European hostilities erupted. They would soon be married in New York, after Tanguy's Las Vegas divorce.)[6] The Swiss artist Kurt Seligmann had preceded them all in 1939 at the outbreak of European hostilities.[7] The photographer Raoul Ubac, whom Ford had met in Paris just prior to the war, had been thrown out of Brussels and was reportedly going to America, though he finally settled in Carcassonne with the Belgian Surrealist René Magritte.[8] The Austrian painter Wolfgang Paalen ended up in Mexico City, where he waited out the war.

Many of the Surrealists fleeing to America had been preceded by exhibitions of their work in New York. Apart from the mammoth Surrealist show at The Museum of Modern Art in 1936, Julien Levy was joined by Pierre Matisse (the son of Henri) in offering the main venues for the Surrealists during the 1930s. Ernst was on exhibit at Julien Levy's as early as 1932, Tanguy and Magritte in 1936, and Paalen, en route to Mexico City, in 1940. Pierre Matisse exhibited Masson and Miró as early as 1931, and frequently thereafter. Miró's exposure culminated in a retrospective at The Museum of Modern Art during the winter of 1941–42 in tandem with Dali's. Kay Sage had a solo exhibition of seventeen paintings at the Matisse Gallery in 1940, soon after her return from France.[9]

All eyes, of course, were on Breton, who, as early as April 1939, had confided to Ford that he wanted to emigrate to the United States in the event of war.[10] He was mobilized in the medical corps at the outset of French-German hostilities, and then he was just as quickly demobilized in the unoccupied zone. His former associates Aragon and Eluard remained

in Paris, and, trusted by Communists because of their political turn-abouts, they soon joined the Resistance. The political situation in occu-pied Paris was clearly untenable for the anti-Stalinist and anti-Fascist Breton.[11] He stayed briefly in Salon-de-Provence with his family physician and Surrealist associate Pierre Mabille (who later appeared in *View* with an apocalyptic essay on "The Destruction of The World").[12] They consid-ered asylum in Mexico, and Mabille actually landed in Guadeloupe, while Breton moved with his family to Marseilles, where other Surrealists had congregated. Because of visa restrictions, getting out of France was diffi-cult and nerve-racking. As a result, Ford lost track of Breton until Tanguy provided "welcome news" through the grapevine that he was "safe, some-where in France." [13] Americans in France would ensure his eventual re-lease to the United States.

An obscure French general, Charles de Gaulle, refusing to surrender, had captured the broad significance of events. "This war is a world war," he broadcast in exile over the BBC in June 1940. "There is in the universe all the means needed to crush our enemies one day. . . . The destiny of the world is there." At the same time, De Gaulle's world war was still being fought on the local level in Marseilles and environs, where Varian Fry, an equally obscure but diffident American, had established a beachhead with an American center for refugee aid, which provided a (semitruthful) cover for the dangerous business of the Emergency Rescue Committee estab-lished stateside: he illegally conspired to extricate artists, writers, and po-litical dissenters from France, which he described as "the most gigantic man-trap in history." [14]

Among his co-conspirators was Mary Jayne Gold, an American so-cialite on an extended European vacation, who had surfaced in Marseilles after a chaotic retreat from Paris. "Young, blond and beautiful," according to Fry, she volunteered her services and also provided some desperately needed money for his organization.[15] She rented a large farmhouse just be-yond the suburbs of Marseilles where Breton, his second wife Jacqueline Lamba, and young daughter Aube stayed, along with Fry and others. Villa Air-Bel soon attracted the Surrealists on Sunday afternoons for games and conversation. Finally freed from detention, Max Ernst arrived in Mar-seilles with his canvases, which he unrolled and tacked up for an im-promptu exhibition at Breton's "château." [16]

Another key figure in this tense situation in Marseilles was Peggy

Guggenheim, the maverick member of the Guggenheim family who had been slowly planning a museum of modern art as the 1930s came to a close. Despite the declaration of war, she went on a buying spree among artists still in Paris, vowing to purchase a painting a day, and then with the aid of Maria Jolas smuggled her collection to Grenoble, where it was stored at a local museum. Her risk of loss was high on two counts: if her paintings escaped the sheer chaos of the war, then the Gestapo would have destroyed them for their "degeneracy." And though she was an American citizen, whose country had not yet entered the war, she was also Jewish, which added to the escalating uncertainty. Little solace, then, to be told by her concierge after a police interrogation, "Oh, that is nothing, madam. They were just rounding up the Jews." [17] The Vichy government felt no compunction in abetting the murderous anti-Semitism of the Nazi occupiers.

Kay Sage had urged Guggenheim to assist the Bretons, who, because of their association with Fry, were under surveillance of the Vichy government. When visa restrictions for refugees were finally lifted early in 1941, Guggenheim paid the sea passage of Breton and his family to New York via Martinique.[18] They embarked on the *Capitaine-Paul-Lemerle* on March 25, 1941. Less than a week later André Masson followed Breton to Martinique, where they were reunited (and interned) before being allowed to go on to New York. When Masson came through U.S. Customs, some of his drawings were seized on grounds of "obscenity." The painter has described one with "a woman who was landscape, and in this landscape was to be found a cave, a grotto evidently representing her intimate parts, and a little man, the sole genuinely human element, striving to make it through this orifice." [19] That such an image should have been thought obscene is ironic in light of the scorched earth policy and other desecrations of the European terrain that were taking place. Only later did Masson recover his crate of drawings, some still missing.

Soon after shipping their art as household goods to avoid confiscation, Guggenheim and Ernst followed Breton on a Yankee Clipper flight, arriving at La Guardia from Lisbon via the Azores on July 14, 1941. A long, uncomfortable flight was the least of Ernst's problems. Lacking an exit visa from France, he had managed to fast-talk his way into Spain past the French guards, who were mesmerized by the canvases that accompanied him. Once safe beyond this peril, Ernst was later viewed with great

suspicion at U.S. Immigration. His apprehensive son Jimmy Ernst, along with Breton and a high-powered contingent from The Museum of Modern Art, guided the exhausted new arrival safely through the intricacies of U.S. Customs. Ernst was finally released in the custody of his son.[20]

By contrast, Breton's entry had been relatively uneventful, even though his difficulties did not end once he safely landed in Manhattan, where thanks to Kay Sage he found a small walk-up in Greenwich Village. The circumstances were hardly propitious. He was, after all, in forced exile. It was not as though he had chosen to come to New York, as he had gone to Mexico City as part of a political strategy to join forces with Trotsky—a project that had turned to dust after the Soviet exile's assassination in August 1940. (At Air-Bel, Breton's young daughter Aube reported to Mary Jayne Gold that "Papa had cried a lot last night" upon learning of his murder.)[21] Trotsky's death left Breton without a powerful political ally on the left in the New World.

Nor was Breton's adventure of the sort that Duchamp had undertaken almost a generation before in migrating to New York in 1915. With the United States then not yet in the First World War, Duchamp had been briefly accorded celebrity status by the New York press, which a decade later ignored Breton in the formation of Surrealism and then concentrated on the flamboyant Dali, who had surfaced as the wild card in the Surrealist deck during the 1930s. The diffident Duchamp had become a leader who refused to lead, an invisible presence at the heart of an emerging American avant-garde during the First World War. He thus stood in marked contrast to Breton, who was visibly charismatic, demanding deference from his followers but gaining little recognition from the American press except as simply one among many refugee intellectuals from Europe.

Breton's imperious expectations accentuated all the more his meagre finances, despite a monthly stipend provided by Kay Sage and Peggy Guggenheim. Even eventual employment as a broadcaster for the Voice of America brought limited satisfaction in contributing to the war effort, because he simply read the material of others.[22] His steadfast refusal to learn English may have been as much an article of his faith in the temporary nature of his exile as a sign of cultural chauvinism, but it also added to his discomfiture and sense of cultural alienation. Matters were not helped by a feeling of social isolation from other exiled French artists and writers caused by a lack of café life as it had been lived back in Paris.

The challenges of alien circumstances were only somewhat less problematical than those Breton faced as leader of the Surrealists in the New World. Had he lost all moral authority by leaving Paris instead of joining the Resistance? Eugene Jolas, for one, implied as much. With *transition* terminated in 1938 and his entire library "engulfed" by the Nazi invasion of Paris, Jolas had been relegated to the sidelines in New York.[23] Despite what had become among Americans an apparent need to leap "beyond Surrealism," Jolas conceded in the fall of 1940 that "Surrealism has really conquered America": at least he thought that it had won over the poetry of Ford, Tyler, and Harold Rosenberg. Jolas generously acknowledged the promise of their Surrealism with its "American ambiance." Even so, he went on to identify the collapse of France with the subversive tenor of Surrealism, as though Breton were responsible for the recent debacle! For their own good, then, these younger poets had best tune into the "verticalist" consciousness of the cosmos that Jolas was promoting as a metaphor of avant-garde uplift (see Fig. 4).[24]

Jolas's faint praise of Ford and company in his essay for *Living Age* coincided with the first issue of *View*. No one at *View*, however, wanted to listen to his old song. His hopes of joining *View* or assuming leadership of an international avant-garde regrouping in New York were dashed by Ford's refusal to publish him in *View*.[25] Clearly, the younger poet had ambitions of his own. Early in 1941, then, in *Fantasy*, an obscure little magazine, Jolas had to make do with his own wake over Surrealism, the war supposedly having delivered its "death-blow."[26] Deeply felt, Jolas's elegy delivered a searing indictment of Breton before he arrived in New York. It was no less powerful for conveying half-truths at a time when emotions ran high.

"The age-old city of Marseilles presents a curious spectacle today," Jolas began. "A year ago it was still France's busiest, most colourful port. Today its population is swollen by the presence of thousands of strangers, the majority of whom are marking time while waiting; some for visas that will permit them to envisage an escape to a happier life, others simply for the end of the war which, they hope, will restore to them their liberty of thought and movement." The implication would have been clear: "the last remnants of the French Surrealists," led by Breton, were simply waiting out the war by playing games!

The game of Exquisite Corpse sounded especially grisly in this con-

text. It was, however, simply a verbal exercise long used among the Surrealists as a way of tapping the unconscious. The first participant would record a line of automatic writing, fold over the sheet for the next person, who would do the same without peeking at the first line. With an arbitrary conclusion of the game, the group would be left with a "poem" of incongruous images, presumably an expression of a collective unconscious. The genre gained its name from one of the first efforts, which had produced the memorable phrase "exquisite corpse."

The game easily became a visual exercise as well involving drawing and even collage (see Fig. 5). Following the same rules, one person would begin a drawing on a sheet of paper, which would be passed from hand to hand until a collective image emerged as a surprise to all. Yet for Jolas, the game of Exquisite Corpse, with "its explorations into the subrational powers of the unconscious," seemed frighteningly congruous with the "apocalyptic twilight of Europe." Although Jolas rightly claimed that the war had surpassed Surrealism in creating a "universe of monsters," his final analysis was far off the mark: the Surrealists, he implied, were irrational nihilists whose games provided "an escapade into a vacuum." [27]

Whereas Jolas misconstrued and hence dismissed Breton's Surrealist games outright, Mary Jayne Gold had an ambivalent response that foreshadowed the attitudes of many American artists in New York when they were asked to participate in Surrealist games. In her account of those events in France she rightly recalled that the games had been "revived in Marseilles in this evil time as a distraction from trouble and danger." More crucially, she noted that this collective activity symbolically reasserted the players' solidarity with Surrealism and Breton when their lives and that of the movement were in danger. At the same time, she refused to take the games seriously, especially those involving sexual interrogations, although she joined in simply because she wanted to be a "good egg." [28]

Breton, however, remained for her "a particularly brilliant and severe district attorney" in games that were never innocent in themselves but had also proved to be dangerous as symbols of Surrealist freedom in the increasingly totalitarian situation in the unoccupied zone of southern France. While there were frequent vicious attacks on free thought and Surrealism (obscenities and calumnies reported in *View*: "Dream monger! . . . Freud monger! Jew monger!"), the vichy authorities encouraged such attacks in the name of Marshal Pétain's reactionary program

extolling the French family. In a raid on Air-Bel, the police uncovered an inflammatory phrase in one of the "exquisite corpses": "Le terrible crétin de Pétain." Despite Breton's impromptu explanation that the inspector had incorrectly read "Pétain" for "putain" ("prostitute"), the group at Air-Bel was detained for several days before gaining their release and eventual freedom in the West.[29]

JOLAS'S SORT OF WELCOME awaiting Breton in New York portrayed the Surrealist leader as an Achilles sulking in his tent, deliberately withdrawing himself from the war, and then in turn alienated from his new surroundings by unfavorable circumstances. In *The New Republic* (October 27, 1941), the painter George Biddle lost no time in characterizing the Surrealists as "isolationists in art." While it is difficult to wade through his clichés and mean-spirited ad hominem arguments ("this band of weazened, sapless and occasionally loud-mouthed *homunculi*") to a precise meaning, Biddle apparently thought that the Surrealists wanted to cut themselves off from life, and, like Jolas, viewed them as escapists. That his dismissal in itself was a form of cultural isolationism was an irony lost on Biddle.[30]

Despite past differences with the Surrealists, Matthew Josephson felt compelled to offer a strong rebuttal. "I felt a sense of shame for Mr. George Biddle," he wrote *The New Republic* on December 8, 1941, "when I read his 'Communication' . . . in which he ridicules the modern European painters who have come here as refugees, and scolds the Museum of Modern Art for extending them hospitality." Projecting American competitiveness into the realm of cultural affairs, Josephson argued, "If we are going to be afraid to welcome and learn from a few distinguished foreigners, we are going to be a pretty flabby American art movement." Otherwise, he concluded, "We are going to have the kind of culture that is not worth saving." [31]

Steps, of course, were taken to welcome the émigrés. In March 1942 Pierre Matisse held an exhibition entitled "Artists in Exile," which included the Surrealists, along with sympathetic essays by James Thrall Soby and Nicolas Calas, a young Greek (*né* Calamarais) who, since joining the Surrealists in Paris prior to the war, had migrated to New York and was ready to serve his leader energetically. *Fortune* ran a feature article on "The Great Flight of Culture." Its subheading set forth the moral obliga-

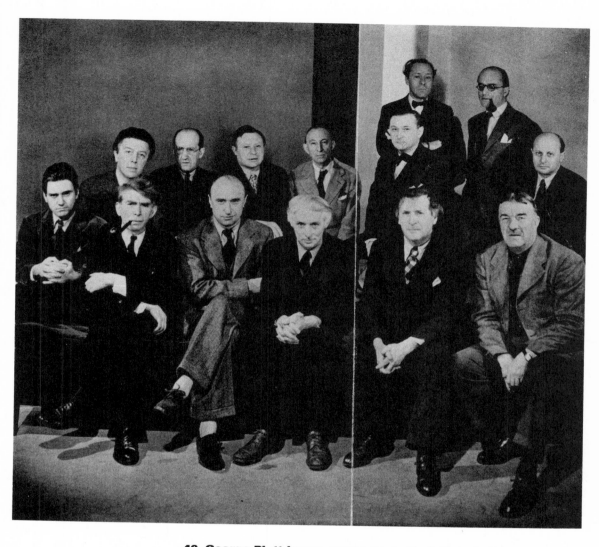

**40. George Platt Lynes, group portrait, *Artists In Exile*,
Pierre Matisse Gallery, New York, March 1942. Seated from left:
Matta Echaurren, Osip Zadkine, Yves Tanguy, Max Ernst,
Marc Chagall, Fernand Leger; second row: André Breton,
Piet Mondrian, André Masson, Amedée Ozenfant,
Jacques Lipchitz, Pavel Tchelitchew, Kurt Seligmann,
Eugene Berman.** *The Young-Mallin Archive, New York.*

tion: "The unprecedented exodus of intellectuals from Europe confers upon the U.S. the opportunities and responsibilities of custodianship for a civilization." [32] These efforts ameliorated the harsh circumstances of their arrival and went some distance toward transforming exile into asylum for the Surrealists.

Despite such generous gestures, political attacks on Breton continued. Not all were from the outside. Breton brought with him political tensions that had been festering since the eve of the European conflict. The defection of Eluard to a Stalinist line in 1938 had been doubly debilitating. Breton had lost not only a close friend but also one of the original poets of the movement. In a precipitous lapse of judgment, Breton could not resist maligning Eluard almost immediately upon meeting Ernst as he came through U.S. Customs at La Guardia. Later, at the Belmont Plaza, Ernst refused to listen to Breton's innuendos. "Eluard is a great man," he forcefully declared. "Perhaps his apologies for Stalin disturb some of us, but his poetry is the blood of our bodies. . . . He is my close friend and brother." Most telling: "He could have come here, like we did. Be safe. But he stayed." [33] Faced with a recalcitrant Ernst (who had clearly taken the high ground, whatever Eluard's political errors) Breton was forced to be more tolerant than he would have been in Paris, in order to retain his few remaining allies.

Breton's patience was especially tested by Matta and his English friend, Gordon Onslow Ford. The two fledgling artists, Matta nominally an architectural student, had met in a Parisian boardinghouse in 1937. Onslow Ford was immediately struck by Matta's automatic drawings, "the most extraordinary landscapes full of maltreated nudes, strange architecture and vegetation," as he later recalled.[34] First Matta, through the auspices of Dali, and then Onslow Ford, was accepted into the Surrealist ranks by Breton, who welcomed them both in *Minotaure* (much to the chagrin of Charles Henri Ford, who had tried unsuccessfully to sway the Surrealist leader to endorse the canvases of Tchelitchew.) [35]

Within six months of his arrival in November 1939 Matta had an exhibition at Julien Levy's, along with Tchelitchew and Walt Disney (original watercolors for Pinocchio)! That incongruity alone would have garnered him some notoriety. Levy and Calas raised the hype by turning out a brochure in tabloid form. Breton, who had been enthusiastic about Matta's work since their first meeting in 1937, lent his endorsement to this latest

exhibition of automatism—"a festival where all the games of chance are played." [36]

During the next few years the "irrepressible" Matta would crop up everywhere. With his tremendous vitality—Levy could not recall seeing him at rest—Matta threatened to be a reincarnation of the banished Dali.[37] Despite the consternation caused by such a comparison, Matta energized Surrealism in New York. He was not a shameless self-promoter like Dali, but like Dali he lived on nerves, acting as a catalyst for avant-garde activity. His idyllic stay with Onslow Ford, Tanguy, and Breton at Gertrude Stein's villa in 1939 having been interrupted by the war, Matta felt a persistent need for community, which he tirelessly sought by his activities in New York. (His "black light" paintings at Levy's, involving black fluorescent paint that would allow double images as a variant on Dali's visual puns, had been extolled as antidotes to "the black night of ignorance and war!") [38]

During the fall of 1940 Kay Sage and the Society for the Preservation of European Culture had invited Onslow Ford to the United States from England. He was to give a series of lectures that would accompany four small exhibitions of Surrealist painters, running from late January into March 1941 at the New School for Social Research. These were organized by Howard Putzel, an art dealer from the west coast who had mounted Surrealist exhibitions both in San Francisco and Los Angeles and then served as one of Peggy Guggenheim's advisors in Europe. It was Putzel who invited viewers to participate in games of Exquisite Corpse set up on rolls of paper at the New School gallery—blue for verse, pink for drawing (discreetly called "composite drawings").[39]

Onslow Ford's lectures generated excitement, but hardly because of their academic format. The very presence of this young British émigré signaled that Surrealism was not dead or even dying, as its many detractors over the past decade had claimed. That a young man, who was not French, to boot, could claim to represent Surrealism held out the possibility of participation to the American artists in the audience, who paradoxically felt like outsiders to a movement on the run, to a movement that they now felt obliged to host as a consequence of the war.

Above all, Onslow Ford claimed originality for his ideas. As he said later, he had intended to join Surrealism as one who would make a "radical contribution" to the movement, not as a passive participant.[40] In the

spirit of Surrealism he extended an invitation to the audience to join in "the transformation of the world" at a time when the world was going to hell. In the process he served as an interpreter of sorts for Matta, who despite his proficient English theorized in the absurdist tradition of Alfred Jarry's "pataphysics" and was hence prone to doubletalk. The articulate Onslow-Ford elevated the "psychological adventure" of Surrealism as it had been played out by a first generation of painters and poets to a dynamic cosmic plane activating the collective unconscious.[41]

Breton could not have felt threatened by such ideas when a loyal Tanguy reported the gist of Onslow Ford's lectures. After all, hadn't he himself viewed Surrealism as an adventure when as a young man he had urged his friends to leave everything behind? Breton quickly incorporated the ideas of Onslow Ford and Matta into his own pronouncements.[42] More troubling was the possibility that Matta, with his charm and ability to communicate directly with American painters, would form a rival movement. Although American critics initially derided Matta as "mad as a hatta" he was eventually taken seriously. As late as 1944, when Breton was clearly in charge of Surrealism, Matta was reportedly "meditating on the need for a Third Surrealist Manifesto." Despite his alleged affinity with the Surrealists, he wanted "to rebuild their ideas into a school of his own," it was claimed.[43] This was a possibility that Breton had to avert.

Lacking adequate resources at the outset of his exile to establish his own forum for Surrealism, Breton had to depend upon the hospitality of others. Soon after his arrival in New York he gravitated to *View,* where he renewed acquaintance with Ford and Nicolas Calas. It was Calas who had carried the torch for Surrealism by editing an anthology of Surrealist writing in a special section of *New Directions* in November 1940, which was the first collection of Surrealist writing in translation since Julien Levy's *Surrealism* in 1936 and *This Quarter* in 1932. It was Calas who had acted as a Surrealist capo by denouncing the wayward Dali in *View* before Breton's arrival: "I say his flies are ersatz," ran the headline, shattering Dali's trompe-l'oeil dreams. It was Calas who dogmatically hewed to the Surrealist line, affirming total liberty and inspiration against all comers and acting as Surrealist cheerleader in pronouncing lyrical manifestos.[44]

It was only fitting, then, that Ford should have deferred to Calas, who conducted Breton's first American interview for a special Surrealist issue of *View* Calas edited in the fall of 1941. Here, thanks to Ford's generosity,

was a direct view of the Surrealist leader attended by an enthusiastic disciple. *View*, moreover, exposed Breton to a select public, comprised of writers, visual artists, and intellectuals—in sum, a serious readership, whatever their predispositions toward Surrealism.

Not surprisingly, this issue was dominated by the word, as a virtual throwback to the first numbers of Breton's *Révolution Surréaliste* at the start of the movement almost two decades before. Clever use of visual elements compensated for the few—only four—black-and-white illustra-

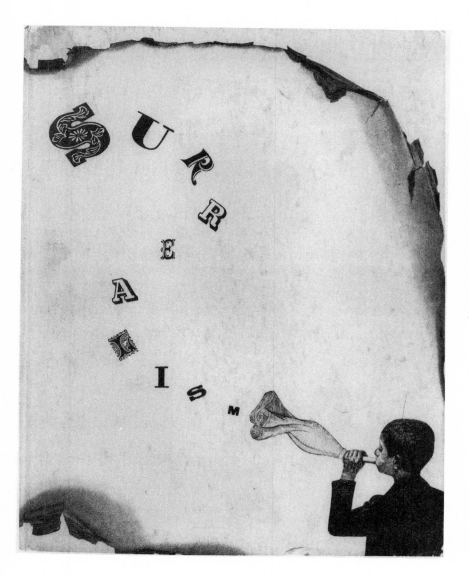

41. Joseph Cornell, cover for Julien Levy, *Surrealism* (New York: Black Sun Press, 1936). *Photograph courtesy Special Collections, University of California, Los Angeles.*

tions. Small line drawings by Tanguy, Wilfredo Lam, Oscar Dominguez, and even Breton's daughter Aube (among others) were interspersed among the writings to remind readers of the cadre of visual artists who had joined Surrealism over the years. The writing of Ernst, Masson, and Seligmann also served to offset their visual absence.[45]

Most crucially, Calas geared his selection of material to the critical issues that gripped Surrealism at a time of war. Communiqués from around the world included an extended message from Georges Heinen in Cairo, who exhorted American poets to join in forging a materialist revolution for the world. The urgency of his plea was heightened by an exposure to the cultural horrors of life under the Nazis in Vichy France. "Nazism and Culture," as the article was called, was plainly an oxymoron of the most vicious sort.[46]

Even with Calas's attempt to shore up a favorable welcome in *View*, Breton's American debut was not auspicious. It was a missed opportunity, since previous interviews by Jolas and S. A. Rhoades for the American public had offered only glimpses of the Surrealist leader.[47] Calas's interview ran curiously flat—a result, perhaps, of two ponderous personalities, so evident in Breton's reply to Calas's first question: "Have you ever dreamed of Hitler?" Granted, Hitler was on everybody's mind, justifying Breton's concern about a "collective psychosis" that could mythically transform the dictator into a superhuman force. Yet there was a note of caution if not prissiness in Breton's denial that Hitler had ever intervened in the manifest content of his own dreams. Perhaps Breton recalled Dali's juicy fixation on Hitler's fleshy back in their quarrel over such dreams a decade before, as though his own unconscious could maintain an ideological purity against totalitarian politics.[48]

The need in 1934 to distance Surrealism from Hitler became all the more urgent for Breton in 1941, especially since the innuendos of Jolas had been made explicit in *New Directions 1940*, where Herbert J. Muller, a professor of English at Purdue University, had once again equated the dark irrationality of Surrealism with the Hitler nightmare.[49] With this erroneous equation the situation became ironically muddled, even as the Surrealists unequivocally opposed all that Hitler represented.

Despite Breton's failure to project his charisma to American readers, he gave clear notice that his resolve as leader of Surrealism was only strengthened by adverse circumstances. At the prompting of Calas, he de-

lineated the "present orientation" of Surrealism, preliminary to a third manifesto. Excoriating former associates like Aragon, Dali, and Eluard for their dereliction of the movement, Breton reaffirmed the continuation of Surrealism down three paths: "alienation of sensation," "objective hazard," and "black bile." [50]

Most impressively, Breton set this familiar orientation against the current global crisis. He saw the war as an opportunity to shuck old ways of thought, especially a deadly "closed rationalism" afflicting all sides. The current destruction of the old order gave an urgency to Surrealist experiment, such that "the plunge into the divingbell of automatism, the conquest of the irrational, the patient comings and goings in the labyrinth of the calculus of probabilities" were no longer merely utopian activities but live possibilities for a future wiped clean by the war. [51]

Despite Breton's display of intellectual rigor here and in his lecture to Yale University undergraduates a year later (against, he noted, the horrific backdrop of Gaudalcanal, Stalingrad, and North Africa), he remained portrayed as isolated, disoriented, and ineffectual. In an article for *The American Mercury* in February 1943, for example, Klaus Mann tried to make Breton look silly by citing "edifying passages on the 'truly surrealist flora' of the New York countryside" from Calas's interview. "The nation at large will be thrilled to learn that Breton liked 'enormously' what he had seen of the Hudson," Mann mocked, "and has already begun his 'initiation into the mysteries of American butterflies.' " Mann had little way of knowing that Breton's interest in the American terrain was a marked improvement over his morbid fascination with copulating praying mantises in Marseilles, emblematic of the current European cannibalism. [52] The shift indicated not simply differences in ecology but a rising morale as well.

Contrary to Mann's view, Breton did not wear cultural blinders. He had demonstrated his receptivity to life outside of France on his pilgrimage to Mexico City and Trotsky only a few years before. Breton had returned to Paris laden with artifacts from Mexico. He was especially fascinated by popular imagery for the Day of the Dead, which accompanied his essay on the trip for *Minotaure*. Breton also met the Mexican painter Frida Kahlo, who was married to Diego Rivera. He immediately recognized her painting (essentially self-taught) as Surrealist and arranged for her to exhibit in Paris. Through these connections she also exhibited her paintings in November 1938 at Julien Levy's gallery. [53]

Once in New York, Breton combined an interest in things American with his concerns about the war. In his interview with Calas, Breton had spoken of the need to "look through the eyes of Eros" in order to counterbalance the war and its destruction. As examples of this erotic sight he offered Edward Hopper's *New York Movie* (1939) and Morris Hirshfield's *Nude at the Window* (see Fig. 36). While noting that these dissimilar paintings were not Surrealist, Breton succinctly pointed out their oneiric qualities, such that he crowned Hirshfield as "the first mediumistic painter." The shared motif of raised curtains in both paintings signaled for Breton a transition "from one epoch to another." [54]

Hirshfield, who had only begun painting in 1937, had been discovered by Sidney Janis, who would call Hirshfield and others like him "self-taught" painters in *They Taught Themselves*, a monograph that he wrote to accompany an exhibition of their work at the Marie Harriman Gallery in February 1942. The project had its origins in a small show of such painters that Janis had organized at The Museum of Modern Art in 1939.[55] Janis's interest in contemporaneous Sunday painters brought together modernism and a resurgence in patriotism occasioned by the war. These self-made artists could be viewed as distinctly American at the same time that they hearkened back to the Douanier Rousseau, whose painting *The Dream* (1910) Janis owned. Perhaps these painters would usher in a new American era in art.

Breton must have come upon Hirshfield soon after his arrival in New York, certainly by July 1941, when several chapters of Janis's book had been published in *Decision* (edited by Klaus Mann). In the Preface to *They Taught Themselves*, Janis thanked Breton for his "sensitive appreciation and understanding," and in the text he offered Breton's suggestion of "autodidacticism" to describe these artists, a term that reverberated with the Surrealist technique of automatism. Janis also compared Hirshfield's techniques to those of Ernst, Dali, and Duchamp. Breton in turn wrote a blurb for the monograph, and elsewhere he connected such artists with the need for new myths and pointed to Rousseau's *Dream* as directing "the line of their production." "In this great canvas," he claimed, "all poetry and with it all the mysterious gestations of our time are included: none other holds for me, in the inexhaustible freshness of its discovery, the feeling of the *sacred*." [56]

In the meantime, Breton remained cordial to Ford. On October 19,

1941, Ford wrote to his mother, "Nico translated part of my long poem for André Breton . . . [who] was enthusiastic and insists it be published in this [Surrealist] number." "I Wonder," as he titled the poem, was certainly apposite with its repetition of a childlike but pertinent question, "Where do we go from here?" One response followed the Surrealist line: "To steal the real from unreality." Ford also mentioned that he had seen Breton and "helped on the English translation of a long poem of his (500 lines) for the next *New Directions* volume (November)"—a reference to "Fata Morgana," which Breton had written in 1940 while biding time in Marseilles. Out of gratitude for Ford's support, Breton gave him presentation copies of his writing, among them a limited edition portfolio of *Pleine Marge*, including a watercolor by Seligmann, printed by the Nierendorf Gallery in 1943. The poem was translated by Edouard Roditi as "Full Margin" and appeared in a generous two-page spread in *View* in December 1944.[57]

A highpoint of collaboration between Ford and the Surrealists was the Max Ernst issue of *View* in April 1942, concurrent with the exhibition of thirty-one recent paintings by Ernst at the Valentine Gallery. The new series afforded fresh meaning to *View*'s slogan, "Through the eyes of the poets." Not only was Ernst himself a painter with a literary sensibility, but writers came out in force to celebrate Ernst and his (self-) mythic persona. Ernst's creativity went far beyond careerism (as a "professional painter"), to permeate the depths of his psychic identity. His attempt to integrate the arts beyond the arbitrary distinctions of society was echoed by the mix of writers and painters in this special issue of *View*.

Breton led off with an essay on "The Legendary Life of Max Ernst." He was referring to what the English Surrealist Leonora Carrington, the German painter's former lover, called "The Bird Superior, Max Ernst" in the title of her essay. And in Berenice Abbott's portrait, Ernst sits, birdlike and elegant, in a throne purchased on Third Avenue. In another photograph, taken by James Thrall Soby, he sits bemused among a large cast of Hopi and Zuni kachina dolls, which he bought for very little at a Grand Canyon curio shop during an extended auto trip across the United States with Peggy Guggenheim, her daughter Pegeen, and Jimmy Ernst. The issue also retrieved Henry Miller from the margins of Surrealism in Paris; he recalled Ernst as "a bright messenger from the other world seated on the terrace of a French café with a potation of powdered gold within grasp of his avid fingers." Miller wistfully remained at a distance:

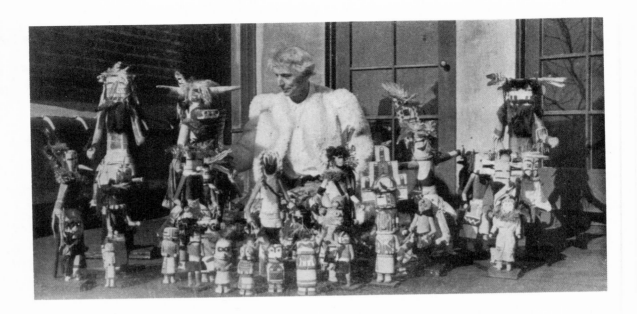

42. James
Thrall Soby,
"Max [Ernst]
Among Some
of His
Favorite Dolls
[Kachinas],"
photograph,
in *View*,
Ernst issue,
ser. II, no. 1,
(April
1942): 29.

"I always wondered what he was talking about, yet never dared approach him." [58]

Breton also contributed a lead essay for the next issue, devoted in part to Yves Tanguy. He concluded an acute analysis of the paintings with the pronouncement, "Yves behind the bars of his blue eyes." (Ford contributed one of his funniest poems, "There's No Place to Sleep in This Bed, Tanguy.") In 1945 Breton would celebrate Marcel Duchamp in a complex production of *View* designed by Frederick Kiesler, who had been commissioned earlier to design Peggy Guggenheim's Art of This Century gallery. Kiesler had come to New York from Germany in 1929 and soon established a reputation in avant-garde circles for his experimental architectural designs for theater and commercial buildings. Although Ford complained about the cost of the issue, Kiesler ingeniously designed an intricate cutout as a centerfold that opens to reveal Duchamp among his work.[59]

In 1946, before Breton's departure to a liberated France, *View* Editions published his collection of poetry translated by Edouard Roditi under the title of *Young Cherry Trees Secured Against Hares*. With the cover illustration of the Statue of Liberty, Duchamp gained the opportunity to reciprocate his friend's generosity—though not without a characteristic irony. Duchamp replaced the face of Lady Liberty with Breton's. The su-

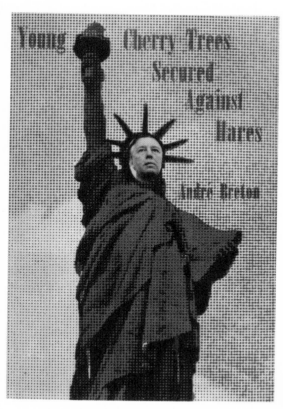

43. Marcel Duchamp,
cover for André Breton,
*Young Cherry Trees Secured
Against Hares* (Metuchen, N. J.:
Van Vechten Press, 1946). *Photograph
courtesy Library of J. Paul Getty Museum,
Malibu, California.*

44. Marcel Duchamp,
cover, *View*, Duchamp issue,
ser. V, no. 1 (March 1945).

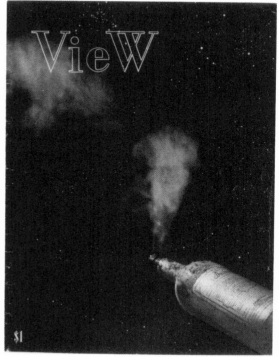

perimposition celebrated Breton as a beacon of freedom in the guise of anarchistic androgyny.

A CASUAL SURVEY of Breton's collaboration in *View* fails to expose the tensions that remained just below the surface of civility and mutual need. Whereas Calas was deferential, Ford was not about to cede ground to Breton, certainly not on his home turf, even as his Southern upbringing required that he observe the amenities of a gracious host. Years later, Ford spoke of a "rivalry" with Breton "for the New York scene." [60] Even though the scene was sufficiently varied and dispersed to withstand cultural monopoly, Ford had an advantage over Breton precisely because of his eclecticism. In a note to Tyler, Ford asserted, "As long as *View* is a clique on the basis of personalities with Something to Say—then it's all right by me— cliques on the basis of values are boring—such as the surrealist clique which excludes good and great artists and includes extremely insignificant ones—merely because of their 'values'." [61] Despite a growing tolerance borne of circumstance, Breton still sustained a narrower focus than did Ford.

At first, Ford masked his antagonisms with a playful air. The fourth issue of *View* (December–January 1941), "Reports and Reporters," coyly asked, "André Breton: Are you aware that it is being whispered in certain quarters that Nicolas Calas is hiding the corpse of surrealism in his rooms, unbeknownst to his closest collaborators in America?" By wickedly implicating loyalist Calas in the death of Surrealism, such patently ersatz "gossip" in the vein of Hollywood columns avoided the issue of schism while letting others broach the possibility—as Henry Treece had written in his column on "Literary London" for *View* that he looked forward "to a new phase of Surrealism, controlled and transmitted by British artists and writers solely." [62]

Against this desire for independence coming from many quarters, Breton needed to exert his own leadership. It was soon evident that Ford would not relinquish his editorial control of *View* to Breton or his surrogate, Calas. Indeed, Ford's relations with Calas—who could be dogmatic and as overbearing as Breton in laying down Surrealist dicta—became strained to the breaking point. By early 1942, their friendship "came to a violent end," according to Jimmy Ernst, during a cocktail party at Peggy Guggenheim's brownstone. "I have rarely seen so much blood and gore in

a relatively short span of time," he has recalled. "All the doorways were crammed with spectators, who watched not only the flailing arms, legs and fists, but also my wild dashes in and out of the fight's arena to get at least some of the paintings [Ernsts and Kandinskys] out of harm's way."[63]

Beyond the clash of personalities (and bodies), there were several substantive issues at stake. Ford remained steadfast in viewing Surrealism as a way to create poetry. In opposition to Breton and Calas, he rejected an anti-art stance. This attitude emerged most clearly in his variation on the Exquisite Corpse, first offered in the 1940 Surrealist number of *New Directions*. Ford played on the notion of "chainpoems," a group activity in which any participant in the chain was privy to those lines previously written.

In explaining "how to write a chainpoem," Ford suggested multiple ways that a poet might proceed—from contradicting the previous line or integrating an individual style to adding a line based on Surrealist automatism. (Among the examples offered was "Dirge for Three Trumpets," written by Matta, Tyler, and Ford: "Surprising my dupe by his egg of Oedipus / My brow grows horns that whisper like knives / While his hair on bended knee goes gold.") In the same issue of *New Directions* Calas disavowed the chainpoems as Surrealist precisely for the intrusion of consciousness into the writing process, thereby disrupting "the creation of an *unconscious* reality in the personality of the group."[64]

In the gulf growing between them, Ford offered not so much a declaration of independence from Breton—nothing quite so dramatic or final (to the credit of everyone)—as a concise summary of his disagreements in a rare editorial for *View* in April 1943, such that his "Point of *View*" allowed him to be an American fellow-traveler to Surrealism henceforth. In bidding farewell to the artist's dilemma of the 1930s, either "in expressing the deeper feelings of the masses or in giving form to his own dreams," Ford saw the need to raise other questions, to formulate a new position that would respond to the exigencies of the war.[65]

Without naming Breton, Ford rejected his proposal that the artist should create new myths. Citing the "hitlerian adaptation of the theory of a chosen race," he vehemently argued that "it is the forces of reaction, not we, that cling to the mythical explanation of the world!" Against the "escapism" of myth Ford proposed that "the artist should be understood as a contemporary magician," with "imagination and insight," essentially in

the tradition of Arthur Rimbaud as "seers," seeking "the magic view of life." [66] (That such a position might be informed by its own mythic values was overlooked.)

In seeing the connection between myth and (totalitarian) politics, Ford sought ways to have power without myth. Implicit, then, was a rejection of Marxist politics. While Trotsky's death had not diminished Breton's commitment to an independent Marxism, his public political pronouncements became ideologically muted. Ford, whose commitment to Marxism during the 1930s was tenuous, had published a communiqué from Wolfgang Paalen, who strongly rejected the Surrealist stance. Critical that the Surrealists had ceded the political realm to the Communist party in the 1930s, Paalen sought further to demythologize revolution. "It must be deprived of its pedestals of belief," he insisted, "its capital R, all the trappings beneath which it finally resembled so much the 'God' of yesterday; it must be unburdened of the weight that it bears of suppressed religiosity." [67]

That Ford ran Paalen's communiqué from Mexico City in the same issue that featured Breton's interview suggests a boring from within, a discreet signal that the war with its "zealous rebestialization of Europe" had posed new challenges to old political faiths. Politics, Paalen argued, had to be directly taken up by the artist. And so it was that Ford finally posed the crucial question in his editorial of 1943: "How are we [artists] to wield power?" This was a concern that the editor had raised in proposing that artists be exempted from military conscription in the national interest.[68]

Breton in Paris surely would not have tolerated Ford's deviations. Yet he had never anointed Ford as a Surrealist either in Paris or New York. By having forestalled that gesture he was able to ignore heresy and still stay on good terms with the American—to mutual advantage. At the same time, Ford had shown restraint (as well as civility and generosity) in staking out his own position so that the two could remain allies, however uneasily, in New York. As a consequence, Ford was able to pursue his own editorial interests and entrepreneurial ambitions for *View* without Breton's constraints. The benefits were mutual.

Thus Ford picked up on Breton's interest in American self-taught painters. The Surrealist leader's benediction brought Janis's project to the attention of Ford, who had been promoting the painting of his mother, Gertrude Cato, "a very delightful, handsome woman [and] a really very

good artist," according to Edward James, the diminutive English patron of Dali and one-time suitor of Ford's sister. On November 1, 1941, Ford wrote to his mother about the Surrealist issue of *View*. "Did you see the ad in View for the book on self-taught painters?" he asked. "You're one—sorry I didn't know about the book beforehand. I'd have talked to him about putting you in." Ford soon published her feline portrait of *Jimmy Lonesome* in *View* to coincide with the Janis show at the Marie Harriman Gallery in February 1942.[69]

Ford was also free to pursue his entrepreneurial ambitions. Thus the Ernst issue with its expensive illustrations became possible because Ford had come up with a new and clever plan to finance *View* by linking issues to Surrealist exhibitions in New York. The Valentine Gallery picked up some of the printing costs and used the special issue as a catalogue for the exhibition. With this method of financing, Ford turned out other compact issues, featuring Yves Tanguy at Pierre Matisse's and Tchelitchew at Julien Levy's (in a single issue), and Joseph Cornell at Peggy Guggenheim's new gallery, Art of This Century for an "Americana Fantastica" issue. With characteristic lack of modesty Ford confided to his mother that "everyone thinks it a brilliant idea—and of course it will put *View* on the map like crazy as well as pay for the printing and reproductions." [70]

The following year Ford devised yet another plan to expand *View*, by incorporating and selling shares. The immediate effect was to enlarge the magazine's format and include more visuals. No doubt recalling his own efforts to ditto *Contact* on cheap yellow stock provided by his father-in-law in the early 1920s, Williams wrote enthusiastically, "You're creating the impossible magazine of the arts no one could have dreamed." [71] The culmination of this strategy came in 1945 with an expensive issue devoted to Duchamp and intricately designed by Frederick Kiesler.

With the additional funds Ford was able to hire Tyler as assistant editor in charge of advertising and layouts. (The difficulties of dealing long distance with James A. Decker led to finding a local printer in New York—"it's a pain to try to deal with him in Prairie City," Ford complained.)[72] Although Ford's sister Ruth was skeptical about the latest hire ("Honey, I think Parker is the wrong person to send out for ads. He can't sell himself, how can he sell an ad?"), Tyler spruced himself up and energetically went about earning his eighteen-dollar weekly salary, so that Ford was thankful for the relief provided by his friend.[73] In October

1944 a young John Myers from Buffalo, New York, came on board as managing editor. It was then possible to speak of an editorial staff.[74] *View* was becoming stabilized into something more than a catch-as-catch-can little magazine.

With this expansion Ford found a new office for *View* in a small penthouse at 1 East 53rd Street, above Sherman Billingsley's chichi Stork Club and convenient to The Museum of Modern Art. With its "sweeping views on 3 sides and a little terrace running across the front," Ford thought it was a "divine set-up" in a "first-class building." [75] Its address at the corner of 53rd Street and Fifth Avenue symbolized that intersection where fashion and modernism could continue their mutually profitable courtship.

With its sumptuous layout and enlarged format for the third series, *View* came to rival the French Surrealists' *Minotaure* of the previous decade, another sign of its growth beyond the status of a little magazine. Man Ray, Seligmann, Masson, Alexander Calder, O'Keeffe, and Fernand Léger would provide covers in full color for *View*. The wealth of visual material—the spacious layouts, the ads solicited from galleries, photographs, reproductions, reviews, essays by and about artists—all contributed to an impression that the visual arts were close at hand, as close as the turn of a page, that the eyes of these poets took in the world—and that the Surrealists were never far out of the line of vision.

Beyond *View*, Ford had ambitions to be a cultural impresario. The office became a bookstore and a gallery; *View*, Inc., sponsored exhibitions and jazz concerts ("it was a brilliant and chic audience and the balconyites came down to STARE . . . like they do at the Met").[76] An increasingly institutionalized *View* was shifting from a specific avant-garde focus on the Surrealists to a wide range of artists working in the modern tradition. The eclecticism of *View*, which disturbed Breton, was obviously the price that the Surrealist leader had to pay in order to gain access to a forum beyond a small coterie of surviving Surrealists.

By December 1943 Ford accepted a full-page color advertisement from Schiaparelli. More shocking than her "Shocking Radiance" was its visual, featuring one of Dali's flimsy beach scenes that had once passed for Surrealism but now could only be called Dali-esque. Although Dali had been excoriated in the pages of *View* for his well-known sins, he now reappeared in an advertisement. Was this a sign of his proper sphere as a

commercial artist or an indication of Ford's independence from the Surrealist line? Did the advertisement symbolize *View*'s increasingly ambiguous station between the avant-garde and fashion, and hence signal the magazine's acquiescence to glamour and celebrity? The questions multiply, with few clear answers.

Ford's gravitation toward the wealthy for their patronage and privilege did not, however, deflect his energies as a cultural entrepreneur. He remained the essential driving force behind *View* despite its growth. Near the end of the war Ford wrote to his mother that "*View* is now the *world's leading journal of avant-garde art & literature*." He was very close to the mark, not simply by default, because of Europe's exhaustion, but by an accurate claim of "over four years hard work and struggle." Using the language of Social Darwinism throughout, Ford asserted a "position won" for *View*, wrested from a "rival" Paris. The touch-and-go of establishing *View* apparently required the work ethic of a Ben Franklin—such that Ford even gave up drinking and smoking to surmount the rigors of cultural competition. He predicted that "even Paris from now on will always look toward New York—there is no Museum of Modern Art in Paris, for instance." [77] Ford was remarkably prophetic in foreseeing the cultural shift, though within two years, acting on desire, he would terminate *View* to go back to Europe after the war.

8
A Season for Surrealism and Its Affinities

New York—in the early forties: a strange mixture of Cole Porter and Stalinism,
immigrants and émigrés, establishment and dispossessed, vital and chaotic,
innocent and street-wise—in short, a metropolis clouded by the war.
 —Robert Motherwell, in interview with Barbaralee Diamonstein

If men are to meet and love and understand each other it must be as equals.
 —William Carlos Williams, CONTACT, January 1921

The treacherous cultural terrain of Manhattan during the Second World War made it difficult for everyone, European Surrealists and American artists alike, to achieve equal social footing for sustained collaboration. Misunderstandings and misconceptions were easily generated on all sides, as visual artists and writers were caught up in the social disequilibrium of the war. Whereas Americans were wary of André Breton's sectarianism and a reputation for French superiority, the Surrealists on their part faced the inherent difficulties of exile, which were compounded by exacerbated political feelings and wartime xenophobia.

Even though this disorientation was a common affliction for all par-

ties, what has emerged (and persisted) is a picture of a caged Breton, trapped in New York and rendered ineffectual.[1] Such a portrayal, however, does not entirely capture Breton during the war. Despite his manifold difficulties and attendant limitations, the Surrealist leader was hardly paralyzed and not without resources. That he remained the governing force of Surrealism was certainly a result of personal energy and courage. Almost any other person would have wilted. A disadvantaged Breton, however, could not engage in business as usual. He had to adapt to the challenging circumstances unleashed by the war.

In the helter-skelter passage of Surrealism to the New World, only one development seems apparent in retrospect: the movement became oriented more than ever toward the visual. With its sea change Breton had surfaced as the lone poet among the Surrealist painters who had fled Paris for New York. Always more difficult to discipline than the Surrealist writers, and faced with the ongoing problem of exploring the visual possibilities of psychic automatism, they would persist in challenging Breton in New York. Would he be able to continue to steer this "boatload of madmen" who had descended upon Manhattan? Ever the bricoleur, Breton found it all the more necessary to fall back on his powers of improvisation in order to retain his leadership without his intimate writing companions.

At the outset, one important ally remained in France. Duchamp had been in Paris constructing multiples of his *Box in a Valise* (containing miniatures of his life's work) when Nazi Germany began the hostilities. He spent the next two years in and out of the French occupied zone, eventually posing as a cheese merchant in order to gather parts for his *Valise*. However compelling this project, Duchamp knew that he must finally leave France. His request of Breton to find an "artistic (sic) mission" in New York for him—written on an official fill-in-the-blanks correspondence card of the government censor in January 1941—was published in the Surrealist issue of *View*.[2]

Upon seeing this cryptic and ironic message, Kay Boyle wrote urgently to Ford:

> And there, at the beginning of that page, Marcel's little card which makes the blood—actually and truly—stand still in the heart; although I have seen him since then. Charles, please take Marcel seriously now and speak to Peggy, as I cannot; I can speak to Katherine Dreier, but

that is futility in the extreme. I am talking to Mrs. Fry about it again tomorrow. If you learn that, on the contrary Marcel does not wish to come, let me know that too so that I may cease a lot of useless despair. I know how these things are done; not so much by money as one might think, but by the proper indignation, and I have it, and I think people must have it to get what they want for others. And if Marcel wants to come, I will manage it in spite of foolishness. Obviously, the affidavits must be signed; but I hear they have been. There are so many devoted friends on the case, that I should like to know more before butting in.

On edge, tired, writing at three in the morning, Boyle found the night illuminated by Duchamp. "I beg of you to help me," she concluded, "for surely Marcel remains for all of us one of the symbols of what life should be: the absolute individual, and the right to be." [3]

It took more than a year of nerve-racking efforts by Duchamp's patrons, Walter Arensberg on the west coast and Katherine Dreier on the east, to get him out of France. (Duchamp's American friend Mary Reynolds had an even more difficult time of it, obstinately staying in Paris, and finally walking across the Pyrenees with the Gestapo at her heels.)[4] With a calculated insouciance that Ford must have envied, Duchamp told a credulous *Time* reporter that his Atlantic passage had been "perfectly delicious": "All the lights were on and we had dancing on deck every night." Privately, after his arrival in New York on June 25, 1942, he told a different story to Katherine Dreier, of ships torpedoed on all sides, leaving a gruesome sensation in their wake. Peggy Guggenheim generously provided him a summer haven at her spacious brownstone overlooking the East River at Fifty-first Street.[5]

With an urgent need for old allies, Breton sought to strengthen his ties with Duchamp, who always maintained a certain distance from the Surrealist leader. The two friends eventually collaborated on several projects during the war years in New York, culminating in a window display for Brentano's, the Fifth Avenue bookstore, which wanted to advertise Breton's recent publication of *Arcana 17* in April 1945. Here was an opportunity to respond to Dali's advertising fiascos without acquiescing to a rank commercialism. Because the League of Women found Matta's painting in the window to be offensive, the display was moved to the nearby Gotham Book Mart, which had long been an outlet for international avant-garde

writing (see Fig. 37). Along with Breton's book (among others), Duchamp set up a headless mannequin wearing an apron and sporting a faucet on its exposed thigh. That the League of Women did not object to *Lazy Hardware*, as Duchamp called this risqué figure, was but one of the marvels of the project, which managed to balance intellectual entrepreneurialism with Duchamp's (not-so)-secret sexual preoccupations.[6]

The alliance of Breton and Duchamp had unintended salutary effects. Kay Boyle had put her finger on Duchamp's significance for the current Franco-American art encounter. In serving Breton, the aloof but cordial Duchamp would paradoxically show American artists and writers how to accommodate the Surrealist leader without compromising their own independence. Thus the renewal of this friendship in New York was as important for American writers and artists as it was for Breton, though for a different reason: cultural authority and subversion came together with all the attendant tensions and open-ended possibilities. Breton himself later generously acknowledged Duchamp's role by describing him as "the great secret inspirer of the artistic movement in New York during the years 1941–45 as during 1918–23." [7]

Breton urgently needed to establish his own forum once it became clear that he would not be able to dominate *View*. His effort served as a catalyst for other projects. From the start, Calas had been working behind the scenes to organize a new magazine. He enlisted the aid of William Carlos Williams, an old hand at such matters, who had given his imprimatur to *Blues* a decade before and who was keenly interested in the development of *View*. Impressed by Calas's criticism in *Foyers d'Incendie* for "touching all the relationships between the artist's impulses and the world about him," Williams gradually forged a friendship with the Greek Surrealist.[8]

Williams, however, remained wary about joining forces with Calas on a magazine devoted to Surrealism. He most emphatically did not want to be submerged by a foreign movement. And despite his affinities toward Surrealist theory and practice, he had become impatient with sloppy poetic forays into the unconscious. He pungently complained to his publisher James Laughlin about those "virile dreamers" and likened them to sexual braggarts. In order to maintain his own integrity, he saw the need to keep his distance from the Surrealists. He did not want to be a mere figurehead for the new movement, nor did he think it his place to lead a

movement that involved émigrés in a new situation. Moreover, he made it clear that France's domination was finished: its acquiescence to the Nazis disqualified it from moral leadership. Williams was not about to embark on a project to "save a corpse." [9] There was a touch of grim satisfaction in an otherwise appropriate stance.

By October 1940 Williams had met Tanguy, Matta, Onslow Ford, and Seligmann. By early November he began to compile "random notes" on "Midas," as the magazine was to be called. At about this time, too, he began to read Calas's poetry and decided to try his hand at translation. "I'd like to translate one of the poems," he wrote to Calas, "and then look at it more carefully in English—that is to say American!—when I may be able to formulate what I perceive more ably." His translation led to a collaboration with Calas and Seligmann on a handsome folio printed by the Nierendorf Gallery in midtown Manhattan. The poem, "Wrested from Mirrors," concerns the narrator's fears and anxieties generated by the terror and nihilism of Nazi aggression, "the wind of fear... / which robs jackals of their dreams / and nurslings of the future." These ominous feelings are echoed by Seligmann's etching of a monstrous, metallic and skeletal creature or organism that looms over a desolate landscape. Writing later to Charles Henri Ford, Williams claimed, "The drawing accompanying my translation of Calas' poem was superbly appropriate and a fine thing in itself. I was taken off my feet. Full of genius along an avenue I hadn't traveled." [10]

Although the magazine failed to materialize, Williams had his essay published as "Midas: A Proposal for a Magazine" in the August 1941 issue of *Now*. Williams's essay, written against "distressing thoughts" about the war, took the launching of a new magazine as an occasion for a deeply felt statement on the arts in a time of war—and more: how could American artists stand up and work with the émigrés, the Surrealists prime among them, who had escaped from Europe? It was not enough to oppose in common the Nazi terror. Nor could one ignore cultural differences between America and France. Williams freely acknowledged the "foreign" conception of Surrealism, even its "antagonistic" thrust against the "advance of thought and effort in America," creating as a result a "battleground of intelligences." [11]

Stating once again his avant-garde convictions, which he had energetically sustained since the previous war, Williams celebrated the pursuit

45. Kurt
Seligmann,
etching for
Nicolas Calas,
*Wrested from
Mirrors*
(New York,
Nierendorf
Gallery, 1941),
37 x 26 cm.
*Courtesy the
Harris Collection,
Brown University.*

of the new. And so while he praised Surrealism as the only movement of the previous decade that had "emasculated" the war, he still wanted to scan a "new horizon" beyond Surrealism. In line with *View*, he claimed that "the poet's advances cannot but be the passionate news of the moment." And echoing the FIARI proposal of anarchism for the arts, he argued for "an unfettered imagination." [12]

Williams, however, recast these familiar attitudes within the context of asylum for the new émigrés. "War," he claimed, "has brought together, by release, divergent intelligences for new trial and opportunity, let us acknowledge it." From Calas and Seligmann, Williams picked up the metaphor of the alchemist's gold to unfold the possibilities of a new relationship, fostered in a climate of "love, as gold, its symbol, is most gold when it is given freely to the beloved." Americans and the French émigrés must unite on the basis of "the Midas touch, the alchemy of the mind which cannot be seduced by political urgencies." "Gold," he argued, "is the standard," which he equated with "the revolutionary element" of poetry. And so he exhorted an "impossible task...to dig under where, hidden in the soil of the mind, divergent excellences may be found stemming from the same pure stem of gold." [13]

In translating the hermetic interests of the Surrealists (Seligmann in particular among them would publish a study of magic after the war) to the cultural situation in New York, Williams was keenly aware that he was also talking about himself in his translation of Calas's poetry. The exercise in Calas's language, steeped in the tradition of French Symbolism, revealed to Williams his own poetic distance from one Surrealist at the least. But if he wasn't a Surrealist, what was he? Williams himself did not have the answer, or rather his solution allowed him to live without an immediate answer. As he characterized himself to Calas, he was "in a transition period, very much undeveloped as to what is next waiting to be done." In the first of two letters sent to Calas on December 4, 1940, Williams noted that he had done "nothing much" for the past month—a rough first draft of "Midas" and the first translation of a Calas poem. But he was hardly marking time. In the second letter later in the day he indicated that he had finished another translation and projected more in the near future. "You know," he wrote, "all this fits well into my scheme. I don't care how I say what I must say. If I do original work all well and good. But if I can say it (in the matter of form I mean) by translating the work of others that is also valuable. What difference does it make?" [14]

Translation thus still offered Williams an opportunity to pursue poetic form. "There must be a new formalism, invention," he had insisted to Calas. And he thought that the mysterious quality of Calas's poetry had to gain its clarification in form. But the mystery resided not only in the poetry but also in Williams as he tried to puzzle out its meaning:

[The poems] appear to tell a story, a tragic story of escape into—. It is not clear into what to me as yet, into the stars, the aurora, the unknown.

The form of the poems should be the answer—into what it is that you are advancing...

What has the character of these lines to do with the world of combination in which I may enter? Is it a personal world unadapted to anyone but yourself? I cannot say.

Williams then proceeded from the poetry to Calas himself, and set aside what he had heard about the young émigré from others: "Now I am looking at you and it is somewhat of a shock." [15]

The passage from poem to poet was significant. By borrowing Calas's metaphor of the mirror, Williams identified himself with the Surrealist poet and implicitly denied that his Surrealism was solipsistic. The poetry *was* accessible through translation. But Williams had hardly become Calas's double in the process. The shock of recognition also involved a shock of difference. To look *through* the mirror was to take translation as an act of transmutation, moving Williams through a period of crisis in a world in shambles, shifting him betwixt and between one language and another, between a European avant-garde and the American. Ultimately he moved toward the world of *Paterson*, a long poem that increasingly developed beyond Surrealism, through the collaborative translations during the summer of 1941.

Williams's interest in Calas gradually shifted to David Joseph Lyle, an eccentric archivist who drew the poet back to the local scene. Williams enthused over his "discovery of a personality in Paterson itself, a man of extraordinary characteristics." As a new figure in the cultural landscape that Williams inhabited, Lyle became a character in Williams's poem about Paterson. By spring of 1943 *View* published "Paterson: The Falls" as a trial run for the extended poem that the doctor was slowly assembling.[16] Translation became crucial in the making of *Paterson*, the gold, the "gift of love" that Williams generously had at hand for the Surrealists.

AFTER SEVERAL MONTHS of planning and false starts, Breton and Ernst patched up their political differences sufficiently to become editorial advisors of a new magazine called *VVV*, a triple V for allied victory in the war,

a gesture toward the war effort, to indicate that the voices of the Surrealists had not been stilled by the forces of destruction. The title page of each issue bore an elaborate logo that spelled out at length the implications of the triple V, as though there were not enough fingers to translate Churchill's simple gesture into the realm of Surrealism.

The first issue appeared in June 1942, and then it was produced sporadically as an annual: a double issue (nos. 2–3) in March 1943 and the fourth in February 1944. After his arrival in New York Duchamp joined his friends as an editorial advisor for the second issue, for which he designed the covers. This triumvirate was the power behind the editorial front of David Hare, a talented young American photographer, sculptor, and painter (a cousin of Kay Sage, he would eventually marry Breton's wife Jacqueline Lamba).[17]

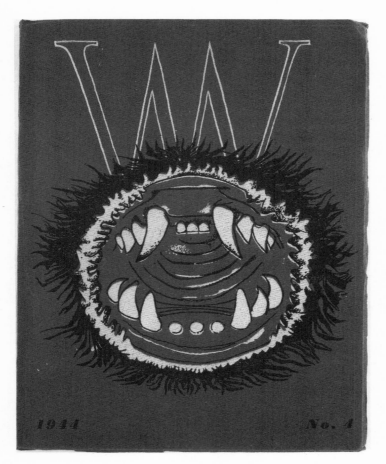

46. Matta (Roberto Sebastian Antonio Matta Echaurren), cover, VVV, no. 4 (February 1944). *Courtesy Bancroft Library, University of California, Berkeley.*

Ford was apparently asked to be editor of *VVV*, but declined the position for the same reasons that he refused to hew strictly to the Surrealist line in *View*. "I knew [Breton] would be looking over my shoulder," he later said, preferring a catholic stance for *View*. In a "Review of Reviews" for the first issue of *VVV*, the partisan Calas took to task those magazines that were neutral by virtue of their eclecticism. Neutrality was a sign of intellectual incompetence if not moral death. He damned *View* with faint praise as "an organ of advanced art" as evidenced by the past few issues, but then made his point clear by alluding to the "neutral zone" of the magazine.[18] No wonder that his relationship with Ford deteriorated into fisticuffs.

Like previous Surrealist journals, *VVV* explicitly addressed a range of human endeavor beyond poetry and the visual arts to include anthropology, sociology, and psychology. With this range *VVV* followed Williams's proposal for a new magazine "to notice the work of creative agents in other fields." [19] Above all, Breton shaped *VVV* to his own interests, which gained a public forum and force that would not have been possible through guest appearances in *View*.

With the publication of Breton's "Prolegomena to a Third Manifesto of Surrealism or Else" (in French and English, and illustrated by Matta), *VVV* elaborated upon the ultimate proposal drawn out of its title to "take account of the myth in process of formation behind the VEIL of happenings." Described as a "condensation" of the earlier manifestos, the "Prolegomena" nonetheless offered a new direction for Surrealism in the quest for new myths, one of which had been proposed by Matta and had fed into Breton's ruminations with Trotsky just prior to the war—the notion of "The Great Invisibles" as a way of decentering human consciousness in the universe.[20]

If Williams could have been persuaded to serve as a coeditor with Breton, *VVV* might have achieved a French-American parity with increased collaborations.[21] (Ernst's foldout of *Vox Angelica* with images of the Eiffel Tower and the Empire State Building held the promise of such possibilities—though rather late, since the canvas was reproduced for the last issue.) As it was, David Hare, though competent, was a third choice behind the critic Lionel Abel and Robert Motherwell, whom Breton disqualified on various grounds. Hare later claimed that Breton viewed *VVV* essentially as an outlet for French writing in exile.[22] In retrospect, however, *VVV* had an international cast of contributors, ranging from Leonora

"Pour la guerre et récréation."

Carrington and Onslow Ford to Aimé Césaire, Frederick Kiesler, and Claude Lévi-Strauss (the last of whom arrived in New York on the same boat with Breton).

Americans, moreover, were still welcome in its pages. The first issue prominently displayed photographs of Alexander Calder, who had settled in Roxbury, Connecticut, close to Masson and Tanguy. Calder's circus had been a sensation among the avant-garde in Paris during the late 1920s,

and Duchamp had come up with the generic term "mobile" to describe the sculptor's kinetic forms made of wire. In Roxbury, Calder generously provided hospitality for the Surrealists, and during the course of his compulsive tinkering made jewelry for Masson's wife. *VVV* showed his studio in a photograph taken from an angle above the floor looking into a deep space filled with the paraphernalia of the mobile. Mobiles hang from the ceiling throughout the studio. The caption left no doubt about the marvelous effect: "In our days the aviary of all light and the nocturnal refuge of all tinkling." Two years later Motherwell brilliantly summed up Calder's synthesis of "native American ingenuity" turned upon "an art of motion" that combined "abstract forms" and "the Surrealist understanding of the desirability of the object of pleasure." [23]

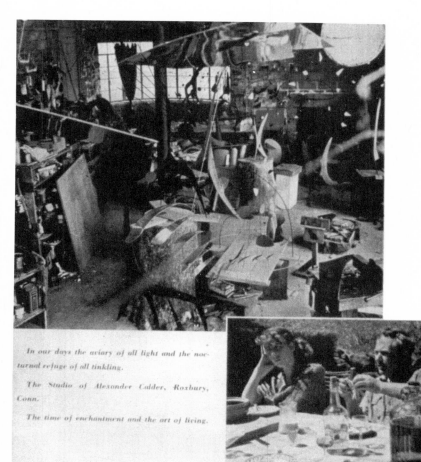

In our days the aviary of all light and the nocturnal refuge of all tinkling.

The Studio of Alexander Calder, Roxbury, Conn.

The time of enchantment and the art of living.

Photo Herbert Matter

48. Alexander Calder's studio, Roxbury, Connecticut: "In our days the aviary of all light and the nocturnal refuge of all tinkling," in *VVV*, no. 1 (June 1942): 9. *The Young-Mallin Archive, New York Photograph by Herbert Matter.*

Other Americans who gravitated to *VVV* were Dorothea Tanning, a young American painter who was taken with Ernst; Robert Motherwell, who wrote a critique of De Chirico; John Laughlin, a photographer from New Orleans who also appeared in *View*; and Philip Lamantia, a fifteen-year-old poet from San Francisco, whom Ford claimed to have discovered. Williams contributed a poem titled "Catastrophic Birth," and even Ford submitted "Lullabye." Whereas Lamantia pledged fidelity to Surrealism, other Americans were generally fellow-travelers who gained an outlet in *VVV*. They could hardly be said to comprise even a loose alliance, let alone a tightly disciplined group as in the previous decade, when Breton could imperiously anoint and excommunicate followers. Ultimately, *VVV* was compelling primarily as a sign of the persistence and resilience of Surrealism under the most trying circumstances. Breton and his allies refused to knuckle under to the forces of terror loose in the world, vowing to continue, as Breton told Yale undergraduates, "the passionate quest for freedom." [24]

WHILE THE WAR CONTINUED TO prey on his mind, Breton plunged into the visual arts (see Fig. 38). He continued to collect ethnographic artifacts; collaborated on a portfolio with Masson; and even contributed a "poem-object" to the Whitney Museum of American Art for a 1945 exhibition of European artists in America. Most importantly, other projects provided a new visibility for Surrealist painting according to his own lights. After years of misrepresentation, misreading, ridicule, and distortion, Breton had the opportunity to rebut those "impatient gravediggers" of Surrealism who had been predicting its death to the American public for the past twenty years.[25]

Breton's first major project was close at hand. After a trip to the west coast to visit her sister, Peggy Guggenheim had installed herself and Ernst in the Nathan Hale House on the east side in Manhattan. While the Hale House became a center of bohemian living, highlighted by bizarre parties, Guggenheim set about finding a gallery space for her collection. She finally settled on the seventh floor of a building at 30 West 57th Street. At the suggestion of her advisor, Howard Putzel, she commissioned Frederick J. Kiesler, who had previously designed a large-scale theater exhibition for Jane Heap in the 1920s, to design Art of This Century, as the gallery was to be named.[26] The results would dazzle the public and the critics.

In the meantime, Guggenheim turned to Breton to write the catalogue for her collection, as he had promised to do back in France. Breton first livened the catalogue's visual design by heading each artist's list of works with a photograph of their eyes—echoing *View*'s slogan. Ernst contributed a line drawing for the cover. The improved visual design could not conceal the fact that the catalogue remained a strung-out hodgepodge. The final version involved three prefaces (by Breton, Arp, and Piet Mondrian) as well as an appendix with four manifestos, followed by two addenda that listed what had not been included in the main catalogue.

Although Art of This Century was oriented toward the Surrealists, with an understandable prominence given to Ernst, Peggy Guggenheim hoped to put together a comprehensive collection of modern art. Breton's essay, then, was ostensibly a survey of modern European art from 1910 to 1942. Notwithstanding an additive structure, which reflected Guggenheim's ongoing process of acquisition in New York, Breton's opening preface endowed the history of avant-garde art with a Surrealist teleology, the "Genesis and Perspective of Surrealism." He casually negotiated the movement from Cubism to Surrealism, characterized as a movement from the depiction of the outer world to the inner world, as though it were inevitable. The young Duchamp, for example, was "quite naturally led to *Surrealism*." [27] Breton left little doubt that Surrealism had taken center stage in the visual world of the avant-garde.

No sooner was Breton done with this project than Peggy Guggenheim lent his services to Elsa Schiaparelli to direct an exhibition held under the auspices of the Coordinating Council of French Relief Societies. As in the international Surrealist exhibition of 1938 in Paris, Breton once again turned to Duchamp for assistance. The show was called "First Papers of Surrealism," to celebrate the arrival of Surrealist émigrés to New York. It took place at the Whitelaw Reid mansion, 451 Fifth Avenue, from October 14 through November 7, 1942. In his foreword, the collector Sidney Janis eloquently praised the occasion as a "communion [of artists], a sort of festive ceremonial dedicated to the imagination." [28]

Duchamp designed the catalogue, which stood in marked contrast to the conventional appearance and pedagogical aura of *Art of This Century*. A photograph of Seligmann's barn with five bullet holes (shot by Duchamp himself) served as a background for the cover, perforated in replication of the holes. A photograph of Gruyère cheese for the back cover perhaps re-

ferred to Duchamp's recent disguise as a cheese salesman when he was moving through occupied France.[29] In a bilingual statement for the preface Breton identified the "cause of freedom" with that of Surrealism. Wanting to leave no doubt about the ascendancy of Surrealism, Janis hailed the movement as "the cardinal germinating source for many of the most gifted and far-seeing artists on the international scene."[30]

Although the organizers regretted that some artists—Jean Arp, René Magritte, and Frida Kahlo among them—could not participate because of the war, the exhibition presented the major Surrealists still in the fold: Leonora Carrington, Victor Brauner, Kurt Seligmann, Max Ernst, André Masson, Kay Sage, and Yves Tanguy. Also included were some younger artists like Onslow Ford, Matta, and Jimmy Ernst, as well as Americans David Hare, Alexander Calder, William Baziotes, and Robert Motherwell. If their status as Surrealists was unclear, a nascent ecumenical spirit that included the austere Mondrian in the exhibition tried to override an appearance of clannishness in the New World.[31]

The rest of the catalogue had something of an improvisatory air. It hardly provided adequate documentation of either the participants or the works that were shown. (Only from a review might one learn that 105 artifacts, "including dolls, idols, [and] ceremonial masks by American Indian primitives," were on display.)[32] Duchamp decided to include disparate photographs to serve as "compensation portraits" of the contributors. Supposedly chosen at random, these portraits offered, for example, Duchamp as a woman photographed by Ben Shahn during the Depression; Matta as a young boy in a sailor suit; Breton as a film noir character. In part a Dada joke, these displacements served to turn attention away from the artist, now rendered anonymous, toward the possibility that art might be created by all (in the exhortation of Lautréamont). Breton rounded out this curious catalogue with a portfolio of myths, a kind of visual-verbal compendium that ranged from original sin to the "Great Invisibles," cosmic beings suggested by Matta, as well as Father Divine and Superman from the comics.[33]

Asked by Schiaparelli to be economical in mounting the show (unlike Kiesler, with his forthcoming extravaganza for Art of This Century), Duchamp strung the "gilt-encrusted drawing-rooms" of the Victorian mansion with a mile of twine (out of sixteen miles purchased!) enmeshing the paintings in a tangled skein. This visual hindrance was allowed to go only so far: Breton objected to Duchamp's request that Calder tie large paper

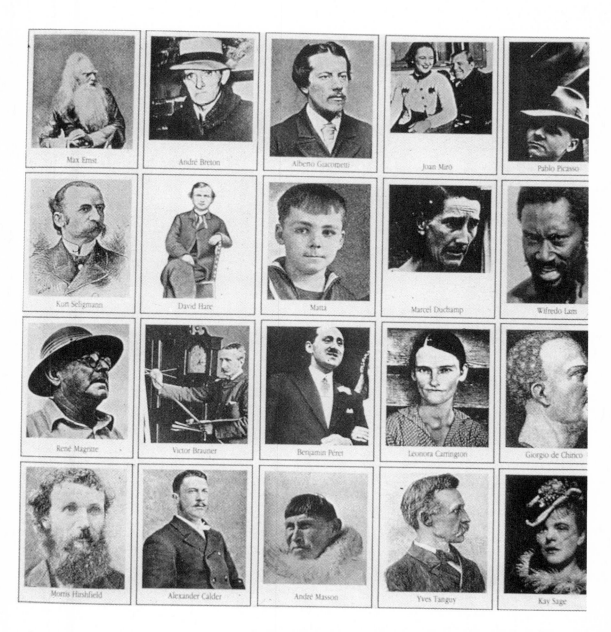

49. "Compensation" portraits selected by exhibitors for "First Papers of Surrealism" (New York, 1942). *Calas Papers, The Young-Mallin Archive, New York. Photograph by John D. Schiff.*

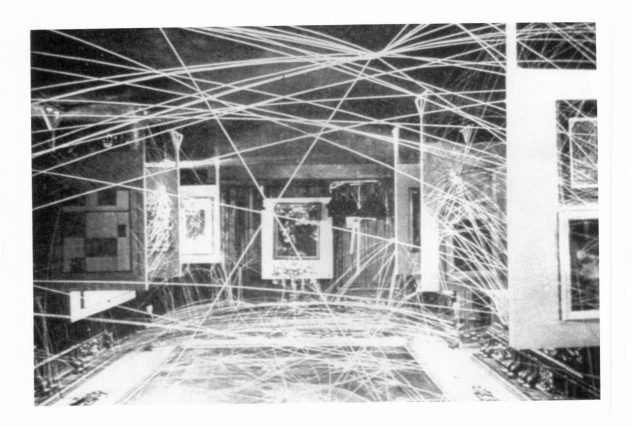

butterflies to the webbing as an additional visual obstruction. Apparently, however, some "queer little bird-like forms" were allowed to remain overhead among the chandeliers in the drawing room. The Dada effect of the setting was reinforced at the opening by the raucous play of Sidney Janis's children at the invitation of Duchamp, who did not attend the festivities.[34]

Of all the art critics, Edward Alden Jewell of *The New York Times* gave "First Papers" the most coverage. Just prior to the opening he witnessed Duchamp walking "spell-bindingly back and forth unwinding a ball of twine," lending the works a "labyrinthine setting," a description that hinted at the myth of the Minotaur, so favored by the Surrealists. A few days later Jewell devoted several columns to a discussion of the implications of the exhibition. He found the unexpected decor of "innocent white string" witty and engaging, yet almost beyond rational explanation. "The net result, geometrical at least by implication, in its interlacing and festooning, is appropriately weird and devious," he claimed. "It forever

gets between you and the assembled art, and in so doing creates the most clarifying barrier imaginable."[35]

For Jewell, Duchamp's "shroud of irrational logic" enveloping the aggregate of Surrealist works on display exposed questions of definition. Duchamp had raised the "ghost" of Dada, whose "demise," Jewell thought, "like that of Mark Twain's, was greatly exaggerated." Although he did not accurately gauge its presence, Duchamp's twine did indeed reverberate with allusions to *The Large Glass,* with its filaments and cracks, and to his earlier twine-wrapped object, *With Hidden Noise* of 1916. More importantly, the conflation of Dada and Surrealism was haunting because of Duchamp's subversive aura, which gave American artists license to play in the wake of Surrealism. Jewell himself was provoked to suggest that Surrealism did not have a monopoly on "inner vision" and subjective art. At the same time, he found that Surrealism "has become inexplicit, heterogeneously inclusive." He devoted the remainder of his column to a survey of American painters on view in the galleries, Philip Evergood among them, whose work he claimed displayed Surrealist "overtones."[36]

Despite the generally favorable reviews of the critics, "First Papers of Surrealism" had mixed results. Duchamp's twine generated some negative connotations for Surrealism in New York. The critic for *Art News,* dismayed by the apparent need to shock the bourgeoisie at such a late date in the development of modernism, found the string an annoying obstruction. And despite the apparent ecumenicism of the exhibition, some American artists felt left out. Jimmy Ernst, for example, later thought that "there was about this new exhibition the unmistakable aura not of an alive movement but rather that of a closed circle of licensed practitioners." Was he the unnamed "young disciple" who was quoted in *Newsweek?* "They're all in deadly earnest," someone complained. "If it's humor, it's a kind of agonized humor."[37]

Finally, there was a political controversy. The exhibition had been intended to raise money for the Coordinating Council of French Relief Societies, which remained willing to countenance the Vichy regime. Ford was indignant that Breton "just had the bad taste to organize a Surrealist show sponsored by a French Relief business that is pro-Vichy and anti-British!" Jimmy Ernst recalled that "the low point of the entire affair was the fact that most of the festive opening crowd seemed not at all embarrassed at having to enter the exhibition past a life-size bust of Marshall Pétain." De-

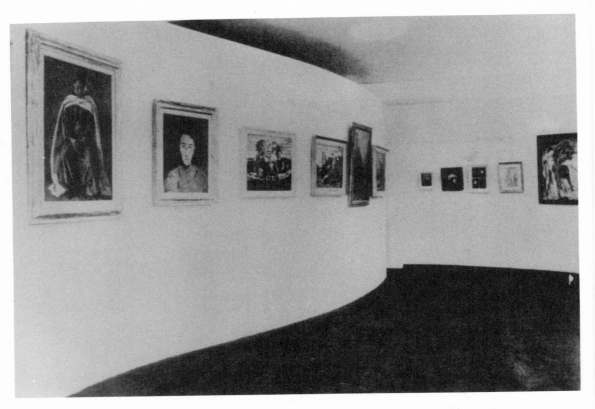

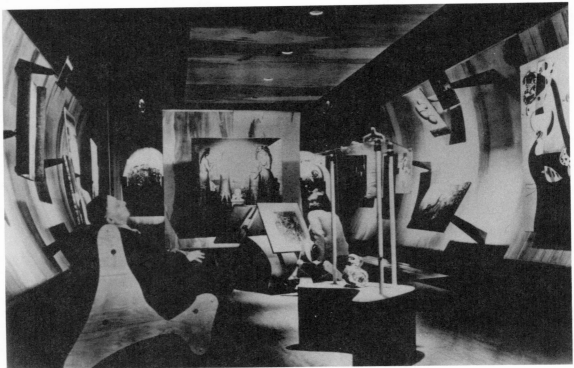

spite the protests of younger artists, the bust was not removed. That the Coordinating Council (and the State Department) might have had its own political reasons for retaining contact with the Vichy government does not explain Breton's willingness to do business with the organization.[38]

Peggy Guggenheim's Art of This Century opened a week after "First Papers"—also as a benefit, but for a less controversial cause, the International Red Cross. Cost overruns resulting from the complexity of Kiesler's design for the galleries led to a delay of the opening. Unlike Duchamp's installation for "First Papers," Kiesler designed permanent spaces for Art of This Century. Taking the curved walls of Julien Levy's second gallery (on East 57th Street) to their extreme, he constructed vertically concave walls with a lowered ceiling for the long, rather narrow gallery that housed the Surrealist works. (Another gallery was reserved for abstract art, another for temporary exhibitions, and yet another for mechanical displays in the manner of fun houses.) Unframed paintings were projected from the walls so that they appeared to float—an illusion reinforced by a complex lighting system that moved from work to work in the darkened gallery. The recorded sound of a train filled the gallery at frequent intervals. Peggy Guggenheim's anxieties that she would be upstaged by "First Papers" were certainly laid to rest by Kiesler's imaginative realization.

The bizarreries of this environment would seem to confirm its Surrealist credentials no less than Duchamp's twine revealed a Dada imprint on "First Papers." *Newsweek* described the gallery "setting as fantastic as the art itself." But just as Duchamp's installation echoed many of his own personal, and essentially private, motifs that would not have been known to most viewers, the Surrealist environment of Art of This Century was not self-evident except in a superficial fashion. The suspended paintings left unframed were supposed to signify their connection with life.[39] From the very first *Manifesto of Surrealism* Breton had wanted to break down the arbitrary barriers between "reality" and "unreality," unconscious and conscious experience, the rational and the nonrational, art and life: false antinomies, he thought, that once overcome would lead to Surreality. Gallery goers would gain an intimacy with the paintings by virtue of their flexible mountings that allowed viewer manipulation.

PEGGY GUGGENHEIM BROKE WITH BRETON over a petty disagreement when he refused to let her advertise gratis in *VVV*. Another tie to Surrealism was

Opposite: **51. Interior of Julien Levy's gallery with curved walls at its second location at 15 East 57th Street, New York, c. 1937.** *The Young-Mallin Archive, New York.*

Opposite: **52. Frederick Kiesler lounging in his Surrealist gallery at Art of This Century, New York, 1942.** *Courtesy The Young-Mallin Archive. Photograph by Berenice Abbott.*

lost when her marriage to Ernst fell apart in 1943, after Ernst met Dorothea Tanning. Even so, certain fundamental affinities with Surrealism stayed constant at Art of This Century. Just as the Centrale Surréaliste had been a center of experimentation in Paris, so too Guggenheim conceived of her gallery as a "research laboratory." This was not a hollow notion, even though she did not encourage Breton's sort of psychic exploration. Art of This Century became vitally interested in exhibiting and hence nurturing young artists. Joseph Cornell, Dorothea Tanning, William Baziotes, Robert Motherwell, David Hare, and Jackson Pollock were all shown individually and in groups after the opening exhibition in 1942.[40]

Such a commitment, however, reinforced the predilections of American artists to plunder Surrealism for its aesthetic possibilities in their intent to create art. As John Myers, Ford's young assistant on *View,* later succinctly recalled, "They were interested in the art of painting strong, expressive pictures which were valued in themselves."[41] Those attitudes collided with Breton's interdictions against pursuing the arts and all that it entailed. Yet even the Surrealists felt basic cultural tensions animating their projects, which were supposed to exist apart from aesthetic considerations. Unless the Surrealists were extremely vigilant, writing and painting out of the unconscious were easily construed as art by the dominant society and hence exploited in the marketplace. But immune to the sanctions of Breton, most American artists were eager to turn from experimentation for its own sake to its development into art.

The Surrealist technique most vulnerable to such tensions was psychic automatism. Its premises became subject to close scrutiny, as a new generation of American artists gained an opportunity to explore its possibilities in the company of its proponents. For all that automatism had been defined since the 1924 *Manifesto,* and existed earlier than that in practice, the method remained problematic and subject to skepticism from the very beginning among the Surrealists themselves. Could this technique of involuntary transcription actually provide direct access to the unconscious? And how was automatism to be carried over to painting, a self-conscious act if there ever was one? To the extent that psychic automatism was questioned, the very possibility of a Surrealist visual project remained in doubt.

From a rational point of view, automatic writing is mere gibberish, characterized by what Breton exactly prized as its "extreme degree of immediate absurdity." As these incredible images take hold, one gradually

becomes "convinced of their supreme reality." Taken out of context, these statements erroneously suggest that Breton ascribed "reality" solely to dream and fantasy. Yet this was not the case, as indicated by Freudian theory and Breton's understanding of language. Dreaming does not offer a direct view of the unconscious but rather evidence of a disguised unconscious rendered evasive by the conflicting imperatives of the ego and superego. There is no reason to believe that automatic writing is not governed by the same psychic mechanisms. Moreover, written language—syntax, grammar, diction—all work against the opening of a verbal conduit from the unconscious. Finally, the writer witnesses the writing. Breton cautioned against self-observation in its extreme form of rational guidance. The role of reason was to be "limited to taking note of, and appreciating, the luminous phenomenon." [42] But self-observation is hardly ever neutral, and probably cannot ever be completely neutralized, so it constantly impinges upon the writing. In sum, there is a doubleness to automatic writing such that it does not reveal the unconscious directly.

While such a theory of automatism was implicit in the 1924 *Manifesto* in that Surreality modulated between the conscious and the unconscious, Breton's stress upon language and writing was explicit. His "dictionary definition" closely associated language (virtually to the exclusion of any other means) with "psychic automatism," his synonym for Surrealism. At one point he claimed, "Language has been given to man so that he may make Surrealist use of it." If the Surrealist writer is successful, the language recorded on paper should take on the absolute reality of Surreality. As Breton argued, "Poetry alone [by which he meant in this context automatic writing] is capable of codifying the compromise between dream and reality." [43] His bias toward writing would become problematic in the search for a visual automatism.

Automatic writing, trance monologues, the recording of dreams, simulations of madness—the Surrealists were willing to try anything to plumb the depths of the unconscious. Breton, however, had his limits, for he was soon aware of the dangers of his experiments, as when Desnos violently attacked Eluard with a knife during one of his trances. There were, however, other, more insidious conflicts than the possibility of violence. The writer René Crevel gradually became skeptical about the entire process and concluded that the unconscious did not yield a language such that it could be uttered or transcribed involuntarily by hand.[44]

Crevel's disenchantment had been prefigured by Pierre Naville, one

of the editors of *La Révolution Surréaliste,* who dismissed the possibility of Surrealist painting modeled on psychic automatism right on the heels of the 1924 *Manifesto.* It was all well and good for Breton to speak of the "voice" of the unconscious, but where was its eye? How were visual images, if indeed there were visual images, to be elicited from the unconscious? Assuming that one could cross over from the verbal to the visual, could the hand be an adequate visual recorder without premeditation, with spontaneity? Pictorial organization involving conscious formal decisions seemed all too probable if not inevitable, rendering visual automatism suspect as nothing other than art after all.[45]

Despite all the difficulties in recording the unconscious, automatic drawing persisted as a favorite method, first practiced as early as 1916 by Jean Arp, the Alsatian Dadaist, with a biomorphic image done in brush and ink, called *Automatic Drawing.* It surfaced in New York some twenty years later at the landmark exhibition "Fantastic Art, Dada, Surrealism" at The Museum of Modern Art in 1936 and was illustrated in the accompanying catalogue. *Secession,* an American magazine of the avant-garde that had been sabotaged by Josephson in his Dada phase, and then *transition,* had kept the prolific Arp before American viewers with cover illustrations in 1922 and 1932.

As "mere" chance or as part of a larger design of which one is but dimly aware, automatic drawing and writing shared the line in common. Automatic drawing thus easily carried over to the calligraphic and the verbal. Yves Tanguy's *Letter to Paul Eluard* (1933) visually presents an epistle both as a crumpled sheet of writing paper and as a mountainous landscape. Letters are visually depicted in the transformation of the letter, with punctuation falling scattered like snow. Tanguy's discursive message is both revealed and concealed, finally subject to the surmise of the reader, who must fill in the text with the missing words. The reader becomes a voyeur, opening someone else's mail.

By 1938, even Breton was capable of displacing automatic writing with visual imagery in a photomontage that is both engaging and unsettling. Breton portrays himself looking up from a microscope. His probing eye and visionary, yet direct, look indicate that the act of seeing has become central to the Surrealist quest. The inscription "L'écriture automatique" seems to serve as a title even when the real title is *Self-Portrait.* At the same time, with its bold calligraphy, the inscription has the feel of a

signature, as though it stood for "André Breton," thereby suggesting the extent to which the Surrealist leader identified with automatic writing. Yet signature is not all, for "L'écriture automatique" moves toward self-effacement, inasmuch as Breton's collaboration with his unconscious is almost entirely visual.

Ultimately, psychic automatism is a process such that its dynamics cannot be fully appreciated or understood from simply viewing the writing or the drawing that results. American painters needed to try their hand at this method of plumbing the unconscious. André Masson was important in this regard because he kept automatic drawing alive in their midst. Thus he turned insomnia into drawings, which appeared in a *Nocturnal Notebook*, published by the Curt Valentin Gallery in 1944. In a brief preface, Masson wrote that "these drawings were made in a few hours one night in May, 1942, and are presented in the order of their appearance." Rather than toss and turn, "the author preferred to leave his bed and shorten the hours by letting his pen wander across the paper in the lamplight." [46] Employing the familiar language of automatic drawing in describing his work, Masson had been one of the earliest Surrealist practitioners, whose automatic drawings for *Nocturnal Notebooks* reveal a continuous line, sometimes pressured, sometimes attenuated and broken, but always as if on a trajectory made intricate by creatures that exist among the tangled skeins of his imagination driven by insomnia.

Masson, however, never learned to speak English, and remained mostly in New Preston, Connecticut, where he had settled almost immediately upon his arrival in the United States in 1941. That he was a marginal Surrealist in and out of favor with Breton might have been encouraging to Americans eager to find their own place in relation to Surrealism, had they been able to know him personally. Masson's work, however, became quickly known in the small world of the New York avant-garde. After his debut at the Baltimore Museum of Art in October 1941, Jolas recruited him for three drawings in *Vertical: A Yearbook for Romantic-Mystic Ascensions*. Masson then published portfolios titled *Mythology of Being* in 1942 and *Anatomy of My Universe* in 1943. During the 1930s he had been regularly featured at Pierre Matisse and then, during the war, at the Buchholz Gallery. Masson's automatism contributed to a nascent desire for "total freedom of expression," as abstract painter Peter Busa later recalled. [47]

With Masson at one remove, and Onslow Ford off to Mexico in 1941

for the duration of the war, Matta became the catalyst who energized activity among American painters. Matta, the rebel angel of Surrealism, had not so much a coherent agenda as emotional drives that he tried to channel into his paintings and explain to others. "Matta Engulfed" (by his paintings) is the apt title of a photograph accompanying Sidney Janis's article on the European émigrés for *Decision* in 1941. Charming and boyish in appearance, Matta also looked vulnerable, not entirely in control of his situation.[48]

As an architectural student in Paris, Matta had moved toward Surre-

alism with his drawings. (It was Onslow Ford who initiated him into painting on a trip to Switzerland.) Matta brought a fresh look to automatism, which, he later claimed, had two crucial shortcomings. It had a "dose of control" and "pretended to be a language." Unlike Crevel before him, Matta had no commitment to writing, and so he felt no compunction in stripping automatism of its scriptural pretensions to expose a visual field of the unconscious. By purging automatism of both language and control, he hoped to engage a visual "morphology" of "real feeling." [49] Even though he agreed with Breton in stressing spontaneity, he shifted radically from the verbal to the visual realm in improvising an automatic process.

As a consequence, the art talk so necessary for painting came not so much from Breton as from Matta, who was an immediate presence among a small number of New York artists about his age at the outset of the war. Whereas Ernst complained that "it was hard to see one another in New York" because of a lack of café life, Matta energetically improvised by seeking out American painters in their studios (as well as cafeterias, bars, and hole-in-the-wall coffee shops, which were among the staples of every New Yorker). He thus overcame Ernst's growing despair that "in New York we had artists, but no art. Art is not produced by one artist, but by several. It is to a great degree a product of their exchange of ideas one with another." [50] In subversive counterpoint, Matta was a youthful catalyst in a way that the older Ernst, though adaptive, could never be. But even Matta the catalyst was not a decisive force in galvanizing the Americans. Their situation was far too unstable for any individual to assume sustained leadership for an alternative movement to challenge Surrealism.

Those who were attracted to Matta had already formed a loose network of friendships and sporadic working alliances. Peter Busa, Gerome Kamrowski, William Baziotes, Jackson Pollock, and Robert Motherwell—they were all relatively young, and in the instance of Motherwell, virtually a beginning painter. Busa and Kamrowski, both from Minnesota, were close friends in the WPA, where they were acquainted with Baziotes and Pollock. All four were interested in abstraction, and hence they were isolated if not alienated while working in the WPA, which was running down as the war revved up. Years later, Busa placed himself and his friends squarely in the camp of abstraction, which he sharply distinguished from Surrealism. The distinction came largely because he equated Surrealism entirely with the figurative Dali.

In virtually the same breath, however, Busa claimed that he and Kamrowski, along with Baziotes, had experimented with painting techniques related to visual automatism prior to the arrival of the Surrealists at the outbreak of the war. Kamrowski has recounted that during the winter of 1940–1941 Baziotes came to his studio with Pollock and began to talk "about the new freedoms and techniques of painting." That they were in a studio rather than a café allowed them to move beyond theory to practice as their interests quickened. They improvised on a canvas that they stretched out on the floor, deploying a fast-drying lacquer with palette knives and brushes, Pollock "flipping the paint with abandon." [51]

This modestly sized *Collaborative Painting* (with a hint of a tripartite structure) has survived less as evidence of interest in Surrealist theory than as a token of the heuristic paths taken by American painters to break out of a confining situation (see Fig. 39). Geometric abstraction was deemed unsatisfactory, and Picasso was oppressive in the magnitude of his achievement. Matta later claimed that "the situation was *very* WPA," that is, very restrictive and frustrating for these young American painters, who had not yet found their own way. Matta thought that they "were all ready to explode." His "time bomb," however, was yet to be ignited. Attempts at automatism were scattered, nothing was sustained. "The flashes of understanding were momentary," Busa claimed. Desultory activity would require the energizing of Matta, who would "personalize Surrealism" for these painters. [52]

In the meantime, the scene was "lethargic," according to newcomer Motherwell, who had landed in New York in 1940 from the west coast via Harvard and a brief stint at painting in France. Toward the end of that year in Manhattan, Meyer Schapiro introduced him to Seligmann, who offered him lessons in his print studio. It was a perfect chance to hang out with the Surrealists and gain some experience in exchange for some assistance in negotiating unfamiliar territory. Like Busa and Kamrowski, Motherwell was interested in abstraction, though with a broader literary and philosophical base, and like Busa and Kamrowski again, he was initially not keen on Surrealism to the extent that it was represented by Dali, who was most obviously not an abstract painter. [53]

The inexperienced Motherwell was clearly a kindred spirit who gravitated toward the youthful Matta. The two of them quickly hit it off in the spring of 1941 and by summer they decided to travel together to Mexico

City. On that trip Matta initiated Motherwell into the mysteries of Surrealism, which was further elucidated by Wolfgang Paalen, who met them in Mexico City. Upon Motherwell's return in December, Matta introduced him to William Baziotes. The two became good friends over dinner at Matta's. A painting network gradually began to coalesce toward the close of 1942, as Busa and Kamrowski, who had met Matta at the loft of Francis Lee, a young filmmaker, joined Motherwell and Baziotes to piece together the possibilities of Surrealism through Matta's interpretation. He recalled that their interest quickened as a result of "First Papers of Surrealism" in October 1942, Motherwell and Baziotes having been invited to exhibit.

At first, Matta met individually with these painters, but then they came together in their apartments and studios, and eventually on Saturdays in Matta's studio on Ninth Street, where they engaged in a practicum that involved sessions of Surrealist games and critiques of their painting. Busa has favorably recalled "a period of good times and productive as hell." Meetings overflowed to restaurants where "the food was spiced with parlor games." Kamrowski also found these occasions enjoyable, characterizing them as more "structured" than informal in their exchanges and critiques. In practice, "automatic techniques were a springboard for the imagination," allowing Kamrowski to escape from European avant-garde painting as well as midwestern American Scene, which had dominated the previous decade.[54]

By the winter of 1942–1943 the situation seemed modestly favorable for the formation of a new movement. The obstacles, however, were many. Apart from an essential need to recruit talent beyond a handful of participants, the logic for a new movement had to be developed. If it was to be a manifestation against Surrealism, then the group would have to demonstrate that its work went beyond Surrealism. Such a possibility was worth entertaining because of Matta's ambivalence, which Motherwell later described as his "deep love-hate relationship with the Surrealists," paralleling the existing skepticism of his American friends. Motherwell later claimed that their collaboration never got off the ground because of Matta's mixed feelings. He was a more established painter than his American friends, and despite a desire "to show the Surrealists up," he did not want to lose all the advantages of associating with them.[55]

Even though the Americans felt that Matta perversely withdrew from this collaboration, leaving them high and dry, they were not prepared to

accept his agenda in a passive fashion. While skepticism and ambivalence toward Surrealism colored prospects from the start, their collaboration faltered because they were essentially at cross purposes. Josephson's (semi-)ironic plea to his Surrealist friends in 1926 persisted over the decades: "YOU HAVE NO RIGHT TO BE LITERARY," he had protested. "LEAVE THAT TO US. We wish to write immortal prose and verse." [56] And in its cultural reverberations during the 1940s his plea had crossed over from American writers to painters. They added their own subtext, pursuing abstraction against figuration.

From his vantage point, Matta later claimed that he was surprised to find that American painters were engaged in "magazine painting" when he first arrived, their canvases modeled on reproductions of European art. He rightly argued that painting needed to come from within, not from an external culture, and so he felt that psychological morphology would offer an effective antidote, allowing each painter to develop a unique vision. To account for the missed connections, Matta added that his painting interests took a social turn in 1943 as the war became "a ferocious thing" that he could no longer ignore. His initial notion of psychological "morphology" for individual development gave way to social morphology. Whether or not Americans ought to have been ripe for such an approach, they showed little enthusiasm for Matta's social morphologies, sensing that his paintings had veered toward representation, as indeed, Matta sought "new images of man" in painting, as opposed to what he later dismissed as "pure painting." In the heat of discussion Kamrowski dismissed his paintings as "science fiction." [57] The Americans set Surrealism, including Matta's variations, against their own preference for abstraction. Would they ever attain a synthesis?

Deeply interested (and trained) in philosophy and literature, Motherwell took it upon himself to be the American theoretician for the group. With his academic proclivities, he was suited for such a role. (His metaphor of a "postgraduate education in Surrealism" with Paalen in Mexico was thus apt.) Yet the role was thankless, as he recognized by the summer of 1944 in characterizing American artists as "anti-intellectual." [58] But were the Europeans any better? Although in retrospect he felt that the exiles had treated him "generously," John Myers later recalled that Breton ironically referred to Motherwell as "le petit philosophe," a put-down that reveals both Breton's sense of French superiority (how could Americans

be his intellectual peers?) and Motherwell's naiveté in approaching him as an equal who took ideas as the coin of the realm. The American neglected to inquire as to whose realm it was.[59] Breton was not going to concede ground to a young American, one who did not come properly accredited, as Man Ray did years before with Duchamp's backing.

Motherwell later claimed with accuracy that he took a quick turn in and out of Surrealism. Who would not have spun off its orbit, with Matta as his vertiginous guide? Motherwell's "postgraduate education" with Paalen was no less subversive. Despite a common interest in primitivism, Paalen was already on the outs with the Surrealists. When his journal *Dyn* first appeared in the spring of 1942, Paalen took congenial leave of all movements. After paying his respects in a "Farewell to Surrealism," Paalen declared that he could no longer follow its politics because the crisis of the war had disqualified Surrealism from defining the artist's place in the world.[60]

In a companion essay translated by Motherwell, called "The New Image," Paalen presented an alternative to Surrealism for the empowerment of artists. He challenged Marx and Engels's view of art and religion as "superstructural" rather than fundamental to a society. "Far from being a late superstructure," he claimed, "they are from earliest times inseparably interwoven with the growth and development of human intelligence." Thus he cited as "irrefutable evidence" from anthropology the Pacific Northwest Indians for integrating art "with the fundamental problems of the community which produces them." [61] By implication modern artists should not view themselves as superfluous in addressing political issues. And even more crucially, he implied that the very making of art was in itself a political act.

While Paalen's rejection of Marx was a clear signal of his departure from the Surrealists, his attraction to the "primitive" was commensurate with the views of the Surrealists, most recently expressed by Kiesler in his design of the galleries for Art of This Century and by Breton in the catalogue for "First Papers of Surrealism." Kiesler translated Breton's quest for the Surreal into architectural terms by enhancing a viewer's perception beyond conventional spatial categories. He wanted to return to a "primordial unity." "Primitive man," he claimed, "knew no separate worlds of vision and of fact. He knew one world in which both were continually present within the pattern of every-day experience. And when he carved

and painted the walls of his cave or the side of a cliff, no frames or borders cut off his works from space or life—the same space, the same life that flowed around his animals, his demons and himself." [62]

Breton's enthusiasm for ethnographic artifacts, shared with Ernst, had a rationale that was revealed in *First Papers*: "Surrealism," Breton explained, "is only trying to rejoin the most durable traditions of mankind. Among primitive peoples art always goes beyond what is conventionally and arbitrarily called the 'real.' The natives of the Northwest Pacific coast, the pueblos, New Guinea, New Ireland, the Marquesas, among others, have made *objects* which Surrealists particularly appreciate." [63] Although Paalen's recognition of the political implications of primitivism was more profound than Breton's appreciation of artifacts, the two still shared common ground.

Paalen's Surrealist affinities allowed Motherwell to be a fellow-traveler who could raid the Surrealist arsenal without feeling bound to ideas that he could not embrace. Thus the Austrian painter reinforced the American's distaste for Dali by emphatically rejecting the Spanish painter's representational dream images as reactionary, in no wise automatic. True automatism, Paalen argued in "The New Image," involved "techniques of *divination,* whose function is to sense unexpected images in esthetically amorphous material." Paalen insisted that "the artist of our time can be authentic only when he creates new modes of seeing, only when he is original." The artist as visionary finally had to heed the imagination, not the unconscious, which could offer only preliminary materials that required conscious aesthetic form derived from the imagination. [64]

Paalen, then, reinforced Motherwell's preference for the aesthetic. After renewing contact with Matta upon his return to New York in late 1942, Motherwell sought ways to channel his friend's variations on Surrealism into art. Like Matta, he felt that American artists needed a creative principle, more than a specific style of painting. But Matta recognized "a tremendous incompatibility of ideas." As he later complained, "[Motherwell] would translate in terms of esthetics what I was trying to say, and then I would say, 'No, it's not that at all that I am trying to say.' He would try to drive everything into esthetics, you know." [65] Precisely so, Motherwell wanted to channel automatism into the art enterprise.

Psychic automatism was a means of "emancipation" for Matta, whereas Motherwell viewed it as that and more, as a starting point for

making a painting. Later, he claimed that "the question of the subconscious as uncontrolled abandon never was an issue." One began by drawing out the unconscious by means of "doodling." [66] Although Motherwell also used the term "plastic automatism" as a way of distinguishing his claim on the process from automatic writing, "doodling" became the preferred phrase because it was unpretentious and untheoretical, certainly un-French sounding, and hence most likely to appeal to American "anti-intellectual" painters. Beyond rhetorical strategies, "doodling" set this initial improvisation in its place as a means toward an end. It was no longer an end in itself, as it had been for Breton and the Surrealists, but rather a way to begin a work of art involving conscious decisions.

With all the cross purposes of this enterprise, it should come as no surprise that the collective results were meagre. The Americans continued sporadically after Matta dropped out. Motherwell took up the slack by organizing some evenings of Exquisite Corpse (writing rather than drawing). The notebook of poems has since disappeared. Although Motherwell has regretted their loss, particularly "a beautiful poem" about rain, he has also shrugged them aside as "nonsense." [67] His dismissal is consonant with his desire at the time to move beyond experimentation to the creation of works of art.

A more intangible but yet profound result was the way that the game itself had been subtly changed, as Matta later phrased his desire to challenge the Surrealists. He had wanted to infuse with life what he felt was a stagnant situation. But whereas he equated the imagination with life, Busa later associated Matta's vitality with the transformational and liberating powers of paint: "Paint was not just paint," he rhapsodized. "It could become crushed jewels, air, even laughter. It was quite open." [68] It was precisely in this sense of paint, activated through an initial "doodling" on the canvas, that Motherwell—who had tacitly become Matta's antagonist—acquiesced to the entirety of French modernist culture and transformed it in the realm of his art.

In the wake of Matta's retreat before American interests in "pure painting," Baziotes shared a Symbolist sensibility with Motherwell even though he informally considered himself a Surrealist. Busa later claimed that Baziotes was the most "orthodox" Surrealist, while Matta construed Baziotes's interest in Surrealism mainly as a desire for emancipation. [69] Liberation, however, finally meant independence from the Surrealists, in-

cluding Matta, whose presence is most evident in Baziotes's duco enamel *The Butterflies of Leonardo da Vinci,* a canvas that was solicited for "First Papers of Surrealism" in 1942. Beneath the flash and movement of Matta's automatism can be found a subtlety and indirection that would eventually characterize the achievement of Baziotes.

From those Americans surrounding Matta, Breton eventually singled out only Kamrowski as a Surrealist. Looking back to the war years from the vantage point of 1950, he cited Kamrowski's originality and quality, as might rightly be expected by such works as *Rouge* (1940) and *Emotional Seasons* (1943), but he put his finger on Kamrowski's Surrealism by pointing out "the sustained character of his research," with "a praiseworthy disdain for the 'gallery.'" Kamrowski's departure for Ann Arbor, Michigan, in 1946 may have deflected the commercial pressures of New York's art scene. Yet his evasion of a "career" can be more readily attributed to his willingness to stay within the realm of experimentation. He worked through variations on automatism for "self-actualization" without concern for "an identity commodity."[70] On that understanding of Surrealism Kamrowski resisted the assimilation of automatism into visual art, a process that Motherwell actively pursued and accelerated during the Second World War.

Joseph Cornell, "The Enchanted Wanderer" 9

New York was decidedly not the ultra-modern metropolis I had expected, but an immense horizontal and vertical disorder attributable to some spontaneous upheaval of the urban crust. . . . Whoever wanted to go hunting needed only a little culture and flair for doorways to open in the wall of industrial civilization and reveal other worlds and other times.
—Claude Lévi-Strauss, "New York in 1941," in THE VIEW FROM AFAR

In contrast to Breton, whose Paris was so ingrained that he could not fully surrender to New York, the exiled Lévi-Strauss eagerly explored the back alleys of Manhattan. Picking his way through urban debris for hidden worlds of enchantment, he could have come upon Joseph Cornell's home on Utopia Parkway in Queens. The garage was a cramped workspace and repository for the materials that Cornell brought back from his forays into the cosmopolitan dumping ground of Manhattan.[1] His explorations of used bookstores, magazine stands, and junkshops around Times Square and Greenwich Village did not have quite the same erotic purpose as Breton's aleatory movements through the labyrinthine streets of Paris.[2] Yet Cornell went further afield than the Surrealists, who also visited fleamarkets in search of objects banal and exotic that might spark their imagina-

tions. More than the Surrealists, Cornell made the serendipitous quest an integral part of his life and a necessary aspect of the boxes that eventually housed the jetsam garnered from chance encounters.[3]

In 1941 Cornell assembled a small box out of printed images and a mélange of domestic items. Simply called *Object*, this was one of the first "aviaries" or "habitats" that Cornell would make during his life (see Fig. 61). It contains two brightly colored parrots and three parrakeets that are crowded into the shallow space of the box. These cutouts "perch" on twigs tangled among a few feathers and dried weeds—all of which economically allude to their natural habitat. An old clock with yellow weights, an image of a blonde baby girl in a red dress and white bib, and corks pierced by small utensils can also be discerned interspersed and half-concealed in the habitat. The subtle but intrusive presence of these cutouts and objects takes the scene through its Victorian evocations into another, more disquieting realm. What might have been merely charming or sentimental assumes an irrational guise. It is an aviary and something else as well.

This element of anxiety, generated by essentially benign images in mysterious juxtaposition, also comes from the way that Cornell packed the box. *Object* is visually dense, seemingly verging on the chaotic—an effect heightened by a glass front randomly stippled with white paint that obscures the view within. A formal device that accentuates the picture plane and reinforces the box's "objectness," this painterly gesture paradoxically contributes to the illusion that the box belongs, say, in the children's room of a public library as a cluttered nature display. *Object* might also be taken to repeat in miniature a thrift shop window casually piled with discards over the years. On the interior walls of the box, French phrases ("Hôtel du Géant," "Monte Carlo") and patches of German newsprint cast an international aura on *Object*, which remains unmistakably a product of industrial urban culture, be it New York, Paris, or Berlin.[4]

By 1941 Cornell had known Charles Henri Ford, Pavel Tchelitchew, and Parker Tyler for the better part of a decade. He would soon be urged to contribute to *View*, as he did in one of the early issues with a homage to Hedy Lamarr as an "Enchanted Wanderer" (see Fig. 62). From the start, Cornell had fancied himself an enchanted wanderer as well. A very early collage dating from 1931, untitled but known informally as "Schooner," shows a two-masted vessel whose aft sails have been replaced by a large

rose, whose inner petals harbor a spider in its web (see Fig. 70). The integration of flower and ship is masterful, rendering the juxtaposition all the more disparate and startling as a Surreal perception. Ships are traditionally female, an identity reinforced by the rose in the rigging, as though in her hair. At the same time, the vessel might not be a schooner but a hermaphrodite brig, its foremast square-rigged, its aft (partially concealed by the rose) offering hints of triangular schooner-rigging. (The spider in its web recalls, even as it displaces, Man Ray's 1929 photograph of a nude woman montaged on a spider's web.) The rose, with its connotations of birth, is disrupted by the spider, which lends an ominous air to what might have been a paradisaic image.

A lone figure rows out to the ship—what sort of pleasure cruise lies ahead? The image brings to mind Baudelaire's "Voyage," and in its disturbing overtone, Rimbaud's "Bateau Ivre"—the two French Symbolists having been precursors for Cornell and the Surrealists alike. Cornell the enchanted wanderer ranged far and wide through the geography of his boxes. That such voyages occurred close to home, nonetheless, was a paradox activated by the image hunter. *His* quest made these wanderings possible through assemblage on home ground after foraging in Manhattan. Cornell had few illusions about the hunt. His "chasseur d'images," as he also called Hedy Lamarr, was not entirely innocent. Hunting meant relentless pursuit, capture, and dismemberment of the quarry—not such a melodramatic inference insofar as Cornell felt constrained to cut up the images for collage and assemblage alike.

"Chasseur" also denotes a military rifleman, a signification made timely by the outbreak of European hostilities. In 1939 Cornell constructed *The Black Hunter*, an ominous image of a rifleman in triplicate, suggesting a firing squad (see Fig. 63). This repetition, however, was simply a projection of an earlier collage derived from an engraving of the French experimental photographer Etienne-Jules Marey "shooting" his instrument to record multiple exposures of moving objects—birds, for example, as in Cornell's *Habitat Group for a Shooting Gallery* (1943), replete with a shattered glass front. At the very least, the box serves as a grim reminder that habitats are both natural and artificial, that in standing for living creatures these birds might be stuffed, that the play targets of Times Square are a surrogate for live targets in the field.

Cornell's complexities have most often been relegated to the realm of

poetic allusion along an essentially benign, if not "innocent," horizon of the marvelous. Yet his sensibility embraced complexities that brought him closer to the Surrealists than we have imagined. To adjust our understanding, it is both necessary to recognize the strength of Breton's affirmations and to grasp the scope of Cornell's vision. While he managed "to let the poetry in and keep the revulsion out," as Dorothea Tanning wistfully noted in 1948, his restless gaze surveyed the world as poetry.[5] An ability to "embrace multitudes" in the manner of an earlier New York poet, Walt Whitman, allowed Cornell to transform the contradictions of experience in his assemblage, which reveal a moment that Breton called Surreal.[6]

Cornell's participation in the Surrealist quest for the marvelous did not, however, commit him to Surrealism. While his contacts with Surrealism, which extended back a decade to its Manhattan inauguration at Julien Levy's gallery, prepared him for the Surrealist orientation of *View* in the 1940s, Cornell felt a deep ambivalence toward the movement and its ideas as well as to the quality of Surrealist experience in which he himself became engaged. Consider, for example, a phrase which, taken out of context, suggests his nostalgia for Surrealism after the fact. He seemingly says as much in recalling a "revelation world of surrealism—a golden age—one of white magic without which I don't know where in the world I'd be today without it." [7] This exclamation occurs, however, in a complex narrative of fragments whose very sequence is broken, perhaps not to be retrieved except in its authenticity for the way that it falters. Though addressed to another person, most likely written (undated) to Julien Levy, Cornell's narrative also bears the characteristics of a meditation upon his past forays in Manhattan.

Writing as much for himself as anyone else, then, Cornell recalled an occasional "dream of the facades of lower B'way and the lofts housing the cutting up trade I used to solicit [that] evokes those times with a nightmarish but wondrous imagery and is tied to the gallery experiences" [Julien Levy's gallery?]. This urban experience, framed as a quest urged by Walt Whitman ("Now Voyager Sail thou forth to seek and find"),[8] is summarized as the "revelation world of surrealism," a world that evokes "nightmarish but wondrous imagery," a world that is shadowy and "sinister," with "images of such splendid terror," yet is worthy of being recalled for its "visions" and "illuminations." Even though Cornell underlined the "*re*creative force of the dream," he also realized that the experience is vir-

tually ineffable, requiring the "genius" of a Gérard de Nerval to communicate it.

Embedded in this diary entry, with its hesitations, phrases crossed out and rephrased, is the reference to Surrealism itself, creating a "golden age" for Cornell, a form of white magic that, he claimed, saved his life. Coagulating throughout these fragments are dream experiences, waking and sleeping, light and dark, past and present, raw experience remembered and filtered through literary sensibilities both French and American. That Cornell chose to associate Surrealism with "white magic" does not disguise the dark chaos of his original quest through lower Manhattan nor its powerful attraction lingering in retrospect. Though he exerted his memory here, its retrievals are cast in terms of dream and nightmare, both equally attractive, the basic stuff of Surrealism.

Cornell thus recognized that Surrealism was not simply a foreign movement that could be kept entirely at bay. It described both a sensibility and a range of experiences that were all too close to his own. There was limited consolation that others felt as he did, that he was not alone in a frightening world that drew him in like Pascal's "abyss." Having discovered a term that was both an avant-garde movement and a state of being, Cornell was drawn to its magnetic fields with his own alternating currents. He equivocated about Surrealism throughout his life, as a way of charging his own identity.[9] His was an ambivalence assiduously cultivated in order to proceed on his own terms. Ambivalence, then, became a sign of cultural health. Rejection of Surrealism would have closed off the most vital avant-garde movement of his day. Complete acceptance, risking subservience to Breton, might have led to a second-rate or second-hand Surrealism.

LIKE DUCHAMP's BRIDE, though himself a bachelor, Cornell engaged in an elaborate courtship with Surrealism without seeking consummation. And it was the independent Duchamp whom Cornell commended to Alfred Barr in 1936. His "constructions" were instances of "healthier possibilities than have been developed" within Surrealism.[10] At first glance, Cornell's alignment with Duchamp is puzzling. The Frenchman's games were never innocent, no matter how much Cornell may have appreciated his irony and wit. Had he seriously misunderstood Duchamp as a healthy alternative in the pursuit of Surrealism? "Health," after all, was not merely a metaphor for a positive outlook; it was a religious term with profound spir-

itual implications for Cornell, who had become a practicing Christian Scientist by the mid-1920s.[11]

Duchamp's erotic nihilism had little or nothing to do with Cornell's sensibility. Even Rrose Sélavy, the Frenchman's female alter-ego, would have had difficulties in seducing Cornell. Nowhere is this more evident than in *Poetry of Surrealism*, a collage that Cornell made in the 1930s, which poses an elegant, fashionable young woman within a decorative perfume jar.[12] The image recalls, by way of contrast, Duchamp's *Belle Haleine, Eau de Voilette,* an earlier bottle with Rrose Sélavy peering forth from the label (photographed by Man Ray in 1921). Cornell's model reaches to pull a cord that will then raise a butterfly to the red-bowed stopper. The charm of her improbable gesture plays vividly against the hilariously mordant image of Duchamp in drag on his assisted readymade.

The relationship between the two men gains clarification in Cornell's homage to Duchamp, which was published in the March 1945 Duchamp issue of *View.* This tribute also sheds light on Cornell's earlier homage to Ernst, who had been celebrated in the April 1942 issue of *View.* Cornell's gifts were not readily negotiable. What appears to have been a simple matter of influence that Ernst's collages exerted on a young Cornell was actually quite problematic, while Cornell's attraction to Duchamp, elusive in all aspects, helps to explain Cornell's development in the presence of Surrealism. The timing of *View* was propitious, for by the 1940s Cornell had gained sufficient confidence as an artist to acknowledge his debts. Yet it is an error to think of the 1930s as a decade of apprenticeship for Cornell. Debt, along with influence, hardly explains the subtle connections. At the same time, though he was self-taught, he did not belong among the American home-growns collected by Sidney Janis. It was Duchamp's indeterminacy that offered Cornell a key to his own independence.

Cornell's offering to Duchamp in *View* was a photomontage captioned "3/4 Bird's-Eye View of 'A Watch-Case for Marcel Duchamp'" (see Fig. 64).[13] The object, photographed and montaged in varying sizes, was a throwback to the small, circular pillboxes of the previous decade. In this instance, Cornell removed the cover to reveal the delicate intricacies of a watch with its face down. He had collaged the interior side walls and bottom of the case with French newsprint. Although this testimonial remains enigmatic, some of it can be delineated. Duchamp's elaborate titles and plans for *The Large Glass* are echoed in the caption. The watch gears al-

lude to his interest in machines, just as the photographic multiples suggest mass production. And as Levy, who owned a group of Cornell's tiny pillboxes, later surmised, the miniaturized object has its affinities with Duchamp's *Box in a Valise* (see Fig. 65), which Cornell helped to assemble once the Frenchman finally landed in Manhattan.[14]

Levy regarded Duchamp as his spiritual "godfather" for having taken him in hand and encouraged him to go to France in the late 1920s, but to claim Duchamp for Cornell as well suggests an influence far beyond mere imitation (difficult to discern in any case) or similarity of motif, as in the instance of the "watchcase." [15] Cornell instead kept his eye on Duchamp's readymades for the ideas they embodied regarding the nature of art. (In 1942 he visited Duchamp's small studio—"room a mess with debris"— where he was delighted to receive a readymade "done on [the] spot": a glue carton labeled "gimme strength.")[16] Cornell's originality derived from how he applied those ideas to his own work, collage and assemblage alike.

Duchamp's "assisted" readymades have been commonly taken as a logical starting point because they are assembled objects with motifs that Cornell would have found congenial. Thus *Apolinère Enameled* (1916–1917) was an advertisement for Sapolin paint that Duchamp turned into an "assisted" readymade by anagrammatically rephrasing the brand name to evoke the French poet. Cornell would have appreciated Duchamp's attempt to conjure the French Symbolist tradition in popular American culture, especially in an image of a little girl painting her bed.

Another assisted readymade, *With Hidden Noise* (1916), illustrated in the Duchamp issue of *View*, involves a ball of twine that contains a secret object (known only to Duchamp's patron, Walter Arensberg). It would have appealed not only to Cornell's sense of play (guessing games) but also his need for concealment that partially opened and closed boxes satisfied. With a title that echoes Duchamp's assisted chromo, *Pharmacie* (1914), Cornell had constructed a box in 1942 that contains glass vials of ephemera.[17] Their partial concealment in this "drugstore" also recalls the secret packaging of *With Hidden Noise*.

Cornell, however, incisively went to the heart of the readymade: its governing principle was to select an object that existed in its own right in the world and to modify it in some fashion as one's own presentation. Unlike the assisted readymades, Duchamp's first readymades involved minimal modification. *Bicycle Wheel* (1913), for example, was indeed a bicycle

wheel, removed with its fork from the frame and attached upside down on a stool. The notorious *Fountain*, entered in the 1917 Independents Exhibition in New York, was immediately recognized as a urinal despite its genteel title. The indeterminacy of these artifacts, decontextualized yet intractable, situated between cultural categories, had an immediate appeal for Cornell, who by his own admission was a hunter of images—readymade images that proliferated throughout an industrial society.[18]

Such multiple images—steel engravings, book illustrations, old Valentines, photographs, lithographs, advertisements—were readily borrowed and manipulated by Cornell to make collages that in many instances depart only in subtle ways from the original material. Similarly, a Cornell miniature does not merely imitate an object but often has its origin and identity with the object.[19] His "watchcase" for Duchamp thus utilized watch parts, so its container took on the appearance of a timepiece. As a result, the transformation of such objects is always indeterminate. On the bottom line, Cornell's signature was a Duchampian forgery. Its originality required a sleight of hand in creating objects with an illusion of authenticity based on the authenticity of illusion. Either/or disappeared in this magic of equivocation in his objects. But how would this equivocation play itself out in the art world of the 1930s?

"It was a dull afternoon in November, 1931, and a gray young man came into the gallery," as Julien Levy later recalled his first encounter with Joseph Cornell. Tall and thin, increasingly "gaunt" and even "cadaverous" by the 1940s, Cornell had been "haunting" the gallery when on this day he decided to show Levy some of his collages, among them one made of steel engravings that alluded to Lautréamont's umbrella/sewing machine motif from *The Chants of Maldoror*.[20] (It later appeared sanitized in the pages of *Harper's Bazaar*, presumably because of its sewing/fashion connection, which was akin to viewing Jack the Ripper as your friendly neighborhood butcher.)[21] Levy was in the process of crating works for the Surrealist show that was scheduled for the Wadsworth Atheneum, so the resemblance between Cornell's collages and those of Max Ernst was readily at hand.

The use of old steel engravings, the odd juxtapositions flawlessly joined, what more evidence was necessary for Levy? But unlike Arshile Gorky, who would soon concede being "with" Cezanne and then Picasso, Cornell would not admit to an apprenticeship to Ernst. In retrospect, Cor-

nell's disclaimer had the ring of inner conviction even though he reasoned along lines that he would not always follow. In their first conversation, Cornell told Levy that he was "disturbed" by Ernst. He sensed some "deviltry" in the images, whereas he wanted to perform "white magic" with his. Within the past year, Louis Aragon had made precisely such a distinction in referring (favorably, however) to the "black magic" of Ernst's collages.[22] As a practicing Christian Scientist, Cornell denied the existence of evil and so felt constrained by elliptical logic to filter Ernst's work through his own positive religious views.[23]

Taking the explanation of this strange young man at face value, Levy corralled Cornell for his New York Surrealist exhibition in January 1932, following its time in Hartford. Cornell designed the show's announcement, which depicted a boy trumpeting "surréalisme," the ornate letters about to be whimsically scattered to the winds. Wittily suited to the occasion, the image combined visual and verbal elements to herald Surrealism's embrace of written as well as graphic media. (The design would be used again on the cover of Levy's Surrealist anthology in 1936.) By the end of 1932 Levy would show Cornell's "Objects" in tandem with Picasso's etchings. Over the decade he would feature Cornell four times. Cornell was also included in the 1936 extravaganza at The Museum of Modern Art, then at Peggy Guggenheim's Art of This Century in 1942 and 1943, and in Sidney Janis's traveling exhibition of "Abstract and Surrealist Art in the United States" in 1944.

Despite these highly regarded venues, Cornell's work during the 1930s and well into the 1940s was but slowly assimilated into the art world. No doubt his exhibitions at Julien Levy's would have been sufficient to establish an ordinary artist, especially one working in a traditional medium, but these exhibitions were not of an ordinary sort. They appeared idiosyncratic because Cornell's assemblages defied ready categorization, bridging several disparate worlds. Collages and objects began in the home (once removed from the dustbins of Forty-second Street) and slowly moved into a network of art galleries, museums, and bookstores in New York. Because of their multiple identities, their transition was hardly negotiated with ease. Domestic entertainment, toys and games for children, toys for adults, gifts, artifacts of nostalgia, Valentines, Christmas cards, files, dossiers, collages, shadow boxes, découpages, boxes, miniature theaters, constructions, assemblages—the possibilities were metamorphic and vir-

tually endless for Cornell.[24] The world preferred an either/or chop logic for his objects, which nevertheless managed to sustain their ambiguous status among cultural categories.

As a consequence, the work was not described in ways that would gain them ready acceptance as art, serious or otherwise. Levy advertised Cornell's work as "objects" throughout the decade. The designation was not as neutral as it sounds. Caught up as he was in the work, Levy elaborated upon "objects" in 1932 by referring to "Minutiae, Glass Bells, Shadow Boxes, Coups D'Oeil, Jouets Surréalistes."[25] He needed a generic label, and "objects" was as good as any. Cornell was not much more helpful in 1943 when he designed an exhibition announcement with charming border cuts of shells, compasses, swans, parrots, and stars. Listed in different typeface were phrases consonant with the imagery, but unclear in meaning. Some phrases established categories of artifacts ("Medici Slot Machines," "Roses of the Wind," "Habitat Parrakeets") while others conveyed specific titles ("A Feathered Constellation [for Toumanova]," "American Rabbit").[26] Without foreknowledge, a gallery goer was bound to be mystified, at best captivated by the poetic quality of an announcement that failed to be sufficiently informative.

The ambiguity was compounded by the exhibitions themselves. In pairing Cornell with Picasso in 1932, Levy may have hoped that Picasso's name would be a drawing card for the unknown Cornell. But Picasso's etchings, like Toulouse-Lautrec's posters in a subsequent pairing, would do little to place Cornell's "objects" among the culturally established categories of art. Nor would Cornell fare any better in later being shown with Duchamp, who presented his *Box in a Valise*, or with Lawrence Vail, a former husband of Peggy Guggenheim, who collaged bottles! Such contexts failed to rub off, providing few clues for objects that eluded ready definition. In another way, such contexts may have rubbed off all too well, establishing Cornell's objects as idiosyncratic like Duchamp's *Box* or Vail's bottles. How would his work fare among the Surrealists?

EQUIVOCATION REACHED ITS GREATEST PITCH when Cornell's objects entered the magnetic fields of Surrealism in Manhattan. Only in a realm that denied art and related aesthetic considerations could Cornell's work be taken seriously and seen without cultural preconceptions. There were, however, some superficial, if not false, comparisons. Sidney Janis almost

got it right in 1944 when he claimed that Surrealism was "a way of life" for Cornell, not merely "an aesthetic" or a style, as it was for many American artists interested in Surrealism. Cornell, however, absorbed and digested the Surrealist ethos not by renouncing the aesthetic, but by seeking it in all aspects of his experience and relocating it in the art of his collages, assemblages, and boxes. Only through a contrary independence could he gain Breton's "pure Surrealist joy," which, the leader claimed, was reserved for "the man who...sets off from whatever point he chooses, along any other path save a reasonable one, and arrives wherever he can." Like Breton at the conclusion of the first *Manifesto*, Cornell knew that "existence is elsewhere." [27] It was to be found in the life of his objects derived from the aesthetic feeling discovered in unique moments of his life. Transference was everything (yet difficult for Cornell to sustain).

To locate Cornell's work as Surrealist was perhaps the most comprehensible category available, though it was an ironic alternative inasmuch as Surrealism itself was hardly accepted or understood at the time by the American public. In his 1936 anthology *Surrealism* Levy was aware of this situation in promoting Cornell as "one of the very few Americans at the present time who fully and creatively understands the surrealist viewpoint." At the same time, however, he lamented a "considerable misunderstanding of the surrealist point of view" and deplored "the numerous semi-surrealist efforts of the past few years" with their "superficial details." [28]

In an exhibition during the 1939 holiday season Parker Tyler turned Levy's Surrealist claims for Cornell to the realm of the child, who was presumably in touch with the unconscious in ways that adults had lost. Tyler asserted that Cornell made "creative toys...with all the power of Pandora's chest." His friend had become "master of the world as bilboquet," as Tyler picked up an image of the French toy printed on the exhibition announcement. He saved the best for last: Cornell "returns lost articles of the imagination." [29] Who could resist such prowess?

Early reviewers were quick to pick up the Surrealist angle. They assumed that Cornell's objects were somehow derived from his subconscious or unconscious. Following Tyler's lead, one reviewer proposed that "Cornell's subconscious is the conscious life of a child coated with an overlay of the years, the debris of adulthood forming the top crust." Still others preferred to concentrate on Cornell's work merely as "toys." As late as

1943, Cornell's exhibition at Levy's was described as "an adult playland." Cornell was thought "to make peep shows that rouse the play-and-putter instinct in adult breasts." Earlier, another critic was less condescending in describing a Cornell exhibition as "a holiday toy shop of art for sophisticated enjoyment and intriguing as well as amusing." [30] Since both exhibitions occurred during the Christmas season, reviewers had no reason to believe that they were engaged in metaphor instead of direct descriptions of gifts.

In point of fact, Cornell encouraged such views by cultivating the spirit of the child in his work. As late as 1948 he continued to design his exhibition announcements by scattering letters capriciously on a field strewn with cuts of bicyclists, soap-bubble pipes, and planets—as though the Futurists had liberated words so that Cornell might delight in playing with letters in the manner of whimsically scrambled alphabet blocks. In 1940 he collaborated with Charles Henri Ford on *ABC's*, a series of quatrains written "for the children of no one, who grows up to look like everyone's son." [31] Cornell's cover design again dispersed line engravings—a hand, a snake coiled around a woman's arm, a moon, an acrobat on a horse, a rosebush with a foundling, as well as birds and butterflies. This creation scene set a visual ambience for Ford's twenty-six quatrains, organized as an alphabet primer.

Despite such genuine affinities for the child, Cornell came to resent having his objects viewed as toys, and understandably so, because Levy was using the analogy as a marketing tool.[32] But given the nature of his early collages and the subsequent development of his work, Levy was certainly a logical venue for Cornell. For his first Surrealist exhibition in 1932, the dealer included some of Cornell's collages and an object titled *Glass Bell*. These works seemed to be at home not only with Ernst's collages but also with Man Ray's modified paperweights. As a portable object that fit the hand, *Glass Bell* had a format roughly similar to Man Ray's glass containers. And in proffering a hand and an eye (enveloped by a rose), *Glass Bell* bore iconographic affinities with Man Ray's *Boule de Neige*, which also contained an eye.[33]

Cornell revealed his Surrealist affinities in subsequent exhibitions. In The Museum of Modern Art's 1936 show, he lent a recent soap-bubble set, dismantled from its box for an extended display format. George Platt Lynes photographed it for the catalogue, where it was shown next to Ex-

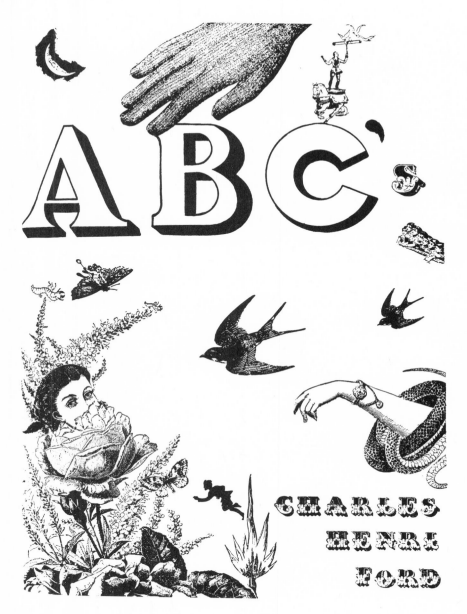

54. Joseph Cornell, cover for Charles Henri Ford, *ABCs* (Prairie City, Ill.: The Press of James A. Decker, 1940). Also published in *New Directions in Prose and Poetry 1940* (Norfolk, Conn.: New Directions, 1940), 315.

quisite Corpse collaborations. The juxtaposition had its own logic in that Cornell's set was thought to characterize a "Confrontation of Incongruities," obviously an essential Surrealist principle. Yet he was identified as an "American constructivist," which was another potentially confusing tag in its reference to the defunct Soviet avant-garde movement.[34]

Before the Modern's exhibition, Cornell became concerned about

some nonsense that was bruited about his work in *Harper's Bazaar*. In a letter to Alfred H. Barr, Jr., on November 13, 1936 he succinctly summarized the misrepresentation. "The article in 'Harper's Bazaar' said that I 'objectify' instead of paint," he began. Such a notion was innocuous enough until it was elaborated: "That if I dream of sticking a needle through a wooden ball, when I awake, that is what I do." The explanation, presumably offered by Levy in an interview, was an ingenious variation on Dali's "photographing" his dreams as they developed on his meticulously painted canvases.[35] Cornell's objects were thought to represent his dreams—not in the finished product but in the making itself! Cornell supposedly repeated the oneiric act of assemblage in his waking moments. Such dreams are boxes made of—an absurdity picked up by Henry McBride in claiming that Cornell "dreams well." [36]

To rebut an explanation that denied the art of his objects, Cornell went on to elaborate his views to Barr: "In the event that you are saying a word or two about my work in the catalogue I would appreciate your saying that I do not share in the subconscious and dream theories of the surrealists. While fervently admiring much of their work I have never been an official surrealist."[37] Barr, however, still included Cornell among the Surrealists in the biographical section of the catalogue rather than among "artists independent of the Dada-Surrealist movements," and Georges Hugnet, who wrote the essays on Dada and Surrealism, was not sufficiently familiar with Cornell's work to write about it. Under those circumstances, to label Cornell an "American constructivist" was probably a stroke of genius.

Levy had been careful not to say that Cornell was a Surrealist but rather an American who understood Surrealism. Cornell in turn was correct in disclaiming an official status as a Surrealist despite "fervent" admiration. He had never made a pilgrimage to Paris, and Breton would never initiate him into the group—not even during his sojourn to New York during the war. (In his essay for Peggy Guggenheim's *Art of This Century*, Breton would tersely concede that Cornell had "evolved an experiment that completely reverses the conventional usage to which objects are put," but that was the closest the Surrealist leader would come to endorsing him.)[38] Levy, however, was quoted as claiming that Cornell was "more surrealist than the surrealists themselves in so far as his objects derive from a pure subconscious poetry unmixed with any attempt to shock or

surprise."[39] Here again was the innocent Cornell, who like a child could plumb the depths of a "pure" unconscious for a visual poetry of benevolence. Cornell's public presentation, then, overlooked or suppressed the dark implications of his work.

DESPITE THE CLAIMS OF THE CRITICS and his friends alike, Cornell's work was hardly innocent. His homage to Ernst was not without its own deviltry. Published in the April 1942 issue of *View* that was dedicated to Ernst, *Story without a Name—for Max Ernst* was not substantially different from Ernst's collage novels, which Cornell had seen: *The Hundred Headless Woman* (1929) and *A Little Girl Dreams of Taking the Veil* (1930)—and later, *Une Semaine de Bonté* (1934). Ernst's visual novels are full of sex, violence, and cruelty. His oneiric juxtapositions are most often bizarre and incongruous, startling if not shocking. Irrationality reigns throughout his narratives. While Cornell's sixteen collages in homage, made during the 1930s, do not match Ernst's in sexual intensity, they are not without the spectacle of violence in offering a series of natural and manmade disasters: snowstorms, thunderstorms, shipwrecks, and conflagrations energize these visual melodramas (see Fig. 66).

Pressed by Parker Tyler to contribute to *View* in its early issues, Cornell demurred, though he mentioned in passing some collages "in the Ernst manner," an acknowledgment that suggests his growing confidence as an artist over the previous decade.[40] "Manner" is sufficiently ambiguous to include formal similarities and more. Thus Cornell's homage was not simply a sign of his own technical proficiency, a way of showing the world that he could cut collage on par with Ernst, for that would stress technique at the expense of sensibility. If Cornell tested his skills at découpage on steel engravings, he was also willing to turn his scissors on Ernst's visual sources as well as on Victorian valentines.[41] There was a profound attraction to motif and sensibility in addition to the possibilities of technique. In a climate demanding avant-garde originality, Cornell undertook his homage to Ernst without fear of subordination, and sublimely indifferent to insubordination. He was willing to go public despite Levy's initial reservations because he was confident from the very beginning that his collages were not mere pastiches. Neither imitations nor displacements, his collages simply took their indeterminate place next to Ernst's.

Cornell's confidence in risking anomalous Ernst-not-Ernsts derived

from an awareness of what he could do by way of white magic. Some of his collages make overt reference to the apparatus of stage magicians, as in an image of a young man seated amidst suspended plates and bottles—at second glance even his head floats on a platter (see Fig. 68). Others work their magic in a more covert fashion. *Snow Maiden* (strictly speaking, a "shadow box" rather than a flat collage) verges on the sentimental, as it draws upon the saccharine imagery of Victorian Christmas cards. At the same time, however, this angelic child stands in the shadow of Hawthorne's short story, in which the snow maiden is allowed to melt by adult neglect and insensitivity. Will Cornell's snow maiden be rescued? In a related collage, involving doves at a window that frames a winter scene, Cornell set the tranquil night against a child painfully exposed to the cold and the snow (see Fig. 67). Similarly, in another collage a dancing bear with its teeth bared rises up against its precariously balanced young trainer. Despite the genuine charm of these vignettes, Cornell rendered his children vulnerable to nature and its dangers.

Nevertheless, Cornell is best remembered for conjuring convincing illusions of childhood innocence. *Panorama* (1934), for example, mimics a paper amusement that unfolds like an accordion to reveal a series of bears in bright colors, reminiscent of alphabet blocks (see Fig. 69). But in a reversal of an alphabet book, where an image illustrates a letter, short verbal tags here defer to the imagery. Several cutout bears soar through the sixteen panels. A bear on a fan (made out of a planetary map) is released by hand to "dance over fire and water": the bear as constellation, *Ursis Minor* miniaturized, completes its odyssey by returning to the bowl of the big dipper. Cornell has exercised white magic at its most delightful.

At the same time, however, Cornell could also convey the terrors of childhood. In an early collage comprised of steel engravings (undated), he once again took the animals of childhood, tigers along with bears, and placed them in the familiar, even domestic, milieu of the zoo, ever a favorite of children (see Fig. 71). Tigers and bears in a cage, but with a difference. Seeing these animals behind bars in the background provides small comfort against their ferocity as they growl and lunge out of the darkness. Their menace is heightened by the claustrophobia of the middle ground, where a mother holds her swathed baby sucking its thumb. A top-hatted doctor (a patriarchal figure) vaccinates the baby while staring at an adolescent girl who tugs at a rope. In the foreground a dog watches these

incongruities intently, as a cat ignores the action while holding a corkscrew in its paws to open a bottle of wine.

Further complications come from two young boys, who also tug at ropes that triangulate the mise-en-scène, but in no logical way. The boys seem to be aided by a uniformed man with a bored expression on his face. At the center is an antagonist who lunges at the family group and reiterates in reverse the looming figure of the central bear. Struggle and restraint to the point of bondage are clearly powerful forces animating the group. Isolation and alienation pervade the nuclear family even as it is threatened by violence hardly under control.

The differences between this tension-laden scene and the foldout of bears could not be more stark. Yet who is to say that the delight sparked by the celestial bears isn't an adult's delight, that the terror provoked by adults and caged animals alike isn't a child's terror? Cornell's visions of childhood covered a wide range of possibilities, from idyllic frolic and unabashed sentimentality to hellish anxiety. No wonder, then, that his Edenic collage for the cover of Ford's *ABC's* included a snake. He obviously read Ford's quatrains, which move from A to Z, from demons to garbage, a child's alphabet forgotten by adults yet redeemed by Ford.

Such horrors, held in suspension by Cornell's white magic, are symptomatic of covert sexual tensions that run throughout his collages of the 1930s. His two collages based on an allusion to Lautréamont thus dramatize the creative issues animating the quest of the "enchanted wanderer" delineated by the "Schooner" collage. The frank sexual brutality of *The Chants,* openly exploited by Man Ray, was muted by Cornell, to the extent that *Harper's Bazaar* was willing to publish two related illustrations for their "innocent" Victorian air. Careful examination, however, reveals sexual dissonances no less disturbing for their visual disguises than, say, Ernst's overt sexual violence. Cornell's transmutation of dark imagery finally occurs not in a sentimental discharge echoing the hackneyed perils of Pauline but in a troubled statement about the art of collage itself, the quest that Cornell had embarked upon (see Fig. 72).

The sewing machine, its armature at a diagonal, has been partially dismantled. The plate at its foot (which holds the needle and thread) has been set to one side so that the machine can be oiled. An oilcan and a screwdriver remain on the table, as does a plaited length of cloth to which a pleated strip is partially sewn. Faintly engraved in the background is a

row of factory women at their sewing machines. To this basic image Cornell added but few elements. He glued a magnolia to the wheel of the sewing machine, a partially opened ear of corn to the cloth, and the bust of a woman to the cloth, thereby transformed into a gown worn by a woman now prone on the sewing-machine table.

At this point, the allusion to Lautréamont's sewing machine and umbrella on a dissecting table surfaces. The women sewing in the background are transformed into a woman being sewn in the foreground. The sexual implications of the collaged image can then hardly be ignored. The threat of rape is superseded by the sexual reversals of the constituent imagery. The masculine armature is positioned near the woman's genital region, while her elongated body passes through the arc of the armature. The sewing machine becomes androgynous by virtue of the voluptuous magnolia and its pendant seeds. The ear of corn is strategically placed at the juncture where the two strips of cloth are being sewn. The partially shucked ear is both phallic and vaginal (with teeth suggested by the exposed kernels). Whereas Lautréamont's imagery involved homoerotic aggression, Cornell's verges on sexual suppression, since the almost sewn female takes on the appearance of a mermaid, all the more seductive for her inaccessibility.

Because the sewing machine is partially dismantled, the woman is able to stay the foot of the machine with her arm and hand as she points to the ear of corn. Despite the veiled threat of male violence and rape, she appears calm, hardly terrified by her predicament. Willing self-sacrifice and auto-eroticism are reciprocal possibilities in an image that becomes self-referential. It offers a series of ambiguous sexual inversions with metaphoric resonance for the process of collage, involving the act of cutting, destroying readymade images, dissecting them, to make new composites, "stitching" them together. Masculine violence and feminine creation are joined together in the androgynous act of cutting and pasting, making collage, a new image out of old images. The seamlessness of collage is revealed as an illusion, for a collage is never without seams, no matter how they are disguised. Seams devolve to seems, as appearance and reality become problematic in Cornell's collage.

CORNELL'S QUEST finally coincided with Ford's desire to distance himself from the dominance of Breton. The editor of *View* asked Cornell to help

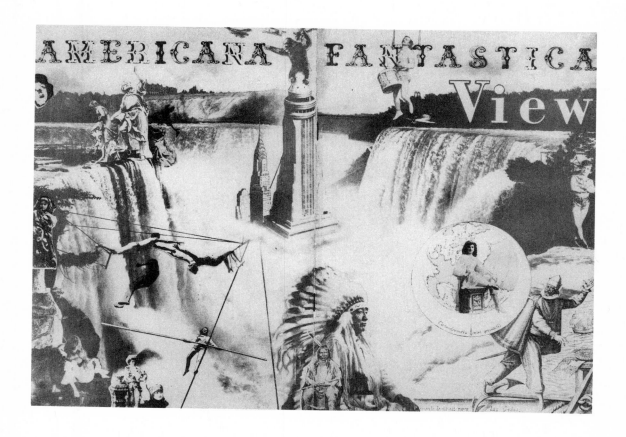

design an issue on "Americana Fantastica." The phrase served to stress the New World while suppressing Surrealism in favor of the fantastic, an allied though traditional term. Published in January 1943, this issue of *View* came on the heels of "First Papers of Surrealism," Breton's only Surrealist exhibition in New York. In its attempt to be ecumenical, the catalogue included a short essay by Robert Allerton Parker, who traced an American tradition of "native eccentrics," ranging from Cotton Mather (citing his *Wonders of the Invisible World*) and Mother Ann Lee of the Shakers to Edgar Allan Poe and Father Divine.[42]

Ford took up Parker's challenge "to make our own discoveries of significant eccentrics." [43] By endorsing "Americana Fantastica," he would distance his magazine from Surrealism while broadening its possibilities. At the same time, in a masterful discourse on the subject, Tyler implicitly made his own challenge to Breton. Though he occasionally strained at paradox, he managed to strike the right note in his introductory piece.

55. Joseph Cornell, cover for Americana Fantastica issue of *View*, ser. II, no. 4 (January 1943).

"The fantastic is never exotic," he claimed, here echoing Breton's insight that "there is only the real," yet with the wicked proviso, "Having no home but its own, it cannot be transplanted without transplanting the soil in which it grows." [44] Could French Surrealism survive in the American climate without its own soil?

French soil blended with the American terrain, or American soil made French Surreal—in either case the turf of *View* offered examples of the fantastic "not so much indigenous to America as susceptible to it." [45] That the fantastic transcended national borders was a commonplace borne throughout the issue, down to minor detail. (Advertising "Americana Fantastica," the Gotham Book Mart listed *Les Jouets à la World's Fair*, a French publication about toys displayed at the St. Louis World's Fair of 1904 that would have clearly appealed to Cornell.) [46] Yet such a commonplace also hinted at the disturbing possibility that Breton and company had not yet managed to transplant Surrealism during their exile.

Tyler's critique was low-key, though increasingly pointed. He claimed that "the fantastic is unique in that it does not generate its individual species, it does not hope to duplicate itself by immediate progeny." Here was another commonplace that Tyler turned on the overbearing Breton. "Only methodologies of the fantastic have this logic of generation," he argued, "by which they hope to become the rule rather than the exception." He implicitly aligned Breton with "methodologies," in the exercise of which "the tyrannies of the father and the schoolteacher can appear all too easily and become, if not a fantasy, at least a spectacle." [47] Breton the tyrannical father clearly expected disciples if not progeny, a desire that Tyler understood as counterproductive.

By way of contrast, Tyler identified the fantastic with "the secret of a spontaneous combustion." Its unexpected explosions invited violence along with the monstrous against the deadly order of "the academy, the police or God." Tyler balked at Breton's recent call for new mythologies because he saw them as "orderly" and hence incapable of fantasy. Most crucially, Tyler located the fantastic on the political margin. "It is definable," he claimed, "as the imagination of the underprivileged aware of a fresh and overpowering strength." For Tyler, "the fantastic is the inalienable property of the untutored, the oppressed, the insane, the anarchic, and the amateur, at the moment when these feel the apocalyptic hug of contraries." [48] By signing over Breton's moment of the Surreal to the politi-

cally dispossessed, Tyler was arguing that the fantastic had nothing to do with escapism.

Those who had followed *View* carefully would not have been surprised by Ford's quiet declaration of independence. With the publication of Alva N. Turner's lunar narrative ("A Manuscript Found in an Iceberg"), Ford had certainly found a marginal writer, but one who had come highly recommended a year before by William Carlos Williams. With an ode "To Billy, The Cat That Came Back" to accompany Gertrude Cato's painting, Turner had shown all the proper qualifications. The doctor had identified him as a writer-turned-house painter with a history of insanity brought on by frustration. Best of all, the ever-ambivalent Williams championed Turner as the true goods. "Dear Ford," he wrote, "All you literary guys! Phooie! Here's real American Surrealism." [49]

Designing an issue of *View* devoted to "Americana Fantastica," then, was just the ticket for Cornell, who could lay claim as one of the chief architects of *View*'s independence from the Surrealists. At the center of this issue was a curious work that Cornell titled "The Crystal Cage." A mélange of elements, ranging from photographs to collage, from a visual image comprised of words that echoed Apollinaire's calligrammes to verbal fragments, "The Crystal Cage" was a portfolio that was intended to be available soon in facsimile, along with "original material and notes." Such a format, though never executed, followed Duchamp's *Box in a Valise*. [50]

Other affinities with Duchamp are readily discernible. Cornell subordinated the visual to the verbal and hence to the cerebral in "The Crystal Cage," its title a glancing allusion to *The Large Glass*. Their most important affinity, however, lies in open-endedness. Whereas Duchamp refused to complete his work, allowing it to remain "a delay in glass," Cornell was an avaricious hunter of images, on a never-ending quest. Though a box might be filled to the brim, emptied and then refilled, a portfolio seemed to have infinite capacity for expansion. "The Crystal Cage" appeared as an ongoing project, capable of offering an inexhaustible supply of "original material" even in facsimile. In his additive "research" without closure, Cornell hearkened back to the Surrealists and their "bureau de recherche" in the 1920s.

Most crucially, open-endedness precludes system or systematic thought. [51] Despite its referential impulses, "The Crystal Cage" is not allegorical but rather irradiates nuance and allusion. In discharging these

connotations to Symbolist effect, Cornell nonetheless remained true to Surrealism by avoiding one-to-one meanings. Early in the 1924 *Manifesto* Breton had rightly insisted upon the literal meaning of fantastic imagery, although even he sometimes had difficulty in resisting Freudian decodings of enigmatic images—as did some Americans. Cornell alone consistently maintained the enigma and its reality against interpretation. As he noted in 1944 for *Abstract and Surrealist Art in America,* "It is too difficult to get into words what I feel about the 'objects' "—a sentiment that extends to the verbal portfolios as well.[52] In providing a "key" to a collage included in "The Crystal Cage," for example, Cornell simply identified images by name and place, not according to their symbolic meaning.

Involving retrieval from the past into the present, Cornell's research redoubled itself as an activity essential for the gathering of material and then was re-presented as a fiction integral to the portfolio. "The Crystal Cage" is not a hoax, the reader is reassured, but Cornell's own form of Surrealist archaeology, an "unearthing" that "finally establishes beyond any possibility of doubt the existence of the legendary PAGODE DE CHANTELOUP." The "Crystal Cage" itself, we further learn, was an eighteenth-century French pagoda, an "abandoned chinoiserie" so loved by Berenice, "an American child," that her parents transplanted it from France to their "native New England meadows." [53] By Tyler's argument, the survival of this fantastic architecture would depend upon Cornell's success in providing a blend of its own culture with the New World.

Before a photograph of the "Crystal Cage" appears in the sequence of the portfolio that Cornell set forth in the pages of *View,* we are made privy to a verbal collage, configured visually, a tower of Babel dedicated to the fantastic, blending American and European derivatives.[54] Cornell's catalogue flows undifferentiated by punctuation, like an electric sign in Times Square, cut off only by the shape of the tower. The photograph itself serves in much the same way as the photographs in Breton's account of Nadja, which provide empirical verification of the Surrealist's wanderings through Paris and chance encounters with this mysterious (and disturbed) woman.

On the face of it, however, Cornell's choice of Berenice as his heroine for this tower is far removed from Nadja. This little girl enjoys an idyllic childhood in her tower, innocently creating "miracles of ingenuity and poetry." Elsewhere Cornell includes excerpts from letters (perhaps fictive)

The Crystal Cage

56. Joseph Cornell, "The Crystal Cage (portrait of Berenice)," *View*, ser. II, no. 4 (January 1943): 11.

describing his encounters with Berenice on "the north shore of Long Island" and then glimpsed in a tenement window while on a passing elevated train. In each instance, the vignette released endless transformations. The first reminds Cornell of Hawthorne's "Snow Image" while the second recalls Berenice, "leaving a scattering of star-dust in her train"—effecting another transformation in his image of the ballerina Tamara Toumanova, which accompanied Ford's charming poetic "Ballet" for her in the same issue of *View*.[55]

This innocent Berenice takes her penultimate incarnation as a little girl photographed at the turn of the century peering into a darkened window ("gazing into her own past and future").[56] Cornell's heroine has, however, an ominous history fabricated by Edgar Allan Poe in "Berenice," a short story titled after an unfortunate protagonist who ends up murdered and violated. While the calligrammatic pagoda refers to Poe and "Israfel," his ode to an angelic muse, Cornell also included as a companion piece a separate homage to Poe in "Americana Fantastica." [57]

Cornell's dark still life commemorating Poe, comprised of an open French book covered with debris and illumined by a candle, bears an enigmatic caption: "Spent Meteor / Night of Feb. 10, 1843 / (For E. A. Poe) / J.C." This "haunted" Poe conforms more obviously with an American lineage of the fantastic than the idealizing Poe of "Israfel," seeking supernal beauty. *This* Poe, we might surmise, was Cornell's Poe, though the choice remains indeterminate. A "spent meteor" teases out an allusion to Poe's story "Ligeia," in which the narrator, grieving for the dead Ligeia, strains to remember and understand the expression in her eyes. Yet the effort, always beyond his grasp, is echoed, he claims, "in the falling of a meteor," among other (Cornellian) phenomena. With her "immense" learning, Ligeia can be taken as Berenice's dark sister, sexually aware and passionately iron-willed in her transcendental investigations, to such an extent that she returns from the grave claiming the body of the narrator's second wife![58]

The stakes are raised even higher for Cornell in Poe's "Berenice." This heroine resembles Cornell's in her innocence; however, the story's narrator is learned but clearly in an unhealthy fashion. Berenice loves the out-of-doors, while her cousin remains sequestered in his claustrophobic library, supposedly a "palace of the imagination" (like the crystal cage), the place of his birth and his mother's death. At the "noon of manhood"

the narrator remains "stagnated" in his library, preoccupied by the "wild dominions of monastic thought and erudition," implying a chaste relationship with Berenice, whom he has married.[59]

Ultimately self-preoccupied, the narrator comes to understand that a fatal inversion has occurred: "The realities of the world affected me as visions, and as visions only, while the wild ideas of the land of dreams became, in turn—not the material of my every-day existence—but in very deed that existence utterly and solely in itself." [60] At first glance, this inversion bears all the earmarks of Surrealism, but closer inspection reveals that it more accurately characterizes the transcendental tenets of Christian Science. The story becomes a devastating critique of such spiritualism.

Berenice becomes epileptic and gradually wastes away. The narrator contracts his own mental disease that results in unpredictable fixations—a "nervous intensity of interest" that consumes the narrator's consciousness. In a grotesque turn, he develops a fixation on Berenice's teeth! Upon her death (actually an epileptic seizure) and mistaken burial, he disinters and violates her for her teeth while in a trance of his own.

The story might be dismissed as gothic pornography were it not for the narrator's metaphysical speculations that invest the action with a series of conceptual equations and transformations. By virtue of his seclusion in the library, reality became "wild ideas." With his fixation on Berenice's teeth, the narrator came to believe that her teeth were ideas (that he might possess). Metonymic displacement suggests that such possession was a way of possessing Berenice (and avoiding castration). Confessing after the fact, the narrator realizes that these equations were an "idiotic thought" leading to his destruction.[61]

Logically, then, and Poe's narrators are nothing if not logical, the equation is erased: teeth are teeth once again. This cautionary subtext against the dangers of transcendental speculation must have had a shocking resonance for Cornell in its gruesome conclusion. Gradually realizing what he has done while in a trance, the narrator grasps a "little box" on his desk. It "burst into pieces," scattering Berenice's teeth on the floor.[62] The box, her coffin, the library chamber: Cornell's boxes, the crystal cage: what explosions were in store for Cornell?

Cornell must have sensed that he was playing dangerous games. Poe's "Berenice" was not a mere allusion among many in "The Crystal Cage." Cornell had entered into a dialogue with Poe, whom he recognized

as a formidable critic of his own spiritual orientation. Berenice and the crystal cage were Cornell's attempt to respond to Poe with his own affirmative transformations. The effort was not, however, a repression, for Poe surfaces in the words making up the pagoda. Berenice was intended to displace Poe's heroine, though the two remain twins. While as one critic has suggested, Berenice may be the daughter that Cornell never had, Poe's Berenice may be the wife that the story's narrator sought to spiritually possess.[63] And in possession, Berenices deux may be female projections of a self that Cornell needed to acknowledge in the making of his assemblage. With this "apocalyptic hug of contraries," as Tyler put it, Cornell stood at the heart of Americana Fantastica in its challenge to Surrealism.

A Boatload of Madmen

Arshile Gorky's Ethnicity and Surrealism

With Gorky one can understand how art is neither invention nor imitation but primarily an assertion of existence.

—Nicolas Calas, BLOODFLAMES, 1947

A rshile Gorky was approaching the height of his powers as a painter when he unraveled his American life at the end of a rope. He committed suicide in a small shed behind his home in Sherman, Connecticut, on July 21, 1948. The causes of his suicide are readily apparent. In 1946 his studio in Sherman had burned to the ground. Some three dozen paintings and drawings were lost, a disaster soon followed by a colostomy for cancer. It is not clear that he would have recovered. In 1948 his pain was compounded by a car accident—he was with his dealer Julien Levy—in which he suffered a broken neck and a paralyzed right arm, his painting arm. Domestic tensions mounted. Taking their two daughters, his wife Agnes left Gorky for her parents' home in Virginia. A few days later Gorky hanged himself. His neighbors Malcolm Cowley and Peter Blume discovered his body along with a note scrawled in chalk on a packing crate, "Goodbye My Loveds." [1]

Calas's comments for "Bloodflames," a 1947 exhibition of a Surreal-

57. Arshile Gorky, drawing (front)
for André Breton, *Young Cherry
Trees Secured Against Hares*
(Metuchen, N. J.: Van Vechten
Press, 1946). *Photograph courtesy
Library of J. Paul Getty Museum,
Malibu, California.*

58. Arshile Gorky, drawing (rear)
for *Young Cherry Trees Secured
Against Hares* (Metuchen, N. J.:
Van Vechten Press, 1946).
*Photograph courtesy Library of
J. Paul Getty Museum, Malibu,
California.*

ist-oriented group at the Hugo Gallery in New York, suggest that he sensed the increasing intensity of Gorky's life, but he could not have known how much of a struggle it would become, or how much Gorky had struggled throughout his life. Writing to his young nephew Karlen Moora-dian in May 1947, Gorky identified the "secret of creativity" with Armen-ian history: "The secret is to throw yourself into the water of life again and again, not to hang back, no reservations, risk everything, but above all strike out boldly with all you have." [2] Virtually rendered invisible as a trope by his passion, the metaphor of water—entailing the risk of drown-ing, along with the wash and flow of painterly redemption—was finally abandoned a year later as he grasped for the rope.

About a year and a half before his suicide, Gorky broke with the Sur-realists, Breton having taken him into the fold after they had met at a din-ner during the winter of 1944. In a letter to his sister Vartoosh Mooradian in January 1947, Gorky averred that Surrealism, "despite its claim of lib-eration is really restrictive because of its narrow rigidity." [3] The charge might seem familiar in light of Breton's overbearing leadership. Yet Gorky was not one to be intimidated by a charismatic personality. Only a few months had gone by since he had done two line drawings that open and close Breton's poems in *Young Cherry Trees Secured Against Hares*, pub-lished by Ford's View Editions. Breton himself had enthusiastically taken up Gorky as the latest Surrealist painter and was reported to be "unequiv-ocal" in his endorsement.[4] Moreover, the business of art (such as it was) was not disrupted. Gorky continued to exhibit with Julien Levy, who re-mained the preeminent Surrealist dealer in New York, and he participated in "Le Surréalisme en 1947," organized by Breton and Duchamp at the Gallerie Maeght in Paris.

In his letter to Vartoosh, Gorky finally complained that the Surreal-ists were not "earnest" about painting: "Art must be serious," he argued, in dismissing the Surrealists as mere "players." During the 1930s Stuart Davis had used virtually the same language against Gorky, who persisted in devoting himself to the formal issues of painting instead of giving prior-ity to political and social problems. What had Gorky now discovered that made the Surrealists in turn frivolous? For Gorky, the seriousness of art had to do with ethnicity: "We do not think alike since their views on life differ so vastly from mine and we are naturally of opposite back-grounds....Perhaps it is because I am an Armenian and they are not." [5]

Gorky's stress upon his ethnic identity was not a new-found concern but rather one that had preoccupied him since his immigration to the United States. At this juncture, however, he felt his own mortality and was considering a return to his given name, Vosdanik Adoian, even though his assimilation into the ranks of Surrealism implied a renunciation of nationality, which was anathema to Breton as it had been to the Dadaists before him.[6] For Breton, Surrealism was international in scope; that it survived the war testified not only to its resilience but to its international character: Surrealism transcended nations.

From Breton's point of view, Gorky's ethnicity had little relevance. The Frenchman's unwillingness to learn English during his New York exile served notice that there was no doubt about whose ethnicity was to take priority. Steeped as he was in his own past, however, Gorky was not about to submit to Breton's heritage.[7] Gorky's interest in French painters had to do with a passion for painting—not with their national origin. Hence his enthusiasm for Paul Cézanne and Picasso during the 1930s, and into the next decade an equal enthusiasm for Miró, Wassily Kandinsky, and Matta.

For avant-garde artists in New York, modernism in its various guises claimed priority, not ethnicity—unless one were viewed as "primitive," as in Max Ernst's interest in Native American arts of the Southwest or Wolfgang Paalen's in the Northwest.[8] Nevertheless, Gorky's Armenian identity had everything to do with his painting. His avant-garde identity intimately drew upon his ethnic sense of self, which was necessarily shaped by his American immigrant experience. At the same time, the Surrealists in New York played an important role in hastening Gorky's slow gestation as an original painter, more than two decades after his forced migration. Despite his eventual disaffection, Surrealism paradoxically allowed him to explore fully an Armenian life that was forever beyond his grasp. At the same time, his connections and disconnections with Surrealism can be understood only in light of his own emerging accommodation of ethnicity and avant-garde painting, which he brought to bear upon the Surrealist experience in Manhattan during the Second World War. Gorky's paintings trace his agonized yet lyric triumph.

VOSDANIK ADOIAN LANDED at Ellis Island on February 26, 1920. He was almost sixteen. Three days after his arrival he and his younger sister Var-

toosh were reunited with a married half-sister in Watertown, Massachusetts. The following month Vosdanik went to Providence, Rhode Island, and lived briefly with his father, Sedrak, whom he had not seen since 1908. Vosdanik's introduction to American society was hardly different from that of thousands of immigrants during the early twentieth century. He was perhaps more fortunate than many in having some remnants of family awaiting him. Could they heal the trauma of dislocation caused by the Turkish genocide of the Armenian people? Despite the reunion with his father, Vosdanik profoundly missed his mother, who even in death remained at the center of his life.

In 1925 Vosdanik changed his name—not an uncommon act for immigrants, one that often occurred involuntarily at Ellis Island. Vosdanik's self-transformation was not calculated with assimilation in mind—not at first glance. He chose the name "Arshile Gorky," taking the surname from the Russian writer and his given name most likely from Arshak, an ancient Armenian king. "Arshile Gorky" was hardly Anglo-Saxon, but it had a familiar exoticism to it. Some Americans might recognize the literary allusion, whereas "Vosdanik Adoian" would have been completely alien to them. Gorky was willing to capitalize on his chosen namesake. In an early interview he spoke of his cousin Maxim.[9]

Gorky's disguise suggests the complexity of his Armenian identity. Despite this gesture toward a new persona Gorky was in many ways an unmeltable ethnic. He clearly viewed himself as an Armenian in exile. At times he played the professional Armenian, as in a snapshot of him dancing with a handkerchief at a party. Despite the amused, perhaps embarrassed, certainly condescending, expression of the woman off to one side at the back of the room, Gorky continued to dance, a gleam in his eye, ostensibly oblivious to the scene he was creating, yet knowing that he was the center of attention, willing to make a spectacle of himself: a genuine exotic enlivening a provincial New York party. Gorky stood in contrast to those immigrants who seek to make themselves invisible through assimilation.

Gorky himself recognized that "an Armenian in America is indeed a strange creature," though he may not have grasped the full depth of his dilemma: Gorky lived in American culture but was not of it; he was of Armenian culture but hardly in it.[10] This situation created conflicts and contradictions, with an ambivalence that Gorky could not readily resolve. The

painter's own behavior was thus inconsistent. Even though he could not fully restore his ethnicity, he rejected many opportunities to keep assimilation at bay. Instead of retaining his given name and immersing himself in Armenian Watertown, he took an exotic name and chose to live among artists in New York. Indeed, his descent upon Greenwich Village from Boston in 1925 was a bold move that ran counter to the conservative desire of most Armenian immigrants to keep their clans intact in the New World.[11]

That Gorky did not entirely resist assimilation suggests that he gave priority to another agenda—a course that did not reduce the tensions he felt. He had made a fundamental commitment to modern art. To the extent that he had an American community he found it in Greenwich Village with other artists of avant-garde inclinations. Though he admired the thirteenth-century Armenian painter Toros Roslin, whose reproductions in New York were no less available than those of Cézanne and Picasso for someone as avid as Gorky, he resolved to study intensively the French modernists as a way of eventually arriving at his own art. Cézanne was a logical starting point for Gorky inasmuch as the French painter had become a central figure among New York's vanguard, especially painters in the Stieglitz circle.[12]

Gorky's attention, however, was so far from casual, indeed, so openly committed, that it took on the appearance of an apprenticeship. Such a prolonged practice seems at odds with the entire idea of the avant-garde, with its espousal of innovation.[13] Yet his studies become explicable in light of his immigrant status. As a recent arrival and beginning painter (essentially self-taught), Gorky needed to find his artistic bearings in the New World. Since there were few American masters, he turned to European painters and astutely identified for himself a tradition of the new (to borrow Harold Rosenberg's apt phrase). Gorky's studies suited someone who desired the weight of tradition once he was bereft of the immediacy of his own Armenian heritage.

At the same time, however, Gorky was not completely stripped of Armenian culture. Though he chose not to keep in close touch with his heritage through living in an Armenian community, he still remembered much of his own childhood. Memory provides connections between tradition and an individual talent. A person sometimes remembers genuinely unique experiences, but most often memories of experiences have been

shaped and preserved, formalized and transmitted through one's social peers who share a culture. Thus Gorky's memories of his Armenian boyhood centered upon a wide range of customs and traditions. Prominent among them were the stories told by his elders. Like many preindustrial societies, Armenia enjoyed a rich tradition of folk tales, songs, and poems. Gorky inherited what the critic Walter Ong has called a "mindset of primary orality." [14]

Although there were traveling storytellers called *ashugh,* storytelling was a common form of entertainment, carried on by men and women alike. One of Gorky's cousins, who remained behind in Soviet Armenia, has described a typical domestic scene:

> Every evening we sat around the warm tondir [a central hearth] with the elders who drank special Armenian coffee. And someone usually told a story or related history and, during the orations, my grandmother would return from the storehouse with dried apricots, very sweet dried plums, pears and apples. And supplied with those wonderful foods, we young and old alike listened for hours to the histories, legends and tales of ancient times, about the great heroic warriors of Armenia. [15]

Even though this scene might be idealized, the idyllic image of an extended Armenian family sitting by a warm hearth, eating, and telling stories on a cold winter evening, endured in Gorky's memory.

This image was all the more powerful because it suggested a haven against those outside forces that were to bring hunger and death. Gorky's idyll was disrupted in 1908, when his father fled Khorkom for the United States, to avoid the Turkish military draft. His wife, Shushanik, remained behind with three children. She felt constrained to leave her husband's home in 1910 and sought living quarters for her small family in the nearby city of Van. In the evenings she continued to gather her children for a ritual of stories and prayer as a stay against their unsettled existence. With the outbreak of the First World War and the resumption of the Turkish massacres in 1915, Van was besieged and bombed. The Adoians eventually fled on foot to Yerevan, where young Gorky found an unroofed hovel as refuge for the family. After suffering extreme deprivations, Shushanik Adoian died of starvation in her son's arms in March 1919.

Under such circumstances, Gorky's devotion to his mother was

bound to be lasting. She became the memorable, larger-than-life figure of his past who would serve as the focus of his tales.[16] Although she introduced him to Armenian art by taking him to the local churches, he especially remembered the intimate experiences of her stories. That was her art that she conveyed to him. His mother was the essential storyteller in his life. Her death left him a tenuous legacy inasmuch as an oral story in itself is evanescent: "all that exists of it is the potential in certain human beings to tell it." Thus in contrast to written texts, which store knowledge in a fixed medium, the "knowledge…[of an oral culture has] to be constantly repeated or it would be lost." [17] As a consequence of his mother's death, Gorky had to develop the potential to tell her tale. It was twofold, involving not only her folk tales but *her* story as well, that is, her life and death. Understandably, given his vocation as a painter, Gorky translated to his canvases the oral repetition necessary to stave off oblivion.

This complex visual development began in 1926, when Gorky began to paint a portrait of his mother seated next to her young son (see Fig. 73). There were two versions, the second undertaken in 1929. Both were based upon a photograph taken in Van in 1912. Gorky had retrieved it from his father in Providence, to whom it had been sent as an attempt to recall a scattered family. By 1926 the photograph had become both a memento mori and a glimpse of an earlier, more secure existence. Gorky worked on the first portrait for a decade; he did not finish the second until the early 1940s. The austere formalism of these portraits helps to constrain, if not veil, the highly charged drama of a family on the verge of disintegration. Gorky's intensive labor on these portraits, spanning almost two decades, suggests that he found a way to reunite his family symbolically on the eve of its destruction. The reunion occurred through the act of painting, which also paid homage to his mother. Deeply embedded in these double portraits is a narrative, Gorky's story of his own past renewed and sustained through his vocation as a painter.

The formalism of these two paintings suggests that Gorky's sense of storytelling had little to do with visual illustration. The story of the portraits must be inferred. In a letter to Vartoosh, Gorky scorned illustration for its superficial eye-appeal.[18] As a consequence, he did not paint canvases that illustrated specific folktales. Nevertheless, Gorky did enjoy storytelling while painting. In addition to the requirements of the traditional mode, the stories had to be told, not read, because Gorky's eyes were preoccupied: he was looking at the canvas he was painting. But who was to

tell the story? Often Vartoosh performed that function while she lived with her brother in New York. After she moved to Chicago, Gorky was left to tell stories to himself. Painting, like reading or writing, is an individual act that can verge on solipsism. Gorky created company for himself by becoming his own audience, engaged in reflexive performance, not simply to stave off loneliness but to gain inspiration for his painting. His sister's singing, he reminded her in another letter, had enabled him to paint.[19]

This process of storytelling so necessary for Gorky's painting becomes evident in his commentary on a canvas titled *How My Mother's Embroidered Apron Unfolds in My Life* (see Fig. 74). This abstraction was painted in late 1944, some two years after the second portrait of his mother was finished. His mother was still on his mind. As Gorky wrote to his sister in December 1944, "I completed a work inspired from Mother's apron in our Aikesdan. How well I recall the time the photograph of Mother and myself was taken in Armenia's Van in 1912. The one which we sent Father in America. And just a short while ago I completed a most successful work emanating from the abstract Armenian shapes of her apron, those designs so pregnant with memories." [20] The immediate visual source of the painting was the embroidery, which existed in a photograph that was a highly charged mnemonic device, releasing Gorky's memories in the apron's design.

Julien Levy, the painter's friend and art dealer, recorded Gorky's story of the crucial storytelling of the painting:

> I tell stories to myself, often, while I paint, often nothing to do with the painting. Have you ever listened to a child telling that this is a house and this is a man and this is a cow in the sunlight…while his crayon wanders in an apparently meaningless scrawl all over the paper? My stories are often from my childhood. My mother told me many stories while I pressed my face into her long apron with my eyes closed. She had a long white apron like the one in her portrait, and another embroidered one. Her stories and the embroidery on her apron got confused in my mind with my eyes closed. All my life her stories and her embroidery keep unraveling pictures in my memory. If I sit before a blank white canvas….[21]

Although the Surrealist émigrés in New York may have encouraged Gorky to disclose this story as part of their literary approach to painting, he was hardly engaged in a facile attempt to gain their approval. The story was

embedded deep in Gorky's psyche, and it seems to have surfaced first in 1938, with a visual representation of this scene projected upon Gorky's sister and her family. The drawing is entitled *Armenia's Van Dream Moorad, Vartoosh, and Karlen*. Vartoosh is seated in profile, her left hand in her lap, her right arm crossed over her chest. She is conceivably wearing an apron. Gorky's young nephew Karlen stands full face to the viewer, leaning against his mother's legs and knees, his head not quite in her lap but cocked as though listening to a child in her belly. Mother and child reenact the intimate experience of Gorky's childhood. Moorad, the boy's father, is an onlooker, distanced from the primary couple by being encircled as though a picture on the wall, akin to Gorky's father Sedrak an ocean away from Van in Providence, a generation before.

Gorky's sketch hints at the complexities of his verbal statement, especially in relation to his subsequent abstract painting. That statement encapsulates Gorky's sense of the relationship between oral performance and painting.

"I tell stories to myself, often, while I paint, often nothing to do with the painting." For Gorky the acts of painting and storytelling frequently go together, though he cautions the viewer from the outset that the painting does not arise from the story in the form of a visual narrative. While Gorky could cultivate an audience with his stories, here he is a private storyteller, telling stories to himself.

"Have you ever listened to a child telling that this is a house and this is a man and this is a cow in the sunlight...while his crayon wanders in an apparently meaningless scrawl all over the paper?" Gorky takes a child's verbal and motor behavior as an explanatory model for his painting. Given the subsequent discussion of his mother and his childhood experiences, this rather abstract male child refers to Gorky himself—not simply Gorky when he was a child but Gorky as he remains a child evoked in the vignette. Although he gained license to emulate the child from a primitivism reactivated by the Surrealists, his primitivism was derived from a source closer to home.[22]

What is the child telling? Although he is ostensibly telling a story, it is more accurate to say that he is naming things: "house," "man," and "cow." Gorky evokes a poetic simplicity here. The child's naming, however, is not descriptive, any more than it generates a visual allegory. It points to imagery in the making, yet the child's crayon "wanders in an ap-

parently meaningless scrawl all over the paper" (akin to Surrealist automatism). Gorky sees a disjunction between the verbal naming and the visual image. Despite this gap, the crayon's "scrawl" is only "*apparently* meaningless*," Gorky avers. The scrawl lacks meaning only if we expect it to correspond visually to the verbal images uttered by the child. Otherwise, Gorky implies, the visual scrawl has significance even though it is not verified by a verbal meaning. Its significance, however, is not yet clear.

As for the spoken words, since Gorky indicates that they do not conform to the visual configurations, we can infer that the child is engaged in a kind of fantasy wordplay. However, the child's nonsense should not be dismissed. The care and seriousness with which Gorky puts words into the child's mouth suggest that they too possess a significance in their apparent nonsense, despite the fact that they do not really comprise a story. The child is engaged nonetheless in an oral performance in association with the hand's visual scrawl. Both components abjure narrative. There is the sense that the two behaviors are somehow related, but Gorky as a visual artist has his eye on the crayon. His story of storytelling will presumably lead to a greater understanding of his painting.

"My stories are often from my childhood." Here is a major shift, as Gorky moves into his own past. He tries to eliminate the distance between himself as an observing adult and the child by resuming his childhood self. The course of his narrative between past and present suggests the persistent doubleness of his vision. Other layered meanings are equally vital. "Stories" here has several references. It refers first to the stories that Gorky tells to himself while painting. Those stories came from his childhood, told to him by his mother. Her stories and his thus overlap, but since she is dead, the stories can never coincide except, perhaps, fleetingly, when his voice assumes hers in memory and in the telling. Otherwise, the fact that the stories cannot merge is an endless source of tension and generation. Retelling her stories relives the experience of her telling. Thus the stories are essentially one story about his childhood. It is ultimately a story about storytelling, and hence about an art that will help explain his art.

"My mother told me many stories while I pressed my face into her long apron with my eyes closed." Here is the unattainable center of Gorky's story. *She* told him many stories; out of his profound sense of loss,

perhaps even of abandonment, he must tell stories to himself. He will remain faithful to her by telling her stories over and over again. Better yet, he will tell her story repeatedly. This scene has a concrete presence with an emotional charge that transcends the rather abstract primitivism of Gorky's opening comments. The story is stamped with Gorky's authentic sense of his mother's storytelling and his involvement in it as a child. There is also the urgency of Gorky's need to retrieve this oral performance for his painting. The story of his mother's storytelling has vision at its center and thus serves to generate his painting. In the primal telling by the mother, Gorky's eyes are closed, as he turns inward, away from the world, sheltered by his mother. Gorky presses his face into her apron and against her belly.

"She had a long white apron like the one in her portrait, and another embroidered one." In both double portraits, Gorky's mother wears the long white apron, whereas in the original image furnished by the photograph, she wears an embroidered one. Whiteness suggests purity and virginity (as one might expect of a mother idealized by the child). The apron also serves as his mother's shield, preventing his return to the womb. Her protection becomes his obstruction, if not his challenge, for the white apron anticipates the "blank white canvas" even while it masks his eyes.

"Her stories and the embroidery on her apron got confused in my mind with my eyes closed." Embroidery is a conventional metaphor for stories and storytelling.[23] Thus Gorky ties one medium to another. Words in an oral performance, which are essentially ephemeral, are connected to a traditional woman's art, which is visual and tactile. For Gorky the association is confused while his face is pressed into her lap. The phrasing implies that his confusion arises from keeping his eyes closed. Sight should bring clarity. If nothing else, it should restore distinctions between two art forms that have apparently taken on characteristics of the other.

"All my life her stories and her embroidery keep unraveling pictures in my memory." *His* life and *her* art are intimately connected, as Gorky brings the consequences of the story into the present. He emphasizes that her stories and embroidery together unravel pictures in his memory. Pictures in Gorky's mind's eye disintegrate, while her stories and embroidery remain intact. "Unravel" here is extremely ambiguous. It suggests first that her art forms threaten his. Unraveling becomes a specific form of confusion. But "unravel" can also mean disentangle, so that her art might

clarify his. Finally, there is the imminent disintegration of her art, for its preservation depends upon his memory. Given this kinship, how can their art be sustained?

A hint comes from Gorky's conclusion, which is an open conditional that moves from a present vision of the past to an uncertain future: "If I sit before a blank white canvas..." Not improbably, he is sitting once again before his mother's white apron. The blank white apron prevents union but inasmuch as it is the cloth against which Gorky's closed eyes are pressed, it also suggests another possibility: can the white apron-canvas be embroidered? Can he visually stitch his own story? He has a paradoxical need to become independent of his mother, who is clearly a source of creativity but also (more covertly) a potentially destructive force.[24] So his telling of her story has an element of desperation about it—a desperation derived not simply from an irredeemably tragic past. Gorky needed to exorcise the past not by forgetting it but by remembering it as a context for his painting.

The process, then, was fraught with difficulty. The struggle of painting during the Depression was compounded by the personal struggle not to forget a painful past. The story of Gorky's past focused on a beautiful mother intensely loved while she was alive and no less intensely loved in her death, but with profound ambivalence. Of course she had not abandoned her children, any more than a young Gorky could have sustained her through the massacres. The inevitable tensions drove Gorky's stories and his painting. The white canvas to which he returned time and again bore such close ties to his mother's apron. Could he live up to her embroidery? The innocence of childhood was lost, scarcely regained in memory and necessarily lost again in the act of painting the whiteness away. Through it all, the agon of Gorky's painting rehearsed the characteristic struggle of the performing storyteller.[25]

The ending of Gorky's story might lead but with no certainty to the beginning of a painting. Gorky's mother was to storytelling as Gorky was to painting. The simplicity of the equation belies its complex workings. How can we fill in the blank canvas, which is the missing term of this equation? How did Gorky move from the primal story to the painting? Was the story simply a source of inspiration or motivation? Gorky said as much to his sister. Was it even a form of therapy for a man tormented by the loss of his origins? As likely as they are, these conclusions simply lead to the paint-

ings; they do not provide access. That step requires the need to grasp how Gorky translated the dynamics of oral performance to painting.

This process was not without paradox. A written text is visual, inasmuch as words are locked into a graphic space. For Ong, written words are "residue" for future readers.[26] Similarly, a painting presents a fixed graphic space. Painting is also a residue that is reconstituted by each viewer. Thus the permanence of painting, its immortality if you will, comes from its fixed visual forms in contrast to the evanescence of oral performance. Painting projected Gorky's knowledge beyond his oral performances into a static realm not altogether consonant with the process involved. Gradually, in the 1940s he learned how to infuse his painting with a fluidity characteristic of oral performance.

In this regard *How My Mother's Embroidered Apron Unfolds in My Life* is an important canvas even though it does not visually evince a biographical narrative. Indeed, its lack of narrative content is precisely the point. Thus, as a nonrepresentational painting, it did not "receive" Gorky's stories in order to visualize them. The relationship between the abstract visual image and the stories lies in the formal act of painting, not in any similarity of content. Gorky's selection of this painting was hardly capricious. He chose to conjoin this painting with this title along with his subsequent statement because of its particular visual qualities, which were characteristic of other canvases painted in 1943 and 1944. Its fluid line matched by a fluid paint, thinned, transparent, and dripping, had finally taken on the dynamics of oral performance.[27]

PAINTED IN LATE 1944, *How My Mother's Embroidered Apron Unfolds in My Life* corresponded with the advent of the Surrealists in Gorky's life. Their meeting was preceded by another phase of his painting, which would condition the terms of their interaction. Whereas the laborious portraits of his mother were a votive offering to the past, *How My Mother's Embroidered Apron Unfolds in My Life* celebrated the present, as the title clearly indicates. From the mid-1930s Gorky worked on two related groups of canvases devoted to his father and his garden in Armenia.[28] This project signaled a shift in his formal and psychological preoccupations. The two groups, the first called *Garden in Khorkom* (from 1934 to 1939) and the second, *Garden in Sochi* (from 1940 to 1944), spanned a time from Gorky's thrall to what he called "urban cubism" in the mid-1930s to a visual free-

dom that accelerated in 1943. Equally important, these paintings imply a reconciliation with the father and thus led to Gorky's ultimate celebration of his mother in 1944. These paintings were accompanied by Gorky's running commentary in letters to Vartoosh—a tandem that charts the complex development of Gorky's inner life and belies the simple notion of sudden "liberation" or "conversion" in the early 1940s at the instigation of the Surrealists[29]

In the most concise statement of his new thematic preoccupation, Gorky noted to his sister that "in my art I often draw our garden and recreate its precious greenery and life" (see Fig. 75). In a more self-consciously poetic manner, Gorky wrote a statement for The Museum of Modern Art, which had purchased a 1941 version of *Garden in Sochi*. After a Whitmanesque catalogue of sensual pleasures, he described his father's garden: "This garden was identified as the Garden of Wish Fulfillment and often I had seen my mother and other village women opening their bosoms and taking their soft and dependent breasts in their hands to rub them on the rock. Above all this stood an enormous tree all bleached under the sun, the rain, the cold, and deprived of leaves. This was the Holy Tree....I had witnessed many people, whoever did pass by, that would tear voluntarily a strip of their clothes and attach this to the tree." [30]

Gorky's account moves between ethnography and poetry. In contrast to an apple orchard that no longer bears fruit are the village women, including Gorky's mother, who seek fertility by rubbing their breasts on a rock. Towering above them is the primordial (patriarchal) holy tree. In his memory Gorky gathered the once-scattered family. It is now the father's garden where wishes are fulfilled. Nostalgia for the past is satisfied because the father has been restored to his rightful place at the family homestead. The memory mitigated, if it didn't heal, the dislocation of the massacres. Gorky the innocent son bears witness to this pastoral scene. As he rhetorically asked his sister in a letter of early February 1942, "Can a son forget the soil which sires him?" [31] Gorky's use of the present tense suggests that memories of the Armenian land, now associated with the father, continued to provide psychological sustenance despite longing and pain.

The full significance of Gorky's memories of his childhood in Armenia can be grasped only by attending to the rhetorical patterns of his letters to Vartoosh. His first reference to the garden in Khorkom followed an

explanation of Cubist space in a letter dated July 3, 1937. Gorky asked, "What is the thrust of theoretical cubism?" His answer: "To dissect the shape of an object, to explode it and contract it so as to disclose the fusion of space and the object. Cubism implies that space is not empty, that space is alive. Whenever an object strikes a two-dimensional surface, the space around the object becomes part of that object." From this succinct definition Gorky moved to Khorkom, which he described in Cubist terms. "Khorkom's garden images," he declared (referring both to memory and paintings, having worked on several by then), "reflected the absence of absolute boundaries in nature and the symmetry of the passage of moving matter from one state into another." [32]

At this point in 1937, Gorky clearly thought that Cubism, with its visual ambiguities and its dynamic conception of space, would provide the means to visualize his memories, which he realized were fluid and alive. By February 1938, however, he wrote to his sister that he was changing his painting style to strive for "a deeper and purer work." [33] It was at about that time that Gorky added Miró to his repertoire of sources of biomorphic forms (initially gleaned from Picasso). [34] The meaning and identification of those Miróesque shapes remained in the slippers he and his father had worn, in the butterchurn his mother and other women had used—remained, in other words, in the domain of Gorky's Armenian memories.

Miró's greatest impact, however, was not iconographic but formal. Gorky responded to Miró most crucially by lightening up his imagery. [35] This leavening, however, was relative. With but a few exceptions the Khorkom and Sochi series bear a tactile presence as paint on the canvas. The images generally remain embedded in surface paint as part of a Cubist legacy. Along with the weight of those images, Gorky organized his imagery into interlocking shapes. Only after *Organization,* a rectilinear composition finished by 1936, did he begin to release his biomorphic shapes from the geometric design that he construed as "urban cubism." [36] And not until the *Garden of Sochi,* begun in late 1941 and finished by spring 1944, did Gorky really develop a fluidity of line and spatial ambiguity that revealed his own visual signature.

While this canvas of 1941–44 marked the long culmination of the *Khorkom* and *Sochi* series, it was in turn an example of a new phase in Gorky's painting, begun around 1941. His formal efforts were closely tied once again to his Armenian memories. As he wrote to Vartoosh in Febru-

ary 1941, "I am working on a picture deriving from profoundly vivid recollections of our home on Lake Van." [37] What was new was a heightened lyricism informing his verbal descriptions of those memories—a verbal lyricism that surpassed any actual painting he had done at that point and that seemed truer to the fanciful configurations of Miró. It was as though he had almost exorcised the anguish of his mother's memory in retelling their tragic story in the portraits.

In that same letter to his sister, Gorky proceeded to describe what was virtually a conflation of memory and painted image:

> The rectangular walls with butterchurns and clay baking tools and Armenian rugs pasted on them stretch and twist in seeking contact with wheatfields and cloth trees and Armenian cranes and garden stones, all floating within one another and swept up by the universe's ceaseless momentum just as life-nourishing blood when flowing through the body nudges the artery walls on its journey.

In their flow and confluence, these images from the past exist inside the artist as though in his bloodstream, yet they reside finally in Gorky's eye, an eye rejuvenated: "the newly-opened child's eye of your brother." [38]

Painting was no longer an agonizing struggle; it became work that Gorky thrived on. After 1943 he described the act of painting as a flow. "I produce art just as our Armenia's Khoshab flows into Lake Van. It is an act of nature and I simply must follow it," he wrote to Vartoosh. By 1944 Gorky had completely renounced "urban cubism" with its "rigidities and closed structurings" and identified himself as "a curved line." Still later, he claimed that "curved lines define passion and straight lines structure." [39] Arbitrarily assigned though these values may seem, it is clear that Gorky grasped the fresh linear lyricism of his most recent work of 1943, beginning with the Kandinsky-inspired washes of *Waterfall* and *The Pirate*.

Whereas Gorky initially lent rectilinear and static connotations to pictorial organization, by 1944 he could offer a new and infinitely flexible conception:

> It is an organization of agitating points or places or locations. These points can exist in my concept of color, they can consist in taking a form, they can consist in taking a shape. Now try to allow your mind the free-

dom to think in terms of constant motion or flux instead of paralysis. Replace stillness with movement. That is my goal, that is what I am achieving. I am breaching the static barrier, penetrating rigidity. I am destroying confinement of the inert wall to achieve fluidity, motion, warmth in expressing feelingness, the pulsation of nature as it throbs.

Following this abstract account of his formal strategies on the two-dimensional plane of the canvas, Gorky returned again to a lyrical account of his Armenian memories, which elided into his paintings where "they float in my work." Succinctly stated, he exulted that "my recollections of Armenia open new visions for me." [40]

Despite a much-needed acquiescence to the fluidity of his memories, Gorky could not afford to be passive. His memories still required visual organization, for apart from folktales, only some of his personal memories formed coherent stories. His mother's tragic death was one, his father's garden another. Yet for all its coherence the former was a haunting and potentially destructive memory. "Mother's starvation in my arms. Vartoosh dear, how my heart now sinks in even discussing it," he wrote in 1940.[41] By contrast, Gorky clearly associated an organic metaphor for creativity with his father's garden—at about the time of his marriage and subsequent fatherhood.[42] But even Khorkom, though vivid, was often elusive and fragmentary.

Gorky, then, needed to organize, to control his memories, which served as catalysts for his painting. Although he felt "haunted" by his memories, he also felt compelled to explore them in an active fashion. As a consequence, Gorky was not merely a passive slate for his memories any more than he was in the business of transcribing memories in an act of literal recollection. He could tease an isolated impression from the past into a voluptuous sensorium of burgeoning visual forms on the canvas. "Recently the scent of Armenia's apricots captured my mind," he wrote to Vartoosh in February 1944. The scent triggers a childhood experience of picking apricots for his grandfather: "I touch their softness with my nosetip." Then it is transformed in paint: "Now they float in my work as the humble procreators of delicate beauty. They are the many sunsets dancing silently on the horizon and opening as flower petals to allow Armenian maidens to folk dance on their warm leaves to the grateful ovation of nature's grand audience." [43] Gorky's language, poetic and fanciful, pro-

vided metaphors for the visual metamorphoses of his memories that animated his paintings.

GORKY'S LETTERS TO VARTOOSH emanated from the self; brother and sister remained intimates, the fragment of an Armenian family shored against the outside world. (When Agnes Magruder married Gorky in 1941, she opened up an otherwise ethnically closed family life.) Outside events rarely intruded into this closed world, where he could reveal his deepest emotions and feelings to someone who had also experienced the devastations of his youth. In assuming the persona of Arshile Gorky, Vosdanik Adoian did not conceal his Armenian identity so much as mute it in an effort to be assimilated into a vital society of American artists. Even then, his "disguise" was transparent more often than not, as in the misleading titles of his *Garden* series. The town of Sochi, for example, points away from Khorkom to an exotic Black Sea resort.[44]

By 1943, however, Gorky was complaining to Vartoosh that Americans were ignorant of Armenia, that critics saw his Armenian portraits through Picasso and spoke of Picassoid eyes rather than Armenian eyes. Years before, he had told Julien Levy that he was "with Picasso" in his painting; now that he was "with Gorky," as Levy had hoped he would be someday, no one recognized his true identity or that of his work.[45] How was Gorky to negotiate the world, not to lose himself by assimilation, but to reveal himself and his paintings in their true character? That process was to be charted in the New York art world, Gorky's larger sphere of social interaction, where the Surrealists had exhibited since the late 1920s with increasing frequency until they finally arrived after the fall of France in 1940.

No one could ignore the Surrealist presence in the New York galleries and museums during the 1930s, and Gorky was not blind. Although visually voracious, he was also discriminating in his long apprenticeship among the moderns. In that process he was completely immersed in painting, with a self-conscious exploration of formal visual problems. Canvases were engaged simultaneously as well as serially in his studio. Given his uncanny focus on Picasso, Gorky understandably discovered a source of Surrealism in his work. Surrealism that was filtered through Picasso during the late 1920s and 1930s became a formal attraction for Gorky. Surrealism itself became virtually irrelevant as he explored biomorphism as a visual element in the designs of his paintings and drawings.

Gorky's commitment to the deployment of medium was no less intense in drawing, which, he informed Vartoosh in 1942, "is the basis of art." [46] The large portfolio of drawings achieved during the summer of 1946 at the Virginia farm of his in-laws had been prefigured by a large group of drawings in the early 1930s called *Nighttime, Enigma and Nostalgia* (see Fig. 76). The imagery of these drawings, which had led to a painting of the same title in 1934, is difficult to decipher. Visual ambiguities abound. The pictorial space might be interior or exterior or both, with biomorphic shapes that are fixed in the darkness of their "nighttime." Our eyes strain to make them out—hence the "enigma."

It would be too easy to forgo the imagery and simply believe that the drawings exhibit not so much an obsessiveness of theme or psychological concern as an engagement in drawing and its formal problems. Certainly, Gorky expended great energy in the act of drawing, immersing himself in the tactile quality of pencil on paper, at a time, in the Depression, when he was too poor to afford the necessary materials for painting.[47] Yet the title has a literary quality that cannot be ignored, and it was derived, along with some visual allusions, from De Chirico.[48] Gorky's wife has recalled that he characterized the Depression as one of the bleakest periods of his life.[49] Subsequently drawn to the darkness of nighttime, he gave an urgency to De Chirico's nostalgia in longing all the more intensely for an idyllic Armenian past during such hard times.

The notion of "enigma" also came from John Graham, a Russian painter in exile, whom Gorky met in New York, perhaps as early as the close of the 1920s. Opinionated and colorful, the two artists took to each other because of their commitment to painting. On a theoretical level Graham had completed the manuscript of his *System and Dialectics of Art* by 1934, and no doubt Gorky had been a sounding board for those ideas. Graham considered the unconscious an important psychological component in art throughout *System and Dialectics*—a view probably derived from Breton, whom he had met in Paris during the 1920s. Yet Graham made no effort to link the unconscious specifically to Surrealism, which remained but a brief reference in *System and Dialectics,* published in 1937.[50]

Elsewhere, however, Graham acknowledged the importance of Surrealism. In January 1935 he wrote an essay for *Art Front* in review of "Eight Modes of Modern Painting" at the Julien Levy Gallery. Leaving no doubt about his own preference for Surrealism, he typically braved a radical

journal that hewed to Socialist Realism and so had little good to say about the French movement. Also bucking the illusionism of Dali, Graham characterized Surrealism as "an abstract art" that was "truly revolutionary" by virtue of its method of "transposition." He claimed that the Surrealist juxtaposition of distant elements was a form of abstraction ("transposition") that registered upon the unconscious, "the generative sources of the human being," from which it emerges "automatically into the conscious mind as a revolutionary vision." [51]

By implication automatism was a revolutionary creative process in contrast to "storytelling methods" such as might be found in Socialist Realism.[52] Graham was challenging the Communist left by making revolutionary claims for abstraction. Equally important, however, was his claim that automatism was an abstract process. Although Graham was hardly a major spokesman for Surrealism in the 1930s, Gorky would have picked up on these ideas, echoing his aversion to visual narrative, and later would find himself attracted to the relatively abstract automatism of Matta in the 1940s.

In the meantime, however, Gorky remained skeptical about the unconscious. He was especially scornful of the Freudian analysis that had become fashionable in New York. As early as 1939 he realized that his painting in the engagement of memory emerged from an active imagination. But if memory alone did not suffice, neither did the unconscious. In a departure from Graham, he rejected the notion of the "subconscious" as "magic nonsense." Elsewhere, he equated the unconscious with anarchy, and claimed that "unrelenting spontaneity is chaos." "Great art," he concluded, "insists upon consciousness." [53] On the face of it, such views should have disqualified Gorky from the Surrealist ranks. Circumstances, however, remained propitious, and most crucially he himself remained open to the possibilities of Surrealism.

During the first three months of 1941 Gorky was sighted at Onslow Ford's lectures on Surrealism at the New School for Social Research. The prospect of seeing Surrealist paintings must have drawn him as much as the lectures, if not more so. In compensation for his inexperience as a painter, Onslow Ford came armed with theory to explain Surrealism to his attentive American audience. It was theory brewed with Matta in reading the metaphysical P. D. Ouspensky. Matta, the man in motion, extolled paintings of constant movement in an invisible world of forms undergoing transformation, indices of mental fields of energy, in his shorthand, "psy-

chological morphology." Such notions were congenial to Gorky, who would soon develop a dynamic conception of pictorial space that opened onto "infinities." [54]

When Onslow Ford left New York in the spring of 1941 for sanctuary from the war in a Mexican Indian village, Matta remained in Manhattan. His meteoric rise on the New York art scene virtually guaranteed his meeting Gorky in the fall of 1941 (delayed by summer trips for both painters). Gorky's friendship with Matta gradually developed over the next few years, culminating in the winter of 1944, when Isamu Noguchi and Jeanne Reynal took Gorky to a dinner where he met Breton.[55] Whereas Breton would soon ratify Gorky as a Surrealist, Matta had facilitated Gorky's unique adaptation of Surrealist automatism.

Ever the loner, Gorky did not join Matta and other young American painters in their weekly sessions during the winter of 1942–43, although Motherwell spent an evening with him to explain Surrealism. While it is not clear what a recent initiate to the movement, and to painting as well, could offer the savvy Gorky, it is clear that his liaison with Matta became most productive. Peter Busa has recalled one of their first meetings:

> It was at a small gathering. Gorky was saying, "You know, I think that you paint too thin." And Matta graciously replied, "Oh, I don't think I paint so thin." It was an infantile conversation that went on in that way for a while. Gorky, if you remember, was painting very heavy in those days. He hadn't even started to be influenced by any of our ideas. You could hardly lift his palettes; they were like African shields, very heavy. Exasperated, finally, Gorky pulled himself up to his full height (I thought he was going to fight), and he said, "Well, let's put it this way—you don't paint so thin, I don't paint so thick." With that we all relaxed.

From this tentative beginning, Gorky gradually began to loosen up, to thin down his paint with turpentine, as evidenced by his canvases of 1943, among them his painting of his mother's apron. According to Levy, Matta "encouraged him to profit from the inevitable dripping of such a fluid medium, and to use the accidental splotches as suggestive forms for further elaboration, as Leonardo da Vinci used the stains on the wall plaster of his room." [56]

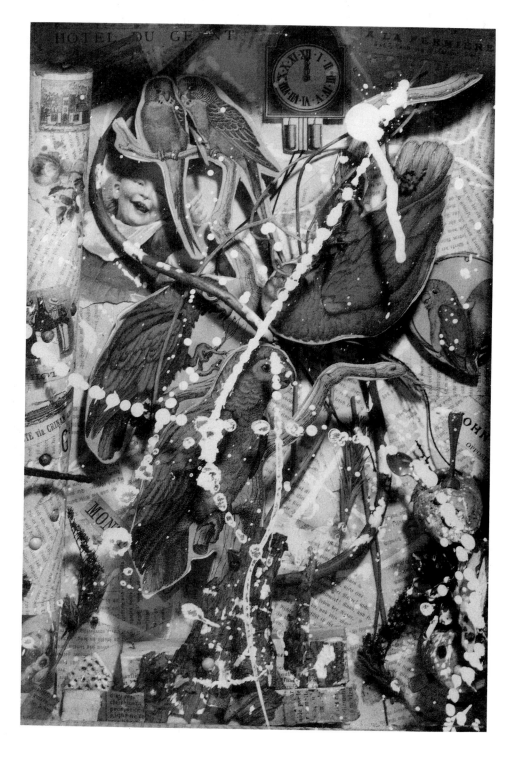

61. Joseph Cornell, *Object (Aviary)*, **1941, box construction,**
14¹/₂ x 10¹/₂ x 3¹/₂ inches. *Collection Richard L. Feigen and Co., New York.*

62. Joseph Cornell, "'Enchanted Wanderer': Excerpt from a Journey Album for Hedy Lamarr," *View* I, nos. 9–10 (December 1941–January 1942).

"ENCHANTED WANDERER"

★ Excerpt from a Journey Album for Hedy Lamarr ★

By
JOSEPH CORNELL

★

Among the barren wastes of the talking films there occasionally occur passages to remind one again of the profound and suggestive power of the silent film to evoke an ideal world of beauty, to release unsuspected floods of music from the gaze of a human countenance in its prison of silver light. But aside from evanescent fragments unexpectedly encountered, how often is there created a superb and magnificent imagery such as brought to life the portraits of Falconetti in "Joan of Arc," Lillian Gish in "Broken Blossoms," Sibirskaya in "Menilmontant," and Carola Nehrer in "Dreigroschenoper?"

And so we are grateful to Hedy Lamarr, the enchanted wanderer, who again speaks the poetic and evocative language of the silent film, if only in whispers at times, beside the empty roar of the sound track. Amongst screw-ball comedy and the most superficial brand of clap-trap drama she yet manages to retain a depth and dignity that enables her to enter this world of expressive silence.

Who has not observed in her magnified visage qualities of a gracious humility and spirituality that with circumstance of costume, scene, or plot conspire to identify her with realms of wonder, more absorbing than the artificial ones, and where we have already been invited by the gaze that she knew as a child.

Her least successful roles will reveal something unique and intriguing — a disarming candor, a naivete, an innocence, a desire to please, touching in its sincerity. In implicit trust she would follow in whatsoever direction the least humble of her audience would desire.

"She will walk only when not bid to, arising from her bed of nothing, her hair of time falling to the shoulder of space. If she speak, and she will only speak if not spoken to, she will have learned her words yesterday and she will forget them to-morrow, if to-morrow come, for it may not."

(Or the contrasted and virile mood of "Comrade X" where she moves through the scenes

* Parker Tyler

like the wind with a storm-swept beauty fearful to behold).

* * * * * * *

At the end of "Come Live With Me" the picture suddenly becomes luminously beautiful and imaginative with its nocturnal atmosphere and incandescence of fireflies, flashlights, and an aura of tone as rich as the silver screen can yield. Her arms and shoulders always covered, our gaze is held to her features, where her eyes glow dark against the pale skin and

her earrings gleam white against the black hair. Her tenderness finds a counterpart in the summer night. In a world of shadow and subdued light she moves, clothed in a white silk robe trimmed with dark fur, against dim white walls. Through the window fireflies are seen in the distance twinkling in woods and pasture. There is a long shot (as from the ceiling) of her enfolded in white covers, her eyes glisten in the semi-darkness like the fireflies. The reclining form of Snow White was not protected more

lovingly by her crystal case than the gentle fabric of light that surrounds her. A closer shot shows her against the whiteness of the pillows, while a still closer one shows an expression of ineffable tenderness as, for purposes of plot, she presses and intermittently lights a flashlight against her cheek, as though her features were revealed by slow-motion lightning.

In these scenes it is as though the camera had been presided over by so many apprentices of Caravaggio and Georges de la Tour to create for her this benevolent chiaroscuro . . . the studio props fade out and there remains a drama of light of the *tenebroso* painters . . . the thick night of Caravaggio dissolves into a tenderer, more star-lit night of the Nativity . . . she will become enveloped in the warmer shadows of Rembrandt . . . a youth of Giorgione will move through a drama evolved from the musical images of "Also Sprach Zarathustra" of Strauss, from the opening sunburst of sound through the subterranean passages into the lyrical soaring of the theme (apotheosis of compassion) and into the mystical night . . . the thunderous procession of the festival clouds of Debussy passes . . . the crusader of "Comrade X" becomes the "Man in Armor" of Carpaccio . . . in the half lights of a prison dungeon she lies broken in spirit upon her improvised bed of straw, a hand guarding her tear-stained features . . . the bitter heartbreak gives place to a radiance of expression that lights up her gloomy surroundings . . . she has carried a masculine name in one picture, worn masculine garb in another, and with her hair worn shoulder length and gentle features like those portraits of Renaissance youths she has slipped effortlessly into the role of a painter herself . . . le chasseur d'images . . . out of the fullness of the heart the eyes speak . . . are alert as the eye of the camera to ensnare the subtleties and legendary loveliness of her world. . . .

[The title of this piece is borrowed from a biography of Carl Maria von Weber who wrote in the horn quartet of the overture to "Der Freischutz" a musical signature of the Enchanted Wanderer.]

Opposite: **63. Joseph Cornell, Untitled [called "Black Hunter"], c. 1939, painted, glazed wooden box for a kinetic construction of glass, paint, wood, paper, strung beads, poker chips, and book illustrations, 30.5 x 20.3 x 7 cm.** *The Lindy and Edwin Bergman Joseph Cornell Collection. The Art Institute of Chicago.*

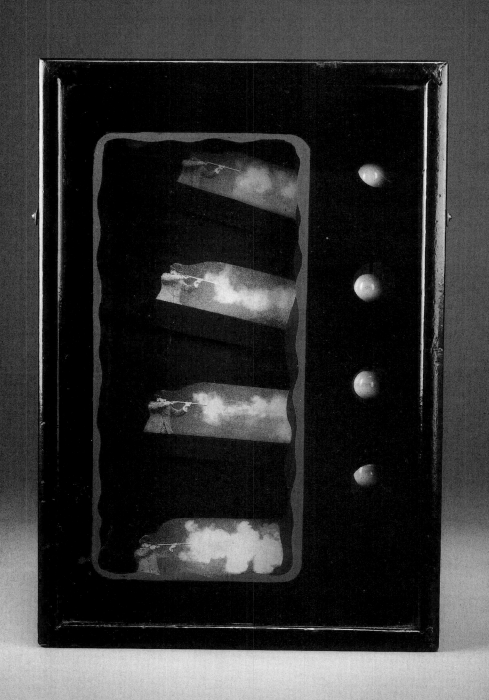

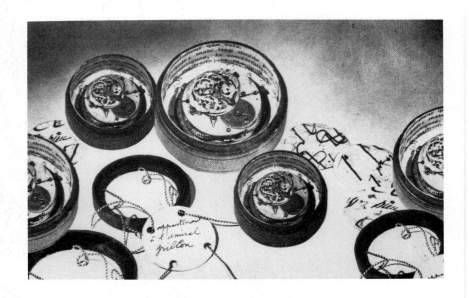

64. Joseph Cornell, "³/₄ Bird's Eye View of 'A Watch Case for Marcel Duchamp,'" *View*, Duchamp issue, ser. V, no. 1 (March 1945): 22.

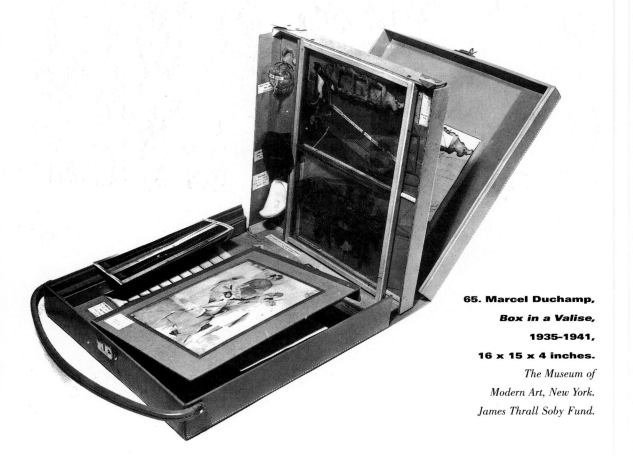

65. Marcel Duchamp, *Box in a Valise*, 1935–1941, 16 x 15 x 4 inches. *The Museum of Modern Art, New York. James Thrall Soby Fund.*

66. Joseph Cornell, *Story Without a Name—For Max Ernst,* in *View,*
Max Ernst issue, ser. II, no. 1 (April 1942): 23.

**71. Joseph Cornell,
Untitled
[The Inoculation],
n.d. (1930s),
collage,
4⁷/₈ x 7⁹/₁₆ inches.**
*Private Collection,
New York. Courtesy
Richard L. Feigen and Co.,
New York. Photograph by
Bevan Davies.*

**72. Joseph Cornell,
Untitled [Sewing
Machine], 1931,
collage, 5¹/₄ x 8¹/₈
inches.**
*Courtesy Pace Gallery,
New York. Photograph by
Bevan Davies.*

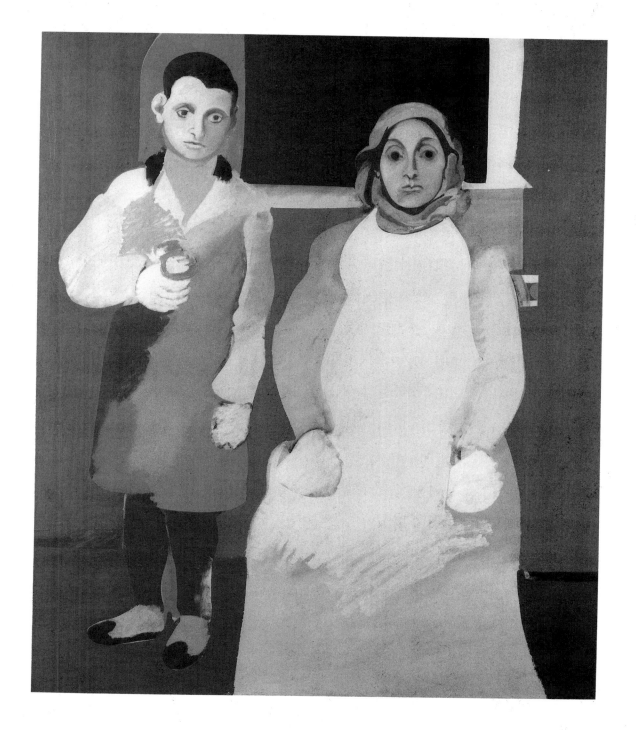

73. Arshile Gorky, *The Artist and His Mother*, 1926–1936, oil on canvas, 60 x 50 inches. *Gift of Julien Levy for Maro and Natasha Gorky, in memory of their father. Whitney Museum of American Art, New York. Photograph by Geoffrey Clements.*

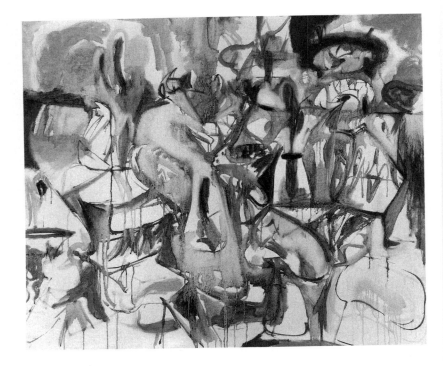

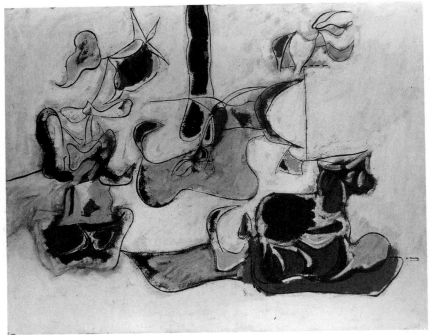

78. Jackson Pollock,
Heading West,
1934–38, oil on
fiberboard,
15¹⁄₈ x 20⁷⁄₈ inches.
National Museum of
American Art,
Smithsonian Institution,
Washington, D.C. Gift of
Thomas Hart Benton.

79. Jackson Pollock,
[Self-Portrait],
n.d. (c. 1930–38),
oil on gesso ground
on canvas, mounted
on board,
15¹/₈ x 20⁷/₈ inches.
Courtesy Jason McCoy Inc.,
New York.

80. Hans Namuth, Jackson Pollock painting on glass,
1950, seven frames from a 16 mm. film.
© 1995 Hans Namuth.

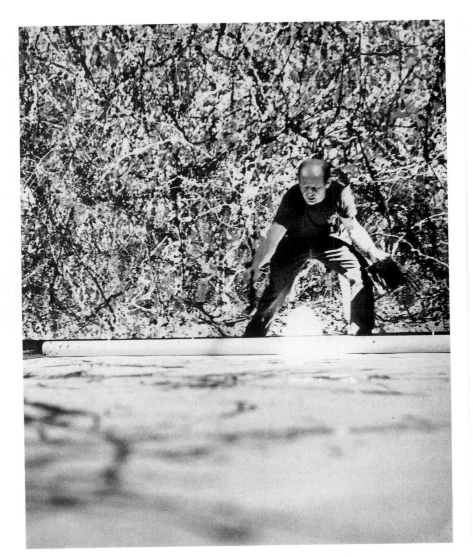

81. Hans Namuth,
Jackson Pollock,
1951, photograph.
© 1995 Hans Namuth.

82. Jackson Pollock, [Composition with Pouring II], 1943, oil and enamel on canvas, 25 x 22¼ inches.

Hirshhorn Museum and Sculpture Garden, Washington, D.C.

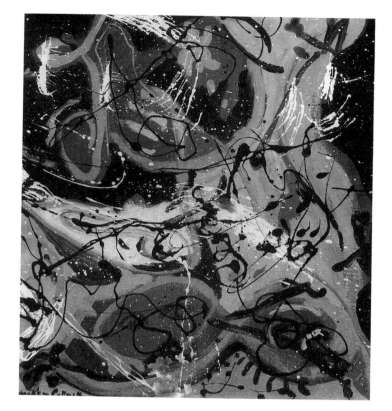

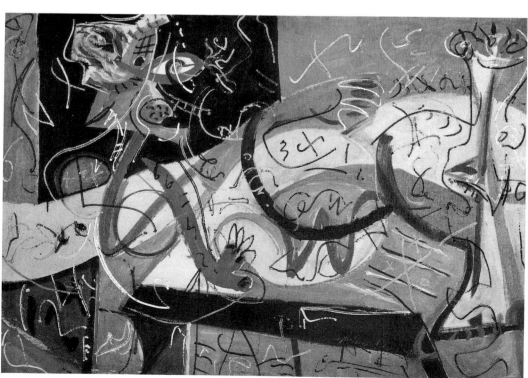

84. Jackson Pollock,
Birth, n.d.
(c. 1938–41), oil on
canvas mounted
on plywood,
45³/₄ x 21³/₄ inches.
The Tate Gallery, London.

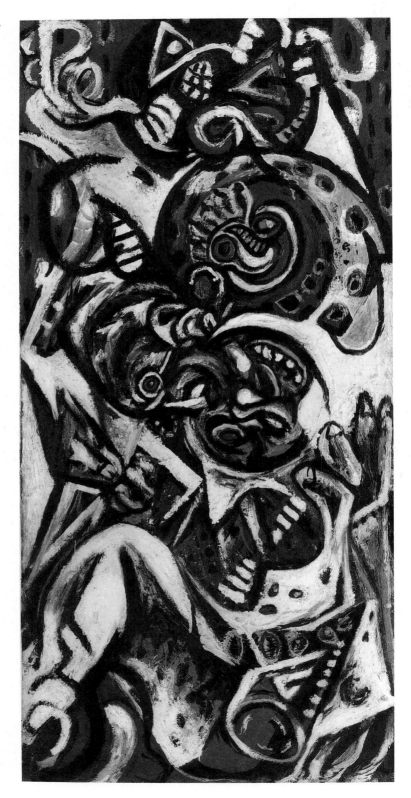

At the same time that this process nudged Gorky away from "magazine painting," as Matta refered to an American interest in European art gleaned from reproductions, Matta's encouragement reinforced Gorky's acquiescence to his Armenian memories. He became receptive to automatism because he had available deep in his own psyche a voice that he could conjure through his memory. The story in turn was a vehicle that held, and was held together by, patterns embedded deep in Gorky's unconscious.[57] And because he did not have to resort directly to the unconscious, thanks to the mediation of oral performance, Gorky was able to assimilate automatism as a profoundly creative technique. It was not merely a facile path to yet another visual style. By heeding that voice, his mother's voice, yet inevitably his own, the act of painting became the gestural discharge of the telling, and the painting itself became an integral part of the oral performance. Automatism relaxed the gesture so that it could follow the essential fluidity of the oral story, not the story itself. Thus what emerged visually was rooted in the dynamics of oral performance even though it did not have an analogous narrative content.[58]

In 1945 *How My Mother's Apron Unfolded in My Life* and its cognate, *The Year of the Milkweed*, were included in Gorky's first one-man exhibition at Julien Levy's, under the imprimatur of Breton, who wrote an accompanying essay. According to Noguchi, the Surrealist leader was first attracted to Gorky's drawings done in Virginia. Ethel Schwabacher, a longtime friend, claims that "their liking for one another was strong and immediate" despite the language barrier. In writing about Matta in 1944 Breton had been lavish in his praise of Gorky's work, as "destined to excite the widest possible attention in the near future." Gorky was sufficiently trusting to collaborate with Breton on titles for his paintings. "Water of the Flowery Mill" and "The Leaf of the Artichoke is an Owl" were elicited from Gorky's comments about his canvases.[59]

In his essay, Breton played with the motif of "the eye's spring." The eye was a spring of water to replenish art with an "unquenchable freshness of feeling." The eye's spring was also akin to the source of energy in a watch, a coiled spring in time that can be unwound in space: "It is made to cast an outline, to provide the *guiding thread* between things of the most dissimilar appearance," Breton claimed, with automatic drawing in mind. "This perfectly ductile thread should allow one to seize, in the shortest possible time, the relations which link the innumerable physical and men-

tal structures, even if there is no possibility of an uninterrupted passage through this labyrinth." [60]

Recalling Gorky's summer idylls in the fields of Virgina, Breton also referred to his practice of "standing in front of nature" in order to draw. In 1944 James Johnson Sweeney had reported Gorky's decision "to look into the grass" for a "free response to nature." Whereas Sweeney implied that this visual immersion was direct, Gorky's response even here was not without cultural mediation. In a letter to Vartoosh in January 1944 he said, "I view nature in America, but memory plays favorites. And for me, that which we had in Armenia has a distinct essence." Breton sensed as much because he described the resulting forms of Gorky's concentrated immersion as "hybrid," a blend of visual contemplation with "the flux of childhood and other memories." Gorky, he claimed, garnered sensations from nature as "springboards" toward a spiritual state—a state that he could not describe because of "the extraordinarily reticent and sensitive aspects of Gorky's personality." [61]

Although the matter went far beyond personality, Breton came very close to divining the painter's life. Gorky's mind had strayed through a labyrinth ever since he had landed in the United States in 1920. His guiding thread had unraveled from his mother's embroidered apron and extended in the line of his drawings extruded from memory. By 1943, his line had been loosened as in his *Anatomical Blackboard,* a wonderfully apt title for the sense of freedom Gorky conveys, as though there were an inexhaustible supply of figures at hand, were these to be erased. Gorky, however, never succumbed entirely to his unconscious. The various automatic means advocated by Matta remained virtuoso instruments at Gorky's disposal. Thus while "dreams form the bristles of the artist's brush," he also claimed that "drawing gives the artist the ability to control his line and hand." [62] Gorky was remarkable in being able to balance these competing claims in the domain of his imagination, which generated the multiform imagery of his memories.

Inasmuch as oral performance involves intense bodily participation, Gorky's act of painting mediated between voice and visual image. The well-known mysterious interiority of Gorky's paintings, then, was not the metaphoric interior of the unconscious. A work such as *The Liver Is the Cock's Comb,* also painted in 1944, was rather the literal viscerality of voice and body turned inside out on the canvas as Gorky sounded his

depths (see Fig. 77). The centeredness of interior sound, as Gorky talked to himself, was held in tension with the characteristic sense of struggle that engaged the painter as storyteller.[63] The elegant line of Gorky's paintings was the trace of his storytelling. Visually encoded was a compelling script that reconciled him with his Armenian past and sustained an identity that moved between past and present, between painting and oral performance. Gorky's art was indeed "an assertion of existence."

11

The Secret Script of Jackson Pollock

The eye exists in its savage state. The Marvels of the earth a hundred feet high, the Marvels of the sea a hundred feet deep, have as their sole witness the wild eye that traces all its colours back to the rainbow. It presides over the conventional exchange of signals that the navigation of the wind would seem to demand. But who is to draw up the scale of vision?

—André Breton, "Surrealism and Painting," 1928

With the Surrealists long gone from New York and Breton swimming against the Existential tide in Paris, 1950 may have been one of Jackson Pollock's best years. He painted some brilliant canvases, made some sales, and solidified his position as arguably the "greatest living painter in the United States," as he had been nominated, and withdrawn in the virtually same motion, by *Life* magazine the previous summer.[1] Now, perhaps, the tide had turned. After a difficult launching and a rocky start, Pollock's painting career appeared to have taken off. Ahab was towing in the whale.

During the summer of 1950 in Springs, Long Island, where Pollock and Lee Krasner, to whom he was married, had moved from a Manhattan studio, the couple met Hans Namuth, a photographer for *Harper's Bazaar*, who had taken an interest in Pollock's paintings. Namuth boldly proposed

that he photograph Pollock at work in his studio. He had good reason to be eager to initiate this project. The *Life* article had widely publicized "How Pollock Paints" and offered two tantalizing photographs of the painter with the tools of his trade: "enamel, sand and a trowel." [2] Even a superficial glance at the monumental canvases with their tangled skeins of paint would have clearly indicated that they had not been produced in any ordinary fashion. And Namuth had taken time to regard the paintings carefully at the Betty Parsons Gallery after his curiosity had been piqued by his art instructor.[3]

For Pollock the *Life* article had been disquieting. Its distortions had underscored the need for visual documentation. By gathering the diverse views of unnamed critics, the magazine typically hedged its bets and assumed the lofty guise of objectivity. Nevertheless, the article transformed the high praise of Clement Greenberg into a question that cast Pollock's work under a pall of skepticism—an attitude that was reinforced by failing to contest Parker Tyler's crack that the paintings looked like "yesterday's macaroni." A Pollock viewed as the coming rage of Paris was implicitly set at a disadvantage against the amusement of the commonsensical plain folk in Springs. Finally, one caption described Pollock as "drooling" paint on the canvas, while the process was seen to entail "days of brooding and doodling." Shabbily treated against expectation, Pollock might well have fit the magazine's description of him as a "puzzled-looking man." [4]

Given the track record of the mass media in presenting modernism to the American public, Pollock might have been simply relieved that the article was not more inflammatory than it was. On the positive side, *Life* did offer excerpts from the painter's statement about his work in *Possibilities,* a little magazine edited by Harold Rosenberg and Robert Motherwell over the winter of 1947–48.[5] And there was, after all, a two-page color spread of Pollock's latest efforts, including a photograph of the painter standing defiantly in front of *Number Nine.*[6] Understandably, then, Pollock, though a man ordinarily sensitive to any slight, kept a stack of that issue of *Life* on hand for friends and visitors.[7] Aware of the large-scale publicity broadcast by the article, and mindful of the entrepreneurial necessity in America to promote and develop his own career, Pollock must have welcomed Namuth's unsolicited proposal as a serendipitous opportunity to set the record straight.

Pollock therefore agreed to the project and set up a meeting on the

following weekend. The session did not begin in a promising way. Pollock told Namuth that he had just finished painting a canvas; there was no good reason to take any photographs just then. Nevertheless, they went to the barn for a look around the studio, where Pollock abruptly resumed work on the canvas unrolled on the floor. "It was as if he suddenly realized the painting was not finished," Namuth has recalled. "His movements, slow at first, gradually became faster and more dancelike as he flung black, white, and rust-colored paint on the canvas [*Autumn Rhythm?*]. He completely forgot that Lee and I were there; he did not seem to hear the click of the camera shutter." [8]

Namuth's recollection of the painter's vacillation is open to several interpretations. Pollock may well have been of two minds about the project—and for good reason. Painting was a private act of great intensity for Pollock; prior to Namuth's arrival only Lee Krasner had really seen him paint, whereas the *Life* photographs had offered merely some preliminary glimpses of that process. That Pollock came up empty when Namuth arrived at the door was perhaps less a dodge than a consequence of not being able to gauge how long it might take to complete a canvas with his methods. ("There is no beginning and no end," he would later claim. That could apply to time as well as to space.)[9] His sudden resumption of work may well have had more to do with an impulsive awareness that the painting was not finished than with any desire to perform for Namuth. But once he was absorbed in the act, he became remarkably unself-conscious about the presence of a photographer (see Fig. 81).

Having gained Pollock's confidence, Namuth returned several times during that summer to take more photographs, eventually around five hundred in all. With so many shots of Pollock painting, it was possible to string together a Muybridge-like sequence of still images to gain a sense of his movement, as a reader could in looking at "Pollock Paints a Picture" in *Art News* a year later.[10] But the possibility of making a movie did not escape Namuth; after all, what was more logical than a cinematic record of a painting process predicated on direct gesture? And so, having won Pollock's approval, Namuth took the project to another level of collaboration.

Using his wife's hand-held Bell and Howell camera, Namuth shot a seven-minute black-and-white film of Pollock working in the barn. Encouraged by the results, he decided to film the painter in color, which meant working outdoors in order to minimize the expense (and obtrusive-

ness) of indoor lighting. Whereas he had shot some of the black-and-white film from the loft above, he now wanted to achieve an intimacy between the camera and the artist in motion. Namuth's filmic solution for a way of dramatizing Pollock's unique approach to painting was ingenious: Pollock agreed to his suggestion that he paint on a large sheet of glass resting horizontally on a platform while Namuth aimed his camera from beneath.

Namuth also wanted to achieve something more than a short documentary fragment, which was the state of his black-and-white version. To lend shape to the film, he composed the final color version in three parts: We first see Pollock in the field getting prepared to paint, striding to a canvas on the ground, putting on his paint-spattered boots, stirring some cans of enamel—and then a close-up of Pollock's head against the sky, drawing on a cigarette in contemplation of the action ahead. In the second sequence we see only Pollock's shadow gesturing on a wall, flexing paint on the canvas. This image alternates with a view of the paint landing on the canvas. In the final sequence we assume the camera's vantage point beneath the glass and see Pollock squinting from above as he pours paint onto the surface. During the film we hear only Pollock's voice-over, interspersed with cello music composed by Morton Feldman.

The rhetorical power of this film, *Jackson Pollock*, is not entirely self-evident, largely because what is most persuasive in it appears the least rhetorical, while the most rhetorical part has an arty pretension to it. Thus the first section of the film appears to be the most straightforward, with Pollock simply offering some biographical information in his voice-over. This laconic introduction lulls us into an acceptance of the film as a documentary. The second part, however, is the least convincing—as Namuth himself conceded.[11] Not only are the gesturing shadows mere simulations of Pollock painting, but they are melodramatic, if not hokey. In addition, the cello music is obtrusive: the obligatory staccato plunks of a "modern" score (a metaphoric echo of paint landing?) are intended to reinforce the impression that the viewer is privy to an avant-garde event.

The last section, of course, purports to offer us that event. The opportunity of seeing Pollock finally at work blinds us to the fact that the camera is not documenting an actual canvas in progress but a glass "canvas" made to order, specifically meeting the needs of the filmmaker.[12] Ironically, by proposing that Pollock paint on glass, Namuth was trying to capture Pollock's sense of entry into the canvas on the floor. Choosing words

that echo Pollock's, Namuth said, "I realized that I wanted to show the artist at work with his face in full view, becoming part of the canvas, inside the canvas so to speak—coming at the viewer—through the painting itself." [13] The film's image of Pollock's face seen through the glass surface becomes a visual metaphor for his desire to "be *in* the painting." An illusion of immediacy is also created by virtue of seeing the paint fly onto the glass surface, which coincides with the screen surface of the film. This illusion thus supports Clement Greenberg's interpretation of Pollock's poured paintings as the culmination of a visual tradition in western art history: Pollock brought the paint to the canvas surface as surface paint. [14]

These filmic illusions aside, what is extraordinary about Pollock's performance is his self-assurance, especially in the drama of seeing him stumble in the process of painting and then calmly begin again. As he said in an earlier statement elsewhere, "I have no fears about making changes, destroying the image, etc., because the painting has a life of its own." [15] We come to believe that he really *was* fearless, as we witness his act of faith in the life of the painting. It is in such a moment that any vestige of disbelief completely vanishes. However arbitrary the setting of the performance might seem otherwise upon reflection, we realize that we have witnessed an extraordinary avant-garde event nonetheless in the filmic collaboration.

Namuth's film manages to maintain the air of a straightforward documentary even though documentaries are never "objective," as commonly surmised. At most they create the illusion of objectivity or at best a directness that allows a viewer an opportunity to assess the filmic experience without feeling manipulated. [16] Beyond this documentary horizon, the film—as much Pollock's as Namuth's—self-consciously fabricated the painter's American identity. The movie portrays Pollock both as American and as avant-garde, in a complex interplay of word and visual image. The tautly drawn voice-over narrative takes us from Pollock's early years during the Depression, through the Surrealist phase of the Second World War, to his triumph in leading an emerging Abstract Expressionism. [17]

Namuth's film has less to do with mythmaking or mythologizing, as those phrases have been imprecisely used with Pollock, than with the creation of a cultural identity: How did Pollock come to be an artist in American society? How did he self-consciously define that cultural role in the process of assuming it? Pollock did not stride out of thin air, more aptly,

the open air of the American west, though he did take a major part in projecting himself. Was he, then, a self-made artist, just as Americans like to think of themselves as self-made? It has been a cultural tradition idealized by Horatio Alger and later rendered ambiguous in the figure of Jay Gatsby, created by F. Scott Fitzgerald, whose fiction attracted Pollock in the waning years of the Depression.[18]

To understand how Namuth's project limned Pollock's American identity as an avant-garde artist, we first need to recognize the painter's own active role in the fictive process. Without Pollock's words accompanying the first section—and they were his words after all—we would not have such an effective opening that overarches the visual action at the conclusion of the film. Pollock was clearly a willing accomplice in the immediate task of explaining his work. In the film's laconic narrative, explanation coined as information disguises the very process of presenting Pollock as an American artist, which in turn dispels the stigma of avant-gardism. This covert process played a primary role in the formation of Pollock's public persona and thus also served to promote his career.[19]

Explanation of Pollock's work during his lifetime (and into ours) was problematic in any number of ways. The American public had long viewed modern art as incomprehensible. What was not understood was ridiculed. Such attitudes had not substantially changed over the four decades since the Armory Show. As the latest avant-garde movement from Europe in the 1930s and 1940s, Surrealist painting by its very nature continued to generate controversy, and in the guise of Dali during his American career, Surrealism only served to confirm the prevailing notion that modern art was not just suspect, but crazy as well.

Against the most recent innuendos of *Life* magazine, which thrived on such misconceptions, Pollock did not bring to bear the most effective verbal weapons—an inability that may have been more apparent than real. Although the young Pollock failed to graduate from Manual Arts High School in Los Angeles, he had taken courses in American and contemporary literature and looked forward to the reading lists and magazines that his brothers mailed from New York, where they were pursuing careers in art. (Because of his financial straits, their father all the more staunchly upheld the ethic of self-improvement for his sons.) Even though the young Pollock found correspondence a laborious and hence a sporadic practice, especially when in "a turmoil," his letters to his family were generally ar-

ticulate (except for atrocious lapses in spelling). And in moments of enthusiasm his letters had a terse immediacy and fluency: "Seeing swell country and interesting people," he wrote his brother Charles on a postcard as he traveled across country, "haven't done much sketching—experienced the most marvelous lightning storm (in Indiana) I was ready to die any moment." [20]

Pollock has been described as inarticulate by some of his contemporaries, including Lee Krasner, who obviously knew him best,[21] but such a portrayal does not entirely hit the mark. The young Pollock had been caught up in an adolescent turmoil ("a bit of damnable hell") that became self-absorbing. As he confessed to Charles in 1930, "My letters are undoubtedly egotistical but it is myself that i am interested in now." [22] During the 1930s he became increasingly afflicted with psychological problems that contributed to his alcoholism—such that his contemporaries viewed (and encountered) him as alternately violent or withdrawn. Pollock's disturbed brooding, however, should be distinguished from the silences of a young man trying to figure things out and gaining a visual fluency when he succeeded. It was this thread of intense concentration that sustained him as a painter throughout his life.[23]

Amid the confusion and anxieties of setting a course for his life (aimlessness to be strenuously avoided in pursuit of the Protestant ethic), Pollock made a curious comment to his father in a letter from New York in February 1932: "Things are about the same here—I'm going to school every morning [Thomas Hart Benton's mural classes] and have learned what is worth learning in the realm of art. It is just a matter of time and work now for me to have that knowledge apart of me." Here was a young man who in reaction to the daily humdrum claimed to have "learned what is worth learning in the realm of art." Somewhat later, in a letter to his mother, he confirmed that he still had much to learn technically, so the earlier claim might then be taken as so much youthful bravado were it not for the earnest tone. While Pollock never revealed what that artistic knowledge was—it remains one of his secrets—he did learn that it was essential to assimilate that knowledge, to make it a part of himself. (Assimilation as a kind of ingestion and blending of experience with one's identity was itself a form of concealment.) Thus in his letter to his mother he added that "it is a matter of years—a life." This integration of art and life— "being an artist is life its self—living it I mean"—was to be the key to Pollock's visual fluency.[24]

Thus other contemporaries rightly felt that Pollock was taciturn by nature yet quite capable of succinct communication when the occasion required or he was so moved. (In this behavior he reinforced the image of the silent westerner in the company of loquacious easterners.) Why was he rarely moved to explain his work in a direct fashion? A certain pattern emerges from his statements. Whereas Pollock was willing to talk *around* his work, as evidenced by an early interview in *Arts & Architecture* in 1944, he was unwilling to discuss or analyze specific paintings. That very same year his aversion was elevated to principle in a terse statement that he submitted to accompany *She-Wolf* (1943), illustrated under the category of American Surrealism in Sidney Janis's catalogue, *Abstract and Surrealist Art in America*: "*She-Wolf* came into existence because I had to paint it. Any attempt on my part to say something about it, to attempt explanation of the inexplicable, could only destroy it." [25]

Compare Pollock's statement with that of Joseph Cornell, which accompanied an illustration of *De Medici Slot Machine* (1941), also in Janis's catalogue: "It is too difficult to get into words what I feel about the 'objects'." [26] Unlike the reticent Cornell, who harbored complex feelings that resisted language, Pollock argued that his painting could not be explained, and hence a viewer should simply stand witness before the intractable silence of the painting. He further implied that the greater the inevitability of a painting, and hence its dominance over the painter, the less he was able to say about the work. For Cornell, feelings were the obstacle to words; for Pollock, painting itself.

The very painting itself, then, more than an inherent inarticulation, visually commanded Pollock's silence in deference to a nonverbal medium. As a consequence, there are only a few extant written statements during the course of his lifetime; most everything else about Pollock is derived from recollection of conversation or from inference. The interview with a *Life* editor apparently did not go well, since it was not published with the 1949 article. So words of explanation to strangers were risky business at best, and the last effort with *Life* had failed. In May 1950 he wrote to Parker Tyler that he "usually 'points' rather than explains in words." Gesture, integral to his act of painting, was appropriately substituted for words.[27]

Thus an interview for *The New Yorker* in August 1950 was preoccupied primarily with conveying a chatty sense of Pollock's rural way of life in Springs (as opposed to urban Manhattan). No surprises there. But in a

tour of his studio the painter once again refused to discuss specific canvases, saying that he had stopped naming his pictures, giving them "neutral" numbers instead: "They make people look at a picture for what it is—pure painting. . . . Abstract painting is abstract. It confronts you." [28] With this intense visual bias, Pollock had all the more reason for a filmic collaboration with Namuth. It allowed others to see how he worked, when he could not adequately explain the process because of the visual exigencies of abstraction, "pure painting," as he aptly put it.

Even so, there was a felt need for words in the film. Namuth had decided to give some shape to his preliminary black-and-white fragment by dubbing Pollock's voice-over from a taped interview that had been planned for a radio show in 1950.[29] Drawn and modified from his 1948 statement for *Possibilities*, Pollock's narration in the color film was more succinct:

My home is in Springs, East Hampton, Long Island. I was born in Cody, Wyoming, thirty-nine years ago. In New York I spent two years at the Art Students League with Tom Benton. He was a strong personality to react *against*. This was in 1929.

I don't work from drawings or color sketches. My painting is direct. I usually paint on the floor. I enjoy working on a large canvas. I feel more at home, more at ease in a big area. Having a canvas on the floor, I feel nearer, more a part of the painting. This way I can walk around it, work from all four sides and be *in* the painting, similar to the Indian sand painters of the West. Sometimes I use a brush, but often prefer using a stick. Sometimes I pour the paint straight out of the can. I like to use a dripping, fluid paint. I also use sand, broken glass, pebbles, string, nails or other foreign matter. The method of painting is the natural growth out of a need. I want to express my feelings rather than illustrate them. Technique is just a means of arriving at a statement.

When I am painting I have a general notion as to what I am about. I *can* control the flow of the paint; there is no accident, just as there is no beginning and no end.

Sometimes I lose a painting. But I have no fear of changes, of destroying the image, because a painting has a life of its own. I kind of let it live.

This is the first time I am using glass as a medium.

I lost contact with my first painting on glass, and I started another one.[30]

Pollock's narration lasts for six minutes in a film approximately eleven minutes long. While his narration is about his act of painting and not about any one painting, it is extremely effective in conjunction with the visual recording of the film in lending a self-portrait of Pollock and his maverick art.

The first visual image of Pollock in the film is also a verbal one: the viewer sees Pollock's hand sign his name with a brush across the screen. The signature most immediately informs the viewer that Pollock is an artist, the painter's name on a canvas being the necessary (and sufficient) element in designating an artifact as a work of art—as Duchamp had maintained since the First World War. Such an assertion was necessary to meet the challenges to Pollock's status as an artist that arose from his unorthodoxy. At the same time, the signatory act anticipates the gestural process (and automatism behind it) that is dramatized in the film; the opening signature thus suggests that the forthcoming filmic event is integral to the painting itself—art and life being coextensive for Pollock.

That there was question about the aesthetic status of Pollock's canvases was occasionally voiced by the artist himself, though it was the public that expressed the greatest skepticism.[31] Pollock received a generously ambivalent letter from a woman in Charleston, South Carolina, after the *Life* article appeared. She wanted to tell Pollock how much her young son delighted in the paintings that he had seen in the magazine but she also felt constrained to say, "Frankly, it looked like some of his finger-painting at school to me." [32] In her comparison she clearly thought that Pollock's painting was inept or even beneath the status of art. Her letter ironically reverberated against modernist interest in the "primitive" paintings of children—their high esteem among the avant-garde since the beginning of the century, and by the Surrealists most recently, was set against the ignorance of civilized society.

Pollock's opening signature, then, conferred the artist's role and status on a man who upon first viewing in the film did not conform to prevailing notions of an artist. Here was no eastern aesthete but rather a rangy man seen outdoors in work clothes and cowboy boots. (The image might well have served the advertising campaign of Marlboro cigarettes a few

years later.) Pollock the painter has the appearance of Whitman the poet, not so much leaning and loafing at ease, for the painter has an edge about him, but a Whitman nonetheless, slouching for the frontispiece of the first *Leaves of Grass* with open collar and informal dress. (There is a wonderful still photograph of Pollock lying in the grass, reminiscent of the poet in "Song of Myself.")[33] While this garb would certainly contrast with the usual group photographs of European and American artists (Pollock included) wearing the suits and ties of middle-class businessmen, western gear joined eastern respectability in an American stance against bohemian posturing.

Although Pollock has been criticized for his macho guise, his filmic presence had an air of authenticity. His appearance in the open air along with his words of introduction—"I was born in Cody, Wyoming, thirty-nine years ago"—takes the viewer back to Pollock's origins in the far west and creates a convincing portrait of the painter as westerner. In actuality, however, Pollock's family had left Cody when he was an infant; except for some time in Arizona, he lived until young adulthood in southern California, in and around Los Angeles, which was not western in quite the same way as Cody, with its aura of wide-open spaces, cowboys on the range, and the simple pioneering life. With its booming urban sprawl after the Second World War, Los Angeles offered a different, perhaps sybaritic, sort of paradise. And Hollywood offered an ersatz version of the west with its cowboy movies.

So Pollock chose to emphasize the old west in establishing his identity in the film. But his assertion stood against his current home in Springs and his having come east to New York to study art with Thomas Hart Benton in 1929 (actually 1930). In a similar migratory pattern, Benton was born in Missouri but studied in the east and Europe. He lived in New York until 1935, when the "cultists" of the avant-garde apparently became too much for him, so he went back to the Midwest with great fanfare for regionalist art as the right ticket for cultural nationalism. Two years later Benton wrote his autobiography, *An Artist in America,* a copy of which he inscribed "to the boys" (the Pollock brothers). Needless to say, Benton's ebullient Americanism was somewhat more complex than his polemics revealed. Pollock's first mentor evinced the tensions between European and American cultures in his efforts to graft "Renaissance" forms onto American themes. Such tensions were reiterated in his belli-

cose attitude toward the avant-garde outpost maintained by Alfred Stieglitz in New York.[34]

Even though Pollock did not harbor precisely those antagonisms, he too held a dual vision that entangled urban New York and the American west. One of the young Pollock's earliest paintings still intact is a dark oil titled *Heading West*, taking off from an old family photograph of Cody.[35] Roughly dated between 1934 and 1938, the painting may have symbolized an automobile trip that Pollock and his brother Charles took across the continent in 1934 (see Fig. 78). Insofar as the scene includes covered wagons and horses, it might be thought to echo Benton's nostalgia for a west no longer in existence, had not Pollock dispensed with Benton's sentimentality and transformed his mentor's vitality into an ominous, swirling landscape.

Pollock painted a dark "Benton" canvas, in which Manifest Destiny has become a grim vortex, sucking pioneers into a nightmare of grinding poverty. Here was no journey to open spaces and freedom, but rather a return to origins, a journey to the interior, to the dark night of the soul. The painting finally becomes a metaphor for the terrors of discovery and self-discovery. Even here, however, Pollock could not escape his mentor, for though the dream-turned-nightmare pointed to the west, the young man had headed east to find the art of his life in New York. Suitably enough, Benton came to own the small canvas.

For his film narrative Pollock had to yield to cinematic (and hence economic) constraints. A short film on a shoestring budget did not allow much opportunity for elaboration beyond the documentary intent. Nevertheless, Pollock's omissions were as significant as his inclusions. Except for place of birth and current residence, Pollock's narrative focuses on himself as artist, omitting personal matters. So there is a leap from birth to the Art Students League: parents and family are not mentioned, suppressed perhaps in favor of Benton as the artist's mentor, who was, however, characterized as a negative force, someone to react against in 1929 (in actuality 1930). Pollock does not mention subsequent years with Benton or any other artistic training or influences, for that matter, but shifts abruptly to a description of his current approach to painting.

At this juncture—with the significant exception of a passing reference to Indian sand painting of the Southwest—the narrative joins the present cinematic time of painting on the glass: "This is the first time I am

using glass as a medium," orienting Pollock's description of how he paints to the project at hand. This gap of two decades, no matter how logical in light of what the viewer is about to see in the film, reinforces the illusion of Pollock as a self-made American artist.

Certain points in the narrative, however, can lead us back through the filmic gaps into the past. In an interview, Lee Krasner has claimed, "All of Jackson's work grows from this period [the mid-1930s]; I see no more sharp breaks, but rather a continuing development of the same themes and obsessions." The film's discontinuities, then, mask the continuities of Pollock's art. Is it possible to reconstruct those continuities, to see his work of a piece? For Krasner, Pollock's break with Benton set an ascendent curve toward independence, when Pollock "began to break free, about in the mid-thirties." This view was corroborated in retrospect by his brother Sande, who wrote to Charles in 1940 that Pollock "has finally dropped the Benton nonsense and is coming out with an honest creative art." [36] To trace that trajectory, however, is not to follow an isolated genius but an extraordinary artist who in his ascent filtered through himself the multifarious, and even contradictory, possibilities of his culture.

What, then, did Pollock react against in Benton? Certainly not his mentor's commitment to painting murals, and certainly not the larger-than-life mentality that accompanied them. In 1932 he wrote enthusiastically to his father, "Its all a big game of construction—some with a brush—some with a shovel—some choose a pen. Benton has just gotten another big mural job—for the Whitney Museum of American Art. Mural painting is forging to front—by the time I get up there there out [ought] to be plenty of it." Although the mural movement pretty much ended at the onset of the Second World War, the scale of murals had a lasting impact on Pollock's sensibility. He titled his first major commission for Peggy Guggenheim *Mural* (1943), and he claimed in 1947, "I believe the easel picture to be a dying form, and the tendency of modern feeling is towards a wall picture or mural." [37]

With *Mural*, Pollock worked toward a synthesis of monumentality and abstraction. In 1932, however, Pollock was hardly prepared to undertake mural projects, any more than *Heading West* was avant-garde. It was certainly not Surrealist, and not even abstract, as geometrically defined, say, by the American Abstractionists group, active during the 1930s. As

though to accentuate that disparity, the film narrative simply makes the leap from Benton, twenty years previous, to the present: "I don't work from drawings or color sketches. My painting is direct. . . . Having a canvas on the floor, I feel nearer, more a part of the painting. . . . I can walk around it, work from all four sides and be *in* the painting, similar to the Indian sand painters of the West." By referring to sand painting in the midst of describing his current methods, Pollock cast a line to his western origins and reinforced his identity in the process.

Sand painting served another important function in the film as an explanatory point of comparison. The horizontality of the canvas on the floor allowed him to approach its surface from all sides and even to enter it in a manner "*similar* to the Indian sand painters of the West" [emphasis mine]. Pollock's use of analogy exposes a double consciousness, a traditional dualism that ranges between the "civilized" and the "savage." "Sand painting" itself was a misnomer inasmuch as Native American practitioners did not use paint, but rather sand, and often other material that could be laid out carefully in traditional patterns on the hogan floor. The misnomer attempts to render an unfamiliar practice comparable to European-American art. The materials of sand painting were akin to Pollock's list of "sand, broken glass, pebbles, string, nails or other foreign matter," though for him they were ultimately subordinate to the poured paint. Ironically, then, an exotic cultural practice was enlisted to explain something purportedly even more exotic, namely, Pollock's new way of painting.

Throughout his film narrative Pollock remained deafeningly silent about the Surrealists, who, in addition to their avid interest in Native Americans, brought other important ideas and attitudes to Pollock's New York scene during the early 1940s. Pollock's American self-portrait and its affirmations elide over such omissions and more. One would have no idea of Pollock's troubled past from this film. (On the wagon for several years, Pollock began drinking heavily once again immediately upon completion of the film.)

The viewer is left with a positive impression epitomized by the final sequence taken from below the glass: Pollock's face is seen through skeins of paint interlacing an open expanse of sky (see Fig. 80). Yet the rhetoric of the camera's point of view virtually mirrors another self-portrait dating back to the start of Pollock's career (see Fig. 79). In a *Self-Portrait* of 1933, the viewer's vantage point is seemingly reversed: we look through a

dark space at the semi-hidden visage of a young Pollock, claustrophobic in a raggedly framed edge, staring at us through the shadows. How Pollock managed to move from that troubled young man that he was to the momentary affirmations of his filmic self-portrait some twenty years later was a complex development hidden in the gaps in the film. That movement over the years was the triumph of his life in painting.

IN CONTRAST TO THE AMERICAN IDENTITY that he projected in *Jackson Pollock Painting* in 1950, Pollock was not so nationalistic in an interview for *Arts & Architecture* in 1944. Asked, "Do you think there can be a purely American art?" he responded, "An American is an American and his painting would naturally be qualified by that fact, whether he wills it or not." His conclusion had a double edge: "But the basic problems of contemporary painting are independent of any one country." [38] By asserting the universality of painting problems, he assented to an internationalism demanded by the war at the same time that he staked a claim for American painters in solving such problems.

Even so, queried about "modern European artists" exiled in New York, Pollock had to concede the importance of French painting and acknowledged the presence of "good European moderns" because "they bring with them an understanding of the problems of modern painting." Pollock concurred with their stress on the unconscious as the "source of art," a proposition that he found more interesting than "specific painters" among them. In an oblique show of independence, he refused to mention the Surrealists by name, clearly the most vocal proponents of the unconscious among the European modernists in exile. Voicing admiration for Picasso and Miró, both abroad, safely at a distance, did little to ease his resistance to European domination. [39]

Pollock's ambivalence had its virtues. Only within the past decade had he emerged from the mentorship of Benton, whom he acknowledged as a "resistant personality" to work against. Despite his stated admiration, he keenly felt in competition with Picasso. [40] It was not likely, then, that he would join the Surrealists, not even at one remove, in an alliance with the restive, potentially insubordinate Matta, who had been stirring up dissent. Pollock stood between Benton, whose retreat to the Midwest symbolized his rejection of European art, and Motherwell, who deferred to the Surrealists at hand and to the French modernist culture that they represented.

Provincialism took many forms, and Pollock's served him well in its indeterminacy.

Pollock managed to keep the Surrealists at bay at every turn in a sporadic courtship. Although he and Lee Krasner joined Motherwell, Matta, Baziotes, and their wives in some weekly sessions of Exquisite Corpse over the fall and winter of 1942, he soon dropped out, most likely annoyed by the directives set forth by Matta. Ironically, he perceived the whirlwind Matta as restrictive, and hence academic. Invited by Motherwell, Pollock refused to lend work to "First Papers of Surrealism" in 1942, though two years later he contributed a drawing to "Natural, Insane, Surrealist Art," an exhibition at Peggy Guggenheim's Art of This Century, which began as a showcase for the Surrealists. In 1944, though included among "American Surrealist Painters" in Sidney Janis's exhibition, "Abstract and Surrealist Art in America," he adamantly refused to talk about *She-Wolf*, in tacit defiance of the literary orientation of Surrealism, even though he had exploited shared mythic themes in his paintings.[41] (Both Pollock and Masson had titled paintings *Pasiphae*, for example.)

This pattern of equivocation and standoffishness was reinforced, of course, by the unstable social situation in New York during the war. Pollock's reputation as a loner, which shored up his western image, also came into play. Yet the pattern suggests that he exploited the margins of shifting groups as a way of maintaining his independence. The war years were a crucial period of gestation that allowed Pollock to assimilate, assimilate, to paraphrase Whitman, while he pieced together his secret script, creating a sense of self as an American artist.[42] At the heart of his quest for identity was the struggle for cultural independence, requiring skepticism toward all authority, both European and American.

The filmic identity of 1950 in *Jackson Pollock* emerged from a series of ideological shifts dating back to the painter's primal separation from Benton in 1935. Subsequent shifts were not so much abrupt (as in Benton's departure) as they were transformational, one shift dissolving into the next, with interests carried over from one to the other. Pollock thus moved from Benton to Jungian analysis (1939–42), then to an interest in Native American sand painting (highlighted by an American Indian exhibition at The Museum of Modern Art in 1941), and finally to the large-scale poured paintings (begun in 1947), a practice demonstrated in the filmic collaboration with Namuth. Set against a backdrop of Surrealist automatism, such

shifts of ideological orientation during the course of a decade required internal assimilation that would result in accommodations of technique. From Benton's muralism and concomitant vitality to Jungian therapy and then to primitivism and sand painting—like Whitman, Pollock was a capacious artist who embraced multitudes.

And like Matthew Josephson, almost two decades before him, Pollock had a jump on the Surrealists in his commitment to the unconscious. Unlike Josephson, however, he did not consider psychoanalysis to be a parlor game. In January 1939 an alcoholic Pollock entered therapy for eighteen months under the guidance of Dr. Joseph Henderson, a Jungian psychiatrist. Reticent in the best of times, only more so in these sessions, Pollock brought in drawings for discussion as a way to remedy an inability to verbalize his problems. Henderson later recalled that "when he did talk, he talked very well," though only about "the most superficial aspects of life." The doctor also stressed that the drawings were not done expressly for psychoanalysis. They were part of works in progress and "idle jottings," what Pollock called "doodles" in an echo of Motherwell.[43]

Pollock did not come to these sessions as an innocent. He had known of Carl Jung through his friend Helen Marot, and Jung himself had been translated by Jolas in *transition* as early as 1930.[44] From Jung, Pollock inherited a congenial system of belief in which the artist was brought to center stage, where the painter himself could assume a leading role in his own therapy. As a practicing artist for almost a decade (though still groping), Pollock gained license to take over the sessions. Always active, he had something to do that was art-related: he could draw, and then ponder the significance of what he had done. Though he would later take a virtual vow of silence before his paintings—perhaps as a way of maintaining privacy, perhaps because he had had his fill of talking during his sessions with Henderson—talking about the drawings was probably less painful than talking directly about himself.

Pollock also inherited a repertoire of visual symbols with mythic resonance that purported to reveal psychological truths. By bringing the artist within the ambit of the unconscious, Jung circumvented Breton's perennial need to disavow art in favor of notes drawn directly from the unconscious. As a consequence, it was possible to overlook Pollock's visual references to Picasso and other artists in his drawings (even if Henderson possessed the visual sophistication to recognize such allusions). That Pol-

lock may have been over-eager to deliver the Jungian goods by alluding in his drawings to archetypal imagery drawn from Jungian texts simply indicates how self-conscious the project had become.[45] The most significant artistic feature of these sessions was the fact that through them Pollock personalized Jungian symbols and drew them into his art. They were not merely an intellectual game but part of an urgent quest that sought to integrate art and life in a healing process.

Pollock's deliberate turn to Jung at the end of the decade simply

shifted from Benton's American Scene mythmaking to another set of myths, presumably more universal in orientation by virtue of their purported source in the collective unconscious. At the same time, Pollock's interest in narrative remained constant, thereby facilitating this shift in a direction toward Breton's new-found emphasis on contemporary myths, though with greater imaginative resonance. With the onslaught of the war, American artists and others acknowledged the "sickness" of the times. Pollock anticipated the interests of Mark Rothko, Adolph Gottlieb, and Barnett Newman, who embarked upon a path of mythic exploration in 1943. By deploying vatic knowledge, the artist might become leader of the tribe once more—or so they hoped.[46]

WITH HIS INTEREST IN NATIVE AMERICANS of the Southwest as a source of "primitive" myth, Pollock paralleled the Surrealists.[47] By the mid-1930s he and his brother Sande had purchased ethnographic reports of the Smithsonian Institution well before the arrival of the Surrealists, whose own enthusiasms could only have confirmed his own. Yet there was a crucial difference. Unlike Breton and Ernst, who coveted Indian artifacts, Pollock came to focus on sand painting, whose imagery was transitory, beyond grasp. Here, the therapeutic ritual became the constant element, taking over Pollock's imagination after his Jungian therapy with Dr. Henderson was discontinued in 1940. Dr. Henderson himself was enthusiastic about Native Americans, and his successor, Violet de Laszlo, also a Jungian, apparently went with Pollock to see "Indian Art of the United States," a large exhibition that took up three floors of The Museum of Modern Art in 1941.[48]

On site were two Navaho medicine men making a sand painting. As recounted in *Time*:

> Their pigment, which they lifted in handfuls from five different bowls beside them, was powdered rock and charcoal—white, blue, yellow, black and red. Trickling each handful in a fine stream between thumb and forefinger, they drew lines and wedge-shaped patches as accurately as draughtsmen, pinched off a dot or a spot of color here and there as neatly as if they were salting the tail of a bird.

The catalogue for the exhibition stressed that sand paintings "are made by medicine men as part of religious ceremonies for healing." [49]

The figurative character of the Native American sand paintings, perceived as fraught with Jungian archetypes and other mythic possibilities, understandably led Pollock to allude to Native American motifs in his work. A geometric shape here and a bright hue there emerge, especially in his drawings, where he could immediately visualize what was on his mind. With *The Magic Mirror* in 1941—a figurative but not mimetic oil, hence the transformational "magic" of the mirror—Pollock mixed sand and paint on the canvas as though in homage to sand painting; and as late as 1945, *Totem Lesson 2* bears a central image whose morphology and vestigial symmetry echo sand paintings of the Southwest.[50] Sand paintings allowed Pollock to make a shift closer to home: to American mythic possibilities away from classical myth, which he had dramatized, for example, in *She-Wolf* (1943), with its allusion to Romulus and Remus. (That *Pasiphae*, a painting of the same year that referred to the Surrealist myth of the Minotaur, was initially titled "Moby Dick" indicates Pollock's concurrent interest in mythic American themes. The switch came at the suggestion of James Johnson Sweeney, who in association with Jolas and *transition* had gravitated toward Jung and the Surrealists in the 1930s.)[51]

The emphasis on Native American sand painting implied that Pollock would plumb a primordial American psyche. The power of attraction for Pollock was that he could see himself both as subject and object, the medicine man and his patient seated at the center of the design: healer and healed. He would thus invariably stress being *in* his painting when comparing his pourings to sand paintings. There was, however, the irony of seeing sand paintings in New York. The geographical distance simply echoed the cultural distance, the impossibility of becoming a shaman in any literal sense.[52] Just as Pollock began to eliminate the figural by abstraction and paintover (echoing the erasure of the sand paintings once the ritual was finished), so, too, he eventually deemphasized the therapeutic function of the sand paintings and concentrated on their formal possibilities in his decisive move toward the poured paintings in 1947. By 1950, the ideological shift toward formalism was completed by numbering his paintings rather than giving them poetic titles as during his Jungian phase.

Animating Pollock's ideological shift from ritual therapy to a ritual formalism was a restless heuristic exploration of the painting process.[53] Driving his energetic experimentation was a demand to transform Surrealist automatism. Pollock was a man possessed by his art (hence the feeling

of shamanism), working feverishly on all fronts, gathering within himself the means to break through to the poured paintings of 1947. Making paintings was his art, and for a while drawing was his therapy: was it possible to bring the two together through automatism? As the art of painting remained at the fore of Pollock's intent, an accommodation of automatism became all the more necessary, driven by the way that he perceived the unconscious to be at the nexus of artistic creativity and a healthy psyche.

The first important variation on psychic automatism cropped up for Pollock at an experimental workshop in Manhattan started by the Mexican muralist David Siqueiros in 1936. Attracted by temperament to a hands-on opportunity, Pollock became acquainted with lacquers and industrial enamels along with new means of application, ranging from spray-guns to drip and spatter, whose chance results bore affinities with automatism.[54] The workshop served to wean Pollock away from the recently departed Benton, who concentrated on subject-matter once he had developed and adapted traditional rhythmic form to convey American energy in his murals. In contrast, the radical Siqueiros was interested in going beyond the mural by developing new technical means and media that would become available to the masses for widespread artistic and political expression. Most crucially, Siqueiros's emphasis on painting techniques hinted at ways that Pollock himself might adapt in transferring psychic automatism to the canvas. Coming in 1936, however, this would require slow gestation before Pollock could develop his own transformation of automatism a decade or so later—a process that took place almost simultaneously in his painting and drawing.[55]

In this crucial development, Pollock played with three variations of automatism: the doodle and calligraphy, initially exercised in the realm of drawing (and therapy), along with a liquid drip/spatter/pouring as he shifted automatism to the realm of painting. "Doodling," in Motherwell's phrase, was at the root: American in connotation, antitheoretical, informal, a trivial motor activity, conscious and unconscious, and above all, fluid in making no distinction between the visual and the verbal: everything at hand became grist for the mill. From the throwaway doodle could emerge an elegant calligraphy, both verbal and nonverbal, as well as the accidental drip or spatter (of ink as well as paint). In little over a decade, from 1936 to 1947, Pollock learned how to modulate these possibilities in his chosen media, which ranged from pencil and pen to gouache and oil, used

singly and in combination. The same stretch was punctuated by these varieties of automatism, no single occasion of which was decisive, but which taken over time prepared Pollock for 1947.

By 1939 Pollock had embarked upon his Jungian quest, in drawing the unconscious image. Though these archetypal images were figurative, the art of drawing them took on an importance of its own by departing from one of the traditional functions of drawing, as a visual rehearsal for painting. Pollock's drawing soon moved from the figurative toward casual doodling, as on his copy of the back cover of *The Nation* in 1949. The magazine contained a review by Clement Greenberg, who noted Pollock among others as a practitioner of "repetitious, over-all composition," a characteristic readily observable on the back of the very same issue.[56] This copy ended up next to the telephone, as evidenced by the numbers written on the margin. At the same time, these markings, coming as they do as Pollock was preoccupied by phone conversations, represent psychic automatism as much as any planned Surrealist session. The voice that he heard on the line may not have been Breton's Surrealist murmur but it did release the line in Pollock's hand nonetheless.

Pollock carried his experiments in automatic drawing over to painting in occasional forays. Perhaps his earliest such attempt in painting occurred in 1941 while he was on the easel section of the WPA. As Peter Busa has recalled, "During the last legs of the WPA even Pollock was squeezing tubes of tempera directly onto the canvas without using brushes. This would have been around 1940 or thereabouts. . . . On the WPA, for instance, we used to practice a clandestine kind of automatic drawing." [57] One of Pollock's surviving variations is a gouache on cardboard, split in half to be smuggled out of the WPA studio: the paint is smeared, clotted, brushed, and streaked over linear images that occasionally come to the surface. Primarily abstract, this tentative effort lacks the swift elegance of subsequent pourings as well as the vigorous touch of *Night Mist* in 1945.

Pollock's next attempt was collaborative, approximating the model of the Surrealist Exquisite Corpse, in an impromptu painting session at Gerome Kamrowski's studio with Baziotes during the winter of 1940–41.[58] Although Pollock's spontaneous collaboration with Baziotes and Kamrowski was a one-time affair, the possibilities of pouring painting, predicated on automatism, punctuated his development en route to 1947. Three

canvases exhibited at Art of This Century in 1943 involved this method, one entitled *Water Birds* and two later identified as "Composition with Pouring." These works represent the unresolved tensions in Pollock's pouring method. The first "Composition with Pouring" is much more painterly, perhaps more spontaneous, than the second, which appears planned in the way the clarity of its background is rendered harmonious with the pourings (see Fig. 82). In the second, too, the pourings are more drawn out, more elegant and attenuated, than the doodles of the first. In bearing an affinity to the cosmological aura of the second pouring, *Water Birds* openly sustained Pollock's mythological interests, its poetic title connoting air and ocean, flight and water. Would he eventually be able to integrate and balance pouring and premeditation, chance and poetry in a single canvas?

Although his initial efforts were sporadic and uncoordinated in comparison to the poured paintings in 1947 and after, they were trials that highlighted a sustained effort in other guises. Pollock would go on to observe, sometimes to participate in Motherwell's weekly sessions of Exquisite Corpse during the spring of 1942. These get-togethers apparently involved collective writing rather than drawing.[59] Although Pollock soon dropped out, perhaps chafing at social constraints, he did not need group activity to paint or draw, since he already believed in the collective unconscious of Jung. Most crucially, Pollock transferred his attempts at automatic writing to the visual realm alone, in the process abandoning the image demanded by the Jungian concept of the archetype. This shift was facilitated by the notion of doodling, which allowed a fluency between writing and drawing. *The Guardians of the Secret* (1943) and *Pasiphae* (1943) both exhibit passages of nonverbal calligraphy, which might best be described as visual doodling.

Pollock had embarked upon his secret script. The process was amenable to a more attenuated line predicated upon calligraphy. In 1942 Pollock thus deployed a broken discursive line, a kind of shorthand, over an entire surface of flatly painted (and composed) areas of *Stenographic Figure* (see Fig. 83). The title is crucially ambiguous. Does it refer to the figure of a stenographer or is the painting an example of stenography, enigmatic figures taken under dictation, presumably from the unconscious? In 1942 Pollock still worked from a figurative impulse, so the illustrative dimension of *Stenographic Figure* cannot be discounted. Four

Opposite: **60. Jackson Pollock, doodles on the back cover of *The Nation*, no. 168 (May 28, 1949).** *Jackson Pollock Papers, Archives of American Art, Smithsonian Institution, Washington, D.C.*

years later, on the eve of his breakthrough, Pollock would persist in the figurative and the illustrative. The witty title of *The Blue Unconscious* (1946) suggests that the painting is less an automatic event than a metaphor for the visual possibilities of automatism.

During the interim, such possibilities were stressed once again when Pollock participated in Atelier 17, the workshop of the British printmaker Stanley Hayter, in late 1944.[60] As a linear process, engraving was amenable to automatism, which Pollock integrated with several media in overpainting a drypoint engraving with ink and gouache in 1945. Pollock, then, was on the verge of taking automatism consistently to painting itself by making painting and drawing one and the same. The distance that he traveled was evident in the disparity between his statement for *Possibilities* and a prefatory apologia for automatic drawing by Hayter during the winter of 1947–48.

Though the two were connected by Pollock's claim, "When I am *in* my painting, I'm not aware of what I'm doing," Hayter was clearly referring to an intimate motor activity of the hand while the artist was seated (in virtual accordance with the modus operandi proposed by Breton in 1924).[61] In contrast, Pollock was talking about bodily activity, which had been activated when he had laid out the canvas for *The Key* (illustrated in *Possibilities*) on the bedroom floor of his house in Springs.[62] Here, indeed, was one key to his poured paintings the next year. "On the floor I am more at ease," he claimed. "I feel nearer, more a part of the painting, since this way I can walk around it, work from the four sides and literally be *in* the painting." Pollock relinquished the comfortable armchair that Breton had recommended for automatism in order to "draw up the scale of vision," commensurate with "the marvels" that a "wild eye" perceived.[63]

In this vision of Surrealist painting, Breton closed his rhetorical sweep with a challenge, and his 1928 call for a visual Surrealism was no less compelling in 1945, when *Surrealism and Painting* was published by Brentano's in New York.[64] Pollock's "wildness" did not derive from Indian sand painting, even though his "pure painting" gained license from that ritual. Their chants requiring years of training, Navaho shamans drew culturally prescribed images through the refined disposition of material sifted through their fingers. In an "apprenticeship" no less arduous, and no less attentive to cultural demands (often conflicting), Pollock had drawn upon the unconscious for almost a ten-year span.

Whereas his statement for *Possibilities* in 1947 included tacking "the unstretched canvas to the hard wall," which remained a rather conventional alternative to stretching a canvas on an easel, by 1950 Pollock was accustomed to rolling out his large canvases on the studio floor. By 1950, too, he could add, "I don't work from drawings or color sketches. My painting is direct." His shift to the floor decisively eliminated the possibility of paint running down a vertical canvas (as in some of Gorky's paintings) for a chance effect. "I *can* control the flow of the paint," he insisted in his filmic voice-over. "There is no accident." The horizontal canvas also insured a "direct" painting by allowing Pollock the freedom to use his entire body in addressing the expanse before him. His version of automatism came to involve not just the hand, or hand and wrist, or even the extended arm, but the entire body, as his movements of applying paint became "dancelike," in the recall of Hans Namuth.[65] In the process, Pollock moved from the intimacy of automatic drawing to a scale that met Breton's Surrealist challenge.

On that memorable occasion when the photographer first saw Pollock paint, the canvas on the studio floor was presumably finished when they went out to the studio to take a look. That Pollock resumed painting suggests that he was visually negotiating with what he had poured on the canvas. Here was a phase of self-consciousness with regard to the canvas after a " 'get acquainted' period" of automatism that he had mentioned in *Possibilities*. Here, then, Pollock returned to the surface in making aesthetic decisions, and as he would soon say in his voice-over, "When I am painting I have a general notion as to what I am about."

The impulse is to smooth out the inconsistency, to suggest that Pollock gained fluency by the time of his collaboration with Namuth, such that he had taken control of the automatic process in making large paintings that would be exhibited as art in the Betty Parsons Gallery. That, of course, was the intended impression of the film, in which Pollock even downplayed his unusual method by claiming that "technique is just a means of arriving at a statement." Yet it was precisely "technique," a term that seems inadequate for Pollock's hard-earned modus operandi, that rendered his "statement" so culturally indeterminate at the time. Pollock himself acknowledged his paintings' anomalous status betwixt and between easel painting and the mural—a new sort of wall painting done on the floor.[66]

Unlike Motherwell, who transgressed the anti-art dictates of Surrealism to celebrate a common Symbolist aesthetic in his art, Pollock worked in the interstices of therapy, automatism, and art, where his poured paintings sustained a powerful liminality on the threshold between art and creation. By virtue of our imperfect knowledge of how he painted, we sense that his own origins are dramatized, a concern that dated back to the early myth paintings. Unlike an oil such as *Birth*, for example, which is expressive, perhaps even emotionally overwrought, but most certainly illustrative, Pollock eventually discovered the art of creation (see Fig. 84). His own life rode that line.

Conclusion: Out of the Labyrinth

I n the spring preceding Hans Namuth's film project, Parker Tyler radically revised his low estimate of Jackson Pollock for the *Magazine of Art*. The article apparently became one of Pollock's favorites. No longer insulting the painter as a purveyor of "baked macaroni," Tyler now thought that the poured canvases looked "as fresh as though painted last night." Sensitive to Pollock's silence before visual art, Tyler praised him for his "impregnable language of image, as well as beautiful and subtle patterns of pure form." [1] Indeterminate secrets prevailed, and Tyler clearly admired the guardian of those "multiple labyrinths."

Despite an allusion to the Minotaur in the title of his essay, "Jackson Pollock: The Infinite Labyrinth," and to automatism in acknowledging the painter's "calligraphy," Tyler did not explicitly mention Surrealism. And although he claimed that the "fluidity of the poured and scattered paint places maximum pressure against conscious design," he also argued that Pollock's exploitation of chance did not negate composition. "And yet the design *is* conscious," he insisted, "the seemingly uncomposable, composed." [2] With this paradox, which went against Breton's insistence upon surrender to the unconscious (and chance) in automatic writing, Tyler simply reaffirmed his own preference for a melding of the conscious and the

unconscious in the act of painting.[3] So by his pourings, Pollock maximized chance, which nonetheless involved "conscious design."

Tyler's essay was suggestive of the ways that the Surrealists were effaced from the American record even while significant traces lingered in the wake of their departure. Tyler interpreted Pollock through a scrim of Surrealist ideas and attitudes that concealed their source. The two Americans intersected favorably at a moment when Pollock himself was also fabricating his identity as an American painter—an identity, however, forged on an adaptation of Surrealist automatism. In each instance critic and painter had transformed Surrealism by an intense assimilation of its ideas. The metamorphoses were their own.

This process of erasure was evident from the very beginning. In the early 1930s Malcolm Cowley had displaced the still active Surrealists with his focus on the Parisian Dadaists in his memoir of the 1920s. Since he was referring back to a time before the 1924 Surrealist manifesto, his account was congruent with events. Yet by ignoring the Surrealists and their persistent challenge to the French Communist Party, Cowley implied their irrelevance in a polemic that tendentiously misrepresented Dada and Surrealism alike. Cowley divested his American "exiles" of their European baggage as he entreated them to return to their homeland, devastated by the Depression. By sheer dint of imagination, the Surrealists were banished from the American cultural terrain, both at the outset and at the conclusion of their encounters with American artists and writers.

Nothing might have been so Surreal as the Surrealists unwittingly becoming their own "grand invisibles," something like Molière's characters speaking prose all along, had not Dali burst upon New York during the 1930s. This fallen angel of the Surrealists became the corrupt darling of high fashion and the media. Yet a preoccupation with Dali as AVIDA DOLLARS threatens to overshadow the process of cultural assimilation that brought him commercial success. Surrealism was the first avant-garde movement that was avidly consumed by the American mass media and broadly disseminated to the public in a sanitized, that is, in a depoliticized guise. The eccentric, if not "crazy," Dali displaced the politically radical Breton in America during the 1930s.

Ironically, Surrealism and Dali were anathema to the Stalinist left even as left-leaning American artists mined him for visual models in fabricating a radical mode of painting. The volatile encounter between Dali's

Surrealism and Socialist Realism (not without its own corruptive element) was eventually consumed by the Second World War. What has endured to our day has been the legacy of media consumption of the avant-garde. Surrealism happened to be the first target.

In retrospect, Breton's consistent opposition to fascism forecast an inevitable conflict, which reached its climax during the Second World War. Even peacetime encounters were sporadically violent, as the Surrealists (Man Ray among them) discovered when fascist thugs trashed a Surrealist exhibition held in conjunction with a viewing of the film *L'Age d'Or* in 1930. Violence, however, engulfed France in 1939, when Breton was forced to flee Paris for Marseilles. The dispersal of the Surrealists worldwide led many of the visual artists to New York, where group activity under Breton's direction took unexpected forms.

The war itself absorbed the attention of everyone, especially those who had been driven from their European homelands. In exile, they anxiously awaited a favorable outcome that was never certain, biding time in a political limbo, not entirely helpless but not able to participate fully in the war effort. In this context, Breton was simply one exile among many, as in a group portrait for *Fortune* magazine. The war necessitated a cessation of Surrealist sectarianism, and called instead for an ecumenicism, such that Mondrian was included in a Surrealist exhibition—a turn of events that neither party could have foreseen or would have countenanced under normal circumstances.

Yet Breton remained the leader of the Surrealists, and Surrealism was the last European avant-garde movement that had managed to survive the war by infiltrating New York. Prewar political hostilities among the Surrealists themselves had to be laid aside, Breton and Ernst reluctantly accepting a truce. The ever-independent Duchamp became a willing accomplice in Breton's New York projects. Matta was but a momentary pretender to the throne. Whatever the depredations of war, the Surrealists felt an overpowering need to combine forces once again in common opposition to Axis powers.

A state of suspension nonetheless prevailed. Breton's political trajectory for Surrealism had been interrupted by the war and brought to earth by Trotsky's death in 1940. No matter how pressing the need for Surrealist pronouncements, if for no other reason than to show signs of life, a new manifesto had to be deferred until the war was over. The situation was so

conditional that it was impossible to set a new course until the destruction ended. The only action possible was incessant opposition to the enemy: VVV. And there were rallying points: showing the "First Papers of Surrealism" signaled the successful crossing of the Surrealists from Europe to America.

Their success was subtly transferred to American writers and artists with avant-garde aspirations. The manic instabilities of wartime Manhattan permitted Americans to subvert longstanding cultural disparities that would have ordinarily favored the Surrealists as European envoys, extraordinary circumstances exerting a kind of cultural judo against such strengths. An aura of avant-gardism accompanied the arrival of the Surrealists in New York, and yet their presence relieved Americans of the need for their own movement and gave permission for shifting alliances, where a fluid exchange of ideas became possible. At the same time, American painters readily socialized in the lofts and cramped apartments that served as their studios, while Parisians felt deprived by the lack of their customary gathering places in Manhattan. The Surrealists regained their cafés when they returned to France, only to discover that they had lost their art in transit. The cultural advantage had invisibly shifted to the United States.

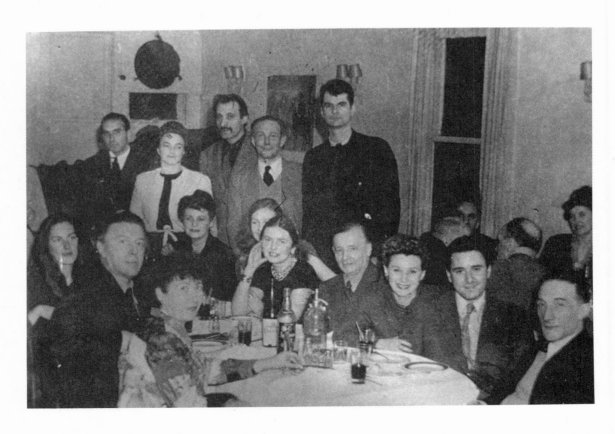

PREFACE

1. For an account of this episode in American cultural history, see Dickran Tashjian, *Skyscraper Primitives: Dada and the American Avant-Garde, 1910–1925* (Middletown, Conn.: Wesleyan University Press, 1975).

2. André Breton, *Manifesto of Surrealism* (1924), in André Breton, *Manifestoes of Surrealism,* tr. Richard Seaver and Helen R. Lane (Ann Arbor: University of Michigan Press, 1969), 26. Henceforth cited as *First Manifesto.*

3. Daniel Aaron, "The Thirties—Now and Then," *American Scholar* 35, no. 3 (Summer 1966): 490–494.

4. A failure to recognize these circumstances of cultural interaction plagues Jeffrey Wechsler in *Surrealism and American Art, 1931–1947* (New Brunswick: Rutgers University Art Gallery, 1977), an otherwise useful survey of American artists attracted to Surrealism. Wechsler has difficulty in determining the significance of the relationship between Surrealism and American art. He concludes, "Historically, in this country, Surrealism simply had terrrible timing . . . no matter which end of the chronological stick Surrealism grasped it was the wrong one" (63). Social Realism in the 1930s, Abstract Expressionism in the 1940s: Surrealism didn't stand a chance. Wechsler was left to codify individual American responses according to Surrealist techniques, a useful research, perhaps, for an art historian, but hardly the means for determining what Surrealism was all about in America.

5. For the standard theoretical discussion of the avant-garde and its defining characteristics, see Renato Poggioli, *The Theory of the Avant-Garde* (New York: Harper and Row, 1971). For the most recent analysis of theories on the avant-garde, see Paul Mann, *The Theory/Death of the Avant-garde* (Bloomington: Indiana University Press, 1991).

6. For a definition of culture predicated on conflict, see Anthony F. C. Wallace, *Culture and Personality* (New York: Random House, 1969). According to Wallace, "Culture . . . is characterized internally not by uniformity, but by diversity of both individuals and groups, many of whom are in continuous and overt conflict in one sub-system and in active cooperation in another" (28).

INTRODUCTION

1. Breton, *First Manifesto*, 20.

2. Breton's political activity on the left was informed by ideas and principles that have been taken seriously only recently. See, for example, Helena Lewis, *The Politics of Surrealism* (New York: Paragon House, 1988) and Malcolm Haslam, *The Real World of The Surrealists* (New York: Rizzoli, 1978). For a snide dismissal of Surrealist politics, see Herbert S. Gershmann, *The Surrealist Revolution in France* (Ann Arbor: University of Michigan Press, 1974).

3. Breton, *First Manifesto*, 26.

4. Breton, Declaration of 27 January 1925, in André Breton, *What Is Surrealism? Selected Writings*, ed. Franklin Rosemont (New York: Monad Press, 1978), 317.

5. Breton, *Legitimate Defense*, in *What Is Surrealism?*, 39, n. 6.

6. Breton, "Speech to the Congress of Writers," in *Manifestoes of Surrealism*, 240.

7. Joseph Freeman, a political radical who observed the Parisian scene after graduating from Columbia University, went so far as to claim that Americans made up a "ghetto" in Paris, no different from those of European immigrants in major American cities (*An American Testament* [New York: Farrar & Rinehart, 1936], 174).

8. Marsden Hartley, "Sur-realism—and Dali, or—Disorderly House," pp. 1–2, Archives of The Museum of Modern Art, New York.

9. The flourishing bohemia of Greenwich Village should not be confused with a community of avant-gardists or an avant-garde movement. The avant-garde and bohemia are not necessarily identical phenomena. Dating back in the United States at least to the Civil War, bohemias developed in the cities, where the diversity of life could tolerate unconventional behavior. Freedom

from daily labor, drinking, socializing, unusual dress, sexual license, and drugs all point to a deviation from the prevailing norms of the American Protestant ethic. With play at its center, bohemia understandably attracted artists, who were also relegated there by a society that expected its artists to be entrepreneurs in a weak marketplace, while failing to provide a strong system of patronage. Bohemia, then, has been congenial to the avant-garde but it has not been comprised solely of artists, let alone avant-gardists. Moreover, despite its dissent from the dominant society and its culture, bohemia has not necessarily been avant-garde in its own cultural orientation. The avant-garde has had its own communal requirements involving the means for innovation to gain a social discourse. For the standard history of American bohemia, see Albert Perry, *Garret and Pretenders* (New York: Dover Publications, 1960).

10. René Daumal, "French Letter," *Hound and Horn* VII, no. 2 (January–March 1934): 270.

11. To borrow a phrase from the anthropologist Victor Turner, the social disruptions of the Second World War might be thought to have engendered a "liminal" phase in American history, in between stable social structures (peacetime as opposed to wartime). This period of grave uncertainty creates a sense of communitas unlike "normal" social relations, mediated by institutions and a hierarchical order. For an exposition and application of these theoretical possibilities, see Turner, *Dramas, Fields, and Metaphors: Symbolic Action in Human Society* (Ithaca: Cornell University Press, 1974).

12. William Carlos Williams, "Comment," *Contact*, no. 2 (January 1921): n.p.

CHAPTER 1: FIRST AMERICAN PHASES OF SURREALISM

1. Eugene Jolas, "Rambles Through Literary Paris," Paris edition of the *Chicago Tribune Sunday Magazine*, 8 June 1924, p. 2. This magazine issue is henceforth cited as Paris *Tribune*. For an anthology of writing from the Paris *Tribune*, see *The Left Bank Revisited: Selections from the Paris Tribune, 1917–1934*, ed. Hugh Ford (University Park, Pa.: Pennsylvania State University Press, 1972).

2. Jolas, "Rambles Through Literary Paris," Paris *Tribune*, 31 August 1924, p. 2; "Rambles Through Literary Paris," Paris *Tribune*, 1 June 1924, p. 2. For Goll's version of Surrealism, see "Une réhabilitation du surréalisme," *Journal Littéraire*, 16 August 1924; the Surrealists around Breton responded with a collectively signed letter, "Encore le surréalisme," *Journal Littéraire*, no. 18 (23 August 1924): 8. Paul Dermée also laid claim to Surrealism, but Jolas devoted his attention to Goll, a fellow Alsatian.

3. Jolas, "Rambles Through Literary Paris," Paris *Tribune*, 19 October 1924, p. 2; "Rambles Through Literary Paris," Paris *Tribune*, 12 October 1924, p. 2.

4. Jolas, "Rambles Through Literary Paris," Paris *Tribune*, 19 October 1924, p. 2. In early October 1924, before André Breton's first *Manifeste du Surréalisme* was published later in the month, Goll's "Manifeste du Surréalisme" appeared in his short-lived journal, *Surréalisme*, no. 1 (October 1924): n.p. Claire Goll has recalled a riot at a recital of "Danses Surréalistes" sponsored by her husband (hence an encroachment upon Breton's territory) at the Théâtre du Champs-Elysées. Breton apparently never forgot the black-eye Goll inflicted in the fracas (Claire Goll, "Goll et Breton," *Europe*, no. 475–476 [November–December 1968]: 108–110).

5. Jolas, "Rambles Through Literary Paris," Paris *Tribune*, 21 December 1924, p. 5; "Rambles Through Literary Paris," Paris *Tribune*, November 30, 1924, p. 5; "Rambles Through Literary Paris," Paris *Tribune*, 31 May 1925, p. 5.

6. Jolas, "Rambles Through Literary Paris," Paris *Tribune*, 5 July 1925, p. 5. Jolas quoted from Breton's statement, "Pourquoi je prends la direction de la révolution surréaliste," in *Révolution Surréaliste*, no. 4 (15 July 1925): 1–3.

7. Jolas, "Rambles Through Literary Paris," Paris *Tribune*, 5 July 1925, p. 5.

8. Ibid.

9. Jolas, "Rambles Through Literary Paris," Paris *Tribune*, 31 May 1925, p. 2; "Rambles Through Literary Paris," Paris *Tribune*, 29 November 1925, p. 5; "Rambles Through Literary Paris," Paris *Tribune*, 5 July 1925, p. 5.

10. For a detailed account of the intricacies of the bearded-heart episode and Breton's aborted Congress of Paris on modernism, see William Camfield, *Francis Picabia: His Art, Life and Times* (Princeton: Princeton University Press, 1979), 150–214.

11. Matthew Josephson, "After and Beyond Dada," *Broom* II, no. 4 (July 1922): 347; "The Great American Billposter," *Broom* III, no. 4 (November 1922): 304–312.

12. Even an astute critic such as William Troy, who was at the wake of *The Little Review*, thought that the editors "had placed their emphasis solely on literary experimentation, without considering the nature or value of the experience available for the artist in America of the period" ("The Story of the Little Magazines," *Bookman* 70 [January 1930]: 480).

13. For a detailed account of Dada in *The Little Review*, see Tashjian, "Dada in Amerika: Wein Verhaltnis zu *The Little Review*," in *Sinn aus Unsinn: Dada International*, ed. Wolfgang Paulsen (Bern und München: Francke Verlag, 1982), 265–276. For an account of the *Ulysses* trial, see Jackson Bryer, "Joyce, *Ulysses*, and *The Little Review*," *South Atlantic Quarterly* 66 (Spring 1967): 148–164.

14. Margaret Anderson, *My Thirty Years' War* (New York: Covici, Friede, 1930), 261.

15. René Crevel, "Which Way," *Little Review* IX, no. 4 (Autumn–Winter 1923–1924): 29–30.

16. Breton, *First Manifesto*, 29–30.

17. Crevel, "Which Way," *Little Review* IX, no. 4 (Autumn–Winter 1923–1924): 30–32, 34.

18. Letter from Matthew Josephson to Malcolm Cowley [March 1926], in the Cowley file, Matthew Josephson Papers, Beinecke Library, Yale University (hereafter Josephson Papers, Beinecke Library). For a detailed account of Josephson's role in American Dada, see Tashjian, *Skyscraper Primitives*, 116–142. For a biography of Josephson, see David Shi, *Matthew Josephson Bourgeois Bohemian* (New Haven: Yale University Press, 1981). George Ribemont-Dessaignes's companion piece to Josephson's open letter simply fanned the flames. Speaking ironically "In Praise of Violence," Ribemont-Dessaignes attacked Dada as self-destructive and hence ephemeral except for its survival in a sexual guise as Surrealism. "Is it not merely Dadaism going on?" he asked. Duplicity, mystification, pseudorevolt, immaturity: "It matters little after all," he concluded ("In Praise of Violence," *Little Review*, XII, no. 1 (Spring–Summer 1926): 40–41.

19. Josephson, "A Letter to My Friends," *Little Review* XII, no. 1 (Spring–Summer 1926): 17–19.

20. Letter from Matthew Josephson to Malcolm Cowley [September 1927], Cowley file, Josephson Papers, Beinecke Library. For a study of the early American reaction to Freud, see Nathan G. Hale, Jr., *Freud and the Americans: The Beginnings of Psychoanalysis in the United States, 1876–1917* (New York: Oxford University Press, 1971). For a brief discussion of Freud in France, see Paul Roazen, *Freud and His Followers* (New York: Alfred A. Knopf, 1975), 449–450. Roazen argues that, in addition to French antipathy toward Germany, the French had their own native tradition of psychoanalysis. Moreover, Pierre Janet (who might have been a source for Breton's automatic writing) became a rival of Freud (74). For a discussion of Freud and the Surrealists, perennially viewed as a problematic relationship, see Jack J. Spector, *The Aesthetics of Freud* (New York: McGraw-Hill, 1974), 146–182.

21. Josephson, "Microcosm: Concerning Super-realism," in Miscellaneous Fragments file, Josephson Papers, Beinecke Library.

22. Josephson, "Microcosm: Concerning Super-realism"; Breton, *Second Manifesto of Surrealism*, in *Manifestoes of Surrealism*, 177.

23. Josephson, "Letter to My Friends," *Little Review* XII, no. 1 (Spring–Summer 1926): 18.

24. Josephson, "Microcosm: Concerning Super-realism," n.p.

25. Ibid.

26. Fifteen articles appeared prior to the publication of Malcolm Cowley's *Exile's Return* in 1934, beginning with "Connecticut Valley," *New Republic* (28 January 1931): 297–299, and ending with "Art Tomorrow," *New Republic* (23 May 1934): 34–36. The only article that did not appear in *The New Republic* was "War in Bohemia," *Scribner's Magazine* (January 1933): 56–59.

27. The turning point for Cowley probably came in the winter of 1932 when he joined forces with Waldo Frank (his anti-Dada nemesis from a decade previous) and a delegation of writers to deliver supplies to striking coal miners in Pineville, Kentucky. In March Cowley made his report from the interior for *The New Republic*. Frank and others had been beaten, and the delegation forcibly driven out of Harlan County by those who supported the mine operators. "Class warfare" raged "nakedly" throughout southwestern Kentucky. Cowley shifted his focus entirely from the artist to the laboring classes: They needed to organize in their strife-torn communities and to fight for their freedom at a grassroots level ("Kentucky Coal Town," *New Republic* LXX, no. 900 [2 March 1932]: 67) .

28. Edmund Wilson to Burton Rascoe, 2 October 1931, in *Letters on Literature and Politics, 1912–1972*, ed. Elena Wilson (New York: Farrar, Straus and Giroux, 1977), 215.

29. Cowley, *Exile's Return*, 168; "Exile's Return," *New Republic* LXVIII, no. 877 (23 September 1931): 153.

30. "The Religion of Art III: The Death of a Religion," *New Republic* LXXVII, no. 998 (17 January 1934): 275. For Crosby's biography, see Geoffrey Wolff, *Black Sun: The Brief Transit and Violent Eclipse of Harry Crosby* (New York: Random House, 1976).

31. Cowley, *Exile's Return*, 288; Malcolm Cowley, *The Dream of the Golden Mountains: Remembering the 1930s* (New York: Viking, 1980), 224.

32. Cowley, *Exile's Return*, 13, 300–303.

33. For a general history of *transition*, see Dougald McMillan, *transition: The History of a Literary Era, 1927–1938* (New York: George Braziller, 1975). For a recent anthology of *transition* material, see *in transition: A Paris Anthology*, intro. Noel Riley Fitch (London: Secker & Warburg, 1990). For a brief account of the Sevire Press, which published *transition*, see Hugh Ford, *Published in Paris: American and British Writers, Printers, and Publishers in Paris, 1920–1939* (New York: Macmillan, 1975), 311–318.

34. Robert Sage, "Farewell to *transition*: A Letter to Eugene Jolas from Robert Sage," *transition*, nos. 19–20 (June 1930): 373.

35. According to McMillan, "Even after [Jolas] returned to Paris to begin *transition*, he came home one day after a discussion with some members of the group and told his wife, 'I almost signed up today,' meaning that he nearly took the formidable step of joining the group officially and thus subjecting himself to Breton's regulations" (*transition: History of a Literary Era*, 81.)

36. Jolas and Elliot Paul, "Suggestions for a New Magic," *transition*, no. 3 (June 1927): 178–179.

37. Jolas, "The Innocuous Enemy," *transition*, nos. 16–17 (June 1929): 209.

38. Jolas, "Revolt Against the Philistine," *transition*, no. 6 (September 1927): 177.

39. Jolas, "On the Quest," *transition*, no. 7 (December 1927): 191–192 .

40. Wyndham Lewis, "The Revolutionary Simpleton," *Enemy*, no. 1 (January 1927): 38, 51–52, 65; "The Paris Address," *Enemy*, no. 2 (September 1927): xxvii. *Blast* was first published in June 1914, the second and last issue in July 1915.

41. Josephson, "Open Letter to Mr. Pound and the other 'Exiles'," *transition*, no. 13 (Summer 1928): 99, 101, 102.

42. Mike Gold, "3 Schools of U.S. Writing," *New Masses* 4, no. 4 (September 1928): 13–14; "Let It Be Really New!" *New Masses* 1, no. 2 (June 1926): 20–26.

43. Gold, "3 Schools of U.S. Writing," *New Masses* 4, no. 4 (September 1928): 13–14.

44. Jolas, Paul, and Sage, "First Aid to the Enemy," *transition*, no. 9 (December 1927): 165.

45. Ibid., 167.

46. Jolas, "Notes," *transition*, no. 14 (Fall 1928): 182.

47. Jolas, "Super-Occident," *transition*, no. 15 (February 1929): 13; "Notes," *transition*, no. 14 (Fall 1928): 182–183.

48. Jolas, "Transatlantic Letter," *transition*, no. 13 (Summer 1928): 274.

49. Jolas, "Revolution of the Word: Proclamation," *transition*, nos. 16–17 (June 1929): 13.

50. Jolas and Paul, "A Review," *transition*, no. 12 (March 1928): 144.

51. Jolas, Paul, and Sage, "First Aid to the Enemy," *transition*, no. 9 (December 1927): 175; "Transatlantic Letter," *transition*, no. 13 (Summer 1928): 277.

52. Jolas, "Necessity for the New Word," *Modern Quarterly* 5 (Fall 1929): 274–275.

53. Breton, "Introduction to the Discourse on the Dearth of Reality," *transition*, no. 5 (August 1927): 129.

54. Jolas, "Notes on Reality," *transition*, no. 18 (November 1929): 15, 19.

55. Ibid., 20.

56. C. G. Jung, "Psychology and Poetry," *transition*, nos. 19–20 (June 1930): 41, 36, 38.

57. Jolas, "Literature and the New Man," *transition*, nos. 19–20 (June 1930): 15, 18, 19.

58. Jolas, "Announcement," *transition*, nos. 19–20 (June 1930): 369. Upon its return to publication in March 1932 (issue 21), *transition* appeared sporadically as an annual for the first few years and then as a quarterly in its final numbers.

59. Jolas, "Literature and the New Man," *transition*, nos. 19–20 (June 1930): 14; Jolas, "The Dream," *transition*, nos. 19–20 (June 1930): 47. In his denial, Jolas was responding to Ivor Winters, who indicted "the delirium in vacuo of the super-realists," among others, who negate "all principles of judgment, discrimination, and organization." ([Untitled], *Gyroscope* [May 1929], n.p.).

60. Jolas, "The King's English Is Dying: Long Live the Great American Language," *transition*, nos. 19–20 (June 1930): 144; Jolas, "From a Letter," *transition*, no. 22 (February 1933): 113; Jolas, "*Transition*: An Epilogue," *American Mercury* XXIII, no. 90 (June 1931): 188. After his return in 1932, Jolas was less willing to be generous toward the Surrealists. He claimed that his Revolution of the Word "owes nothing to Surrealism" ("What Is the Revolution of Language," *transition*, no. 22 [February 1933]: 125). In the strictest sense, Jolas was correct, although the Surrealists did not relinquish their interest in language in exploring the unconscious. More crucially, Jolas would not have come up with *his* revolution had there not been the ongoing conflicts of the Surrealists on the communist left.

61. See Jolas's comments in "Documents: Le Poète peut-il changer la face du monde, Radio-Dialogue de Gottfried Benn et Johannes R. Becher, présentation de Eugene Jolas," *Nouvelle Age*, no. 8 (August 1931): 748; "Poetry Is Vertical," *transition*, no. 21 (March 1932): 149.

CHAPTER 2: THE FIRST PAPERS OF SURREALISM

1. "First Papers of Surrealism," organized by André Breton and Marcel Duchamp, and sponsored by the Coordinating Council of French Relief Societies, ran from 14 October to 7 November 1942 at 451 Madison Avenue, New York.

2. "French Fair Closes With Record Crowd," *New York Times*, 16 November 1931, p. 7. Even in Paris, American journalists remained blind to Surrealist

activity. "There is very little to be seen at the moment," according to Ruth Green Harris, "In The Paris Art World," *New York Times*, 15 November 1931, sec. 8, p. 15. In New York, critics may have been preoccupied with the Whitney Museum of American Art, which opened on 17 November 1931 at a new West 8th Street location.

3. "Puts Future of U.S. Art Up to Women," *Hartford Courant*, 2 December 1931, p. 5; "Whistler Etchings Barred as Obscene by Customs Agent," *Hartford Courant*, 12 November 1931, p. 11.

4. "Super-Realist Works Shown at Memorial," *Hartford Courant*, 16 November 1931, pp. 1, 4. Along with the exhibition, René Clair's film *Le Million* was run, and elsewhere some Surrealist photographs and books, "of which some examples have been placed on the shelf in the reference room of the Hartford Public Library where for the last few days borrowers of books have found placed in them book markers bearing printed reminders of the coming show" (*Hartford Courant*, 13 November 1931, p. 3).

5. Julien Levy, *Memoir of an Art Gallery* (New York: G. P. Putnam's Sons, 1977), 79–80. Deborah Zlotsky argues that Austin was not merely a passive partner in mounting the Surrealism exhibition at the Wadsworth but rather took active part in conceptualizing and gathering works for the exhibition (" 'Pleasant Madness' in Hartford: The First Surrealist Exhibition in America," *Arts Magazine* 60, no. 6 [February 1986]: 55–61). For an account of Austin and his curatorial accomplishments at the Wadsworth, see *A. Everett Austin, Jr.: A Director's Taste and Achievement* (Hartford: Wadsworth Atheneum, 1958). Also see Nicholas Fox Weber, *Patron Saints: Five Rebels Who Opened America to a New Art* (New York: Alfred A. Knopf, 1992), 133–176.

6. According to James T. Soby, "It was equally inevitable that Chick should very early have championed the surrealist artists. Fantasy in art had always held an immense appeal for him, and he himself had been a practicing magician since childhood." ("A. Everett Austin, Jr., and Modern Art," in *A. Everett Austin, Jr.: A Director's Taste and Achievement*, 29).

7. Levy, *Memoir of an Art Gallery*, 80.

8. Excerpts from Samuel Putnam's *European Caravan* were gathered in the Wadsworth foldout under the heading of "Notes on Surrealism." The anthology, which appeared just after the opening of "Newer Super-Realism," was compiled and edited by Samuel Putnam, Maida Castelhun Darnton, George Reavey, and J. Bronowski (*The European Caravan: An Anthology of the New Spirit in European Literature* [New York: Brewer, Warren and Putnam, 1931]). The excerpt from Breton's "Soluble Fish" was simply taken from *European Caravan*, 172. Cary Ross's poem was entitled "Nothing." Previously, "Parade

Internationale," another poem Ross had written, appeared in *transition*, no. 9 (December 1927): 156–158. Although Gertrude Stein's writing might bear some affinity to Surrealism because of its nonsensical quality, she was never a member of the group, and it is difficult to understand why Lynes chose her work to title his photomontage.

9. Samuel Putnam, "The After-War Spirit in Literature," *European Caravan*, 24–26.

10. Ibid., 34–35.

11. In his preface to the Surrealist number of *This Quarter*, Edward Titus confessed: "If there are any gaps apparent in his [Breton's] essay, the fault is ours, not his. It is ours, because . . . we made it clear that we should not mind in the least what he might say in his exposé of surrealism, nor what material he would give us to print in this issue, so long as he eschewed politics and such other topics as might not be in honeyed accord with Anglo-American censorship usages, although entirely permissable in France. He generously agreed, but his happiness was not complete. *Nostra culpa*" ("Editorially: By Way of Introducing This Surrealist Number," *This Quarter* V, no. 1 [September 1932]: 6). In his essay "Surrealism Yesterday, To-day and To-morrow," Breton drily noted that he was not about "to over-estimate an opportunity to make ourselves heard only in undertones" (*This Quarter* V, no. 1 [September 1932]: 8).

12. Levy, *Memoir of an Art Gallery*, 80–81.

13. Ibid., 82–83.

14. Matthew, Josephson, "The Superrealists," *New Republic* 69, no. 896 (3 February 1932): 321–322.

15. Levy, *Memoir of an Art Gallery*, 79–80. Levy's flexibility in Breton's absence was subject to criticism. In a review of the exhibition, John Becker raised the issue: "I do not know what prompted Mr. Levy's selection for his current exhibition. It is likely that some of the paintings which he would have shown were inaccessible: perhaps others were thrust upon him; perhaps the inter-eclecticism of the surréaliste group with other schools of contemporary painters makes a cleaner distinction impossible. At any rate, no matter the cause, there are omissions and confusions." He noted that Miró and Masson were missing, while a seventeenth-century Dutch landscape entitled *Ambiguous Subject* was "novel" and "charming" but not Surrealist in quality ("Surréalisme: The Exhibition at the Julien Levy Gallery," *Fifth Floor Window* 1, no. 3 [February 1932]: n.p.).

16. For a biography of Barr, see Alice Goldfarb Marquis, *Alfred H. Barr, Jr., Missionary for the Modern* (Chicago: Contemporary Books, 1989). The Harvard

connection was obviously an important one. Surrealism actually entered academia when Levy's Surrealism exhibition traveled to Cambridge, where it was sponsored by an undergraduate Harvard Society for Contemporary Art (founded in February 1929) from 14 February to 5 March 1932 (Weber, *Patron Saints*, 122–123).

17. Russell Lynes, *Good Old Modern: An Intimate Portrait of The Museum of Modern Art* (New York: Atheneum, 1973), 143.

18. Martha Davidson, "Surrealism from 1450 to Dada & Dali," *Art News* XXXV, no. 11 (December 12, 1936): 11, 13; Gertrude R. Benson, "The High Fantastical, *Magazine of Art* 30, no. 1 (January 1937): 48; Lewis Mumford, "The Art Galleries: Surrealism and Civilization," *New Yorker* XII, no. 44 (December 19, 1936): 68. It is very difficult to generalize about critical response to the show except to say that it was lively and impassioned. An account in the *New York Herald Tribune* was restrained, perhaps because the reporter thought that the "experts in modern art were unanimous in saying that the show was among the most important ever held in the history of the United States" ("Fur-Lined-Cup School of Art Gets Spotlight," *New York Herald Tribune*, December 9, 1936, A. Conger Goodyear file, Archives of The Museum of Modern Art). Yet commentary was often no less virulent or ridiculing than that for the 1913 Armory Show. The critics as "experts" were hardly unanimous.

19. Mumford, "The Art Galleries: Surrealism and Civilization," 68.

20. According to Russell Lynes, "Figuratively speaking, Barr was conducting a public course in the history of the modern movement, and his blackboard (or, possibly more accurately, projection screen) was the Museum (*Good Old Modern*, 141).

21. Charles W. Ferguson, "Art for Art's Sake," *Harper's Magazine* 175 (July 1937): 218.

22. Emily Genauer, "Real Value of Dada and Surrealist Show Rests on Few Good Pictures," *New York World-Telegram*, 12 December 1936 (Goodyear file, Archives of The Museum of Modern Art); Royal Cortissoz, "Art Turned Into a Veritable Puzzle," *New York Herald Tribune*, 13 December 1936 (Goodyear file, Archives of The Museum of Modern Art).

23. See the exchange of letters, 13 January 1937, from Barr to Goodyear, and 15 January 1937, from Goodyear to Barr, in the Goodyear file, Archives of The Museum of Modern Art. For Goodyear's account of the disagreement, see A. Conger Goodyear, *The Museum of Modern Art: The First Ten Years* (New York: 1943), 64.

24. Alfred H. Barr, Jr., ed., *Fantastic Art, Dada, Surrealism* (New York: The Museum of Modern Art, 1936), 8.

25. Ibid., 61.

26. Ibid., 9, 13.

27. Georges Hugnet, "Introduction," *Fantastic Art*, 14; Hugnet, "In the Light of Surrealism," *Fantastic Art*, 25, 36, 46, 52.

28. Hugnet, "Introduction," *Fantastic Art*, 9.

29. Hugnet, "In the Light of Surrealism," *Fantastic Art*, 52.

30. Mumford, "The Art Galleries: Surrealism and Civilization," *New Yorker*, 72.

31. "Surrealistic Art Called Foul Plot of Communists," *New York Herald Tribune*, 30 December 1936, Goodyear file, Archives of The Museum of Modern Art.

32. "Man Ray Finds Surrealism in Roosevelt Boat," *New York Herald Tribune*, 2 January 1937, Goodyear file, Archives of The Museum of Modern Art.

33. "Surrealistic Art Called Foul Plot of Communists," *New York Herald Tribune*, 30 December 1936 (Goodyear file, Archives of The Museum of Modern Art); Henry McBride, "Farewell to Art's Greatness: Modern Museum's Surrealism Says Goodby to All That—A Sensational Show," *New York Sun*, 12 December 1936 (Goodyear file, Archives of The Museum of Modern Art).

34. McBride, "Farewell to Art's Greatness."

35. Levy, *Memoir of an Art Gallery*, 80.

36. "Why Scranton?" *Art Digest* IX, no. 4 (15 November 1934): 10. For a survey of critical reactions to Blume's Carnegie Award, see "Critics Stirred by Awarding First Carnegie Prize to Surrealist," *Art Digest* IX, no. 3 (1 November 1934): 6–7. By the mid-1940s, Blume was engaged in automatic drawing (see Jeffrey Wechsler, *Surrealism and American Art, 1931–1947* [New Brunswick: Rutgers University Art Gallery, 1977], 69–70).

37. See René Crevel, *Mr. Knife and Miss Fork*, tr. Kay Boyle, with illustrations by Max Ernst (Paris: Black Sun Press, 1931). A portion of the novel was printed earlier as "Mr. Knife, Miss Fork" (*transition*, no. 18 [November 1929]: 242–251).

38. Salvador Dali, *The Secret Life of Salvador Dali*, tr. Haakon M. Chevalier (New York: Dial Press, 1961), 327.

39. Ibid., 330–331; for Caresse Crosby's account, see her memoir, *The Passionate Years* (New York: Dial Press, 1953), 318–322.

40. "Dali Has Exhibit at Julien Levy's, *Art News* XXXII (25 November 1933): 18; J. S., "Salvador Dali," *Art News* XXVIII (1 December 1934): 8.

41. See, for example, a headline for Nixola Greeley-Smith's article on the 1913 Armory Show: "An Alienist Will Charge You $5,000 to Tell You If You're Crazy: Go to the Cubist Show and You'll Be Sure of it For a Quarter" (New York *Evening World*, 22 February 1913 [Armory Show Papers, Archives of

American Art, Smithsonian Institution, Washington, D.C.] Hereafter AAA). For Greeley-Smith, insanity was a humorous possibility, a comic metaphor to attract the reader's attention. Yet the metaphor took a literal turn in Chicago, if we can believe the reportage of Caryl B. Storrs: "Gazing at Weird Work of the Cubists Is Rude Shock to One's Nervous System" ran the headline, with the following caption, "Tribune Critic Sees Chicago Exhibit—Feels Ill-Effects at Once" (Minneapolis *Tribune*, 6 April 1913 [Armory Show Papers, AAA]). If the American public in 1913 construed Cubist paintings as evidence of the craziness of modern artists, then the Surrealists some two decades later at The Museum of Modern Art simply corroborated that earlier notion. There were several instances of the sort offered humorously by Henry McBride: "Almost at the same moment two young men passed me on the stairway [in the Modern while viewing the exhibition], . . . and one of them had a wild look in his eyes. His friend asked him, in consternation, 'What's the matter?', and he replied, 'I don't know but I don't feel right'" ("Farewell to Art's Greatness: Modern Museum's Surrealism Says Goodby to All That—A Sensational Show," *New York Sun*, 12 December 1936, n.p.). The popularization of psychoanalysis in America, however, provided a certain Freudian grid through which viewers could be sanguine about what they saw.

42. Dali, *New York Salutes Me* (New York: 1934), tract reprinted in *La Vie publique de Salvador Dali* (Paris: Centre Georges Pompidou, 1980), 41.

43. A different account of the event is given in Paul C. Ray, *The Surrealist Movement in England* (Ithaca: Cornell University Press, 1971), 138–139. In this version the helmut was screwed on so tightly that it was removed only with great difficulty, almost asphyxiating Dali in the process.

44. The *New York Herald Tribune*'s report was summarized with the caption, "Not a Madman!" in *Art Digest* IX, no. 7 (1 January 1935): 16. *Un Chien Andalou* was shown the same evening and must have assuaged the disappointed crowd.

45. *New York Times*, 10 January 1935, 21; H. G. Johnson, "If You Were in New York," *Arts and Decoration* 43 (March 1935): 46. Before Dali's lecture, Levy asked the painter for his notes in order to facilitate an on-the-spot translation: "As I had these notes, I paid very little attention, and launched into translating what I thought was his speech—until, from the tittering and amused expressions of those in the audience who knew French, I realized he wasn't following the script of what he had told he would say and was, Dali-like, into something infinitely more shocking. Dali looked at me with spiteful glee. Those who understood French, including the indomitable dowager Mrs. Murray Crane, a trustee of the museum, giggled happily when they realized the

dilemma, followed by my hasty improvisation meant to clean up his risqué talk" (Levy, *Memoir of an Art Gallery*, 204).

46. H. G. Johnson, "If You Were in New York," 46.

47. "Mad 'Dream Betrayal' of New York Society at the Astounding Party to its Newest Idol," *New York Mirror*, Sunday Magazine Section, 24 February 1935, p. 11.

48. Ibid.; Dali, *Secret Life*, 337.

49. "Mad 'Dream Betrayal' of New York Society," *New York Mirror*, 10–11.

50. Dali, *Secret Life*, 331.

51. "New York as Seen by the 'Super-Realist' Artist, M. Dali," *American Weekly*, 24 February 1935, p. 3.

52. "New Reputations of the Year," *Vanity Fair* 42, no. 4 (June 1934): 39; "Examples of Surrealist Art by Salvador Dali," *Vanity Fair* 43, no. 6 (February 1935): 48–49. The two paintings illustrated were *Remorse* and *The Weaning of Furniture-Nutrition*.

53. Alfred Stern, who evaluated such proposals as "building the sphinx in glass," brought Woodner and Levy together. While it was Woodner who first proposed bringing Surrealism to the World's Fair, Levy came up with the ideas for a Surrealist pavilion. Woodner worked for three or four months on the project with Dali. Stern eventually became director of personnel for Dali's Dream of Venus, and hired the women (Interview with Ian Woodner and Alfred Stern, 8 January 1981).

54. Julien Levy and Ian Woodner, "Surrealist House: New York World's Fair 1939," c. March 1938, pp. 1–3, in Dali Dream of Venus File, 1939 New York World's Fair Archive, New York Public Library.

55. Ibid.

56. Memorandum from George P. Smith, Co-Director of Amusements, to Maurice Mermey, Director of Concessions, 14 July 1938, Dali Dream of Venus File, 1939 New York World's Fair Archive.

57. Herbert Drake, "Fun for All and It's All for Fun," *New York Herald Tribune*, World's Fair Section, 30 April 1939, p. 52; Charles Grutzner, "Building the Fair," *Brooklyn Eagle*, 26 March 1939 (1939 New York World's Fair Archive, New York Public Library).

58. Levy and Woodner, "Surrealist House: New York World's Fair 1939," 2.

59. "Dali's Surrealist Dream House at the World's Fair," *Vogue*, 1 June 1939, 56; Gerald Goode and James Proctor, press release, 15 June 1939, Dali Dream of Venus File, 1939 New York World's Fair Archive; "Life Goes to the World's Fair," *Life* 7, no. 1 (3 July 1939): 67; Margaret Case Harriman, "Profiles: A Dream Walking," *New Yorker* XV, no. 20 (1 July 1939): 22.

60. Gerald Goode and James Proctor, telegram, 30 May 1939, Dali Dream of Venus File, 1939 New York World's Fair Archive. For Levy's rather light-hearted account of the project, see *Memoir of an Art Gallery*, 205–223. Dali's view of his dream turned "nightmare" can be found in his *Secret Life*, 376–377.

61. *Memoir of an Art Gallery*, 218.

62. *New Yorker* XV, no. 20 (1 July 1939), p. 8; *Art Digest* XIII, no. 18 (1 July 1939): 12; Harriman, "Profiles: A Dream Walking," 22.

63. It fell to George P. Smith, Jr., Co-Director of Amusements, to deal with all the daily problems that arose with the Dali pavilion. His concerns can be charted through an amusing series of memoranda and letters in the Dali Dream of Venus File, 1939 New York World's Fair Archive.

64. Reprinted in Levy's *Memoir of an Art Gallery*, 220–221.

CHAPTER 3: SURREALISM IN
THE SERVICE OF FASHION

1. "Super-Realist Works Shown at Memorial," *Hartford Courant*, 16 November 1931, p. 1.

2. Allene Talmey, "Vogue's Spot-Light," *Vogue* 89 (15 January 1937): 69.

3. "The Surrealists," *Harper's Bazaar* (November 1936): 126.

4. George Platt Lynes, Portrait of Rosalind Russell; Man Ray, "Schiaparelli's Taffeta. Pagliacci Trousers in Yellow with a Changeable Orchid Coat"; "Writings in the Sand"; Carole de Peyster Kip, "Lip Service"; "The Surrealists"; "Miss June Preisser . . . ," *Harper's Bazaar* (January 1937): 55, 47, 82–83, 68–69, 63, 41.

5. Man Ray's fashion photographs have been collected in John Esten, *Man Ray Bazaar Years* (New York: Rizzoli, 1988).

6. "We Nominate for the Hall of Fame," *Vanity Fair* 18, no. 4 (June 1922): 76; "New Reputations of the Year," *Vanity Fair* 42, no. 4 (June 1934): 39. For a detailed study of Cornell's consuming interest in the ballet, see Sandra Leonard Starr, *Joseph Cornell and the Ballet* (New York: Castelli, Feigen, Corcoran, 1983).

7. *Vanity Fair* 19, no. 3 (November 1922): 50. *Vanity Fair* regularly commissioned Man Ray's forceful portraits for its "Hall of Fame" page, but accepted nothing out of the usual, the only exception being a photograph of the Marchesa Casati with her eyes blurred. The caption hastened to reassure readers that this "striking portrait" merely "intended to convey the Marchesa's gift of double vision"—here literally rendered. (Actually, the image was printed as

an afterthought since the marchesa whimsically approved an accidental take.) "Marchesa Casati: A Subject for Twenty Painters," *Vanity Fair* 19, no. 2 (October 1922): 46. After a sitting at the marchesa's hotel, Man Ray recounts: "That night when I developed my negatives, they were all blurred; I put them aside and considered the sitting a failure. Not hearing from me, she phoned me sometime later; when I informed her that the negatives were worthless, she insisted on seeing some prints, bad as they were. I printed up a couple on which there was a semblance of a face—one with three pairs of eyes. It might have passed for a Surrealist version of the Medusa. She was enchanted with this one—said I had portrayed her soul, and ordered dozens of prints. I wished other sitters were as easy to please" (*Self Portrait* [Boston: Little, Brown and Co., 1963], 161).

8. For a sweeping treatment of Surrealism and fashion, see Richard Martin, *Fashion and Surrealism* (New York: Rizzoli, 1987). Only a Scrooge could resist the marvelous blandishments of this study and the accompanying exhibition at the Fashion Institute of Technology in New York. My own view is more skeptical than Martin's, though I do not ascribe to economic determinism. After seeing the exhibition I decided to take a more temperate stance by balancing the constraints placed on Surrealism by the fashion industry's social and economic agenda against the creative possibilities derived from their intersection. For an account that focuses on fashion photography and Surrealism, see Nancy Hall-Duncan, *The History of Fashion Photography* (New York: Alpine Book Company, 1979), 84–121.

9. *Harper's Bazaar* (December 1936): 70.

10. *Harper's Bazaar* (April 1936): 152–3.

11. *Harper's Bazaar* (July 1939): 31.

12. Quoted in Paul Hill and Tom Cooper, "Interview—Man Ray," *Camera* (February 1975): 38.

13. *Harper's Bazaar* (1 September 1939): 72.

14. "Worn Out and Repaired," *Harper's Bazaar* (February 1937): 102–103.

15. "It's a Beautiful Day," *Vogue* 89 (15 January 1937): 75.

16. "Fur Copy Goes Surrealist," *New York Times*, 12 February 1937, p. 43; "Sloane *could* do this . . . ," *New Yorker* XII, no. 51 (6 February 1937): 57; P. H. Erbes, Jr., "Surrealism Invades Advertising (or Is It Vice Versa?)," *Printer's Ink* 205, no. 10 (3 December 1943): 23.

17. "Links Surrealism and Ads," *New York Times*, 23 January 1937, p. 32; Frank Caspers, "Surrealism in Overalls," *Scribner's Magazine* 104 (August 1938): 17–21; P. H. Erbes, Jr., "Surrealism Invades Advertising," 23.

18. "Surrealism or the Purple Cow," *Vogue* 88 (1 November 1936): 61.

19. Ibid., 146.

20. Ibid., 129, 131.

21. Ibid., 129, 130, 61.

22. Ibid., 131, 146.

23. Ibid., 130.

24. Ibid., 61, 131.

25. "Third Report from Paris Openings: Revolt Against Monotony," *Vogue* 88 (1 October 1936): 59; *Vogue* (1 October 1935): 76–77; *Vogue* (15 November 1935).

26. "Flaunting Their Faith," *Harper's Bazaar* (November 1936): 61.

27. Susan Sontag, "Fascinating Fascism," *New York Review of Books* (6 February 1975): 23–30.

28. *Harper's Bazaar* (June 1936): 47.

29. For Renato Poggioli, a leading theoretician of the avant-garde, fashion and the avant-garde go hand in hand. He rightly argues that "the chief characteristic of fashion is to impose and suddenly to accept as a new rule or norm what was, until a minute before, an exception or whim, then to abandon it again after it has been a commonplace, everybody's 'thing'." But he then claims that "the inevitable, inexorable destiny of each [avant-garde] movement [is] to rise up against the newly outstripped fashion of an old avant-garde and to die when a new fashion movement, or avant-garde appears" (*The Theory of the Avant-Garde,* [New York: Harper and Row, 1971], 79, 32).

 Poggioli is merely playing with words in glossing over basic differences between fashion and the avant-garde, thereby trivializing the latter. Avant-garde activity and fashion are not inevitably complicit despite many points of contact. The fashion industry creates a rationale for consumerism endorsing novelty and quality ("haute couture") so as to attract the wealthy and in the process create a sufficient demand for standardization ("ready-to-wear" and "off-the-rack") and subsequent mass consumption. In the economic network of art galleries, museums, patrons, and collectors, fashion serves a similar function of arbitrating for the public. But an avant-garde artist engaged in innovation does not necessarily seek the fashionable, which is often an indirect result of participation in the art market. Likewise, avant-garde movements may become "old-fashioned," but that social (and/or aesthetic) judgment is often predicated on the market and has little to do with genuine innovation or what was genuine innovation at a given moment.

30. Breton, *Second Manifesto of Surrealism,* 177.

31. *Harper's Bazaar* (March 1937): 77; *Harper's Bazaar* (February 1937): 3.

32. *Harper's Bazaar* (March 1934): 38, 41;
33. *Harper's Bazaar* (May 1936): 91.
34. For a survey of George Platt Lynes's photographs, see Jack Woody, *George Platt Lynes: Photographs, 1931–1955* (Los Angeles: Twelvetrees Press, 1980).
35. Hill and Cooper, "Interview—Man Ray," 38.
36. Hall-Duncan, *History of Fashion Photography,* 87.
37. *Harper's Bazaar* (October 1934): 52.
38. *Harper's Bazaar* (November 1936): 63; de Peyster Kip, "Lip Service," 68–69.
39. Man Ray, "The Age of Light," Tristan Tzara, "When Things Dream," and Rrose Selavy, "Men Before the Mirror," in *Photographs By Man Ray 1920 Paris 1934* (New York: Dover, 1979; Hartford: James Thrall Soby, 1934), n.p. For an informal biography of James Thrall Soby, see Nicholas Fox Weber, *Patron Saints: Five Rebels Who Opened America to a New Art* (New York: Alfred A. Knopf, 1992).
40. Man Ray, in *Minotaure,* no. 7, June 1935.
41. Man Ray, in *Harper's Bazaar* (May 1937): 88–89; (October 1936): 104–105; (October 1935): 108–109.
42. Man Ray, "Is Photography Necessary?" *Modern Photography* (November 1957): 126.
43. Breton, "The Visages of the Woman," n.p.; Man Ray, "Age of Light," n.p.; Man Ray, "Is Photography Necessary," 126.
44. Man Ray in *Harper's Bazaar* (January 1936): 88; Man Ray, *To Be Continued Unnoticed: Some Papers by Man Ray* (Beverly Hills, Ca.: Copley Galleries, 1948), 11.
45. The ensuing tensions had been rehearsed for American artists by a controversy following the publication of Carl Sandburg's *Steichen the Photographer* in 1929. Steichen had broken with Stieglitz, his former ally, in espousing the possibilities of commercial art. He paid the price when Sandburg's book was reviewed by Paul Strand ("Steichen and Commercial Art," *New Republic* LXII, no. 794 [19 February 1930]: 21) and Paul Rosenfeld ("Carl Sandburg and Photography," *New Republic* LXI, no. 790 [22 January 1930]: 251–253). Matthew Josephson's Dada argument that had opened the decade was here turned on its head. Where Josephson had claimed originality and vitality for advertising, Strand saw banality prevail. Neither Stieglitz nor Breton, however, could immunize their followers against the depredations of the fashion industry.
46. "New York as Seen by the 'Super-Realist' Artist, M. Dali," *American Weekly,* 24 February 1935, p. 3; "Dream Fashions by Salvador Dali," *Harper's Bazaar* (September 1935): 76–77.

47. Breton, *First Manifesto*, 15.

48. "Surrealist Background," *Vogue* (15 January 1936): 43; *Vogue* (1 September 1936): 63; "The Surrealists," *Harper's Bazaar* (November 1936): 126. According to Elsa Schiaparelli, "Dali was a constant caller. We devised together the coat with many drawers from one of his famous pictures. The black hat in the form of a show with a Shocking velvet heel standing up like a small column was another innovation. The Hon. Mrs. Reginald Fellowes, 'Daisy' to her friends, the most talked about well-dressed woman, the supreme word in elegance at that time, had the courage to wear it" (*Shocking Life* [New York: E. P. Dutton, 1954], pp. 114–115).

49. *Vogue* 89 (15 March 1937): 82; *Vogue* (1 June 1939): 33, 58–59.

50. *Esquire* (October 1944): 37.

51. "The Talk of the Town," *New Yorker* XII, no. 48 (16 January 1937): 13.

52. Dali, *The Secret Life of Salvador Dali*, tr. Haakon M. Chevalier (New York: Dial Press, 1961) 372.

53. Ibid.

54. *New York Daily Mirror*, 17 March 1939, p. 1; *New York World-Telegram*, 17 March 1939, p. 1; *New York Herald Tribune*, 17 March 1939, p. 1; "Art Changed, Dali Goes on Rampage in Store, Crashes Through Window Into Arms of Law," *New York Times*, 17 March 1939, p. 1.

55. "Life Calls on Salvador Dali," *Life* 10, no. 14 (7 April 1941): 98–101.

CHAPTER 4: MAN RAY ON THE MARGIN

1. According to Neil Baldwin, the first biographer of Man Ray, Emmanuel Radnitsky and his brother came up with "Ray" in 1911. The family reluctantly went along with their choice (*Man Ray: American Artist* [New York: Clarkson N. Potter, 1988], 16–17). Lisa M. Steinman uses the apt phrase, the "Americanization of modernism," in *Made in America: Science, Technology, and American Modernist Poets* (New Haven: Yale University Press, 1987), 39.

 I am indebted to the recent renewal in Man Ray scholarship, beginning with Rosalind Krauss and Jane Livingston, *L'Amour Fou: Photography and Surrealism* (New York: Abbeville Press, 1985), in which Man Ray plays a major role, then Neil Baldwin's biography, and finally a retrospective exhibition organized by Merry Foresta, with a catalogue of essays entitled *Perpetual Motif: The Art of Man Ray* (New York: Abbeville Press, 1988). Beyond the sheer mass of historical information, I was stimulated into refining and in some instances rethinking my ideas about Man Ray for this chapter.

2. Merry Foresta notes that Man Ray "wove into the fabric of his story [in writing *Self Portrait* (Boston: Little, Brown and Co., 1988)] a personal event

linked irrevocably with revolution and freedom" (Foreword to Man Ray, *Self Portrait,* 8). For two accounts of Man Ray abroad, see Billie Kluver and Julie Martin, "Man Ray, Paris," and Elizabeth Hutton Turner, "Transatlantic," chapters 2 and 3 in *Perpetual Motif.* For a marvelous daybook of Paris in the 1920s, see Billie Kluver and Julie Martin, *Kiki's Paris: Artists and Lovers, 1900–1930* (New York: Harry N. Abrams, 1989).

3. Turner has noted the allusion to ocean liners in "Transatlantic," *Perpetual Motif,* 137.

4. The notion of two addresses arose because his first patron, Ferdinand Howald, thought that Man Ray's presence would be necessary in order to sustain a market in New York (Turner, "Transatlantic," *Perpetual Motif,* 148).

5. In a 1932 review devoted mainly to Alexander Calder, McBride claimed that Calder, like Man Ray, had been adopted by the French. "There is no sense in lamenting these two artists as expatriates," he argued, "since we cannot provide them with the sustenance necessary to their mental existences; and Paris can." From this premise, however, he drew an unwarranted conclusion: "If an American artist must live in Paris for his soul's good, that's his affair; but in doing so he automatically becomes French and must gain French support rather than live, parasitically, upon funds from home" ("Motorized Calder," in Henry McBride, *The Flow of Art* [New York: Atheneum, 1975], 293). Aside from the dubious notion that assimilation is "automatic," McBride failed to see that the art market had become international. "Buy American" had gone by the boards many years before.

6. This is not to say that Man Ray was unacquainted with modern art or was not experimenting in a modernist (Cubist) idiom prior to Duchamp's appearance in 1915. The charismatic Frenchman, however, galvanized the modernist interests of young American artists and gave them an avant-garde direction in Dada values (or disvalues). Man Ray's friendship with Duchamp sealed his commitment to those attitudes for the rest of his life. Art historians have generally identified Man Ray as a Dadaist in sensibility rather than a Surrealist.

7. In *Man Ray* (London: Thames and Hudson, 1975) Roland Penrose states that the image was engraved on glass (203), whereas Arturo Schwarz claims that the original work was an aerograph (*Man Ray: The Rigour of Imagination* [New York: Rizzoli, 1977], 51). In *Self Portrait,* Man Ray said that it was an "airbrush composition" though he makes no mention of glass (92). In any case, the work was broken and now survives only as a photograph.

8. Breton, *First Manifesto,* 29.

9. Roger Shattuck briefly discusses this "spectral portrait" as a "proper tribute of the photographer to the painter," without, however, noticing Man Ray's

media crossings ("Candor and Perversion in No-Man's Land," *Perpetual Motif*, 329–330).

10. "The problem of woman is the most wonderful and disturbing problem there is in the world. And this is so precisely to the extent that the faith a noncorrupted man must be able to place, not only in the Revolution, but also in love, brings us back to it" (Breton, *Second Manifesto of Surrealism*, 180). Also see Breton, *Mad Love (L'Amour Fou)*, tr. Mary Ann Caws (Lincoln, Neb.: University of Nebraska Press, 1987).

11. Quoted in Man Ray's *Self Portrait*, 129.

12. Anne d'Harnoncourt and Kynaston McShine, ed., *Marcel Duchamp* (New York: Museum of Modern Art, 1973), 17.

13. For the Ferrer Center, see Ann Uhry Abrams, "The Ferrer Center: New York's Unique Meeting of Anarchism and the Arts," *New York History* LIX, no. 3 (July 1978): 307–325. Also see Francis M. Naumann and Paul Avrich, "Adolf Wolff: 'Poet, Sculptor and Revolutionist, but Mostly Revolutionist'," *Art Bulletin* LXVII, no. 3 (September 1985): 486–500. Man Ray illustrated two covers of *Mother Earth* IX, no. 6 (August 1914) and no. 7 (September 1914). Schwarz characterizes Man Ray as an anarchist throughout *Man Ray: The Rigour of Imagination*. *TNT* has been reprinted in Rudolf E. Kuenzli, ed., *New York Dada* (New York: Willis Locker & Owens, 1986), 146–163.

14. *Self Portrait*, p. 214. Although his assessment of political conditions in France was accurate, Man Ray used his status as an American in Paris as a convenient dodge to mask his desire to remain politically independent on the cultural scene (unlike Matthew Josephson, whose French friends urged him to steer clear of politics they presumed he did not understand—advice that the headstrong Josephson studiously ignored). *Hands Off Love*, a group manifesto, can be found in Maurice Nadeau, *The History of Surrealism* (New York: Macmillan, 1965), 263–271; André Breton, "On the Time When the Surrealists Were Right," in Breton, *Manifestoes of Surrealism*, 243–254. The Chaplin manifesto would have been especially compelling in light of Man Ray's own marital problems before he left New York for Paris.

15. Breton, *First Manifesto*, 27.

16. Breton, *First Manifesto*, 27; Man Ray, *Self Portrait*, 222–223.

17. This account is offered by Nadeau, *History of Surrealism*, 155–156.

18. Sarane Alexandrian, interview with Man Ray held 11 October 1972, in Sarame Alexandrian, *Man Ray* (Chicago: J. Philip O'Hara, 1973), n.p.

19. Schwarz, *Man Ray: The Rigour of Imagination*, 161, 133. James Laughlin first published Lautréamont in 1943. See Lautréamont, *Maldoror (Les Chants de Maldoror)*, tr. Guy Wernham (New York: New Directions, 1966). For the

best discussion of Lautréamont in English, see Paul Zweig, *Lautréamont: The Violent Narcissus* (Port Washington, N.Y.: Kennikat Press, 1972). Also see Wallace Fowlie, *Lautréamont* (New York: Twayne Publishers, 1973).

20. *To Be Continued Unnoticed: Some Papers by Man Ray* (Beverly Hills, Cal.: Copley Galleries, 1948), 4–5. Arturo Schwarz also emphasizes Man Ray's quest for freedom as "more than a right, it is an obligation" (*Man Ray: 60 Years of Liberties* [Milan: Gallerie Schwarz, 1971], 8).

21. "Private Notes for and on Man Ray," in Jules Langsner, ed., *Man Ray* (Los Angeles: Los Angeles County Museum of Art, 1966), 40; Arp quoted in Hans Richter, *Dada: Art and Art*, 45. Foresta argues that Man Ray belongs in "a whole category of American tinkers who looked beyond practical applications and profits and instead found something visionary" ("Perpetual Motif: The Art of Man Ray," *Perpetual Motif*, 39).

22. Quoted in Calvin Tomkins, *The Bride & The Bachelors: Five Masters of the Avant-Garde* (New York: Viking, 1968), 13.

23. Man Ray, *Self Portrait*, 85–86.

24. Ibid., 66–67, 115.

25. Man Ray to Katherine Dreier, 24 September 1928, Société Anonyme Collection, quoted in Turner, "Transatlantic," *Perpetual Motif*, 166.

26. Paul Hill and Tom Cooper, "Interview—Man Ray," *Camera* (February 1975): 38. Also see Man Ray, *Self Portrait*, 94, 267, and Kluver and Martin, "Man Ray, Paris," in *Perpetual Motif*, 128.

27. For a discussion of Stieglitz and straight photography, see Dickran Tashjian, *Skyscraper Primitives: Dada and the American Avant-Garde, 1910–1925* (Middletown, Conn.: Wesleyan University Press, 1975), 15–28.

28. Joseph Pennell, for example, cited photography as "the refuge of incapables" and made a passing swipe at "Russian Jews," so gratuitous and irrational that anti-Semitism does not begin to account for it ("Can a Photograph Have the Significance of Art?" *Manuscripts*, no. 4 [December 1922]: 2).

29. Marcel Duchamp to Alfred Stieglitz, *Manuscripts*, No. 4 (December 1922): 2. Man Ray, however, was acknowledged as the source, along with Duchamp, for the cover design of *Manuscripts*, based as it was on their cover for *New York Dada* (1921).

30. Man Ray, "The Age of Light," *Photographs by Man Ray 1920 Paris 1934*, n.p. Hill and Cooper, "Interview—Man Ray": 37.

31. Man Ray, "Deceiving Appearances," *Paris Soir* (23 March 1926), reprinted in Janus, ed., *Man Ray: The Photographic Image* (Woodbury, N.Y.: Barron's, 1980), 211.

32. Quoted by Jean Gallotti, "Is Photography an Art?" *L'Art Vivant* (1928), in Janus, ed., *Man Ray: The Photographic Image*, 216. As early as 1922 Man

Ray wrote to Ferdinand Howald that "I have freed myself from the sticky medium of paint and am working directly with light itself" (quoted in Kluver and Martin, "Man Ray, Paris," *Perpetual Motif*, 116).

33. Quoted by Andrée Royon, "Man Ray," *L'Intransigent* (1929), in Janus, ed., *Man Ray: The Photographic Image*, 218.

34. I am indebted to Merry Foresta for pointing out the implications of this drawing to me.

35. Man Ray, "The Surrealist Exhibition," from "La Résurrection des mannequins," Paris 1966, in Nicole Parrot, *Mannequins* (London: Academy Editions, 1982), 152.

36. Merry Foresta in conversation pointed out that some of the photographs in *Facile* could have been used in fashion magazines. For an analysis of *Facile*, see Renée Hubert, *Surrealism and the Book* (Berkeley: University of California Press, 1988), 76–83.

37. For an extensive discussion of Bataille, see Rosalind Krauss, "Corpus Delicti," in *L'Amour Fou*, 57–114.

38. André Breton, preface to Man Ray, *La Photographie n'est pas l'art* (Paris: GLM, 1937), n.p.

39. Kiki (Alice Prin), *Kiki's Memoirs*, tr. Samuel Putnam (Paris: Black Manikin Press, 1930), 138.

40. Man Ray, *Self Portrait*, 146.

41. Rrose Sélavy, "Men Before the Mirror," *Photographs by Man Ray 1920 Paris 1934*, n.p. Neil Baldwin also describes Man Ray as having "a chameleon personality." (*Man Ray*, p. 108).

42. Lautréamont, *Maldoror*, 263.

43. Hubert also stresses the enigma of Man Ray's assemblage: "Were we to view this content, we would destroy the art work made of very ordinary material" (*Surrealism and the Book*, 191).

44. *The Enigma of Isidore Ducasse* is superficially reminiscent of Duchamp's *With Hidden Noise* (1916), which was comprised of a ball of twine caught between two brass plates. Duchamp had asked Walter Arensberg to place a small object known only to himself inside the ball before its ends were sealed. This "assisted" readymade is visually undistinguished. The assemblage of parts points primarily to a gesture of conceptual proportions, intimated by unintelligible statements that Duchamp engraved on each plate. In contrast, Man Ray's *Enigma* dominates our visual attention by its ominous presence and intimation of violence.

45. Schwarz directed my attention to the object on the cart (*Man Ray: The Rigour of Imagination*, 123–124).

46. Man Ray, *This Quarter* V, no. 1 (September 1932): 55.

47. For excellent accounts of Lee Miller, see Antony Penrose, *The Lives of Lee Miller* (New York: Holt, Rinehart and Winston, 1985) and Jane Livingston, *Lee Miller Photographer* (New York: Thames and Hudson, 1989).

48. According to Man Ray, "A painter needs an audience, so I also clipped the photo of an eye to the metronome's swinging arm [to regulate the pace of his brushstrokes!] to create the illusion of being watched as I painted. One day I did not accept the metronome's verdict, the silence was unbearable and since I had called it, with a certain premonition, *Object of Destruction*, I smashed it to pieces" (quoted in Schwarz, *Man Ray: The Rigour of Imagination,* 205–206). Baldwin sees the eye as being as much Man Ray's as Miller's (*Man Ray: American Artist,* 168–169). For the final reincarnation of this object, see Foresta, "Perpetual Motif: The Art of Man Ray," *Perpetual Motif,* 47.

49. Sandra S. Phillips views the apple as a substitute for the female ("Themes and Variations: Man Ray's Photography in the Twenties and Thirties," *Perpetual Motif,* 217).

50. Baldwin, *Man Ray: American Artist,* 172.

51. Man Ray, "À l'Heure de l'Observatoire . . . les Amoureux," *Cahiers d'Art* X, no. 5–6 (1935): 127.

52. Ray, *Self Portrait,* 255–256.

53. Lautréamont, *Maldoror,* 112–113.

CHAPTER 5: SURREALISM ON THE AMERICAN LEFT

1. Dali, "I Defy Aragon," *Art Front* 3, no. 2 (May 1937): 7.

2. Louis Aragon, "Red Front," tr. e. e. cummings, *Contempo* III, no. 5 (1 February 1933): 4–5, 8. The poem was also finely published as a red-covered pamphlet (Chapel Hill, N.C.: Contempo Publishers, 1933). Although e. e. cummings had returned to the United States disenchanted with the Soviet Union after his visit in 1931, he was willing to translate the poem as a favor for Aragon, who had paved his way to Moscow. For an account of cummings in the Soviet Union, see Richard S. Kennedy, *Dreams in the Mirror* (New York: Liveright, 1980), 305–326. From his experiences cummings fashioned *Eimi* (New York: Covici-Friede, 1933).

3. Jay Du Von, "L'Affair Aragon," *Contempo* III, no. 5 (1 February 1933): 1–2 .

4. Breton, "The Poverty of Poetry," in *What Is Surrealism?*, 82; Du Von, "L'Affair Aragon," 2.

5. Ibid.; Michael Gold, "Carnevali and Other Essays," *New Masses* 2, no. 2 (December 1926): 18. Although he extensively quoted Du Von's rather biased article on the Aragon affair, David Gascoyne offered a straightforward rebuttal

of Aragon and the Communists in *A Short Survey of Surrealism* (San Francisco: City Lights Books, 1982 [1932]), 110–122.

6. A. B. Magil, "Pity and Terror," *New Masses* 8, no. 5 (December 1932): 18. Magil took the Kharkov statement about the Surrealists from a "Resolution on Proletarian and Revolutionary Literature in France," from the Second International [Kharkov] Conference of Revolutionary Writers, in *Literature of the World Revolution*, Special Number (1931), 103.

7. This account is offered in Daniel Aaron, *Writers on the Left* (New York, Oxford University Press, 1977), 224.

8. Stanley Burnshaw, "Notes on Revolutionary Poetry," *New Masses* X, no. 8 (20 February 1934): 21.

9. Samuel Putnam, "French Writers Fight Fascism," *New Masses* XII, no. 8 (21 August 1934): 21.

10. Louis Aragon, "From Dada to Red Front," *New Masses* XV, no. 7 (14 May 1935): 23–24.

11. Louis Aragon, "Painting and Reality," *Art Front* II, no. 12 (January 1937): 7; the essay first appeared in *transition*, no. 25 (Fall 1936): 93–103.

12. Louis Aragon, *La Peinture au Défi* (Paris: Librairie José Corti, 1930), 6, 29, 17–19, 21, 13.

13. Aragon, "Painting and Reality," 7. Despite the fact that *La Peinture au Défi* was written specifically for the occasion of a collage exhibition at Galerie Goemans in Paris, six years later Aragon wrote, "In my brochure 'La Peinture au défi' . . . I attempted to show that painting, during a certain epoch, found itself confronted with a challenge, the challenge of photography"[!] (7).

14. Aragon, "Painting and Reality," 7–8. At least Aragon did not completely trash Man Ray's work as "pretentious, empty, and meaningless," as did an anonymous reviewer in *New Masses* XIII, no. 13 (25 December 1934): 26.

15. Man Ray, "The Age of Light," *Photographs By Man Ray 1920 Paris 1934* (Hartford: James Thrall Soby, 1934; reprint, New York: Dover Publications, 1979), n.p. Stephen Foster cursorily notes the social implications of this passage in his "Configurations of Freedom" (*Perpetual Motif*, 242–243) while neglecting, however, to identify Man Ray's deep political commitment to anarchism.

16. Aragon, "Painting and Reality," 9.

17. See Edouard Jaguer, *Les Mystères de la Chambre Noire: Le Surréalisme et la Photographie* (Paris: Flammarion, 1982): 74–78.

18. Aragon, "Painting and Reality," 9.

19. Ibid., 9–11.

20. Dali, "I Defy Aragon," 7. For reviews of Dali in *Art Front*, see Stuart Davis,

"Paintings by Salvador Dali," *Art Front* I, no. 2 (January 1935): 7; Clarence Weinstock, "A Letter on Salvador Dali," *Art Front* I, no. 3 (February 1935): 8. Dali also received negative reviews in *The New Masses*. See Stephen Alexander, "Art: Salvador Dali or Life Is a Nightmare," *New Masses* XIII, no. 11 (11 December 1934): 28; and Jacob Kainen, "Dream-World Art," *New Masses* XVII, no. 7 (12 November 1935): 25.

That Dali appeared in rebuttal of Aragon in *Art Front* was a result of the magazine's political situation on the left. As the organ of the Artists' Union, *Art Front* claimed to be independent of any political party even though it was clearly sympathetic toward the American Communist party. An avowed attention to practical matters of survival facing American artists did not deter the editors from considering theoretical issues, especially those concerning the development of a revolutionary art. Even though the Stalinist bureaucracy had decreed Socialist Realism as an official art and aesthetic in repressing Soviet avant-garde activity, *Art Front* was relatively open in regarding revolutionary art as problematic in the United States. The editors tacitly acknowledged that revolutionary art was still in the making; further, that it was not simply a matter of execution according to a set of aesthetic (or sociological) principles; most crucially, that an aesthetic needed to be formulated to provide a necessary self-consciousness for revolutionary art.

Because of the newly instituted Popular Front against fascism, which called for a broadly based alliance, the magazine from the outset was more tolerant and less strident in its criticism of avant-garde art than *The New Masses* had been. Despite an underlying preference for Socialist Realism, avant-garde artists were not automatically disbarred from the realm of revolutionary art and aesthetics. This openness was further encouraged by Stuart Davis, who as a young man had stood witness to the 1913 Armory Show. His turn to radical politics had not compromised his long and arduous commitment to modern painting. Even though he had not managed to synthesize political and aesthetic radicalism in his painting, his participation in the Artists' Union suggested the possibility of some sort of rapprochement, thereby extending a measure of tolerance toward the avant-garde.

21. Dali, "I Defy Aragon," 7–8.

22. Clarence Weinstock, "The Man in the Balloon," *Art Front* III, no. 2 (May 1937): 10 .

23. Samuel Putnam, "Marxism and Surrealism," *Art Front* III, no. 2 (May 1937): 10–11. Putnam's arguments were supported by other writers in *Art Front* and elsewhere. In *The New Republic*, for example, Malcolm Cowley would soon argue that Freud and Marx were fundamentally incompatible, with Freud's

idealist and individualist interpretation of human nature being opposed to Marx's materialist, class interpretation of social behavior. If the Surrealists were seen as riding a Freudian crest, a rejection of Freud obviously swept away the Surrealists as well. And if the Surrealists wanted to straddle Freud and Marx, Cowley simply denied that a synthesis of the two was possible. "Psychoanalysis as a social theory—something it often becomes—is fundamentally opposed to Marxism," he claimed, "and no poet or prose writer has ever succeeded in making a synthesis of the two" ("Homage to Ancestors," *New Republic* LXXXVI, no. 1109 [14 March 1936]: 114).

Putnam had demonstrated the proper ideological credentials to lead this counterattack against Surrealism. He too had joined the Communist cause, and had criticized the Surrealists anthologized in his *European Caravan* for what he considered the vagueness of their revolutionary goals and their apparent lack of commitment to the PCF. Earlier, in a little magazine of his own, he published a diatribe against Surrealism by Emanuel Berl, one of Breton's rivals: "The Bankruptcy of the Unconscious," *New Review*, no. 3 (1931): 84–86. For an account of Breton's affair with a young woman who married Emanuel Berl amid continuing sexual intrigues, see André Thirion, *Revolutionaries Without Revolution*, tr. Joachim Neugroschel (New York: Macmillan, 1975), 250, 277.

In his memoir written after the Second World War, Putnam smeared the Surrealists as homosexuals—a vicious tactic at a time when homophobia went essentially unchallenged. He thought that the actions and speech of the Surrealists echoed American homosexuals. He also referred to "extremely effeminate" Surrealists (*Paris Was Our Mistress* [New York: Viking, 1947], 73, 91).

24. Charmion von Wiegand, "The Surrealists," *Art Front* II, no. 12 (January 1937): 12–13.

25. Ibid., 12, 14.

26. Ibid., 14.

27. The first extended scholarly discussion of Social Surrealism was made by Jeffrey Wechsler, *Surrealism and American Art, 1931–1947* (New Brunswick: Rutgers University Art Gallery, 1977), 39–43; also see Dickran Tashjian, *William Carlos Williams and the American Scene* (New York: Whitney Museum of American Art, 1979), 133–136, and Ilene Susan Fort, "American Social Surrealism," *Archives of American Art Journal* 22, no. 3 (1982): 8–20. For specific painters, see John Baker, *O. Louis Guglielmi: A Retrospective Exhibition* (New Brunswick: Rutgers University Art Gallery, 1980), and Mary Towley Swanson, *Walter Quirt: A Retrospective* (Minneapolis: University of

Minnesota Gallery, 1979). I have used these sources for basic biographical information.

28. Only Julien Levy's anthology of 1936 offered some of Breton's political statements, which in their abstraction were difficult to translate into pictures. While one statement clearly asserted the importance of politics for the Surrealists, it was still problematic. "I really cannot see," Levy quoted Breton from the *Second Manifesto of Surrealism*, "*pace* a few muddle-headed revolutionaries, why we should abstain from taking up the problems of love, of dreaming, of madness, of art, of religion, so long as we consider these problems from the same angle as they, and we too, consider the Revolution" (Julien Levy, ed., *Surrealism* [New York: Black Sun Press, 1936], 55). The anthology was reviewed, or rather, Surrealism was excoriated, by Isidor Schneider, "Shrines of Unreason," *New Masses* (December 1936): 23–24.

29. Letter from James Guy to the author, Winter 1980.

30. Meyer Schapiro, "Blue Like an Orange," *Nation* 145, no. 13 (25 September 1937): 323–324.

31. Georges Hugnet, "In the Light of Surrealism," in Alfred H. Barr, Jr., ed., *Fantastic Art, Dada, Surrealism* (New York: The Museum of Modern Art, 1936), 37.

32. Letter from Guy to the author, Winter 1980.

33. Ibid.

34. Swanson, *Walter Quirt*, 11.

35. Letter from Guy to the author, Winter 1980. In her catalogue essay, Mary Swanson notes that she learned of Quirt's membership in the Communist party from the painter Anton Refrigier (*Walter Quirt*, 26).

36. Charmion von Wiegand, "Art: Walter Quirt," *New Masses*, no. 13 (24 March 1936): 25.

37. Guglielmi, "I Hope to Sing Again," *Magazine of Art* 37, no. 5 (May 1944): 176; statement in Dorothy Miller and Alfred H. Barr, Jr., eds. *American Realists and Magic Realists* (New York: Museum of Modern Art, 1943): 38.

38. Guglielmi, statement in *American Realists and Magic Realists*, 38; Guglielmi to Sidney Janis, 27 April 1942, Guglielmi Papers, Archives of American Art, Smithsonian Institution, Washington, D.C. Hereafter AAA, roll N69–119, frame 347.

39. See Baker, *O. Louis Guglielmi*, 23.

40. *Art Front* II, no. 2 (January 1936): 7. Unlike Duroc, who could see only "opposites," Baker cleverly interprets *Phoenix* as the dialectic visualized in a landscape: "The active capitalist production center in the background, to the scene of collapse and destruction symbolizing revolution in the middle dis-

tance, to the socialist Lenin (with an attribute of agriculture?) in the foreground" (*O. Louis Guglielmi*, 12).

41. There is no little irony in *The Daily Worker* championing a small farmer resisting a powerful bureaucracy at a time when Stalin was brutally pursuing the "collectivization" of the peasants, a euphemism for mass murder.

42. "The social revolution, it seems, is moving uptown. Until now the Julien Levy Gallery, at 602 Madison Avenue, has devoted itself mainly to considerations that may be classified as esthetic" [presumably as opposed to political] (Edward Alden Jewell, "Paintings of Quirt Recall Dali's Art," *New York Times*, 20 February 1936, p. 22).

43. Levy was quoted by Jewell, "Paintings of Quirt Recall Dali's Art," ibid.; Jacob Kainen, *Exhibition of Paintings by Quirt* (New York: Julien Levy Gallery, 1936), n.p.

44. Ann H. Sayre, "Propaganda from a New Surrealist Painter," *Art News* XXXIV, no. 22 (29 February 1936): 9; *New York Sun*, 22 February 1936, n.p. (Quirt Papers, AAA, roll 570, frame 1087).

45. Charmion von Wiegand, "Art: Walter Quirt," *New Masses*, no. 13 (24 March 1936): 25; Clarence Weinstock, "Quirt," *Art Front* 2, no. 5 (April 1936): 13.

46. Louis Lozowick, "Towards a Revolutionary Art," *Art Front* 2, no. 7 (July–August 1936): 13. As early as September 1936 Lozowick was planning the symposium with Alfred H. Barr, Jr. In town during the Surrealist exhibition at The Museum of Modern Art, Man Ray was invited to participate but demurred because he claimed to have "no experience in addressing a public" (letter to Lozowick, 21 November 1936). For the pertinent correspondence with Barr, Ray, Schapiro, and others, see the Louis Lozowick Papers, AAA, roll D-254A, frames 8, 11, 12, 18, 24.

47. Raphael Soyer, "Reminiscences 1932–1968," *Walter Quirt: A Retrospective*, 11; Anita Brenner, "Surrealism and Its Political Significance," *Brooklyn Daily Eagle*, 24 January 1937, p. 8C.

48. For a balanced view of Dali's rightwing politics, see Dawn Ades, *Dali* (London: Thames and Hudson, 1982), 105–117.

49. "Wake Over Surrealism," *Pinacotheca* (1941), n.p.; "Dali a Fascist?" *Art Digest* 16, no. 5 (1 December 1941): 6, 141; Peyton Boswell, "Name Calling," *Art Digest* 16, no. 6 (15 December 1941): 3; Guglielmi subsequently wrote a letter of apology to Quirt for his personal attack and claimed that he tried to have his letter withdrawn from *The Art Digest* but to no avail (letter to Quirt, 15 December 1941, Quirt Papers, AAA, roll 570, frame 381).

50. Quirt to Coates, 5 March 1942, Quirt Papers, AAA, roll 570, frames

654–655; "Social Content Versus Art in Painting," *Pinacotheca* (1942), Quirt Papers, AAA, roll 571, frames 17–18. For Quirt's political development, see Townsend, *Walter Quirt: A Retrospective*, 19–21.

51. Edward Alden Jewell, "In the Realm of Art: Activities of a Waning Season," *New York Times*, 17 May 1936, section 9: 10. Feitelson exhibited six paintings at Brooklyn; Lundeberg, eleven; Lucien Labaudt, six; Grace Clements, six; Knud Merrild, three; and Helen Klokke, one. Lundeberg and Feitelson each had a painting in The Museum of Modern Art show. For a survey of the work of Lundeberg and Feitelson, see Diane Degasis Moran, *Lorser Feitelson and Helen Lundeberg: Retrospective Exhibition* (San Francisco: San Francisco Museum of Modern Art, 1980). Also see Diane Moran, "Post-Surrealism: The Art of Lorser Feitelson and Helen Lundeberg," *Arts* 57, no. 4 (December 1982): 124–128.

52. Lundeberg statement, circa 1942, Lundeberg Papers, AAA, roll 1103, frame 1367.

53. "Postsurrealism, the Supermodern," *Literary Digest*, 11 July 1936, p. 23.

54. Arthur Millier's articles for the *Los Angeles Times* (14 April and 29 September 1935) were reprinted in *Post Surrealism: Subjective Classicism*, a brochure for the exhibition at the Brooklyn Museum of Art, May–August 1935.

55. Jules Langsner, statement for exhibition brochure, *Post-Surrealists and Other Moderns* at Stanley Rose Gallery, May 1935.

56. Interview by Arthur Millier for the *Los Angeles Times*, 14 April 1935, reprinted in *Post Surrealism: Subjective Classicism*, brochure for exhibition at the Brooklyn Museum of Art, May–August 1935.

57. Excerpt from "New Classicism," in interview by Jan Butterfield, 19 July and 29 August 1980, AAA, roll 3198, frames 538–539.

58. Stuart Davis, "Paintings by Salvador Dali," *Art Front* I, no. 2 (January 1935): 7.

59. In "Introduction to the Discourse on the Paucity of Reality," Breton inveighed against symbolic interpretations of phrases from the poetry of Saint-Pol-Roux, preferring instead the words as they stood in creating a literal reality (in André Breton, *What Is Surrealism? Selected Writings*, ed. Franklin Rosemont [New York: Monad Press, 1978], 25).

60. Quoted in Joseph E. Young, "Helen Lundeberg: An American Independent," *Art International* XV, no. 7 (September 1971): 46.

61. T. S. Eliot, *Four Quartets*, in *The Complete Poems and Plays, 1909–1950* (New York: Harcourt, Brace, 1952), 117; Breton, *Second Manifesto*, 123.

62. William Rubin suggests that this organism bears the visage of Dali:

small consolation there! (*Dada and Surrealist Art* [New York: Abrams, 1968], 220).

63. Jan Butterfield, interview with Helen Lundeberg, 19 July and 29 August 1980, Helen Lundeberg Papers, AAA, roll 3198, frames 572–573.

64. Grace Clements, "New Content—New Form," *Art Front* 2, no. 4 (March 1936): 9.

65. "Postsurrealism, the Supermodern," *Literary Digest*, 11 July 1936, p. 23.

66. Joe Solmon, "The Post Surrealists of California," *Art Front* 2, no. 6 [misnumbered issue, actually no. 7] (June 1936): 12.

67. Feitelson to Francis V. O'Connor, in 1964 letter of inquiry, Pollock papers, AAA, roll 1103, frame 1112.

CHAPTER 6: THE PRISON-HOUSE OF POLITICS

1. Charles Henri Ford and Parker Tyler, "*Blues*: What Happens to a Radical Literary Magazine," *Sewanee Review* XXXIX, no. 1 (January–March 1931): 62; Ford, in "Ira Cohen Interviews Charles Henri Ford," in Winston Leyland, ed., *Gay Sunshine Interviews*, no. I (San Francisco: Gay Sunshine Press, 1978), p.42; "Gossip on Parnassus," *Contemporary Verse* (April 1929); Kathleen Tankersly Young to Ford, n.d., but prior to the first issue of *Blues* (*Blues/View* file, Beinecke Library, Yale University); the reviews are taken from Ford's uncatalogued *Blues/View* scrapbook at the Beinecke Library, Yale University: Birney Imes, "Tommyrot, Bunk and Junk," *The Commercial Dispatch*, 29 July 1929; Harry Hansen, "The First Reader," *New York World*, 13 March 1929; Birney Imes, "Tommyrot, Bunk and Junk," "Crazy Quilt," *Poetry World*, February 1930.

2. James Rorty, *Nation*, 17 April 1929 (*Blues/View* scrapbook).

3. Donald Davidson, in *Tennessean*, 3 March 1929 (*Blues/View* scrapbook).

4. *Blues* advertisement, *Hound and Horn*, July–September 1929 (*Blues/View* scrapbook).

5. Tyler's antipathy to local color was clearly evidenced a few years after *Blues*'s demise when he panned John Herrmann's novel *Summer Is Ended* (about midwesterners and "the incredibly but unconsciously dreary complications of their lives") as "simply corn-eared—irredeemably and insubordinately corn-eared" ("Book Reviews," *The New Act*, no. 1 [January 1933]: 37).

6. William Carlos Williams, "Caviar and Bread Again: A Warning to the New Writer," *Blues* II, No. 9 (Fall 1930): 47.

7. *Blues* advertisement, in *Hound and Horn* (January–March 1931) (*Blues / View* scrapbook).

8. Ford to Ruth Ford, 5 April 1931, Charles Henri Ford Papers, Harry Ransom Humanities Research Center, University of Texas at Austin, hereafter Ford Papers, HRC.

9. Ford to his father, Charles Lloyd Ford, Paris, 28 April 1932, Ford Papers, HRC; Kay Boyle to Ford, 22 December 1930, written from Nice (*Blues/View* file).

10. Ford to Charles Lloyd Ford, 26 February 1934, Ford Papers, HRC.

11. Interview with Ford, New York, 17 December 1980. Ford mentioned Jolas specifically in an interview with Bruce Wolmer, September 1986: "My first surrealist thrill came from a nonmember of the official group who was, however, an advocate of surrealism—Jolas himself. I remember that distinctly" (*Bomb*, no. XVIIII [Winter 1987]: 54). It is difficult to imagine the mercurial Ford attracted to the heavy-handed Jolas, though Ford was young, and the memory in 1987 aligned the young Ford with those artists who, for various reasons, felt themselves to be Surrealist in sensibility but were not accepted by Breton.

12. Ford has speculated that Crevel's suicide in 1935 had to do with "a complication between adherence to surrealism or to communism or to homosexuality; he couldn't get it all worked out" ("Ira Cohen Interviews Charles Henri Ford," p. 37).

13. Ford and Tyler, "New Generation in American Poetry," *Earth* (May 1930): n.p. Ford and Tyler, "Blues: What Happens": 64.

14. Parker Tyler, "Beyond Surrealism," *Caravel*, no. 4 (1935): 2–4.

15. Paul Eluard, "Drinking," *transition*, no. 5 (August 1927): 108.

16. "Hands Off Love," *transition*, no. 6 (September 1927): 163.

17. Charles Henri Ford, "Danse Sensuelle," *Contemporary Verse* 24, no. 2 (February 1929): n.p.; Ford, "Short Poem About a Gunman," *Morada*, no. 1 (Autumn 1929): 20; Breton, *Second Manifesto of Surrealism*, 125.

18. Charles Henri Ford, "Dreams," *A Pamphlet of Sonnets* (Majorca: Caravel Press, 1936), n.p.

19. Dickran Tashjian, interview with Ford, 15 January 1981.

20. William Carlos Williams, "The Tortuous Straightness of Charles Henri Ford," *The Garden of Disorder and Other Poems* (London: Europa Press, 1938), 9.

21. Charles Henri Ford, "Commission," *Garden of Disorder*, 42, originally published in *New World Monthly* (January 1930); "Sonnet," in Peter Neagoe, ed., *Americans Abroad, An Anthology* (The Hague: Servire Press, 1932), 160, republished with slight variations as "The Jewelled Bat," *A Pamphlet of Sonnets*, n.p. and *Garden of Disorder*, 31.

22. Matthew Josephson, "After and Beyond Dada," *Broom* II, no. 4 (July 1922): 347.

23. Ford, "Commission," *Garden of Disorder*, 22; "The Jewelled Bat," *Garden of Disorder*, 31.

24. Williams, "The Tortuous Straightness of Charles Henri Ford," 9.

25. For Breton's passage, see his first *Manifesto of Surrealism*, 21–22. If Williams did not read the original French version in 1924, and he may well have, since he was eager to meet the Surrealists through Robert McAlmon on his visit to Paris at that time, the passage was quoted by Breton himself and translated into English in "Surrealism, Yesterday, To-Day and To-Morrow," in the Surrealist number of *This Quarter* V, no. 1 (September 1932): 15. Tyler quoted the same passage in his essay, "Beyond Surrealism," *Caravel*, no. 4 (1935): 2.

26. Williams, "The Tortuous Straightness of Charles Henri Ford," 9; Ford, "The Garden of Disorder," *The Garden of Disorder*, 13–20; Breton, *First Manifesto*, 18–20. Breton was quoting the poet Pierre Reverdy with a difference: the Surrealist leader believed that these "distant realities" could not be willfully evoked; the verbal juxtapositions could be achieved only without premeditation, involuntarily.

27. Williams, "The Tortuous Straightness of Charles Henri Ford," 9.

28. Ibid., 10.

29. Ford, "The Desire To Be In Two Places At Once," *The Garden of Disorder*, 57. Years later, Ford wrote to Calas, "It's a universally accepted maxim that art may begin with anything at all" (16 February 1965, Ford Papers, HRC). Ford's doggerel, "Song of the Muse," was reported by Henry McBride: "Halfway in the great parade of entering guests, there appeared a group of young men [supposedly "young braves"], almost as nature made, and nature had made them well, and they supported on their bare shoulders a litter on which reposed a princess [Ruth Ford] who paused when exactly in the center of the room, to chant a poem written expressly for the occasion by Charles Ford, the novelist. The almost not-clothed young men, I was afterward informed, were poets from Greenwich Village This surprised me. I had not known that poets were so plump." ("All Arts United in Hartford," *New York Sun*, 22 February 1936, p. 26). Tyler later recalled that he and Ford missed their entrance, "taking so long at the hotel to dress and make ourselves up as canonic Western cowboys, getting tight meanwhile on whisky" (*The Divine Comedy of Pavel Tchelitchew* [London: Weidenfeld and Nicolson, 1969], 384).

30. Joseph Vogel, "Literary Graveyards," *New Masses* 5, no. 5 (October 1929): 30; Tyler, letter to the editor, *New Masses* 5, no. 6 (November 1929): 22.

31. Ford to Charles Lloyd Ford, 23 December 1931, with enclosure of article by Alex Small, Ford Papers, HRC.

32. Ford to Tyler, 3 September 1936, Ford Papers, HRC.

33. Ford's early notebooks are actually tiny appointment calendars. His quota-

tion from Trotsky was entered 5 November 1936. Djuna Barnes to Ford, 14 April 1937, Paris, Ford Papers, HRC.

34. Tyler, "Beyond Surrealism," 6; André Breton, "Visit with Leon Trotsky," in André Breton, *What Is Surrealism? Selected Writings*, ed. Franklin Rosemont (New York: Monad Press, 1978), 182. In this speech of 11 November 1938 for the International Workers Party, Breton could have been describing himself in describing Trotsky: "What self-control; what conviction of having, in the face of everything, kept his life in perfect accord with his principles; what exceptional courage, however tested, has guarded these principles from any alteration!" ("Visit with Leon Trotsky," 177).

35. The disputes were silly in themselves, though they revealed some underlying philosophical disagreements. According to Abel, Breton objected to Trotsky's reference to his dog as a "friend." The Surrealist took this as the worst sort of sentimentality. Trotsky objected to Breton's notion as a form of idealism or errant mythmaking that we are microparts of a huge organism of which we are unaware. See Lionel Abel, *The Intellectual Follies: A Memoir of the Literary Venture in New York and Paris* (New York: W. W. Norton, 1984), 98–100.

36. André Breton, Diego Rivera, [and Leon Trotsky], "Manifesto for an Independent Revolutionary Art," in *What Is Surrealism?*, ed., Franklin Rosemont, 183 and 186.

37. Ibid., 184.

38. Ibid., 184–185. According to Breton, "It was Comrade Trotsky, indeed, who, seeing my formulation of 'Every liberty in art, except against the proletarian revolution,' put us on guard against the new abuses that could be made of the last part of the phrase, crossing it out without hesitation" ("Visit with Leon Trotsky," 181).

39. Ibid., 184.

40. Ibid., 184–185.

41. Even the *Partisan Review* was not comfortable with the synthesis of Marx and Freud, for in the next issue a Paris letter was published from Sean Niall, who regretted Breton's infusion of "the Vienna Dreambook school of psychology" into the manifesto, while generally approving of FIARI ("Paris Letter," *Partisan Review* VI, no. 1 [Fall 1938]: 102).

42. Breton, Rivera, [and Trotsky], "Manifesto for an Independent Revolutionary Art," 187.

43. Ford to Tyler, 5 April 1939, Ford Papers, HRC; "IFIRA," *Partisan Review* VI, no. 1 (Fall 1938): 7.

44. Ford to his mother, Gertrude Cato, day before Easter 1939, Ford Papers, HRC.

45. Ford to Tyler, 5 April 1939, Ford Papers, HRC.

46. Ford to Tyler, 27 April 1939, Ford Papers, HRC.

47. "Statement of the L.C.F.S." *Partisan Review* VI, no. 4 (Summer 1939): 125–127. Tyler did not sign the League for Cultural Freedom and Socialism's second statement, which reduced the program to an antiwar stance and called upon American artists and writers to oppose the entry of the United States into the European conflict ("War Is The Issue!" *Partisan Review* VI, no. 5 [Fall 1939]: 125–127). Tyler revealed his disillusionment in an "American Letter," *Seven*, no. 4 (Summer 1939): 41–42.

48. Ford to Gertrude Cato, day before Easter 1939, Ford Papers, HRC.

49. Ford to Tyler, 5 April 1939, Ford Papers, HRC.

50. Breton telephoned Ford in response to a letter, Ford wrote to Gertrude Cato (day before Easter 1939, Ford Papers, HRC). Ford had written Breton on March 14, 1939, indicating that he had just arrived from the United States, had sat in on FIARI meetings at the *Partisan Review,* and had been asked by Dwight Macdonald to bring the Surrealist leader up to date on the American front (letter to Breton, March 14, 1939, Charles Henri Ford Papers, Special Collections, The Getty Center for the History of Art and Humanities, Santa Monica, California, henceforth Ford Papers, Getty Center.)

51. "Ira Cohen Interviews Charles Henri Ford," in *Gay Sunshine Interviews*, 37.

52. Ford to Tyler, 23 January 1932, Ford Papers, HRC.

53. Ford to Tyler, 3 September 1936, Ford Papers, HRC.

54. Ford to Gertrude Cato, 20 April 1939, Ford Papers, HRC; Ford to Tyler [letter fragment], probably around the above date of letter to his mother, Ford Papers, HRC.

55. Ibid.

56. Ford had received an inscribed copy of Breton's first *Manifesto of Surrealism,* probably at about this time. Exactly when he read and underlined this copy (Ford Papers, HRC) is not known, although the underlinings are remarkably consistent with his views in the late 1930s.

57. Ford to Tyler, 5 April 1939, and fragment thereafter, Ford Papers, HRC.

58. William Carlos Williams, "An Afternoon with Tchelitchew," *Selected Essays* (New York: Random House, 1954), 250–252.

59. Ford to Gertrude Cato, day before Easter 1939, Ford Papers, HRC; Ford to Tyler, typewritten fragment, Ford Papers, HRC.

60. Ford to Gertrude Cato, day before Easter 1939, Ford Papers, HRC; Breton, *Manifesto of Surrealism*, p. 63. "An Afternoon with André Breton" appeared in Charles Henri Ford, *The Overturned Lake* (Cincinnati: The Little Man Press, 1941), 60–61, reprinted in Ford, *Flag of Ecstasy: Selected Poems,* ed. Edward B. Germain (Los Angeles: Sparrow Press, 1972), pp. 55–56.

1. Charles Henri Ford to his father, Charles Lloyd Ford, 4 October 1939, Charles Henri Ford Papers, Harry Ransom Humanities Research Center, University of Texas at Austin, hereafter Ford Papers, HRC.

2. Ford to his mother, 9 December 1941, Ford Papers, HRC. For anthology of *View,* see Charles Henri Ford, ed., *View: Parade of the Avant-Garde, 1940–1947*, compiled by Catrina Neiman and Paul Nathan (New York: Thunder's Mouth Press, 1991).

3. "The Poetry Paper," a flier probably circulated in the early part of 1940, Ford Papers, HRC. Ford's was an important concept in stressing that poets needed to be empowered to speak out on public events.

4. "Communiqué from Kay Boyle," *View* I, no. 2 (October 1940): 1.

5. "Reports and Reporters," *View* I, no. 1 (September 1940): 4.

6. Peggy Guggenheim, *Out of This Century* (New York: Dial Press, 1946), 236.

7. Kurt Seligmann had visited Alaska and the Pacific Northwest in 1938 and then returned with his wife to New York in September 1939 at the outbreak of European hostilities. For an account of Seligmann in America, see Martica Sawin, "Magus, Magic, Magnet: The Archaizing Surrealism of Kurt Seligmann," *Arts* 60, no. 6 (February 1986): 76–81.

8. Writing to Parker Tyler from Paris, Ford mentioned that Benjamin Peret, the Surrealist poet, had introduced him to Raoul Ubac, "who does very extraordinary things by cutting up photographs and re-photographing the fragments, in a pan of sand for example, and then 'solarizing' the plate. I may get a short article from him on his methods & ideas & send with examples of his work to US Camera Mag" (5 April 1939, Ford Papers, HRC). Ubac's photographs were reproduced in an issue of *View* devoted to Surrealism in Belgium after the war (*View,* ser. VII, no. 2 [December 1946]: 14).

9. For a list of Levy's exhibitions, see Julian Levy, *Memoir of an Art Gallery* (New York: G. P. Putnam's Sons, 1977), 296–312; for a list of exhibitions and works exhibited at the Pierre Matisse Gallery, see the Pierre Matisse Papers, Archives of American Art, Smithsonian Institution, Washington, D.C., roll NPM1. James Johnson Sweeney curated the Miró exhibition at The Museum of Modern Art, while James Thrall Soby curated the Dali retrospective.

10. "In case of war AB and B[enjamin] Peret want to refugee in Amerikee" (Ford to Tyler, 27 April 1939, Ford Papers, HRC). For a survey of the dispersal of the Surrealists during the Second World War, see *La Planète Affolée: Surréalisme Dispersion et Influences, 1938–1947* (Marseilles and Paris: Direction des Musées de Marseilles and Editions Flammarion, 1986).

11. The irony of Breton's situation did not escape his biographer, Anna Balakian, who noted that his freedom was "viable only under the permissive bourgeois structure of prewar France which he had cursed most of all!" (*André Breton: Magus of Surrealism* [New York: Oxford University Press, 1971], 172–173).

12. Pierre Mabille, "Destruction of the World," *View* I, nos. 9–10 (December 1941–January 1942): 1, 8.

13. "Reports and Reporters," *View* I, no. 2 (October 1940): 4. Also see "Reports and Reporters," *View* I, no. 3 (November 1940): 1.

14. Quoted in William L. Shirer, *20th Century Journey: The Nightmare Years, 1930–1940*, vol. II (Boston: Little, Brown and Co. 1984), 530; Varian Fry, *Surrender on Demand* (New York: Random House, 1945), ix. Fry has received scant attention for his heroic efforts on behalf of others, perhaps because his own story is so gripping. See Donald Carroll, "Escape from Vichy," *American Heritage* (June–July 1983): 84–93; Cynthia Jaffee McCabe, " 'Wanted by the Gestapo: Saved by America'—Varian Fry and the Emergency Rescue Committee," in Jarrell C. Jackman and Carla M. Borden, eds., *The Muses Flee Hitler: Cultural Transfer and Adaptation, 1930–1945* (Washington, D.C.: Smithsonian Institution Press, 1983). For an art history of this period, see Michele C. Cone, *Artists Under Vichy: A Case of Prejudice and Persecution* (Princeton: Princeton University Press, 1992).

15. For this brave young woman's story, see Mary Jayne Gold, *Crossroads Marseilles 1940* (Garden City: Doubleday, 1980).

16. Fry, *Surrender on Demand*, 184.

17. Guggenheim, *Out of This Century*, 270. For her biography, see Jacqueline Bograd Weld, *Peggy: The Wayward Guggenheim* (New York: E. P. Dutton, 1986). Both Weld and I were independently frozen by the chill of the concierge's casual comment to Guggenheim recorded in her memoirs (also singled out by Bernard Noel, *Marseilles New York: A Surrealist Liaison*, tr. Jeffrey Arsham [Marseilles: André Dimanche, 1985], 80).

18. With the inexplicable easing of visas by the Gestapo, Fry claimed that the relief effort became a "kind of travel bureau"—an ironic development in light of the risks and failures of previous efforts. (The critic Walter Benjamin committed suicide in despair at the Spanish border when he could not get through.) Fry and his brave assistants managed to get some one thousand refugees out of France (*Surrender on Demand*, 187–189).

19. Noel, *Marseilles New York: A Surrealist Liaison*, 62–66.

20. Jimmy Ernst, *A Not-So-Still Life* (New York: St. Martin's/Marek, 1984), 198–208.

21. Gold, *Crossroads Marseilles 1940*, 308.

22. For an account of Breton's exile in New York, see Balakian, *André Breton: Magus of Surrealism*, 173–181.

23. Eugene Jolas, ed., foreword, *Vertical: A Yearbook for Romantic-Mystic Ascensions* (New York: Gotham Bookmart Press, 1941), n.p.

24. Eugene Jolas, "Poets and Poetry: Beyond Surrealism," *Living Age* V, 359 (September 1940): 93–94.

25. Although years later, Ford credited Jolas as the catalyst for his conversion to Surrealism, he was brutal in his dismissal of Jolas at the outset of the war: "The JOWL of Jolas, to write saying he's given me a review in L[iving] Age & asking to write himself up for View—when the MS comes what shall we DO: wd it be too obvious to (mEREly) clip a rejection slip thereto—or will you take the pleasure in wording the letter (I'll sign)" (Ford to Tyler, 27 June 1940, Ford Papers, HRC).

26. Eugene Jolas, "Surrealism: Ave Atque Vale," *Fantasy* 7, no. 1 (1941): 30.

27. Ibid., 23, 30.

28. Gold, *Crossroads Marseilles 1940*, 251, 248.

29. Ibid., 246; Paul Riche, "Nazism and Culture," *View* I, nos. 7–8 (October–November 1941): 8. Ford published an extract from an article by Paul Riche, "Gallimard and his 'Pretty' Crew," an obscene diatribe against the publisher Gallimard, published in *Le Pilori*; also "End of an Imbecile Literature," published in *Le Midi Libre* in Vichy France.

 Accounts of the police detention can be found in Fry, *Surrender on Demand*, 133–149, and Gold, *Crossroads Marseilles 1940*, 264–279. Of course, one might well mistake Pétain for a prostitute—of the worst sort.

30. George Biddle, "The Surrealists—Isolationists in Art," *New Republic* 105, no. 17 (27 October 1941): 538. Biddle's animus against the Surrealists may have been motivated by an unwitting snub on the part of Peggy Guggenheim, who on her California trip had insulted him by naively asking, "Do you paint too, Mr. Biddle?" (*Out of This Century*, 255). Jimmy Ernst, however, has suggested that the snub was deliberate (*A Not-So-Still-Life*, 215).

31. Matthew Josephson, "Mr. Biddle on Art," *New Republic* 105, no. 23 (December 8, 1941): 766–767.

32. "The Great Flight of Culture," *Fortune* 24 (December 1941): 102–115.

33. Jimmy Ernst, *A Not-So-Still Life*, 206. Max Ernst's friendship with Eluard had been bonded in Paris after they learned that they had probably fired at each other from opposing sides in one of the battles during the First World War.

34. Gordon Onslow Ford, *Towards a New Subject in Painting* (San Francisco: San Francisco Museum of Art, 1948), 11. For a survey of Ford's painting, see *Gor-*

don Onslow Ford: Retrospective Exhibition* (Oakland: The Oakland Museum, 1980), and Susan M. Anderson, *Pursuit of the Marvelous: Stanley William Hayter, Charles Howard, and Gordon Onslow Ford* (Laguna Beach, Cal.: Laguna Art Museum, 1990).

35. Before returning to the United States in 1939, Ford wrote to Tyler that "Breton is visiting near us for the summer in a chateau rented by the untalented surrealist painter (English) Onslow-Ford" (Ford Papers, HRC).

36. "André Breton Praises New Paintings by Matta," in *Twenty-one Star Final*, 16 April–7 May 1940. Levy borrowed Breton's statement from "Des tendances les plus récentes de la peinture surréaliste," *Minotaure*, nos. 12–13 (1939), 16.

37. Levy, *Memoir of an Art Gallery*, 248. According to Robert Motherwell, "There was some suspicion that Matta might be ultimately another Dali" (quoted in Sidney Simon, "Concerning the Beginnings of the New York School: 1939–1945. An Interview with Robert Motherwell," *Art International* 11, no. 6 [Summer 1967]: 21. Henceforth, Simon, "Interview of Motherwell").

38. "Pictures Demonstrate Black Light," *Twenty-one Star Final*, 16 April–7 May 1940. Levy has described how these black light pictures, painted with fluorescent mineral paints, worked: Matta "meant to include in his coming exhibition a series of these 'black light' pictures. His problem, as he outlined it, was to devise multiple compositions that would look one way in ordinary daylight and another under the 'black' fluorescent light, and still maintain a pictorial relation between the two. We built a peepshow box in which to view these pictures, a series of six, with a toggle switch on the front panel to change the lights, and a viewing aperture. This made drama and news at his exhibition" (*Memoir of an Art Gallery*, 250).

39. On 22 January 1941, De Chirico was shown; 5 February 1941, Ernst and Miró; 19 February 1941, Magritte and Tanguy; 9 March 1941, a group show that included Victor Brauner, Paul Delvaux, Wolfgang Paalen, Stanley Hayter, Seligmann, Matta, Onslow Ford, and Esteban Frances. There was apparently some confusion about Onslow Ford's role in this project because in a later interview he claimed that he discovered only upon arrival that he was to give a series of lectures. For an account of Howard Putzel and his role in promoting Surrealism, see Melvin Lader, "Howard Putzel: Proponent of Surrealism and Early Abstract Expressionism in America," *Arts* 56, no. 7 (March 1982): 85–96.

40. Onslow Ford, *Towards a New Subject in Painting*, 13.

41. Quoted in Martica Sawin, "The Cycloptic Eye, Pataphysics and the Possible: Transformations of Surrealism," in *The Interpretive Link: Abstract Surrealism*

into Abstract Expressionism, Works on Paper, 1938–1948, organized by Paul Schimmel (Newport Beach, Cal.: Newport Harbor Art Museum, 1986), 37–39. Unfortunately, Onslow Ford has not published his notes for his lectures at the New School in 1941.

42. Nancy Miller, Interview with Matta, *Matta The First Decade* (Waltham, Mass.: Rose Art Museum, Brandeis University, 1982), 16.

43. J. W. L., "Matter of Matta," *Art News* 38, no. 31 (4 May 1940): 23, 35; Rosamund Frost, "Matta's Third Surrealist Manifesto," *Art News* 43, no. 1 (15–29 February 1944): 18.

44. Nicolas Calas, "Anti-Surrealist Dali," *View* I, no. 6 (June 1941): 1, 3. Calas was enormously productive during his first years in New York. In addition to writing two books of criticism, *Foyers d'Incendie* (Paris: Les éditions Denoel, 1938) and *Confound the Wise* (New York: Arrow Editions, 1942), he edited a Surrealist section called "Values in Surrealism" for *New Directions 1940* (Norfolk, Conn.: New Directions, 1940), 383–579, for which he wrote "Toward a Third Surrealist Manifesto" (408–421), the title nicely hedging usurpation of Breton's role as leader of the group. Calas also wrote essays for many early issues of *View* and in a related area compiled a visual essay on "Incurable and Curable Romantics" for *Art News* XL, no. 16 (1–14 December 1941): 27–28, 39–40.

45. See Max Ernst, "The Hundred-Headless Woman," *View Poetry Supplement,* vol. I, nos. 7–8 (October–November 1941), n.p. André Masson, "The Bed of Plato," Kurt Seligmann, "An Eye for a Tooth" *View* I, nos. 7–8 (October–November 1941): 3. Ford himself later claimed Breton's *Revolution Surréaliste* as a predecessor for *View* ("An Interview with Charles Henri Ford: When Art and Literature Come Together," by Clive Philpot and Lynne Tillman, *Franklin Furnace Flue* [December 1980], 1).

46. Georges Heinen, "Message from Cairo to Poets in America," *View* I, nos. 7–8 (October–November 1941): 3; Riche, "Nazism and Culture," *View* I, nos. 7–8 (October–November 1941): 8.

47. For interviews of Breton, see Eugene Jolas, "Rambles Through Literary Paris," Paris *Tribune,* 5 July 1925, 5; S. A. Rhoades, "Candles for Isis: A Symposium of Poetic Ideas Among French Writers" I, *Sewanee Review* XLI (1933): 212–224; "Candles for Isis" II, *Sewanee Review* XLI (1933): 286–300. In 1943 Rhoades wrote a brief but spirited defense of Breton ("The Case for the Surrealist Poet," *Books Abroad* 17, no. 1 [Winter 1943]: 13–15).

48. Nicolas Calas, "Interview with André Breton," *View* I, nos. 7–8 (October–November 1941): 1–2.

49. According to Muller, "In Hitler's world, we cannnot afford to pass over the

obvious charge: although the Surrealists pride themselves on fighting against 'all forms of reaction,' insist upon a 'transformation of the world' in the name of liberty, they are actually in the line of the most powerfully reactionary movement of the day, and chiefly exploit the dark powers that enslave man. They hate Hitler, and Hitler despises them. I believe that the feeling is sincere all around. But I suspect that the feeling owes something to an unconscious or unwilling recognition of kinship: each senses in the other the full implications of their creed—the absurd, grotesque, awful logical extreme" ("Surrealism: A Dissenting Opinion," *New Directions in Prose and Poetry, 1940* [Norfolk: New Directions, 1940], 549).

Both Ford and Tyler found James Laughlin, editor (and publisher) of *New Directions* to be conservative. Ford informed Laughlin that he was "a conservative of modernism . . . printing only the socially-aesthetically acceptable— that which resembles the already classical-institutional New" (letter to Laughlin, 18 March 1938, Ford Papers, HRC). Tyler expressed essentially the same view in "What Are New Directions?" *New Directions* 5 (1940): 247–253. As if in confirmation, Laughlin wrote to Ford that he "didn't want any wacky Surrealist covers on New Directions. Frighten the natives, and to what end" (letter to Ford, 4 May 1939, Ford Papers, Getty Center).

50. Calas, "Interview with André Breton," 2.
51. Ibid.
52. Klaus Mann, "Surrealist Circus," *The American Mercury* LVI, no. 230 (February 1943): 179; Gold, *Crossroads Marseilles 1940*, 249–250. Unlike Dali, whose adoption of the grasshopper (related to the praying mantis) was to be considered in an idiosyncratic psychological light, Breton obviously found the praying mantises emblematic of the war. Breton's speech to the Yale students on 10 December 1942 has been reprinted as "Situation of Surrealism Between the Two Wars," in Rosemont, ed., *What Is Surrealism?*, 236–247. It was published in French in *VVV*, no. 2–3 (March 1943): 44–53.
53. For a detailed account of Kahlo's trip to New York, see Hayden Herrera, *Frida: A Biography of Frida Kahlo* (New York: Harper and Row, 1983), 227–240.
54. Calas, "Interview with André Breton," 1.
55. See Sidney Janis, *They Taught Themselves* (New York: Dial Press, 1942), 11–13; "Sidney Janis Presents Self-Taught Artists," *Art Digest* 16, no. 10 (15 February 1942): 21.
56. Sidney Janis, "They Taught Themselves," *Decision* II, no. 1 (July 1941): 26–39. Janis, *They Taught Themselves*, xvii, 13, 20. André Breton, [Two-page fragment], n.d. Ford Papers, HRC.

57. Ford to Gertrude Cato, 19 October 1941, Ford Papers, HRC; Ford, "I Wonder," *View* I, nos. 7–8 (October–November 1941), Poetry Supplement, n.p. Clarke Mills received credit for the English translation of "Fata Morgana" (with illustrations by Wifredo Lam) that appeared in *New Directions* 1941 (Norfolk, Conn.: New Directions, 1941), 651–675. André Breton, "Full Margin," *View,* ser. IV, no. 4, (December 1944): 132–133.

58. André Breton, "The Legendary Life of Max Ernst," *View,* ser. II, no. 1 (April 1942): 5–7; Leonora Carrington, "The Bird Superior, Max Ernst," *View,* ser. II, no. 1 (April 1942), 13; Henry Miller, "Another Bright Messenger," *View,* ser. II, no. 1 (April 1942), 17. Miller also surfaced in a collection of "fantastic stories" edited by Ford, *A Night With Jupiter* (London: Dennis Dobson Limited, 1947), with "A Night With Jupiter" and "Dream of Mobile," 7–13, 95–106.

59. Philpot and Tillman, "An Interview with Charles Henri Ford," 1.

60. "Ira Cohen Interviews Charles Henri Ford," in Winston Leyland, ed., *Gay Sunshine Interviews* I (San Francisco: Gay Sunshine Press, 1978), 42–43.

61. Letter fragment from Ford to Tyler, n.d., Ford Papers, HRC.

62. "Reports and Reporters," *View* I, nos. 4–5 (December–January 1941): 1; Henry Treece, "Literary London," *View* I, no. 1 (September 1940): 5.

63. Ernst, *A Not-So-Still Life,* 223.

64. Ford, "How to Write a Chainpoem"; Matta, Tyler, and Ford, "Dirge for Three Trumpets"; and Calas, "Toward a Third Surrealist Manifesto," 369, 376, 417.

65. Charles Henri Ford, "The Point of *View,*" *View,* ser. III, no. 1 (April 1943): 5.

66. Ibid.

67. Wolfgang Paalen, "Cords and Concord," *View* I, nos. 7–8 (October–November 1941): 5.

68. Ibid.; Ford, "Point of View," 5. In a note to Tyler, Ford argued, "If a Nation doesn't want to consider its artists worth preserving along with its mechanics, doctors, farmers, etc. then it's not a nation worth preserving—I won't say that to President Roosevelt's face—but I think we have a case anyway!" (Letter fragment, Ford to Tyler, n.d., Ford Papers, HRC). His proposal never got off the ground, as, indeed, artists served in the armed forces, Julien Levy and Lincoln Kirstein among them, while others, like Philip Lamantia, the young Surrealist poet from San Francisco, became conscientious objectors—a category that Ford considered completely distinct from his proposal.

69. Edward James to Anna, 10 January 1941, Ford Papers, HRC; Ford to Gertrude Cato, 1 November 1941, Ford Papers, HRC. Cato's exhibition was held at the Bonestell Gallery (11 East 57th Street) 30 October–11 November

1944. Ford carried a full-page advertisement for her one-woman show with the note: "Gertrude Cato was given a box of watercolors for her birthday in Jugoslavia in 1938 [on holiday] and began to paint. She was born in Mississippi and lives in Tennessee."

70. Ford to his mother, Gertrude Cato, 7 March 1942, Ford Papers, HRC. In an earlier letter: "Peggy Guggenheim telephoned the other night and came by with Max Ernst (they're married now). She's thrilled about the special Max Ernst number of *View* which will be the one after next. It will coincide with his exhibition at the Valentine gallery and be sold at the gallery as a catalog. Valentine has agreed to take an ad for $75 and buy 400 copies ($60 to me, for which he will get $100 if he sells them all); Peggy will pay for the reproductions. It will be 32 pages, very elaborate. . . . View is having more and more success—people say 'the most imaginative publication on the market' etc." (Ford to his mother, from NYC to Clarksville, 29 January 1942, Ford Papers, HRC).

71. Quoted in letter from Ford to Cato, 7 March 1942, Ford Papers, HRC.

72. Ford to Henry Treece, 4 December 1940, Ford Papers, HRC.

73. Ruth Ford to Charles Henri Ford, 14 April 1943, Ford Papers, HRC. She went on to say, "People might get the wrong impression about the magazine. They might think it is arty, and uncommercial."

74. For Myers's account of his years with *View*, see *Tracking the Marvelous: A Life in the New York Art World* (New York: Random House, 1983), chapters 3–5.

75. Ford to Cato, n.d. [c. March 1943], Ford Papers, HRC.

76. Ford to Cato, 22 December 1944, Ford Papers, HRC.

77. Ford to Cato, 9 May 1945, Ford Papers, HRC.

CHAPTER 8: A SEASON FOR SURREALISM
AND ITS AFFINITIES

1. Anna Balakian, for example, has eloquently recalled meeting André Breton at that time in his small apartment, where "under the skylight of an artist's mansard roof paced a powerful man trapped in a cage, muzzled by a language he could not speak, circumvented by a society he could not understand, caught in economic obligations to a wife and small child he did not have the means to support, reduced to a fearful reality that seemed forever to obliterate the possibility of the dream" (*André Breton*, [New York: Oxford University Press, 1971], 173). Peggy Guggenheim also described him as a "lion pacing up and down in a cage" at his small gallery in Paris in the late 1930s (*Out of This Century*, 191). These two descriptions, so similar under different circum-

stances, suggest that Breton's powerful restlessness was simply a behaviorial trait, predating exile and hence suggesting that he was not a lion run to ground in New York during the war. His subsequent accomplishments corroborate this view and point to his grace under pressure.

2. "Cords and Concords," *View* I, nos. 7–8 (October–November 1941): 5. The self-conscious and irrepressible Duchamp could not resist doing a parody on such bureaucratic forms. In 1941 he wrote "SURcenSURE" for *L'Usage de Parole,* no. 1 (December 1939): 16. For an excellent account of Duchamp's *Box in a Valise,* see Ecke Bonk, *Marcel Duchamp: The Box in a Valise de ou par Marcel Duchamp ou Rose Sélavy: Inventory of an Edition,* tr. David Britt (New York: Rizzoli, 1989).

3. Kay Boyle to Charles Henri Ford [1941], Charles Henri Ford Papers, Harry Ransom Humanities Research Center, University of Texas at Austin.

4. For Mary Reynolds's hair-raising story, see Janet Flanner, "The Escape of Mrs. Jeffries," *New Yorker* (22, 29 May, 3 June 1943), 23–28, 40–47, 50–67.

5. "Artist Descending to America," *Time* XL, no. 10 (7 September 1942): 100, 102. The dangers of Duchamp's voyage were reported by Dreier to Theodore Size, director of the Yale Art Gallery, in a letter dated 3 July 1942 (quoted in Robert L. Herbert, Eleanor S. Apter, and Elise K. Kenney, eds., *The Société Anonyme and the Dreier Bequest at Yale University: A Catalogue Raisonné* [New Haven: Yale University Press, 1984], 25).

6. For a wonderful untangling of this project, see Charles F. Stuckey, "Duchamp's Acephalic Symbolism," *Art in America* 65, no. 1 (January–February 1977): 94–99. For a history of the Gotham Book Mart and its proprietor, Frances Steloff, see W. G. Rogers, *Wise Men Fish Here* (New York: Harcourt, Brace and World, 1965).

7. Interview with Jean Duche, 1946, in André Breton, *What Is Surrealism? Selected Writings,* ed. Franklin Rosemont (New York: Monad Press, 1978, 262.

8. William Carlos Williams to Nicolas Calas, 15 July 1939. Manuscripts Department, Lilly Library, Indiana University, Bloomington, Indiana, henceforth Lilly Library.

9. Williams to James Laughlin, 26 August 1940, Beinecke Library, Yale University; Williams to Calas, 27 October 1940 and 10 November 1940, Lilly Library.

10. Williams to Calas, 10 November 1940, Lilly Library; Williams to Ford, 23 February 1941, Beinecke Library.

11. Williams to Calas, 10 November 1940, Lilly Library; Williams, "Midas," in Bram Djikstra, ed., *A Recognizable Image: William Carlos Williams on Art and Artists* (New York: New Directions, 1978), 161, 166. In this reprint Djik-

stra has collated the various drafts of Williams's essay, which initially appeared in *Now* I, no. 1 (August 1940): 18–24, and was reprinted in William Carlos Williams, *Selected Essays* (New York: Random House, 1954), 241–249.

12. Williams, "Midas," 158, 159.

13. Ibid., 166, 159, 162.

14. Williams to Calas, 29 December 1940, Lilly Library; Williams to Calas, 4 December 1940, Lilly Library. For Seligmann's study, see *The Mirror of Magic* (New York: Pantheon Books, 1948).

15. Williams to Calas, 12 December 1940 and 10 November 1940, Lilly Library.

16. Williams to Calas, 15 July 1942, Lilly Library; "Paterson: The Falls," *View*, ser. III, no. 1 (April 1943): 19. An account of David Lyle can be found in Mike Weaver, *William Carlos Williams: The American Background* (Cambridge: Cambridge University Press, 1971), 122–127; for an outline of the alchemical aspects of Calas's thinking in relation to *Paterson*, see Weaver, 122–127.

17. For a brief, but one of the few, accounts of *VVV*, see Dawn Ades, *Dada and Surrealism Reviewed* (London: Arts Council of Great Britain, 1978), 375–405. For Hare's work during this period, see Sarah Clark-Langager, "The Early Work of David Hare," *Arts* 57, no. 2 (October 1982): 104–109.

18. Clive Philpot and Lynne Tillman, "An Interview with Charles Henri Ford: When Art and Literature Come Together," *Franklin Furnace Flue* (December 1980): 1; "Review of Reviews," *VVV* no. 1 (June 1942): 66, 68.

19. Williams, "Midas," 158.

20. André Breton, "Prolegomena to a Third Manifesto of Surrealism or Else," in André Breton, *What Is Surrealism? Selected Writings*, ed. Franklin Rosemont, 209–217. The "Prolegomena" appeared in *VVV*, no. 1 (June 1942): 18–26.

21. This, according to Mike Weaver, *William Carlos Williams: The American Background*, 139. Breton's old rival for Surrealism in the early 1920s, Yvan Goll, also escaped to New York and, true to his inclusive instincts, began a magazine called *Hemispheres; French American Quarterly of Poetry*, which ran from 1943 to 1945. Several Americans, including Charles Henri Ford, Parker Tyler, and William Carlos Williams, contributed to *Hemispheres*. See Donna Kuizenga, "Yvan Goll's *Hemispheres*: A Forgotten French-American Review of the 1940's," *The French-American Review* II, nos. 1–2 (Winter 1977 and Spring 1978): 17–27. After the war an English translation of a cycle of his lyric poems was published as *Jean San Terre* (New York: Thomas Yoseloff, 1958).

22. Lionel Abel still assisted Breton with the first issue of *VVV*, long enough to have had a fight with him, he has recalled (*The Intellectual Follies: A Memoir of the Literary Venture in New York and Paris* [New York: W. W. Norton, 1984], 105). For Hare's comment, see Jacqueline Bograd Weld, *Peggy: The Wayward Guggenheim*, (New York: E. P. Dutton, 1986), 270.

23. *VVV*, no. 1 (June 1942): 9; Motherwell, "Painters' Objects," *Partisan Review* 11, no. 1 (Winter 1944): 97.

24. André Breton, "Situation of Surrealism Between the Two Wars," in *What Is Surrealism? Selected Writings*, ed. Franklin Rosemont, 242.

25. Ibid., 237.

26. For a detailed account of Kiesler's commission, see Cynthia Goodman, "Frederick Kiesler: Designs for Peggy Guggenheim's Art of This Century," *Arts* 51 (June 1977): 90–95. Howard Putzel introduced Surrealism to San Francisco in 1934 and then moved to Los Angeles, where he managed the Stanley Rose Gallery, which exhibited the Post-Surrealists. By the late 1930s he had become Peggy Guggenheim's advisor in purchasing modern European art. For details of his life, see Melvin P. Lader, "Howard Putzel: Proponent of Surrealism and Early Abstract Expressionism in America," *Arts* 56, no. 7 (March 1982): 85–96.

27. André Breton, "Genesis and Perspective of Surrealism," in Peggy Guggenheim, ed., *Art of This Century* (New York: Arno Press, 1968), 17.

28. Sidney Janis, foreword, *First Papers of Surrealism*, (New York, 1942) n.p.

29. The shots echoed Duchamp's toy cannon match shots at *The Bride Stripped Bare By Her Bachelors, Even*, his large glass in its schematic construction during the First World War.

30. Janis, preface and foreword, *First Papers of Surrealism*, n.p.

31. In his memoir Jimmy Ernst describes how the Surrealists met to interrogate Mondrian, whose tolerance of diverse painting put them to shame, won over Tanguy, and silenced Breton (*A Not-So-Still Life*, (New York: St. Martin's/Marek, 1984), 227–228). The most conspicuous absence from "First Papers" was Man Ray, even though he was on the west coast. Although Joseph Cornell was not mentioned in the exhibition catalogue, he was listed as a participant on Breton's form letter inviting artists to contribute work to the exhibition (letter to William Baziotes, 7 September 1942, Baziotes Papers, AAA, roll N70–21).

32. "Inheritors of Chaos," *Time* XL, no. 15 (2 November 1942): 47.

33. Breton, "On the Survival of Certain Myths and on Some Other Myths in Growth or Formation," *First Papers of Surrealism*, n.p., reprinted in *What Is Surrealism?* ed. Franklin Rosemont, between pp. 272–273.

34. "Inheritors of Chaos," *Time,* 47; Edward Alden Jewell, "Surrealists Open Display Tonight," *New York Times* (14 October 1942): 26. Duchamp's scheme to invite the children was evidently planned in advance, for the catalogue noted, "Vernissage consacré aux enfants jouant, à l'odeur du cèdre."

35. Edward Alden Jewell, "Surrealists Open Display Tonight," *New York Times* (14 October 1942): 26; Jewell, " 'Inner Vision' and Out of Bounds," *New York Times* (18 October 1942), VIII, 10 .

36. Jewell, " 'Inner Vision' and Out of Bounds," 10.

37. Jimmy Ernst, *A Not-So-Still Life,* 234; "Agonized Humor," *Newsweek* XX, no. 17 (26 October 1942): 76.

38. Charles Henri Ford to Henry Treece, 31 October 1942, Ford Papers, HRC; Jimmy Ernst, *A Not-So-Still Life,* 234. For an explanation of favorable American policy toward Vichy France, see William L. Langer, *Our Vichy Gamble* (Hamden, Conn.: Archon Books, 1965).

39. "Isms Rampant: Peggy Guggenheim's Dream World Goes Abstract, Cubist, and Generally Non-Real," *Newsweek* XX, no. 18 (2 November 1942): 66. Edward Alden Jewell caught the significance of the setting in noting that the art is "framed not within an individual rectangle or square of its own, but instead by the 'spatial' architecture that forms the whole gallery." ("Gallery Premiere Assists Red Cross," *New York Times,* 21 October 1942, p. 22).

40. See Weld, *Peggy: The Wayward Guggenheim,* 445–448 for information about exhibitions of the Surrealists and Americans at Art of This Century during the 1940s.

41. "The Impact of Surrealism on the New York School," *Evergreen Review* 4, no. 12 (March–April 1960): 77. Their interest in painting does not mean, however, that they rejected myth or Freudian theory—not, at least, as stringently as Myers implies in their concern for formal and technical matters.

42. Breton, *First Manifesto,* 37.

43. Surrealist "speech" dated back to Breton's experiences with the mentally wounded during the First World War. In the first *Manifesto of Surrealism* he compared Freud's analytic methods to coaxing a monologue from the patient, *"akin to spoken thought"* (23). Echoing Freud was Tzara, who argued that "thought is made in the mouth." From a Dada point of view this contention suggests an improvisatory speech, a Whitmanesque "barbaric yawp." For Breton, "spoken thought" / "thought made in the mouth" intimately links language and the mind. Breton sought language that would express the mind in its entirety. According to Susanne Langer, such a language is mythopoeic, nonrational, and generative, from which rational discourse deviates (*Philosophy in a New Key* [Cambridge: Harvard University Press, 1973], chapter 4).

For Breton, automatic writing became the *locus* of the conscious and the unconscious, dream and reality—the locus of all those elements and qualities that have been alienated from one another by a society restrained by rationality to the point of oppression. For the sources of automatic writing, see Balakian, *André Breton*, 27–33.

44. According to Jacqueline Chenieux-Gendron, "Almost all the Surrealists of the 1920s practiced automatic writing....Only René Crevel consistently had suspicions about it as an interior language. Combining his own quest with the quest for a 'first state,' he affirmed that this state is silence: 'it is sufficient unto itself and asks the help of neither philosophy nor literature. It experiences itself and has no other expression than an internal, affective, nonsyllabic chant' (*Mon corps et moi*, 1925)" (*Surrealism*, tr. Vivian Folkenflik [New York: Columbia University Press, 1990], 26).

45. For a dismissal of automatic painting, see Pierre Naville, "Beaux-Arts," *La Révolution Surréaliste*, no. 3 (15 April 1925): 27; also see Max Morise, "Les Yeux Enchantés," *La Révolution Surréaliste*, no. 1 (1 December 1924): 26–27. For an insightful discussion of Surrealist attitudes toward automatism, see Werner Spies, *Max Ernst Loplop: The Artist's Other Self* (London: Thames and Hudson, 1983), 68–75.

46. André Masson, *Nocturnal Notebook* (New York: Curt Valentin, 1944), n.p. Masson also produced *Mythology of Being* (New York: Wittenborn, 1942) and *Anatomy of My Universe* (New York: Curt Valentin, 1943). During the 1940s he collaborated with Breton on "Martinique charmeuse de serpents," published in 1948. For the painter's stay in America, see Carmine Benincasa and Cleto Polcina, *André Masson: 1941–1945* (New York: Marisa del Re Gallery, 1981).

47. Sidney Simon, "Concerning the Beginnings of the New York School: 1939–1943. An Interview with Peter Busa and Matta," *Art International* 11, no. 6 (Summer 1967): 18 (henceforth Simon, "Interview with Busa and Matta"). In also noting Masson's influence on American painters during the 1940s, Gerome Kamrowski has stressed Masson as "the freest painter" ("Gerome Kamrowski: An Interview with the Artist," in Evan M. Maurer and Jennifer L. Bayles, *Gerome Kamrowski: A Retrospective Exhibition* (Ann Arbor: University of Michigan Museum of Art, 1983), 2. For Masson's exhibitions in the United States, see William Rubin and Carolyn Lanchner, *André Masson* (New York: Museum of Modern Art, 1976), 230–231.

In his foreword to his *Vertical* anthology (with an elegant spiral by Calder on its cover), Eugene Jolas announced the completion of his "verticalist project": "a romantic, cosmological, and mystical theory of ascent" (*Vertical: A*

Yearbook for Romantic-Mystic Ascensions [New York: Gotham Bookmart Press, 1941], n.p.).

48. Sidney Janis, "School of Paris Comes to U.S." *Decision*, vol. II, nos. 5–6 (November–December 1941): 94. For the most definitive work on Matta, see *Matta* (Paris: Editions du Centre Pompidou, 1985).

49. Max Kozloff, "An Interview with Matta: 'These things were like rain catching up with a man who is running,' " *Artforum* IV, no. 1 (September 1965): 23.

50. James Johnson Sweeney, "eleven europeans in america," *Museum of Modern Art Bulletin* XIII, nos. 4–5 (February 1946): 16–17.

51. Statement by Kamrowski, quoted in Wechsler, *Surrealism and American Art, 1931–1947* (New Brunswick: Rutgers University Art Gallery, 1977), 55. While the element of automatism among American painters during the early 1940s has long been acknowledged, this episode has been recounted most fully by Martica Sawin, " 'The Third Man,' or Automatism American Style," *Art Journal* 47, no. 3 (Fall 1988): 181–186. Also see David S. Rubin, "A Case for Content: Jackson Pollock's Subject was the Automatic Gesture," *Arts Magazine* 53 (March 1979): 103–109.

52. Simon, "Interview with Busa and Matta," 18, 17.

53. Max Kozloff, "An Interview with Motherwell," *Artforum* IV, no. 1 (September 1965): 33; Simon, "Interview with Motherwell," 20.

54. Busa quoted in Simon, "Interview with Busa and Matta," 18; Kamrowski quoted in *The Interpretive Link: Abstract Surrealism into Abstract Expressionism, Works on Paper, 1938–1948*, organized by Paul Schimmel (Newport Beach, Cal.: Newport Harbor Art Museum, 1986), 39, 100. Motherwell does not remember much about those sessions at Matta's (Simon, "Interview with Motherwell," 22).

55. Ibid., 21–22.

56. Matthew Josephson, "A Letter To My Friends," *Little Review* 12 (Spring–Summer 1926): 19.

57. Max Kozloff, "These things were like rain catching up with a man who is running," *Artforum* IV, no. 1 (September 1965): 23–26. Kamrowski quoted in Sawin, "Gerome Kamrowski: 'The Most Surrealist of Us All,' " *Arts Magazine* 62, no. 4 (December 1987): 76.

58. "The Modern Painter's World," *Dyn*, no. 6 (November 1944), 9.

59. John Myers, *Tracking the Marvelous* (New York: Random House, 1983), 35.

60. "*Dyn* will stay independent of all commercial or political compromises. It neither belongs to, nor proposes to establish any 'ism,' group or school" (*Dyn*, no. 1 [April–May 1942]: inside front cover); Wolfgang Paalen, "Farewell au

Surréalisme," *Dyn*, no. 1 (April–May 1942): 26. Some of Paalen's disaffection was derived from an antipathy toward Calas, whom he dismissed as a "budding theologian" of Surrealism, whose academic theorizing had betrayed "the true purport of Surrealism" (Review of Nicolas Calas, CONFOUND THE WISE, *Dyn*, no. 1 [April–May 1942]: 45).

61. Wolfgang Paalen, "The New Image," *Dyn*, no. 1 (April–May 1942): 7. Paalen remarkably foreshadowed Raymond Williams in revising a Marxist theory of art. Williams collapses the metaphor of "base" and "superstructure" by seeing "language and signification as indissoluble elements of the material social process itself" (*Marxism and Literature* [New York: Oxford University Press, 1977], 99). By this view, artists are not superfluous to the crucial social and political issues of their day.

 For a brief but incisive account of Paalen's significance, see Martica Sawin, "The Cycloptic Eye, Pataphysics and the Possible: Transformations of Surrealism," in *The Interpretive Link*, 40–41.

62. Quoted in Melvin Lader, "Peggy Guggenheim's Art of This Century: The Surrealist Milieu and the American Avant-Garde, 1942–1947" (Unpublished Diss., University of Delaware, 1981), 114.

63. André Breton, preface, *First Papers of Surrealism* (New York: 1942), n.p.

64. Paalen, "The New Image," *Dyn*, no. 1 (April–May 1942): 12. For an excellent discussion of Motherwell's early work, see Robert S. Mattison, "A Voyage: Robert Motherwell's Earliest Work," *Arts Magazine* 59, no. 6 (February 1985): 90–93. Mattison argues that Paalen's painting had an effect on Motherwell despite his disclaimer. Beyond the compelling evidence that Mattison presents with regard to the painting, I would argue that Paalen's *ideas*—and Motherwell was nothing if not receptive to ideas—jogged the American free from Surrealism and Matta's version of it.

65. Simon, "Interview with Busa and Matta," 18. Motherwell claimed that "*what was needed was a creative principle. It is never enough to learn merely from pictures....In this sense, the theory of automatism was the first modern theory of creating that was introduced into America early enough to allow Americans to be equally adventurous or even more adventurous than their European counterparts*" (Simon, "Interview with Motherwell," 23).

66. Max Kozloff, "Interview with Motherwell," *Artforum*, September 1965: 34.

67. Simon, "Interview with Motherwell," 22; quoted in Barbara Cavaliere and Robert C. Hobbs, "Against a Newer Laocoon," *Arts Magazine* 51, no. 8 (April 1977): 11; quoted in Jeffrey Potter, *To a Violent Grave: An Oral Biography of Jackson Pollock* (New York: G. P. Putnam's Sons, 1985), 70.

68. Simon, "Interview with Busa and Matta," 17.

69. Simon, "Interview with Busa and Matta," 19.

70. Breton, *Surrealism and Painting*, tr. Simon Watson French (New York: Harper & Row, 1972), 226; Kamrowski, quoted in Martica Sawin, "Gerome Kamrowski: 'The Most Surrealist of Us All,' " *Arts Magazine* 62, no. 4 (December 1987): 76.

CHAPTER 9: JOSEPH CORNELL,
"THE ENCHANTED WANDERER"

1. Sometime in 1941 Joseph Cornell began to convert his basement into a studio. For the details of Cornell's life, I am indebted to Lynda Roscoe Hartigan, "Joseph Cornell: A Biography," in Kynaston McShine, ed., *Joseph Cornell* (New York: Museum of Modern Art, 1980), 91–119.

2. Anna Balakian insightfully compares Breton's walks to the concept of Brownian movement, "the multiplicity of movements following from a single impulsion; they cannot be coded by a mathematical formula but can only be charted graphically by a range of possibilities and statistical probabilities": "It is in this light that we must view the walks that, under the leadership of Breton, the surrealists took across the length and breadth of Paris. What city other than Paris would have afforded so many aleatory interventions of sights and events to this automatic ambulation, logically, intentionally free of destination, as unpreconceived as the subject matter of automatic writing?" (*André Breton: Magus of Surrealism* [New York: Oxford University Press, 1971], 40, 42). Although one might argue that Cornell knew his destinations along Forty-second Street, the prospects of finding something marvelous were always uncertain, vulnerable to chance.

3. Although Dawn Ades rightly notes that "the range of objects found, made, or interpreted by the Surrealists during the '30s is vast," their individual explorations were sporadic ("The Transcendental Surrealism of Joseph Cornell," in McShine, ed., *Joseph Cornell*, 25). With the exception of Man Ray, who invented objects throughout his life, no Surrealist sustained interest in found objects and the assembled object to Cornell's extent.

4. See Carter Ratcliff, who in a far-ranging essay concludes that Cornell "looks like an allegorical figure of The Individual Spirit Confronting the Machine Age" ("Joseph Cornell: Mechanic of the Ineffable," in McShine, ed., *Joseph Cornell*, 64). Although *Object* alludes to an aviary, which Cornell saw in Manhattan pet stores, the box is closer in quality to artificial habitats or cluttered storefront windows.

5. Tanning wrote to Cornell: "It may sound foolish but it is my belief that there

is only poetry and revulsion. I'd like to let the poetry in and keep the revulsion out. That is something that you, of all people I know, have somehow managed to do. How did you do that, Joseph? I wish I were not so aware of what the rest of the world is doing. Maybe that is your secret, maybe that is what you keep out" (March 3, 1948, Cornell Papers, Archives of American Art, Smithsonian Institution, Washington, D.C., roll 1055, frames 509–510, hereafter AAA).

6. Cornell owned a copy of Walt Whitman's *Leaves of Grass* (1900 edition), indicated in a bibliography compiled at the Joseph Cornell Study Center, Smithsonian Institution, Washington, D.C.

7. Cornell Papers, AAA, roll 1058, frame 234. These fragments are filmed on frames 231–235.

8. Cornell quoted from Whitman's poem, "The Untold Want" (1871): "The untold want by life and land ne'er granted, / Now voyager sail thou forth to seek and find." Embedded in a poem in miniature, the quest theme for the ineffable beyond this world obviously appealed to Cornell.

9. At one point, Cornell suggested that his French sources extended back to the late nineteenth and early twentieth centuries, prior to the Surrealists, even as he abjured comprehension of the French Symbolist poets. Late in life, he disclaimed any artistic influence on his work, which he insisted "spontaneously unfolded"! (See Ades, "The Transcendental Surrealism of Joseph Cornell," 24, 22.) Here was a man who tried to cover his tracks in seeking independence as an artist.

10. Cornell to Alfred H. Barr, Jr., 13 November 1936, Archives of The Museum of Modern Art.

11. For an account of Christian Science, to which Cornell was converted in 1925, see Hartigan, "Joseph Cornell: A Biography," 95–96. She notes that Cornell himself claimed an "extraordinary" emotional response derived from a fusion of Christian Science and Surrealism, in a letter to Mina Loy in 1946 (99). Also see the account of Sandra Leonard Starr in *Joseph Cornell: Art and Metaphysics* (New York: Castelli, Feigen, Corcoran, 1982), 1–5.

12. By the 1930s, a phrase such as the "poetry of Surrealism" had become commonplace. Yet the title should not be overlooked for suggesting Cornell's distance from the movement even as he possessed its sensibilities. Surrealism itself became grist for the mill in Cornell's work, an object for consideration rather than a movement in which he was immersed. At the same time, a collage demonstrating such poetry could have been done only by someone in tune with the sensibility of Surrealism.

13. *View*, ser. V, no. 1 (March 1945): 22.

14. Julien Levy claimed that "his miniaturization was in the line of Duchamp's portable universe, the 'Desirable Valise' " ("Joseph Cornell: or Twelve Needles Dancing on the Point of an Angel," in *Joseph Cornell Portfolio* [New York: Leo Castelli Gallery, 1976], n.p.)

15. Although Starr denies that "all roads in Cornell's earlier work lead to Marcel Duchamp," she astutely regards Duchamp as "Cornell's secular and agnostic twin whom Cornell saw as an angel in danger of falling from grace" (*Joseph Cornell: Art and Metaphysics*, 3–4). Whereas Starr's view on the matter is coherent, Diane Waldman presents scattered insights throughout *Joseph Cornell* (New York: George Braziller, 1977). Even though she notes an entire range of similarities and differences, she does not strike at the essential indeterminacy that bonds Duchamp and Cornell.

16. Cornell, Diary entry, 17 February 1947, referring back to 21 December 1942, Cornell Papers, AAA, roll 1058, frame 890.

17. Cornell constructed several boxes on this theme. The first version (1942) belongs in The Peggy Guggenheim Collection, Venice, the second (1943) belonged to Duchamp.

18. In "Joseph Cornell: Mechanic of the Ineffable," Carter Ratcliff also sees the Duchamp connection as "crucial," both for his use of glass (allowing voyeurism) and for the mechanical replication of images (63). Yet Waldman is correct in seeing Cornell's serial works as variations rather than sheer replications (*Joseph Cornell*, 24).

19. In "The Transcendental Surrealism of Joseph Cornell," Dawn Ades rightly notes that Cornell most often borrows an object as an element for an assemblage without submitting it to metamorphosis (26). Nevertheless, there is, I contend, a subtle transformation of the work even as its elements taken individually or together retain an original identity. Waldman argues in passing that Cornell's work exists between the assisted readymade and the found object (*Joseph Cornell*, 12) .

20. Levy, *Memoir of an Art Gallery*, 76–77. William Copley, *CPLY: Reflection on a Past Life* (Houston: Institution for the Arts, Rice University, 1979), 14.

21. "The Pulse of Fashion," *Harper's Bazaar* (January 1937): 45.

22. Aragon, *La Peinture au Défi*, 13.

23. Levy, *Memoir of an Art Gallery*, 78–79. If Levy has recalled accurately, Cornell argued that Ernst's collages "wouldn't exist at all . . . because evil doesn't exist—you would know if you understood Mrs. Eddy" (78) . Such reasoning allowed Cornell to account for the existence of Ernst's work and to misread it to the extent that he would not have to reject it.

24. According to Ades, "the list of categories [of objects Levy cited in Cornell's

first exhibition] itself is impressive—as though with every new work Cornell created a new category, a new type of construction" ("The Transcendental Surrealism of Joseph Cornell," 19). He probably did.

25. These categories would be repeated with some variation as late as 1940.

26. The announcement is reproduced in McShine, ed., *Joseph Cornell*, 268. Some phrases are ambiguous. "Medici Slot Machines," we know, refers to a specific box, yet the plural here suggests that Cornell thought of the title generically, and he did construct other boxes based on the theme and motif of the *Medici Slot Machine.*

27. Sidney James, *Abstract and Surrealist Art in America* (New York: Reynal & Hitchcock, 1944), 88; Breton, *First Manifesto*, 46, 47.

28. Julien Levy, ed., *Surrealism* (New York: Black Sun Press, 1936), 28.

29. Gallery handbill for Cornell exhibition at the Julien Levy Gallery, 6 December 1939–9 January 1940.

30. "Give Art for Christmas—Bargains in Beauty," *Art Digest* 18, no. 6 (15 December 1943): 15; Carlyle Burrows, "Playful Objects," *New York Herald Tribune* (10 December 1939), section 6: 8.

31. Charles Henri Ford, *ABC's* (Prairie City, Ill.: Press of James A. Decker, 1940). The poems have been reprinted in Ford, *Flag of Ecstasy: Selected Poems*, ed. Edward B. Germain (Los Angeles: Black Sparrow Press, 1972), 84–88.

32. Hartigan, "Joseph Cornell: A Biography," 103.

33. Levy later recalled, perhaps erroneously, that the eye was a photograph of Lee Miller's. He may have confused it with *Object of Destruction*, made on the occasion of the dissolution of their relationship in 1932 (*Memoir of an Art Gallery*, 83).

34. Alfred H. Barr, Jr., ed., *Fantastic Art, Dada, Surrealism*, 65, 266, illus. 309.

35. Cornell to Alfred H. Barr, Jr., 13 November 1936, Archives of The Museum of Modern Art. Cornell was alluding to "The Surrealists," *Harper's Bazaar* (November 1936): 126. That Cornell supposedly dreamed about making his assemblages emerged in the context of an interview with Levy, yet the notion may have been concocted by the interviewer. Later on, when the quest for materials became deeply ingrained, Cornell apparently *did* dream about making an assemblage, as he wrote in a letter: "It is long since I've been able to find these sun images but in the dream I found one hidden behind a piece of china in an antique shop" (Cornell to Mrs. [Elizabeth] Hansen, n.d., Cornell Papers, AAA, roll 1055, frame 197).

36. "Varied Gallery Attractions," *New York Sun* (1939): 19.

37. Cornell to Alfred H. Barr, Jr., 13 November 1936, Archives of The Museum of Modern Art.

38. André Breton, "Genesis and Perspective of Surrealism," in Peggy Guggenheim, ed., *Art of This Century* (New York: Arno Press, 1968), 26.

39. "Old Prom Programs, Etc.?" *Art Digest* 14, no. 6 (December 15, 1939): 13.

40. Cornell to Parker Tyler, 25 September 1940, Charles Henri Ford Papers, Harry Ransom Humanities Center, University of Texas at Austin.

41. According to Jean Le Gac, Cornell used Jules Marey, *Les Damnées de Paris* (1883), one of Ernst's visual sources, for an early collage ("Slow, Quick, Quick, Slow," in *Joseph Cornell* [Paris: 1980], n.p.). See collage 29 in *Joseph Cornell Collages, 1931–1972* (New York: Castelli, Feigen, Corcoran, 1978), 48.

42. Robert Allerton Parker, "Explorers of the Pluriverse," *First Papers of Surrealism,* (New York: 1942) n.p.

43. Ibid.

44. "Americana Fantastica," *View,* ser. II, no. 1 (January 1943): 5.

45. Ibid.

46. *View,* ser. II, no. 1 (January 1943): 1.

47. "Americana Fantastica," 5.

48. Ibid.

49. Alva N. Turner, "The Cat That Came Back," *View* I, nos. 11–12 (February–March 1942): 5.

50. Joseph Cornell, "The Crystal Cage," *View,* ser. II, no. 4 (January 1943): 10–16. Most of the groundwork for my discussion of "The Crystal Cage" has been laid by Helen H. Haroutunian, "Joseph Cornell in 'View,' " *Arts* 55, no. 7 (March 1981): 102–109, and Sandra Leonard Starr, "Joseph Cornell's *The Crystal Cage (Portrait of Berenice)*," in *The Crystal Cage* (Tokyo: Gatodo Gallery, 1987), 13–53. They have set forth the essential sources for the portfolio and outlined the basic parameters of interpretation, including Cornell's liaison with Duchamp. Subsequent notes indicate my disagreements on specific matters. More crucially, however, neither considers the pivotal role of "The Crystal Cage" (and Cornell) in the ambivalent context of *View* and the Surrealists.

51. Some of Duchamp's critics, most notably Arturo Schwarz, who sees alchemy everywhere, have insisted upon a systemic interpretation of *The Large Glass,* which in my estimation defies a closed view because it was deliberately left unfinished.

52. Quoted in Janis, *Abstract and Surrealist Art in America,* 106. Contrast Cornell's reticence with Breton's willingness to ascribe specific meaning to elements of his *Poème-Objet* (1941) in the same catalogue (130).

53. *View,* ser. II, no. 4 (January 1943): 12. La pagode de Chanteloup is discussed in Edouard Jaguer, *Joseph Cornell* (Paris: 1989), 83–85.

54. "The Crystal Cage," 11.

55. "The Crystal Cage," 12; Ford, "Ballet for Tamara Toumanova," *View*, ser. II, no. 4 (January 1943): 36–37.

56. "The Crystal Cage," 16.

57. *View*, ser. II, no. 4 (January 1943): 21.

58. Edgar Allan Poe, "Ligeia," in *Complete Stories and Poems of Edgar Allan Poe* (Garden City: Doubleday, 1966), 97–108.

59. Poe, "Berenice," in *Complete Stories and Poems*, 171–177.

60. Ibid., 175.

61. Ibid.

62. Ibid., 176–177.

63. Sandra Starr, "Joseph Cornell's The Crystal Cage," 21. Starr later suggests that Berenice is "a thinly disguised self-portrait of the artist himself." (25).

CHAPTER 10: ARSHILE GORKY'S
ETHNICITY AND SURREALISM

1. For the accounts of Blume and Cowley, see Karlen Mooradian, ed., *The Many Worlds of Arshile Gorky* (Chicago: Gilgamesh Press, 1980), 100–106, 119–123. Not until Mooradian was Gorky's Armenian heritage really taken seriously. See his first article, "The Unknown Gorky," *Art News* 66 (September 1967): 52–53, 66–68. But in subsequent studies, Mooradian has overstated the case: Gorky becomes an exiled Armenian prince who was the greatest painter of the twentieth century. Previous critics are castigated and dismissed for not recognizing his greatness, which Mooradian predicates on his ethnicity. (See, for example, *Many Worlds*, 327).

There is no formal biography of Gorky. The closest is Mooradian, *Arshile Gorky Adoian* (Chicago: Gilgamesh Press, 1978). This study is also undermined by ethnic chauvinism. In order to make his case, Mooradian apparently felt compelled to exaggerate Gorky's artistic interests as a young boy in Armenia. The approach itself is not unreasonable, the hyperbole is. Mooradian's presentation verges on a parody of Leon Edel's life of Henry James: the early, middle, and late years are compressed into something less than the first decade of Gorky's life. Nevertheless, we are indebted to Mooradian for insisting upon his uncle's ethnic identity and for the details of his life.

Mooradian's essential point of view was most recently picked up and modified by the art historian Harry Rand, in *Arshile Gorky: The Implication of Symbols* (Montclair, N.J.: Allanheld and Schram, 1980). For Rand, Gorky was

"a modern history painter," who painted his own history. This thesis is disingenuous, for what was Gorky, then, but autobiographical in his painting? This is a commonplace assertion that can be made about any number of painters, especially Gorky's next of kin, the Abstract Expressionists. Rand, I suspect, found a strategical purpose in the genre of history painting: it allows the possibility of figurative painting by virtue of depicting public events. Thus Rand's study, subtitled "The Implications of Symbols," is essentially iconographic in approach.

The content of that iconography was inevitably Gorky's Armenian life, Rand acknowledges. But that life is not to be found necessarily in the form of identifiable images on the canvas. In tacit recognition of that problem, Rand claims that Gorky's ethnicity gradually faded from the paintings. After 1943 or thereabouts, Rand argues, Gorky shifted in his paintings from depictions of his Armenian childhood to those of his life in America. Yet Rand does not dismiss Gorky's Armenian preoccupations. He simply transfers them from the realm of painting to storytelling: "Almost as if he dreaded losing contact with that past, with his earliest memories of his native land, its serenity and dignity, and the past in which his mother had lived happily and prosperously with her children, Gorky told and retold the stories of his youth." For Rand, nostalgia for Armenia continued to color Gorky's psychology as a general context for his paintings but no longer informed specific works with an Armenian iconography. "Gorky would not release his grip on that idyllic and pastoral moment, although memory naturally and inexorably allowed the scenes to fade" (89).

2. Letter to Karlen Mooradian, 4 May 1947, Mooradian, ed., *Many Worlds*, 321.

3. Letter to Vartoosh Mooradian, 17 January 1947, Mooradian, ed., *Many Worlds*, 314–315.

4. John Bernard Myers, *Tracking the Marvelous* (New York: Random House, 1983), 58. Myers tells the story on himself of how he trashed Gorky's drawings when *View* was terminated and the office closed down (87).

5. Letter to Vartoosh Mooradian, 17 January 1947, Mooradian, ed., *Many Worlds*, 314–315. According to Stuart Davis, "Gorky . . . still wanted to play," despite the "serious situation" of the Depression. (Quoted in Ethel K. Schwabacher, *Arshile Gorky* [New York: Macmillan Co. 1957], 47). Many people whom Mooradian interviewed thought that Gorky did not fit in the fast Surrealist set (see, for example, Lillian Olinsky Kiesler or Margaret La Farge Osborn, in Mooradian, ed., *Many Worlds*, 160, 187). In the first monograph on Gorky, which remains the best for its sensitive insight, Ethel K. Schwabacher concurs that their "sophistication glanced off him." But in the

same breath she acknowledges that Gorky appreciated the poetry and "poetic vision" of the Surrealists (*Arshile Gorky*, 136).

6. That Gorky contemplated reverting to his original name was reported by Yenovk der Hagopian in Mooradian, ed., *Many Worlds*, 57.

7. In light of his enthusiasm for modern European painting, Gorky can hardly be called ethnocentric. Nevertheless, his own Armenian commitments precluded any sort of pandering to Breton's French preferences—as, apparently, in the amusing instance of Miró. According to John Myers, "Miró would commit himself to no movements. It was not his fault that he was included in so many Surrealist exhibitions. Still, if he were asked which were his favorite poets, he would promptly answer the approved pat names, 'Lautreamont, Baudelaire and Rimbaud'—an answer that could always warm Breton's heart" (Myers, *Tracking the Marvelous*, 91).

8. Some in the avant-garde took Gorky's ethnicity as a source of amusement. Julien Levy, for example, found his accent "hilarious" (*Arshile Gorky* [New York: Harry N. Abrams, 1966], 35). Others barely tolerated it. Stuart Davis and his friends had rejected Gorky's Armenian posturing during the 1930s. According to Davis, when Gorky drank, which was infrequently, "he would go into a routine derived from the song and folk-dances of his native land. This performance took up a lot of room and the accompanying vocalizations drowned out all competitive conversations. This idiosyncrasy was frowned on by us, who would not tolerate musical deviations of any kind from our profoundly hip devotion to American Jazz. Gorky became aware of this ban very fast, and respected it after being properly indoctrinated in its rationale. He reserved his routine for other circles where it was appreciated and continued to go over big" ("Arshile Gorky in the 1930's: A Personal Recollection," in Diane Kelder, ed., *Stuart Davis* [New York: Praeger, 1971], 181). Davis simply found Gorky's Armenianism irrelevant; he intended no bigotry, any more than Levy was malicious in finding Gorky's accent a source of amusement. Apparently Gorky could in turn exaggerate his accent when he sought an exotic effect.

9. "Fetish of Antique Stifles Art Here, Says Gorky Kin," *New York Evening Post*, 15 September 1926. Reprinted in Harold Rosenberg, *Arshile Gorky: The Man, the Time, the Idea* (New York: Sheepmeadow Press/Flying Point Books, 1962), 123–126.

10. Letter to Vartoosh Mooradian, 26 January 1944, Mooradian, ed., *Many Worlds*, 283.

11. Gorky's sister Vartoosh has recalled that his family objected to his move to New York ("Recollections of Vartoosh," in Mooradian, *Many Worlds*, 37). For

a study of Armenian emigration to the United States during the diaspora, see Edward Minassian, "They Came from Ararat: The Exodus of the Armenian People to the United States" (unpublished Master's thesis in History, 1961, University of California, Los Angeles, on deposit at the University library).

12. For an account of American avant-garde interest in Cézanne (Gorky's modernist starting point) during the 1920s, see Georgia O'Keeffe, *Georgia O'Keeffe* (New York: Penguin, 1983), n.p.

13. Julien Levy, Gorky's dealer, recounts how he held off the painter when he was first approached, because Gorky was so immersed in the painting of Picasso that he had not, in Levy's estimation, come into his own (*Memoir of an Art Gallery* [New York: G. P. Putnam's Sons, 1977], 283). Levy was clearly basing his initial judgment on the avant-garde premium placed upon originality and innovation. Mooradian rightly argues that the entire process of apprentice-ship as a mode of learning was intrinsic to a traditional culture such as the Armenian (*Many Worlds*, 221).

14. See Walter Ong, *Orality and Literacy: The Technologizing of the Word* (London: Methuen, 1982), 11. It should be noted that there are probably very few cultures left that are purely oral; Armenia at the turn of the century was not one of them. In the small villages and towns, which were isolated from one another, oral traditions coexisted with a literate culture that was largely de-termined by class, status, and gender. For a collection of Armenian folktales, as they survived in the Armenian community in Detroit, see Susie Hoogasian-Villa, ed., *100 Armenian Tales and Their Folkloristic Relevance* (Detroit: Wayne State University Press, 1966).

15. Mooradian, *Arshile Gorky Adoian*, 118–119. For a study of life in rural Arme-nia around the turn of the century, see Susie Hoogasian Villa and Mary Kil-bourne Matossian, *Armenian Village Life Before 1914* (Detroit: Wayne State University Press, 1982).

16. As Ong indicates, "Oral memory works effectively with 'heavy' characters, persons whose deeds are monumental, memorable and commonly public. . . . Colorless personalities cannot survive oral mnemonics" (*Orality and Literacy*, 70). To Gorky his mother was a memorable and tragic figure, whom he ren-dered monumental in his painting.

Beyond the tragic circumstances of his mother's death, there were other reasons for the intensity of their relationship. As the only son, Gorky was the favorite child by Armenian custom. With his father gone, his mother became the focal point of his life and his protector in a hostile world. Yet during the massacres, he had to assume responsibilities usually reserved for the father because he was the only male in the family.

17. Ong, *Orality and Literacy*, 11, 24.

18. Letter to Vartoosh Mooradian, 3 June 1946, Mooradian, ed., *Many Worlds*, 296–297.

19. Letter to Vartoosh Mooradian, 22 April 1944, Mooradian, ed., *Many Worlds*, 287.

20. Letter to Vartoosh Mooradian, December 1944, Mooradian, ed., *Many Worlds*, 289.

21. Levy, *Arshile Gorky*, 34. Levy is the source for Gorky's statement about this painting. While its authenticity is without doubt, Levy does offer a qualification. He tells us that he was not present at the naming of pictures prior to 1947. Nor could he "recapture the precise cadence of Gorky's talk, obscured as it was by his hilarious accent. But it is an approximation, a distillation of endless hours with Gorky, discussing paintings, planning his shows" (35).

22. Vartoosh Mooradian has recounted how she and Gorky would sit in Washington Square to watch the children play: " 'Vartoosh,' he explained, 'this one draws just like Uccello.' And Gorky would put a piece of chalk in the hand of the child, who was barely two years old, and the child would draw on the sidewalk. 'These are the authentic artists,' he told me, 'who draw lines in their days of purity and thereby release innocence. When we try to do that, we face difficulty, but for them it is very natural and easy' " (Mooradian, ed., *Many Worlds*, 38).

23. Ong, *Orality and Literacy*, 13.

24. Beneath the layers of an idealized portrait of Shushanik Adoian is some evidence of tension and conflict between mother and son. On the one hand, Gorky's mother introduced him to Armenian high culture. After they left the family home in Khorkom she took him to see the paintings and stone carvings in the churches around Van. Years later in a letter dated 26 September 1939, Gorky tried to convey to Vartoosh his sense of excitement upon first viewing this art: "The golden wall paintings in our great vank [church] and my heart pounding in fear as Mother held my hand. The Armenian kings on silver horses slaying god's enemies and the purple warriors and all the faces becoming chalk when the procession of the bishop's ancient candles danced toward them" (Mooradian, ed., *Many Worlds*, 265).

But on the other hand, Gorky's mother did not entirely approve of her son's avocation. After his death Vartoosh recalled that her brother "drew all the time" in Armenia, presumably even while they were on the move after leaving their family home. She added, "Mother did not think much of Gorky's art and thought that he was wasting entirely too much time and especially money on foolishness. But Gorky continued sketching on anything he could conve-

niently get hold of" (typescript in Gorky file, correspondence H—O, in Archives at the Whitney Museum of American Art). Vartoosh's testimony suggests, then, some conflict between mother and son over his artistic efforts. His mother's view might have been entirely reasonable, given the precarious economic circumstances of the family. Gorky obviously established an early pattern of sacrificing bodily comfort for art supplies—a predisposition so evident during the Depression.

25. For Ong, struggle is central to oral performance: "orality situates knowledge within a context of struggle" (*Orality and Literacy*, 44). Gorky's struggle in painting can be sensed from a comment to Vartoosh 18 April 1938: "Today I painted so intensely that my knees are trembling from standing so long" (Mooradian, ed., *Many Worlds*, 259).

26. Ong, *Orality and Literacy*, 11.

27. Nora Nercessian claims that Gorky "tried to internalize the conflict and meaning of historical changes Armenians have undergone in the twentieth century." Although his memories were intense, they were memories nonetheless, and hence she considers them "abstractions of earlier moments" existing in constant flux. As a consequence, Gorky could not paint fixed and recognizable images lest he betray the flux of his memory. With this argument, Nercessian accounts not only for Gorky's abstraction but also the metamorphic quality of his imagery, their elusive and ambiguous shapes. See "Beyond the Armenian Self-Image: The Art of Minas Avetisian and Arshile Gorky," in Richard G. Hovannisian, ed., *The Armenian Image in History and Literature* (Malibu, Cal.: Undena Publications, 1981), 224, 237.

28. For an understanding of Gorky's pictorial development, I have relied heavily on Jim J. Jordan and Robert Goldwater, *The Paintings of Arshile Gorky: A Critical Catalogue* (New York: New York University Press, 1982), 69–74, 80–81, for a discussion of the Khorkom and Sochi series respectively.

29. Rosenberg, for example, speaks of Gorky's "transformation" with the timely arrival of the Surrealists during the Second World War (*Arshile Gorky*, 98). Motherwell has also spoken of Gorky's "conversion" to automatism (Simon, "Interview with Motherwell," 22).

30. Letter to Vartoosh Mooradian, 9 February 1942, Mooradian, ed., *Many Worlds*, 276. The statement for The Museum of Modern Art is quoted fully in Rand, *Arshile Gorky*, 73–74. Although Rand offers a sensitive reading of this statement, he nonetheless sees "bizarre particulars" in the description, such that he believes Gorky intended the passage to sound "fantastic and utterly unbelievable" (74). I tend to agree with William Rubin, who sees Gorky's account as made up of "awkward but straightforward recollections" ("Arshile

Gorky, Surrealism, and the New American Painting," *Art International* 7 [25 February 1963]: 34).

It is necessary to go beyond a simple correlation of verbal and visual imagery for an iconographical analysis to an identification of rhetorical patterns in Gorky's writing. At the same time that he acknowledged the integrity of visual communication, he claimed that it did not preclude verbal commentary: "Man communicates through his work," he wrote to Vartoosh, "but it is also necessary for an artist to communicate ideas with those who understand" (letter to Vartoosh Mooradian, 25 February 1941, Mooradian, ed., *Many Worlds*, 269). Gorky's ideas, however, often existed within a poetic framework that transcended rational discourse.

31. Letter to Vartoosh Mooradian, 9 February 1942, Mooradian, ed., *Many Worlds*, 276. The best essay on Gorky's paintings beginning in the early 1940s is Dale McConathy, "Gorky's Garden: The Erotics of Paint," *artscanada* XXXVIII, no. 2 (July–August 1981): xvi, 1–3. He and I arrived independently at our essentially similar interpretations, though he places more emphasis on the erotic qualities of Gorky's painting.

32. Letter to Vartoosh Mooradian, 3 July 1937, Mooradian, ed., *Many Worlds*, 253–254.

33. Letter to Vartoosh Mooradian, 28 February 1938, Mooradian, ed., *Many Worlds*, 257.

34. William Rubin specifically cites Picasso's *Girl Before a Mirror* (1932), which was on view in New York at the Valentine Gallery in 1936, as a source of biomorphism for Gorky ("Arshile Gorky, Surrealism, and the New American Painting," 29).

35. Jordan and Goldwater, *Arshile Gorky*, 76. For another account of the development of Gorky's painterly changes, see Rubin, "Arshile Gorky, Surrealism, and the New American Painting," 29–31.

36. Letter to Vartoosh Mooradian, 26 January 1944, Mooradian, ed., *Many Worlds*, 283. The phrase was implied as early as 3 July 1937 in a letter to Vartoosh Mooradian (Mooradian, ed., *Many Worlds*, 253).

37. Letter to Vartoosh Mooradian, 25 February 1941, Mooradian, ed., *Many Worlds*, 269.

38. Letter to Vartoosh Mooradian, 25 February 1941, Mooradian, ed., *Many Worlds*, 269–270.

39. Letters to Vartoosh Mooradian, 3 May 1943, 26 January 1944, 22 April 1944, Mooradian, ed., *Many Worlds*, 280, 282–283, 287.

40. Letter to Vartoosh Mooradian, 14 February 1944, Mooradian, ed., *Many Worlds*, 285.

41. Letter to Vartoosh Mooradian, 24 November 1940, Mooradian, ed., *Many Worlds*, 268.

42. Gorky implicitly recognized such sustenance to be central to his art. Scarcely a month later in March 1942 he compared the "creative process" to a mental "seed" "buried in fertile ground" (Letter to Vartoosh Mooradian, 20 March 1942, Mooradian, ed., *Many Worlds*, 277–278).

43. Letter to Vartoosh Mooradian, 14 February 1944, Mooradian, ed., *Many Worlds*, 285.

44. Gorky claimed that he named the Sochi series after a resort on the Black Sea because he felt that such a title had an exotic familiarity about it (Letter to Vartoosh Mooradian, July 1943, Mooradian, ed., *Many Worlds*, 280). Too much can be made of Gorky's "disguises," although Rosenberg astutely notes the connection between "making one-self" (the immigrant) and "make-up (self-disguise)" (*Arshile Gorky*, 22–23). Gorky's persona, however, was well within the range of immigrant behavior; that it was put to artistic use does not mean that we should make it any more extraordinary than it was.

45. Letter to Vartoosh Mooradian, July 1943, Mooradian, ed., *Many Worlds*, 280–281; Levy, *Memoir of an Art Gallery*, 283.

46. Letter to Vartoosh Mooradian, 9 February 1942, Mooradian, ed., *Many Worlds*, 276.

47. Rand offers some appreciative descriptions of Gorky's drawings of the Nighttime, Enigma, and Nostalgia themes (*Arshile Gorky*, 53–55).

48. In his detailed discussion of the iconography of the *Nighttime, Enigma, and Nostalgia* series, Rand points out that De Chirico's painting *The Fatal Temple* (1913) was exhibited at the Washington Square Gallery of Living Art. Inscribed on the canvas are a number of phrases, including "enigma" (62–63). De Chirico had several exhibitions in New York galleries during the late 1920s, before the Surrealist onslaught of the 1930s when he was well represented.

49. Quoted in Diane Waldman, *Arshile Gorky: A Retrospective* (New York: Harry N. Abrams, 1981), 41.

50. For a survey of Graham's work, see Eleanor Green, *John Graham: Artist and Avatar* (Washington, D.C.: Phillips Collection, 1987); Marcia Epstein Allentuck, ed., *John Graham's System and Dialectics of Art* (Baltimore: Johns Hopkins Press, 1971). For a consideration of their similarities and differences, see Barbara Rose, "Arshile Gorky and John Graham: Eastern Exiles in a Western World," *Arts* 50, no. 7 (March 1976): 62–69. Perhaps the best account of Graham's contradictions as an artist and a thinker is Hayden Her-

rera, "Le Feu Ardent: John Graham's Journal," *Archives of American Art Journal* 14, no. 2 (1974): 6–17.

51. John Graham, "Eight Modes of Modern Painting," *Art Front* I, no. 2 (January 1935): 7. The same issue contained Stuart Davis's criticism of Salvador Dali, showing at Julien Levy's (7).

52. Graham, "Eight Modes of Modern Painting," 7.

53. Letters to Vartoosh Mooradian, 14 January 1939, 26 September 1939, Mooradian, ed., *Many Worlds*, 261–265.

54. In early 1942 Gorky wrote to Vartoosh: "Dearest one, I search for new infinities. I paint in series for an important purpose. If one painting, Vartoosh dearest, is a window from which I see one infinity, I desire to return to that same window to see other infinities. And to build other windows looking out of known space into limitless regions. Continuously imposing new ideas or changes on one canvas mars the window by fogging it. In elaborating upon the completion of one window or canvas. By that I mean one finite. In doing that I attempt to extract additional unknowns. I place air in my works. They are my windows viewing infinity" (Letter to Vartoosh Mooradian, 9 February 1942, Mooradian, ed., *Many Worlds*, 277). Later, Gorky connected these "infinities" to Armenia: "Infinity transcends space," he claimed. "The beautiful apricot of Armenia is finite in size. But if its interior is probed, if it is exploded and explored, infinities are discovered." In his painting he wants "to make finite the many Armenian infinities" (Letter to Vartoosh Mooradian, 17 February 1947, Mooradian, ed., *Many Worlds*, 317). Mooradian has reconstructed Gorky's aesthetics within the context of Armenian philosophy (see *Arshile Gorky Adoian*, 41–56, 73–97).

 Whatever the source of Gorky's thinking, it paralleled the ideas of Onslow Ford and Matta in the early 1940s. Gorky is thought to have attended Onslow Ford's lectures at the New School in early 1941 (see Martica Sawin, "The Cycloptic Eye, Pataphysics and the Possible: Transformations of Surrealism," in *The Interpretive Link:* 37).

55. Schwabacher, *Arshile Gorky*, 104. Noguchi, however, thought that he might have introduced the two either in his studio or Gorky's (Mooradian, ed., *Many Worlds*, 182).

56. Simon, "Interview with Busa and Matta," 19; Levy, *Arshile Gorky*, 24. According to Motherwell, "About two years later [c. 1944], Matta, on his own, converted Gorky to the theory of automatism. Gorky in those days wouldn't pay much attention to what we said, although I spent a whole evening at Peggy Osborn's house telling him all about Surrealism, about which, incidently, he knew very little. This would be the spring 1942"

(Simon, "Interview with Motherwell," 22). Motherwell's memory of Gorky's resistance rings true, except for the notion that he did not know much about Surrealism.

57. Ong speaks of a "fictional complex held together largely in the unconscious" (*Orality and Literacy*, 25).

58. In addition to Desnos, who could speak automatically, Levy has suggested that Eluard would hum to himself "to stimulate the birth of a poem": Virtually following Ong's theory of orality, Eluard claimed, "I echo very softly in my interior, filling the melody with my own errant words" (Levy, *Memoir of an Art Gallery*, 284).

59. Schwabacher, *Arshile Gorky*, 104; Breton, "Matta," in André Breton, *Surrealism and Painting*, tr. Simon Watson French (New York: Harper and Row, 1972), 184n. For Noguchi's recollections, see Mooradian, ed., *Many Worlds*, 182; for Gorky's comments leading to the titles, see Levy, *Arshile Gorky*, 34–36.

60. Breton's essay was entitled "Eye-Spring" for the March 1945 exhibition. It was retitled "Arshile Gorky" and appears in Breton, *Surrealism and Painting*, 199–201.

61. Breton, "Arshile Gorky," 200; James Johnson Sweeney, "Five American Painters," *Harper's Bazaar* (April 1944): 122, 124; Letter to Vartoosh Mooradian, 26 January 1944, Mooradian, ed., *Many Worlds*, 282.

62. Letter to Vartoosh Mooradian, 9 February 1942, Mooradian, ed., *Many Worlds*, 276.

63. Ong claims a "unique relationship of sound to interiority when sound is compared to the rest of the senses" (*Orality and Literacy*, 71). One's interior is in turn inextricably tied to one's sense of "bodiliness." The ultimate effect is that "the phenomenology of sound enters deeply into human beings' feel for existence, as processed by the spoken word" (*Orality and Literacy*, 73).

CHAPTER 11: THE SECRET SCRIPT OF
JACKSON POLLOCK

1. "Jackson Pollock: Is He the Greatest Living Painter in the United States?" *Life* XXVII (8 August 1949): 42.

2. Ibid., 45.

3. Hans Namuth, "Photographing Pollock," Barbara Rose, ed., *Pollock Painting* (New York: Agrinde Publications, 1978): n.p.

4. "Jackson Pollock: Is He the Greatest Living Painter in the United States?" *Life* XXVII (8 August 1949): 42, 45. Greenberg predicted that Pollock would

compete with John Marin "for recognition as the greatest American painter of the twentieth century" in a review of Pollock's one-man show at Betty Parsons in early January 1948 ("Art," *Nation*, 24 January 1948, p. 108); Tyler compared Pollock's pourings to macaroni in "Nature and Madness among the Younger Painters," *View*, ser. V, no. 2 (May 1945): 30; he soon completely revised his opinion in "Jackson Pollock: The Infinite Labyrinth," *Magazine of Art* 43, no. 3 (March 1950): 92–93. Pollock sent Tyler's essay to Alfonso Ossorio (Francis V. O'Connor and Eugene V. Thaw, eds., *Jackson Pollock: A Catalogue Raisonné of Paintings, Drawings, and Other Works* [New Haven: Yale University Press, 1978], vol. 4, 247). For a discussion of the *Life* article, see Ellen G. Landau, *Jackson Pollock* (New York: Harry N. Abrams, 1989), 181–182. *Life*'s treatment of Pollock is on a continuum with *Vogue*'s publication of Cecil Beaton's fashion photographs, in which Pollock's paintings serve as backdrops for models. Timothy J. Clark discusses their significance in "Jackson Pollock's Abstraction," in Serge Guilbaut, ed., *Reconstructing Modernism: Art in New York, Paris, and Montreal 1945–1964* (Cambridge: MIT Press, 1990), 172–243.

5. Jackson Pollock, "My Painting," *Possibilities*, no. 1 (Winter 1947–1948): 79.

6. This painting was subsequently titled *Summertime: Number 9A*, according to Lee Krasner's recollection of what Pollock had called it (see O'Connor and Thaw, eds., *Jackson Pollock: A Catalogue Raisonné*, vol. 2: 26–27).

7. Noted by B. H. Friedman in Jeffrey Potter, *To a Violent Grave: An Oral Biography of Jackson Pollock* (New York: G. P. Putnam's Sons, 1985), 115.

8. Hans Namuth, "Photographing Pollock," n.p.

9. From his narration for the film *Jackson Pollock* (1951), filmed and directed by Hans Namuth, edited by Paul Falkenberg.

10. Robert Goodnough, "Pollock Paints a Picture," *Art News* (May 1951): 38–41, 60–61.

11. Hans Namuth, "Photographing Pollock," n.p.

12. Rosalind Krauss's emphasis upon the mediation of the camera in discussing Namuth's still photographs of Pollock painting as a way of comprehending that "reality" applies to Namuth's filming of Pollock as well ("Reading Photographs as Text," in Rose, ed., *Pollock Painting*, n.p.). *Number 29, 1950*, as the painting on glass was titled, was actually shown at the Betty Parsons Gallery in 1950, so the painting was not simply a documentary stunt. The work now resides in the collection of The National Gallery of Canada, Ottowa (see O'Connor and Thaw, eds., *Jackson Pollock: A Catalogue Raisonné*, vol. 4: 111).

13. Namuth, "Photographing Pollock," n.p.

14. Clement Greenberg's emphasis upon the picture plane came to the fore in his discussion of those Surrealist painters (primarily Masson, Picasso, Miró, and Arp) who employed automatism. *Their* work (as opposed to the image-oriented painting of Ernst, Dali, and Tanguy) involved "a new way of seeing as well as new things to be seen." As a consequence, their pictures "attain virtuality as art only through paint on a flat surface" ("Surrealist Painting," *Nation* 159, no. 8 [19 August 1944]: 219–220). Here, then, was a link between Pollock's "formalism" of the poured paintings and Surrealist automatist painting as conceived by Greenberg.

 For an analysis of the theoretical assumptions underlying Greenberg's criticism, see Donald B. Kuspit, *Clement Greenberg: Art Critic* (Madison: University of Wisconsin Press, 1979). For a survey of the criticism of the 1940s, see Stephen Foster, *The Critics of Abstract Expressionism* (Ann Arbor: UMI Research Press, 1980).

15. Pollock, "My Painting," 79.

16. For a theoretical and historical discussion of documentary, see William S. Stott, *Documentary Expression and Thirties America* (New York: Oxford University Press, 1973).

17. Irving Sandler, *The Triumph of American Painting: A History of Abstract Expressionism* (New York: Praeger, 1970).

18. O'Connor and Thaw, eds., *Jackson Pollock: A Catalogue Raisonné*, vol. 4: 192. For a discussion of Pollock's efforts at mythologizing himself, see Thomas B. Hess, "Pollock: The Art of the Myth," *Art News* LXII, no. 9 (January 1964): 39–41, 62–63. Hess notes that Pollock (unlike Gatsby) "made neither art nor myth out of nothing and nowhere, but from the available materials of history—in spite of his insistence on his total originality" (40). B. H. Friedman directly attacks the "false myth of Pollock—the story of the artist who came from nowhere" ("A Reasoned Catalogue Is Almost a Life," *Arts* 53, no. 7 [March 1979]: 101).

19. Timothy J. Clark notes Pollock's efforts at self-publicity ("Jackson Pollock's Abstraction," 176). In their recent biography of Pollock, Steven Naifeh and Gregory White Smith go so far as to call his collaboration with Namuth a "promotional" opportunity (*Jackson Pollock: An American Saga* [New York: Clarkson N. Potter, 1989], 619). For a provocative view of avant-gardism, careerism, and Americanism in the period after the Second World War, see Serge Guilbaut, *How New York Stole the Idea of Modern Art: Abstract Expressionism, Freedom, and the Cold War*, tr. Arthur Goldhammer (Chicago: The University of Chicago Press, 1983).

20. Letter to his father, Leroy Pollock, February 1932; postcard to Charles Pollock, 10 June 1931 (O'Connor and Thaw, eds., *Jackson Pollock: A Catalogue Raisonné*, vol. 4: 212, 209).

21. Krasner has said, "Pollock didn't verbalize at all times. He kept things pretty much to himself; occasionally he said something" (Barbara Rose, "Pollock's Studio: Interview with Lee Krasner," in *Pollock Painting*, n.p.). Krasner, however, equivocated on Pollock's verbal abilities. In 1967 she claimed, "It is a myth that he wasn't verbal. He could be hideously verbal when he wanted to be. Ask the people he really talked to: Tony Smith and me. He was lucid, intelligent; it was simply that he didn't want to talk art" ("Who Was Jackson Pollock?" Interviews by Francine du Plessix and Cleve Grey, *Art in America* 55, no. 3 [May–June 1967]: 51). By this view, Pollock's silence about art was deliberate, and conforms to a larger ideological pattern that has been discerned among the Abstract Expressionists. See Ann Gibson, "Abstract Expressionism's Evasion of Language," *Art Journal* 47, no. 3 (Fall 1988): 208–214.

22. Letter to Charles Pollock, 31 January 1931, in O'Connor and Thaw, eds., *Jackson Pollock: A Catalogue Raisonné*, vol. 4: 209.

23. William Rubin has noted Pollock's "meditative phase" in the process of painting, a phase perhaps as important as Pollock's "action." He claims that "Pollock was also at work *during the hours he stared at the unfinished canvas* as it hung tacked to the wall of the studio or spread on the floor" ("Jackson Pollock and the Modern Tradition, Part I," *Artforum* V, no. 6 [February 1967]: 15).

24. Pollock to Leroy Pollock, February 1932, and to his mother, May 1932, in O'Connor and Thaw, eds., *Jackson Pollock: A Catalogue Raisonné*, vol. 4: 212, 213. William Rubin picks up on Pollock's insights about art and life by insisting that every artist engages in "a process of self-interrogation and self-discovery" in making their work ("Pollock as Jungian Illustrator: The Limits of Psychological Criticism," *Art in America* 67 [November 1979]: 112).

25. Sidney Janis, *Abstract and Surrealist Art in America* (New York: Reynal & Hitchcock, 1944), 112. For an implicit corroboration of these attitudes, see *Arts & Architecture* LXI (February 1944): 14, interview reprinted in O'Connor and Thaw, eds., *Jackson Pollock: A Catalogue Raisonné*, vol. 4: 232.

26. Janis, *Abstract and Surrealist Art in America*, 106.

27. Reported by Parker Tyler to Robert Goldwater, editor of *Magazine of Art*, 11 May 1950. Pollock Archives, Archives of American Art, Smithsonian Institution, Washington, D.C., roll 3046, frame 345.

28. [Berton Roueché], "Unframed Space," *New Yorker* XXVI (5 August 1950): 16.

29. Taped interview with William Wright, 1950, reprinted in O'Connor and Thaw, eds., *Jackson Pollock: A Catalogue Raisonné*, vol. 4: 248–251.

30. Pollock, "My Painting," 79.

31. Lee Krasner recounted that Pollock once "asked me, 'Is this a painting?' Not is this a good painting or a bad one, but a *painting!* The degree of doubt was unbelievable at times" (Interviewed by B. H. Friedman, in *Jackson Pollock* [New York: Marlborough-Gerson Gallery, 1969]: 8).

32. Mrs. Helen K. Sellers to Pollock, 8 August 195[?], Pollock Archives, AAA, roll 3046, frames 483–484.

33. Pollock's library had a Modern Library edition (1921) of Whitman's poems. For an impressionistic—in the best sense of the word—comparison of Pollock and Whitman, see Edwin H. Miller, "The Radical Vision of Whitman and Pollock," in Edwin H. Miller, ed., *The Artistic Legacy of Walt Whitman* (New York: New York University Press, 1970): 55–71. For a summary of Pollock's image in the context of popular culture (James Dean and others), see Landau, *Jackson Pollock*, 15–21. Also see Mary Lee Corlett, "Jackson Pollock: American Culture, The Media and The Myth," *Rutgers Art Review* 8 (1987): 71–108.

34. For Pollock and Benton, see Stephen Polcari, "Jackson Pollock and Thomas Hart Benton," *Arts* 53, no. 7 (March 1979): 120–124. For Benton, see Henry Adams, *Thomas Hart Benton: An American Original* (New York: Alfred A. Knopf, 1989): 222–225.

35. Landau, *Jackson Pollock*, 38. She sees the painting as an "inscape," psychological rather than geographical or regional in interest.

36. B. H. Friedman, "An Interview with Lee Krasner Pollock," in Rose, ed., *Pollock Painting*, n.p.; letter from Sanford Pollock to Charles Pollock, May 1940, in O'Connor and Thaw, eds., *Jackson Pollock: A Catalogue Raisonné*, vol. 4: 224.

37. Statement in application for a Guggenheim fellowship (1947), quoted in O'Connor and Thaw, eds., *Jackson Pollock: A Catalogue Raisonné*, vol. 4: 238.

38. *Arts & Architecture* LXI (February 1944): 14, reprinted in O'Connor and Thaw, eds., *Jackson Pollock: A Catalogue Raisonné*, vol. 4: 232.

39. Ibid.

40. Krasner asserted that "there's no question that he admired Picasso and at the same time competed with him, wanted to go past him. Even before we lived in East Hampton, I remember one time I heard something fall and then Jackson

yelling, 'God damn it, that guy missed nothing!' I went to see what had happened. Jackson was sitting, staring; and on the floor, where he had thrown it, was a book of Picasso's work" (B. H. Friedman, "An Interview with Lee Krasner Pollock," in Rose, ed., *Pollock Painting*, n.p.).

41. Janis, *Abstract and Surrealist Art in America*, 112. Closing down the literary was a way to privatize it, to sustain the psychic secrets on the canvas: Pollock did not abjure the literary so much as run it underground.

42. Although Pollock was simmering, simmering, as Whitman wrote about his own poetic gestation, it is obvious that Surrealism alone did not bring him to a boil as Emerson did Whitman. Surrealism, however, certainly raised the cultural pressure in activating Pollock. At the most fundamental level, as Francis V. O'Connor has claimed, Surrealism gave Pollock "a subtle permission to be creatively free" ("The Genesis of Jackson Pollock: 1912–1943," *Artforum* V [May 1967]: 23, fn. 24).

43. "How a Disturbed Genius Talked to His Analyst with Art," *Medical World News* 12, no. 5 (5 February 1971): 25, 18 (unsigned article, thought to have been written by Joseph Henderson). These "psychoanalytic drawings," as they have been dubbed, were published by C. L. Wysuph, *Jackson Pollock: Psychoanalytic Drawings* (New York: Horizon Press, 1970). Unlike Wysuph, who accepted their therapeutic status (at the same time that the drawings had entered the art network), Claude Cernuschi has reassessed these drawings in *Jackson Pollock: "Psychoanalytic" Drawings* (Durham: Duke University Press, 1992). Cernuschi exposes the inconsistencies and contradictions in Henderson's accounts of his sessions with Pollock. For example, it is not at all clear that the artist volunteered to bring in the drawings; he may have been asked by Henderson to do so (18–20). In any case, the status of these drawings, as either therapeutic aids or exercises with artistic intent, remains unclear.

44. Though André Breton did not take up Carl Jung, the Swiss psychoanalyst's virtues over Freud were manifold for Surrealism. Jung emphasized the collective unconscious and so would have provided a useful theoretical bridge for the Surrealists between the individual psyche and society. His sanction for exploring the self in its social connections also would have been helpful during the politically intense decade of the Depression. Equally important, Jung's stress on images from the unconscious would have served to counter skepticism about the visual character of the unconscious and the subsequent validity of automatic drawing. The importance of Jung for Pollock has not been overlooked by critics. See, among others, Judith Wolfe, "Jungian Aspects of Jackson Pollock's Imagery," *Artforum* 11, no. 3 (November 1972):

65–73; David Freke, "Jackson Pollock: A Symbolic Self-Portrait," *Studio International* 184 (December 1973): 217–221.

45. Phillip Leider has noted that Pollock borrowed imagery from a Jungian text by M. Esther Harding, *Woman's Mysteries, Ancient and Modern* (New York: Longmans, Green, 1935), in "Surrealist and Not Surrealist in the Art of Jackson Pollock and His Contemporaries," in *The Interpretive Link: Abstract Surrealism into Abstract Expressionism, Works on Paper, 1938–1948*, organized by Paul Schimmel (Newport Beach, Cal.: Newport Harbor Art Museum, 1986), 43–44. For a rigorous critique of Pollock's Jungian critics, see William Rubin, "Pollock as Jungian Illustrator: The Limits of Psychological Criticism," parts I and II, *Art in America* 67 (November/December 1979): 104–123, 72–91.

46. See, for example, a letter that Rothko, Gottlieb, and Newman (who did not sign) wrote to Edward Alden Jewell, published in the *New York Times* 7 June 1943 (reprinted in full in *Adolph Gottlieb: A Retrospective* [New York: Art Publisher, Inc., 1981], 169).

47. For a survey of Surrealism and "primitivism," see Elizabeth Cowling, "The Eskimos, the American Indians and the Surrealists," *Art History* I, no. 4 (December 1978): 484–500.

48. For Henderson's interests in Native American art, see Naifeh and Smith, *Jackson Pollock: An American Saga*, 336–337. John Graham apparently accompanied Pollock to The Museum of Modern Art's exhibition of "Indian Art of the United States" in 1941 (Naifeh and Smith, 357), as did Violet Staub de Laszlo and Peggy Guggenheim (Landau, *Jackson Pollock*, 56, 251 n. 18). If these reports are reliable, Pollock must have haunted the exhibition, allowing the possibilities of ritual to sink in.

49. "Charley and the Grandson," *Time* XXXVII, no. 14 (7 April 1941): 68; Frederic H. Douglas and René D'Harnoncourt, *Indian Art of the United States* (New York: Museum of Modern Art, 1941), 118.

50. Specific references to Native American visual forms were accompanied by generalized "primitive" images in Pollock's drawings and paintings, ranging from masks and totemic figures to ritual activity.

51. In 1936, when Eugene Jolas moved his magazine to New York, Sweeney became associate editor for *transition*, no. 24 (June 1936). The magazine continued to pursue its interests in the unconscious, myth, and language, publishing the occasional Surrealist.

52. For a contrary view, one that bridges Jung and the "primitive," see Elizabeth L. Langhorne, "Pollock, Picasso and the Primitive," *Art History* 12, no. 1 (March 1989): 66–92. Also see W. Jackson Rushing, "Ritual and Myth: Na-

tive American Culture and Abstract Expressionism," in *The Spiritual in Art: Abstract Painting, 1890–1985* (Los Angeles and New York: Los Angeles County Museum of Art and Abbeville Press, 1986), 273–296.

53. In arguing against Jungian interpretations of Pollock's work, William Rubin rightly stresses Pollock as a *painter*, with intense interest in painting itself: "Little sense of Pollock as painter comes through [in their Jungian interpretations]; in fact, almost everything they say about his work could have been said about a bad painter working with another method in another style—a retardaire Surrealist *imagier*, for example—as long as he used the same symbols. Their texts reflect virtually no awareness of the way in which the problems and choices of the painting process bear upon the determination of the forms and colors that they interpret only iconographically" ("Pollock as Jungian Illustrator: The Limits of Psychological Criticism," part I, 106).

54. See Laurance P. Hurlburt, "The Siqueiros Experimental Workshop: New York 1936," *Art Journal* 35 (Spring 1976): 237–246.

55. For the complex interrelationships between Pollock's painting and his drawing, see Bernice Rose, *Jackson Pollock: Drawing into Painting* (New York: Museum of Modern Art, 1980).

56. "Art," *Nation* 168 (28 May 1949): 621–622. This particular issue with Pollock's doodles on the back cover can be found in the Pollock Archives, AAA, roll 3046, frames 262–263.

57. Simon, "Interview with Busa and Matta," 17.

58. Statement by Gerome Kamrowski, quoted in Wechsler, *Surrealism and American Art* (New Brunswick: Rutgers University Art Gallery, 1977), 55.

59. According to Motherwell, "After several months [late winter or early spring, 1942], Pollock and I became somewhat friendly. He and his wife and I and my wife and the two Baziotes used to write automatic poems together, which I kept in a book. Unfortunately, this book is now lost, given away or stolen" (Simon, "Interview with Motherwell," 22).

60. At about the same time that Pollock was engaged in his print workshop, Stanley Hayter wrote an essay titled "Line and Space of the Imagination," *View*, ser. IV, no. 4 (December 1944): 126–128, 140, which extolled the "expressive ambiguities" of line, involving "motion and the exercise of force of the simplest order" (140, 127). Pollock must have found such ideas congenial. For an account of Hayter and the Abstract Expressionists, see Lanier Graham, *The Spontaneous Gesture: Prints and Books of the Abstract Expressionist Era* (Canberra: Australian National Gallery, 1987).

61. Stanley Hayter, "Of the Means," *Possibilities*, no. 1 (Winter 1947–1948): 77.

62. In an interview with Barbara Rose, Krasner indicated that she could not re-

member when Pollock began pouring paint, though she recalled that *The Key* was painted on the bedroom floor of their house in Springs (c. 1945) before the barn was set up as his studio ("Pollock's Studio: Interview with Lee Krasner," in Rose, ed., *Pollock Painting,* n.p.).

63. Breton, "Surrealism and Painting," in André Breton, *Surrealism and Painting,* tr. Simon Watson French (New York: Harper and Row, 1972), 1.

64. It should be noted, however, that Brentano's published *Surrealism and Painting* in the original French: *Le Surréalisme et la Peinture, suivi de Genèse et Perspective Artistiques du Surréalisme et de Fragments Inédits* (New York: Brentano's, 1945). While it is virtually certain that Pollock would not have read *Surrealism and Painting,* he might well have known of the work through friends, and in any case, Breton's challenge still held.

65. William Rubin rightly notes that "Surrealist automatism involved the artist's wrist, sometimes his arm; Pollock's involved his arm and, especially, in the larger pictures, his whole body" ("Jackson Pollock and the Modern Tradition, Part I," 15).

66. Pollock made this claim for new painting in his 1947 statement for a Guggenheim fellowship and again in 1950 in a taped interview with William Wright (in O'Connor and Thaw, eds., *Jackson Pollock: A Catalogue Raisonné,* vol. 4, 238 and 251).

CONCLUSION: OUT OF THE LABYRINTH

1. Parker Tyler, "Jackson Pollock: The Infinite Labyrinth," *Magazine of Art* 43, no. 3 (March 1950): 92–93.

2. Ibid.

3. Thus in favoring their conception of the "chainpoem," a variation on the Exquisite Corpse, Tyler and Ford had let participants respond to the lines that had been written by previous collaborators instead of writing blindly (which would have maximized chance).

Selected Bibliography

Abel, Lionel. *The Intellectual Follies: A Memoir of the Literary Venture in New York and Paris.* New York: W. W. Norton, 1984.

Ades, Dawn. *Dada and Surrealism Reviewed.* London: Arts Council of Great Britain, 1978.

———. *Dali.* London: Thames and Hudson, 1982.

Agee, William C. *The 1930s: Painting and Sculpture in America.* New York: Whitney Museum of American Art, 1968.

Allentuck, Marcia Epstein, ed. *John Graham's System and Dialectics of Art.* Baltimore: Johns Hopkins Press, 1971.

Alquie, Ferdinand. *The Philosophy of Surrealism.* Tr. Bernard Waldrop. Ann Arbor: University of Michigan Press, 1965.

Anderson, Margaret. *My Thirty Years' War.* New York: Covici, Friede, 1930.

Anderson, Susan M. *Pursuit of the Marvellous: Stanley William Hayter, Charles Howard, and Gordon Onslow Ford.* Laguna Beach, Cal.: Laguna Art Museum, 1990.

Aragon, Louis. *La Peinture au Défi.* Paris: Librairie José Corti, 1930.

Baker, John. *O. Louis Guglielmi: A Retrospective Exhibition.* New Brunswick: Rutgers University Art Gallery, 1980.

Balakian, Anna. *André Breton: Magus of Surrealism.* New York: Oxford University Press, 1971.

Baldwin, Neil. *Man Ray: American Artist.* New York: Clarkson N. Potter, 1988.

Barr, Alfred H., Jr., ed. *Fantastic Art, Dada, Surrealism.* New York: Museum of Modern Art, 1936.

Benincasa, Carmine, and Cleto Polcina. *André Masson: 1941–1945.* New York: Marisa del Re Gallery, 1981.

Bonk, Ecke. *Marcel Duchamp: The Box in a Valise de ou par Marcel Duchamp ou Rrose Sélavy: Inventory of an Edition.* Tr. David Britt. New York: Rizzoli, 1989.

Bonnet, Marguerite. *André Breton: Naissance de l'Aventure Surréaliste.* Paris: Librairie José Corti, 1975.

Breton, André. *Manifestoes of Surrealism.* Tr. Richard Seaver and Helen R. Lane. Ann Arbor: University of Michigan Press, 1969.

———. *Surrealism and Painting.* Tr. Simon Watson French. New York: Harper and Row, 1972.

———. *What Is Surrealism? Selected Writings.* Ed. Franklin Rosemont. New York: Monad Press, 1978.

Brown, Milton W. *The Story of the Armory Show.* Greenwich, Conn.: New York Graphic Society, 1913.

Camfield, William. *Francis Picabia: His Art, Life and Times.* Princeton: Princeton University Press, 1979; University of California Press, 1976.

Caws, Mary Ann, Rudolf Kuenzli, and Gwen Raaberg, eds. *Surrealism and Women.* Cambridge: MIT Press, 1991.

Cernuschi, Claude. *Jackson Pollock: "Psychoanalytic" Drawings.* Durham: Duke University Press, 1992.

Chadwick, Whitney. *Women Artists and the Surrealist Movement.* Boston: Little, Brown and Co., 1985.

Cone, Michele C. *Artists Under Vichy: A Case of Prejudice and Persecution.* Princeton: Princeton University Press, 1992.

Cowley, Malcolm. *The Dream of the Golden Mountains: Remembering the 1930s.* New York: Viking, 1980.

———. *Exile's Return* (New York: W. W. Norton, 1934).

Dali, Salvador. *The Secret Life of Salvador Dali.* Tr. Haakon M. Chevalier. New York: Dial Press, 1961.

D'Harnoncourt, Anne, and Kynaston McShine, eds. *Marcel Duchamp.* New York: Museum of Modern Art, 1973.

Dunlop, Ian. *The Shock of the New.* New York: American Heritage Press, 1972.

Ernst, Jimmy. *A Not-So-Still Life.* New York: St. Martin's Press/Marek, 1984.

Esten, John. *Man Ray Bazaar Years.* New York: Rizzoli, 1988.

Flying Tigers: Painting and Sculpture in New York, 1939–1946 Providence: Bell Gallery, Brown University, 1985.

Ford, Charles Henri. *Flag of Ecstasy: Selected Poems.* Ed. Edward B. Germain. Los Angeles: Black Sparrow Press, 1972.

———, ed. *View: Parade of the Avant-Garde, 1940–1947.* New York: Thunder's Mouth Press, 1991.

Ford, Hugh. *Published in Paris: American and British Writers, Printers, and Publishers in Paris, 1920–1939.* New York: Macmillan, 1975.

———, ed. *The Left Bank Revisited: Selections from the Paris Tribune, 1917–1934.* University Park, Pa.: Pennsylvania State University Press, 1972.

Foresta, Merry. *Perpetual Motif: The Art of Man Ray.* New York: Abbeville Press, 1988.

Fry, Varian. *Surrender on Demand.* New York: Random House, 1945.

Gershmann, Herbert S. *The Surrealist Revolution in France.* Ann Arbor: University of Michigan Press, 1974.

Gilbert, James B. *Writers and Partisans.* New York: John Wiley and Sons, 1968.

Gold, Mary Jayne. *Crossroads Marseilles 1940.* Garden City: Doubleday, 1980.

Graham, Lanier. *The Spontaneous Gesture: Prints and Books of the Abstract Expressionist Era.* Canberra: Australian National Gallery, 1987.

Green, Eleanor. *John Graham: Artist and Avatar.* Washington, D.C.: Phillips Collection, 1987.

Guggenheim, Peggy. *Out of This Century: Confessions of an Art Addict.* New York: Universe Books, 1979.

Guilbaut, Serge. *How New York Stole the Idea of Modern Art: Abstract Expressionism, Freedom, and the Cold War.* Tr. Arthur Goldhammer. Chicago: University of Chicago Press, 1983.

Hale, Nathan G., Jr. *Freud and the Americans: The Beginnings of Psychoanalysis in the United States. 1876–1917.* New York: Oxford University Press, 1971.

Hall-Duncan, Nancy. *The History of Fashion Photography.* New York: Alpine Book Company, 1979.

Haslam, Malcolm. *The Real World of the Surrealists.* New York: Rizzoli, 1978.

Hoffman, Frederick J., Charles Allen, and Carolyn F. Ulrich. *The Little Magazine: A History and a Bibliography.* Princeton: Princeton University Press, 1946.

Homer, William I. *Alfred Stieglitz and the American Avant-Garde.* Boston: New York Graphic Society, 1977.

Hubert, Renée. *Surrealism and the Book.* Berkeley: University of California Press, 1988.

in transition: A Paris Anthology. Intro. Noel Riley Fitch. London: Secker and Warburg, 1990.

Jackman, Jarrell C., and Carla M. Borden, eds. *The Muses Flee Hitler: Cultural*

Transfer and Adaptation, 1930–1945. Washington, D.C.: Smithsonian Institution Press, 1983.

Jaguer, Edouard. *Les Mystères de la Chambre Noire: Le Surréalisme et la Photographie.* Paris: Flammarion, 1982.

Janis, Sidney. *They Taught Themselves.* New York: Dial Press, 1942.

Jean, Marcel, ed. *The Autobiography of Surrealism.* New York: Viking, 1980.

Jordan, Jim J., and Robert Goldwater. *The Paintings of Arshile Gorky: A Critical Catalogue.* New York: New York University Press, 1982.

Josephson, Matthew. *Life Among the Surrealists.* New York: Holt, Rinehart and Winston, 1962.

Kluver, Billy, and Julie Martin. *Kiki's Paris: Artists and Lovers 1900–1930.* New York: Harry N. Abrams, 1989.

Krauss, Rosalind, and Jane Livingston. *L'Amour Fou: Photography and Surrealism.* New York: Abbeville Press, 1985.

Kuenzli, Rudolf E., ed. *New York Dada.* New York: Willis Locker and Owens, 1986.

Landau, Ellen G. *Jackson Pollock.* New York: Harry N. Abrams, 1989.

Langsner, Jules, ed. *Man Ray.* Los Angeles: Los Angeles County Museum of Art, 1966.

La Planète Affolée: Surréalisme Dispersion et Influences, 1938–1947. Marseilles and Paris: Direction des Musées de Marseilles and Editions Flammarion, 1986.

Lebel, Robert. *Marcel Duchamp.* London: Trianon Press, 1959.

Levy, Julien. *Arshile Gorky.* New York: Harry N. Abrams, 1966.

———. *Memoir of an Art Gallery.* New York: G. P. Putnam's Sons, 1977.

———, ed. *Surrealism.* New York: Black Sun Press, 1936.

Lewis, Helena. *The Politics of Surrealism.* New York: Paragon House, 1988.

Livingston, Jane. *Lee Miller Photographer.* New York: Thames and Hudson, 1989.

Lynes, Russell. *Good Old Modern: An Intimate Portrait of the Museum of Modern Art.* New York: Atheneum, 1973.

McMillan, Dougald. *Transition: The History of a Literary Era, 1927–1938.* New York: George Braziller, 1976.

McShine, Kynaston, ed. *Joseph Cornell.* New York: Museum of Modern Art, 1980.

Marquis, Alice Goldfarb. *Alfred H. Barr, Jr., Missionary for the Modern.* Chicago: Contemporary Books, 1989.

Martin, Richard. *Fashion and Surrealism.* New York: Rizzoli, 1987.

Mattison, Robert Saltonstall. *Robert Motherwell: The Formative Years.* Ann Arbor: U.M.I. Research Press, 1987.

Maurer, Evan M., and Jennifer L. Bayles. *Gerome Kamrowski: A Retrospective Exhibition.* Ann Arbor: University of Michigan Museum of Art, 1983.

Miller, Nancy. *Matta the First Decade.* Waltham, Mass.: Rose Art Museum, Brandeis University, 1982.

Mooradian, Karlen. *Arshile Gorky Adoian.* Chicago: Gilgamesh Press, 1978.

————, ed. *The Many Worlds of Arshile Gorky.* Chicago: Gilgamesh Press, 1980.

Moran, Diane Degasis. *Lorser Feitelson and Helen Lundeberg: A Retrospective Exhibition.* San Francisco: San Francisco Museum of Modern Art, 1980.

Motherwell, Robert, ed. *The Dada Painters and Poets.* New York: Harry Wittenborn, 1967.

Myers, John Bernard. *Tracking the Marvelous: A Life in the New York Art World.* New York: Random House, 1983.

Nadeau, Maurice. *The History of Surrealism.* Tr. Richard Howard. New York: Macmillan Co., 1965.

Naifeh, Steven, and Gregory White Smith. *Jackson Pollock: An American Saga.* New York: Clarkson N. Potter, 1989.

Noel, Bernard. *Marseilles New York: A Surrealist Liaison.* Tr. Jeffrey Arsham. Marseilles: André Dimanche, 1985.

O'Connor, Francis V., and Eugene V. Thaw, eds. *Jackson Pollock: A Catalogue Raisonné of Paintings, Drawings, and Other Works.* 4 vols. New Haven: Yale University Press, 1978.

Ong, Walter J. *Orality and Literacy: The Technologizing of the Word.* London: Methuen, 1982.

Pells, Richard. *Radical Visions and American Dreams.* New York: Harper and Row, 1973.

Penrose, Antony. *The Lives of Lee Miller.* New York: Holt, Rinehart and Winston, 1985.

Phillips, Lisa. *Frederick Kiesler.* New York: Whitney Museum of American Art, 1989.

Poggioli, Renato. *The Theory of the Avant-Garde.* New York: Harper and Row, 1971.

Potter, Jeffrey. *To a Violent Grave: An Oral Biography of Jackson Pollock.* New York: G. P. Putnam's Sons, 1985.

Prins, Alice. *Kiki's Memoirs.* Tr. Samuel Putnam. Paris: Black Manikin Press, 1930.

Putnam, Samuel. *Paris Was Our Mistress.* New York: Viking, 1947.

Putnam, Samuel, Maida Castelhun Darnton, George Reavey, and J. Bronowski, eds. *The European Caravan: An Anthology of the New Spirit in European Literature.* New York: Brewer, Warren and Putnam, 1931.

Rand, Harry. *Arshile Gorky: The Implication of Symbols.* Montclair, N. J.: Allanheld and Schram, 1980.

Ray, Man. *Photographs By Man Ray 1920 Paris 1934.* New York: Dover, 1979; Hartford: James Thrall Soby, 1934.

———. *Self Portrait.* Boston: Little, Brown and Co., 1963.

Ray, Paul C. *The Surrealist Movement in England.* Ithaca: Cornell University Press, 1971.

Richter, Hans. *Dada: Art and Anti-Art.* New York: Harry N. Abrams, 1965.

Roazen, Paul. *Freud and His Followers.* New York: Alfred A. Knopf, 1975.

Rood, Karen Kane, ed. *American Writers in Paris, 1920–1929. Dictionary of Literary Biography,* vol. 4. Detroit: Gale Research Company, 1980.

Rose, Barbara, ed. *Pollock Painting.* New York: Agrinde Publications, 1978.

Rose, Bernice. *Jackson Pollock: Drawing into Painting.* New York: Museum of Modern Art, 1980.

Rosenberg, Harold. *Arshile Gorky: The Man, the Time, the Idea.* New York: Sheepmeadow Press/Flying Point Books, 1962.

Rubin, William S. *Dada and Surrealist Art.* New York: Harry N. Abrams, 1968.

——— and Carolyn Lanchner. *André Masson.* New York: Museum of Modern Art, 1976.

Sandler, Irving. *The Triumph of American Painting: A History of Abstract Expressionism.* New York: Praeger, 1970.

Sanouillet, Michel. *Dada à Paris.* Paris: Pauvert, 1965.

Schimmel, Paul. *The Interpretive Link: Abstract Surrealism into Abstract Expressionism, Works on Paper, 1938–1948.* Newport Beach, Ca.: Newport Harbor Art Museum, 1986.

Schwabacher, Ethel K. *Arshile Gorky.* New York: Macmillan Co. 1957.

Schwarz, Arturo. *The Complete Works of Marcel Duchamp.* New York: Harry N. Abrams, 1969.

———. *Man Ray: 60 Years of Liberties.* Milan: Gallerie Schwarz, 1971.

———. *Man Ray: The Rigour of Imagination.* New York: Rizzoli, 1977.

Shi, David. *Matthew Josephson Bourgeois Bohemian.* New Haven: Yale University Press, 1981.

Spector, Jack. *The Aesthetic of Freud.* New York: McGraw-Hill, 1974.

Spies, Werner. *Max Ernst Loplop: The Artist's Other Self.* London: Thames and Hudson, 1983.

Starr, Sandra Leonard. *Joseph Cornell and the Ballet.* New York: Castelli, Feigen, Corcoran, 1983.

———. *Joseph Cornell: Art and Metaphysics.* New York: Castelli, Feigen, Corcoran, 1982.

———. *The Crystal Cage.* Tokyo: Gatodo Gallery, 1987.

Stich, Sidra. *Anxious Visions: Surrealist Art.* Berkeley: University Art Museum, 1990.

Swanson, Mary Towley. *Walter Quirt: A Retrospective.* Minneapolis: University of Minnesota Gallery, 1979.

Tashjian, Dickran. *Joseph Cornell: Gifts of Desire:* Miami Grassfield Press, 1992.

———. *Skyscraper Primitives: Dada and the American Avant-Garde, 1910–1925.* Middletown, Conn.: Wesleyan University Press, 1975.

———. *William Carlos Williams and the American Scene.* Berkeley: University of California Press, 1980.

Thirion, André. *Revolutionaries without Revolution.* New York: Macmillan, 1975.

Tyler, Parker. *The Divine Comedy of Pavel Tchelitchew: A Biography.* London: Weidenfeld and Nicolson, 1967.

———. *The Will of Eros: Selected Poems, 1930–1970.* Los Angeles: Black Sparrow Press, 1972.

Waldman, Diane. *Arshile Gorky: A Retrospective.* New York: Harry N. Abrams, 1981.

———. *Joseph Cornell.* New York: George Braziller, 1977.

Weaver, Mike. *William Carlos Williams: The American Background.* Cambridge: Cambridge University Press, 1971.

Weber, Nicholas Fox. *Patron Saints: Five Rebels Who Opened America to a New Art.* New York: Alfred A. Knopf, 1992.

Wechsler, Jeffrey. *Surrealism and American Art, 1931–1947.* New Brunswick: Rutgers University Art Gallery, 1977.

Weld, Jacqueline Bograd. *Peggy: The Wayward Guggenheim.* New York: E. P. Dutton, 1986.

Wolff, Geoffrey. *Black Sun: The Brief Transit and Violent Eclipse of Harry Crosby.* New York: Random House, 1976.

Woody, Jack. *George Platt Lynes: Photographs, 1931–1955.* Los Angeles: Twelvetrees Press, 1980.

Wysuph, C. L. *Jackson Pollock: Psychoanalytic Drawings.* New York: Horizon Press, 1970.

Zweig, Paul. *Lautréamont: The Violent Narcissus.* Port Washington, N.Y.: Kennikat Press, 1972.

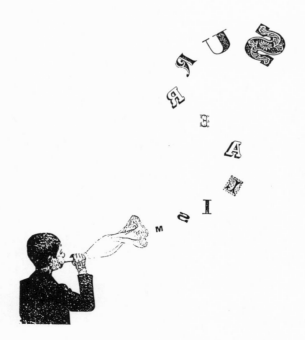

Index